D1243526

EXACTITUDE
HYPERREALIST ART TODAY

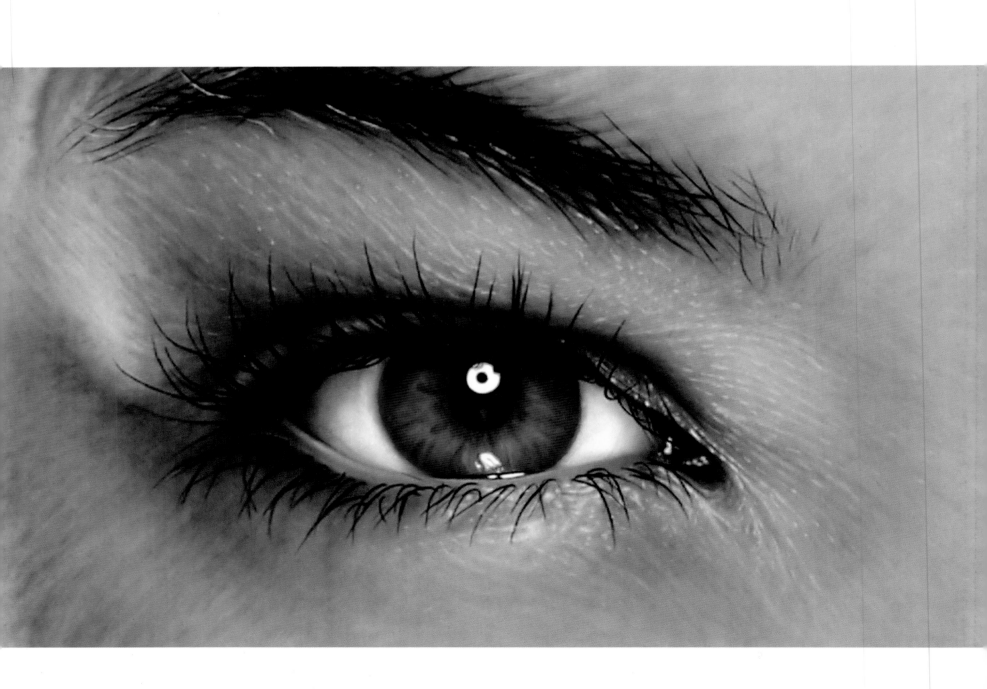

EXACTITUDE
HYPERREALIST ART TODAY

With 550 illustrations, 545 in color

John Russell Taylor

Edited by
Maggie Bollaert

Foreword by Clive Head

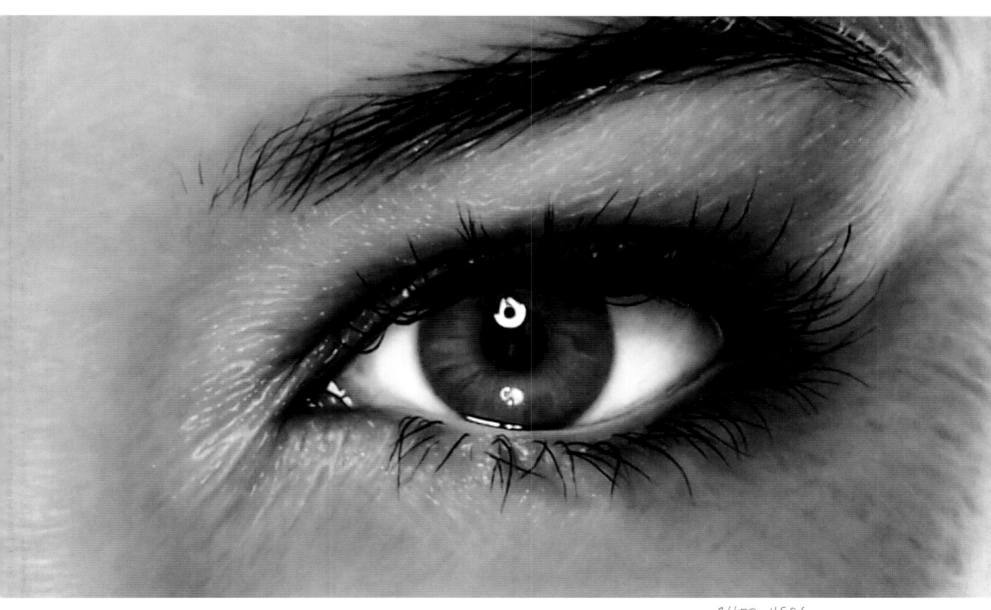

3479 4996
East Baton Rouge Parish Library
Baton Rouge, Louisiana

PLUS ONE PUBLISHING

 Thames & Hudson

To Colin,
Thank you for making it all possible, Maggie

Acknowledgments

The publishers wish to convey a special thanks to Charlotte Goodwin, Colin Pettit and Anne Schabacker at Plus One Gallery for initiating and overseeing the project and for making it happen.

Our gratitude to Louis K. Meisel, Frank Bernarducci, Ethan Karp, Ivan Karp, Cynthia Poole and Philip Wilson. Also to Markus Tellenbach for his support on this ambitious project.

Picture credits

Images by featured artists are copyright the artists; reproduction by kind permission. Images in the section on Clive Head are reproduced courtesy of Marlborough Fine Art, London. Images in the section on Ben Johnson are © Ben Johnson: all rights reserved DACS.

Acknowledgment is made to the following sources for permission to reproduce images in the Foreword and Introduction:

p. 15 © Steve West. Courtesy the artist; p. 17 © Ralph Goings. Courtesy O. K. Harris Works of Art, New York, NY; p. 28 photo Art Institute of Chicago; p. 29 photo Tate, London, 2008; p. 30 photo Tate, London, 2008; p. 31 (left) photo Munch Museum. © Munch Museum/Munch-Ellingsen Group, BONO, Oslo, DACS, London 2009; (right) photo Munch Museum. © Munch Museum/Munch-Ellingsen Group, BONO, Oslo, DACS, London 2009; p. 34 © Richard Estes, Courtesy Marlborough Gallery, New York; p. 39 (left) © Tate, London, 2009; p. 42 © Charles Sheeler. (left) Courtesy Philadelphia Museum of Art; (right) digital image © 2009 Museum of Modern Art, New York/Scala, Florence

First published in the United Kingdom in 2009 by Thames & Hudson Ltd, London WC1V 7QX and Plus One Publishing, London SW1W 8PH

© 2009 Plus Art Galleries Limited

All Rights Reserved. No part of this publication may be reproduced or transmitted in any form or by any means, electronic or mechanical, including photocopy, recording or any other information storage and retrieval system, without prior permission in writing from the publisher.

First published in 2009 in hardcover in the United States of America by Thames & Hudson Inc., 500 Fifth Avenue, New York, New York 10110

thamesandhudsonusa.com

Library of Congress Catalog Card Number 2008910757
ISBN 978-0-500-23863-9

Copy-edited and proofread by Sarah Kane
Designed by Norman Turpin
Printed and bound in China by C & C Offset Printing Co Ltd

Illustration on pages 2 and 3: Detail from Simon Hennessey's *Under Surveillance*, 2005 (see page 153)

CONTENTS

PREFACE

Maggie Bollaert and Colin Pettit
Plus One Gallery, London

WHEN WE OPENED our gallery in 2001 we did not actually have a strong focus on the type of art that we wanted to handle. We knew we would be content only if we had around us works of art that we liked and that it would give us pleasure to be involved with. It soon became apparent that we were very strongly gravitating towards works that were of a precise and even meticulous nature. In short, highly realistic works of art. Neither of us had been particularly attracted to Conceptual Art, then all the rage, but much preferred work that was clear and precise, achieving a lifelike quality in the tradition of the early masters of realism. However, we also wanted to be working with living artists and to work with truly contemporary art. We became aware of and were drawn towards early Photorealism in its many and varied forms.

Photorealism as a specific genre was established in the 1960s by the legendary Louis Meisel in New York, and it was therefore natural that we should visit him, learn from his experience and of course widen our knowledge at the same time. We also met up in New York with Ivan Karp, the other major luminary in the art world of that period. Both Ivan and Louis could not have been more helpful and constructive in sharing their vast knowledge and experience with us: the enthusiasm they both still had for art was truly inspiring and very contagious and encouraging.

Fortunately there are many artists following in these footsteps and whose raison d'être is the pursuit of perfection in their art. We were very lucky to have met great artists in the early days of running our gallery, and this has developed to the present situation, where we now represent many of the true masters actively working today.

Exactitude was the name given to our first major group show at Plus One Gallery, curated by Clive Head. The title was suggested by Clive as it seemed to embody the qualities we all loved in the art which gave us so much pleasure. There have now been four Exactitude group shows over the years, with new artists being added as the time has moved forward. This new book, *Exactitude: Hyperrealist Art Today*, seeks to put on record the works of some of the world's greatest artists in this field, and it has been our enormous pleasure to work on this exciting project.

Some of the work illustrated here is by artists who have been working consistently in this field for very many years, but it is truly wonderful to see that, as well as the more mature artists, there are many much younger artists still following this great tradition. It is clear that from the very early times of highly realistic art to modern Photorealism to Hyperrealism to Exactitude, the long line of great art is unbroken and in its contemporary form is as highly desirable now as it was in the very early days. The discerning art collector of today can still find great work which follows worthily in the illustrious footsteps of the early masters. We hope this book gives as much pleasure to read as it has given us in developing and making available.

OPPOSITE:
Cesar Santander
Passing the Harbour (detail)
2008
Oil and acrylic on canvas
77 x 112 cm

FOREWORD

Clive Head

W HEN I APPLIED THE TERM 'Exactitude', it seemed the most apt
description for a visual art of such breathtaking precision
and remarkable clarity. Although all the art shown at the
first *Exactitude* exhibition at Plus One Plus Two Gallery in 2003 was representational it did not
present a coherent approach towards realism. The work was looking in different directions. These
artists were all too aware of the conceit and the stylistic strategies in which they were engaged to
be regarded simply as realists. They were conscious of the histories that had coloured their work
and its meanings; aware too of the impossibility of divorcing art from the contexts that define it.
And their work, in its various ways, *manifested* this state. It occurred to me then that it was a rep-
resentational art made in a post-realist era.

Then and now I am drawn to such exacting qualities and such uncompromising
resolution. This is a common ground. So to make sense of what has come to
flourish at Plus One Gallery in London and is also in evidence at other galleries
both here and abroad, I would propose regarding this activity beyond the con-
cerns of realist art.

Despite their sheer brilliance in depicting textures, spaces and detail, many of
the artists connected with Exactitude do not have a desire to replicate the world.
There is as much idealism here as there is documentation. To assume that all
these artists share the preoccupations of the Photorealists who emerged in the
1970s is to misrepresent many of their intentions and qualities.

But Exactitude has included both first generation Photorealists and latter-day
exponents, and we must strive to understand what their work has now come to
mean.

Photorealism's history of over forty years inevitably engrafts both conceptu-
al and aesthetic frameworks on to any canvases made today within its param-
eters. The contemporary Photorealist painting is concerned as much with
representing this history and the ideals of its originators as it is with rendering
its mundane subject in paint.

In the light of this, we must recognise that Photorealism can no longer facilitate
an innocent vision of the actual world. If the faithful copying of a photograph ever

OPPOSITE:
Simon Hennessey
Blue Eye (detail)
2005
Oil on canvas
60 x 116 cm

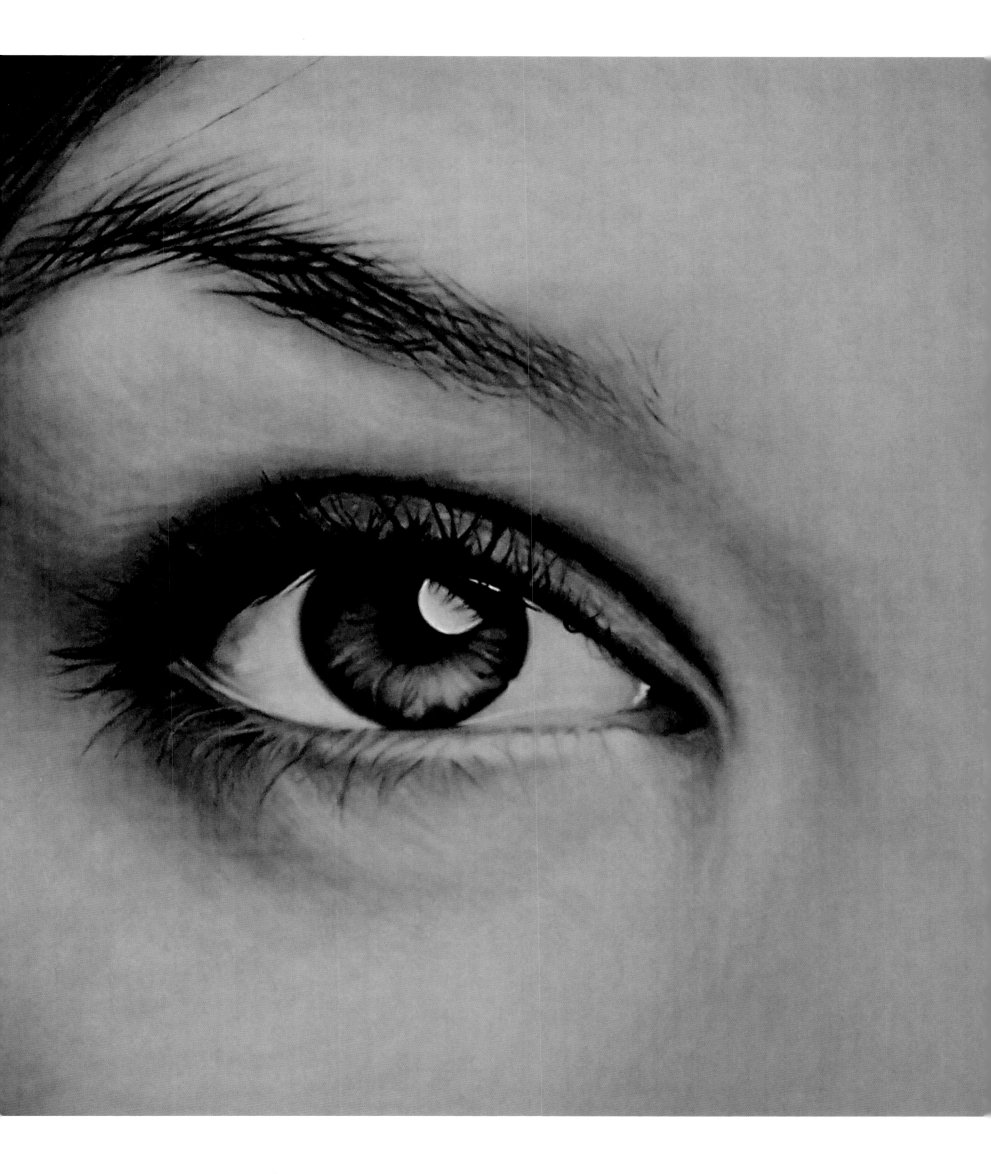

did enable objectivity, unfettered by the trappings of art history, this is surely now impossible, as Photorealism itself has become a chapter within that very history.

Perhaps we might now consider the pursuit of Photorealism as a yearning for a time when an objective realism was thought to be possible? Within this collection of artists such nostalgia is not only tangible but explicit through the sampling of its subjects from within vintage Photorealism. Such deliberate appropriations and stylistic references further substantiate the notion that this is an art aligned to Post-Modernist thinking: another manifestation of 'Post-Realism'.

This is not an easy art movement to describe. The artists who have shown at the three *Exactitude* exhibitions (2003, 2004 and 2007) do not form a coherent group. There is no shared manifesto – although there is dialogue between them. The exhibitions have become a forum for creative exchange and debate. This results in a tension between the pathways chosen as each artist embarks on the challenge of representation in a post-modern world. 'Exactitude' marks a point of arrival from aesthetic, theoretical and personal beginnings, but also a point of departure towards new and diverse visions.

What is indisputable is the mandate that all these artists share to publicly exhibit their work. Their popularity is rooted in a remarkable display of creative skill and technical virtuosity. Each artist has nurtured his or her unique talent and desire to make, and such dedication in itself is worthy of our attention.

Artists do not have a special insight into the human condition. We all hold opinions, have ideas and ask questions. What defines an artist is the ability to examine thoughts and responses to the world *through* the exacting manipulation of materials and visual language. This is much in evidence within Exactitude. It transcends the flatbed of political and social dialogue that we have come to expect from so much contemporary art. For each artist has embarked on a journey of transposition from seeing and thinking to creating a reality that exists at a distance from the everyday. It is not an art of social illustration, although the shift from the actual to the imagined may be very subtle. This is an optimistic art that asserts humanity's ability to create beautiful objects and invent wonderful visions.

For many of these artists, Photorealist methods have provided a pathway, and inevitably there will be those who challenge the creativity of this endeavour. If we look at them carefully we see that only a few actually mimic the photograph. Indeed such deception was never a predominant concern even amongst the Photorealists of the 1970s. Peculiar to Photorealist paintings is that they must be seen in their material flesh. Many defy reproduction, as once reproduced they return to the appearance of the photographs on which they were based. For this reason, and because of the difficulty of conveying in printed form the extraordinary finesse of so many of these works, Exactitude returns to the contemporary agenda the importance of viewing the original work of art.

To imitate the photograph is to highlight the nature of photographic vision, its cropping, focus and blur. Perhaps it is still worth making this point through contemporary paintings for today's generation. It was the principal concern of Chuck Close's seminal portraits from the late 1960s, and many artists have paid tribute to his ideas in recent times.

But Photorealism really becomes interesting as it departs from the photographic facsimile and takes on the personality of the artist. This is what distinguishes the best Photorealists. Despite its early pretensions towards an objective realism through distancing the artist from his or her subjective vision (and the contrivances of existing approaches to representational painting), Photorealism rapidly became invested with the unique concerns of the individual artists.

For Richard Estes, the most significant Photorealist of the first generation, it became a vehicle for his extraordinary draughtsmanship and understanding of pictorial space. He added line and mark to the language of photography, which is a dull surface of homogenised coloured dots.

In the case of John Salt, we find a lyricism and quietness in images that as photographs would be empty and banal. Photorealism then and Exactitude now makes a personal commitment to a place or an object. The genesis of these works of art is what the artists find or where they happen to find themselves and this process of self-discovery is pursued through the creative process. This is an art form of commitment, passion and self-expression. John Baeder's

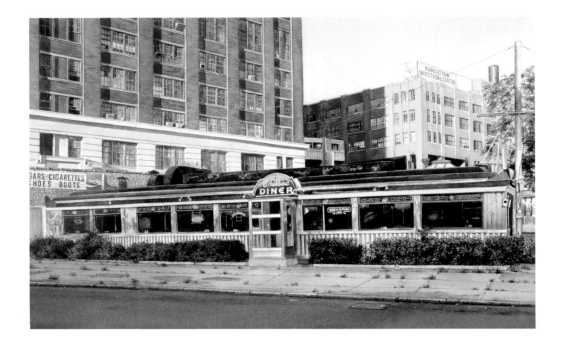

John Baeder
Chelsea Diner
2003
Watercolour
39 x 61 cm

paintings of the American diner are not founded on ironic social comment, but a love of humanity and a personal dedication to a world that has shaped his identity.

The desire to draw from the world around us and to re-create it with precision in paint is timeless. It is a passion that belongs to particular individuals who are driven to possess the world and to remove it from the chaos of its passage through time. The world is re-presented in a state of permanence through artworks that are conceived to outlive the artist. The viewer grows, changes and declines, but the art remains the same. Permanence is the condition of great art. It does not echo the flux of life but provides a stability and beauty to which we can anchor our constantly changing existence.

This aspiration does not belong to a chapter in art history and will never go away. It is an ageless pursuit at odds with the fast-changing fashions and disposability of modern living, but it should not be confused with a desire to reinstate the past.

It is important to discern between contemporary representational artists and those engaged in a revival of academic realist methods and subjects. Many years ago I visited an academy in New York dedicated to the teaching of such methods and saw displays of highly competent drawings, paintings and sculptures, which would not have been out of place in a nineteenth-century Parisian atelier. But they were out of place in the contemporary world. When I stepped outside of its dark interior this became even more apparent as I realised that the Tribeca neighbourhood had been the catalyst for Richard Estes's beautiful urban landscape *Baby Doll Lounge* (1978). These revivalists had lost touch with the present and the means through which it could be represented. They had turned away from the visual excitement of their immediate environment for an antiquated practice. This is not to dismiss the practice of life drawing. To this day I continue to draw and paint directly from life; it connects me to people in a way that photography does not, but I am also alert to modern technologies, modern languages of representation and new materials. In its subject and methods Exactitude artists share this concern for modernity.

The dedication to painting is less to do with traditionalism than an understanding that its long traditions have resulted in a highly complex visual language which can be utilised by the contemporary artist. It has such richness and a versatility to absorb new visual languages. Under the guidance of these artists there are painted echoes of photography, but also some of the myriad styles that make up the history of painting. Paint does not abandon its material identity, its compelling attraction to be scrutinised and its unique depth of space. These paintings hold the viewer's attention in a way that any lens-based art form does not. All this is conditional on the mastery of the artist.

Whereas the photographer will present a vision fixed by a mechanical language over which he or she has little control, the artist must invent the very notation that will create form and space. There is artistry in photography and many of the artists within Exactitude share the skills of the photographer, but there is a point where photography must stop and painting begin. Photography is an art of selection and manipulation; painting is one of creation from nothing to a totality. It is a courageous endeavour, particularly in an era when many have rejected it as being outmoded.

To paint is to deal with a freight of creative and technical difficulties. The totality of the coloured marks that sit on the surface of the canvas must break the actuality of this plane or the painting will not transcend its object-ness. This is not an easy task. Painting demands thought, calculation, instinct, experience, control and strength. The results will not always be successful. Exactitude can be evaluated by exacting criteria, and there will be human failure. Too easily, the paint can return to its origins of coloured earth, or the eye fail to be convinced by the notation of mark and colour.

An alternative to the mediocrities of the mainstream may well reside in a thoroughness of making and a prioritising of aesthetic creation over the illustration of concepts. The American writer and critic Donald Kuspit identifies a glimmer of hope for the future in the work of artists he has called 'New Old Masters'. For him the way forward entails absorbing and building upon the legacies of the past, and critically engaging with traditions to form a truly

contemporary art. I would agree. For the most part the contemporary main-stream, erroneously dubbed as 'challenging', has abandoned any effective notion of art. Kuspit describes it as post-art. But Kuspit's alternative way forward is highly demanding because it requires a level of mastery rarely achieved. Talent is always rare and the conviction and dedication to nurture that talent will always make masterful works of art a very infrequent occur-rence. Couple this with limited opportunities to study art and its history in a highly haphazard education system and it is clear that art of this kind will not proliferate.

A new generation of YBAs championing Exactitude or Kuspit's New Old Masters as its founding principles is too challenging both for the artist and the viewer ever to become a reality. The art world is predominantly a place for polit-ical or social pronouncement, not a forum for aesthetic development. But per-haps it is better to fall in love with just a few extraordinary treasures and enjoy the mainstream simply for the intellectual stimulation it often provides. What is crucial is that we do not lose sight of mankind's desire and ability to create extraordinarily beautiful objects as a means to define civilisation.

All art has a conceptual underpinning. If it has little else we digest its mean-ing and move on. Photorealism may well have been interesting for its stance within Modernism. It might be regarded as an art of both commitment and detachment, of flatness and illusion. But it is also an art that belongs to a long continuum of representational painting. There is room for a painting agenda within a canvas that starts as a projected outline from a slide. A great number of decisions must be taken to create the textures, the space and the atmosphere. There are rare and masterful works within Photorealism.

But it would be erroneous to assume that all the art presented as Exactitude has such a similarly direct relationship with photography. Exactitude is not syn-onymous with an art based entirely on optical devices. The experience of being in front of the subject, and beginning to deal with it directly through drawing and painting remains vital to some of these artists who would refute the label of Photorealism on these terms alone.

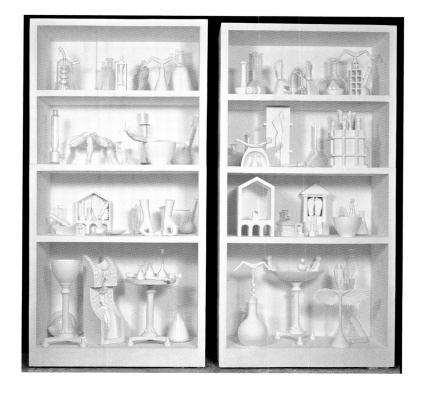

Steve West
*Ancestral Guardians and Other
Useful Objects*
1999
Plaster and glass
270 x 90 x 205 cm

Beyond this, some artists use the camera to bring information into the studio as part of the creation of an autonomous vision. Digital manipulation and computer modelling techniques may be an aid to this process. What is clear is that the resulting paintings demand an invention of space and composition, and skills in drawing and perspective that are more challenging than the copying of a single photograph. It is within these endeavours that the future for Exactitude may have its most exciting pictorial developments.

So much contemporary art is based on the tunnelled vision offered by the camera lens, whether it is video, photography or a stylistically divergent array of painting all based on photography. What is remarkable and truly innovative is the extension of space and time in representational paintings that remain credible. Perhaps it is not surprising that those artists who have so deep a knowledge of pictorial construction and photographic realism are now able to think outside of the confines of the camera. For the first time the aspirations of the Cubists to extend the breadth of looking may well have found a realisation within an art that is not marked by fragmentation.

Within Exactitude there are other concerns. Just beneath the surface of this art are memories of earlier realisms, evocations of Precisionism, magic realism, trompe l'oeil and neoclassicism. Contemporary Exactitude is often a hybrid of earlier painting styles and out of that hybridisation new voices can emerge. And then we have sculpture. Steve West's haunting pieces are a landmark in Exactitude. He shares with the greatest of these painters a thoroughness in his making and a determination to realise a unique vision. His work is a stark reminder that Exactitude is not solely concerned with verisimilitude.

To what extent then is Exactitude founded on a realist impulse? Undeniably much of this art is painstakingly thorough in its documentation of the subject. But it seems unlikely that the call to exactitude is topographical. There are easier ways to record empirical fact. Realist painting has always helped us see our surroundings afresh but there is no longer a necessity for artists to illustrate strange new worlds. Much Exactitude addresses the familiar, not the unknown.

The conception of the Photorealist movement was informed by a philosophical climate concerned with a direct presentation of the actual. But art has moved on. Contemporary art has embraced the readymade, the photograph and the video as a more direct means of shifting the real world into the gallery. For an exhibition of the actual, the painter cannot compete with the real thing. Reality, if not realism, stripped down to a fundamental state, characterises the centreground of contemporary art. Against Tracey Emin's bed or Damien Hirst's animals in formaldehyde, Photorealism's presentation of the seemingly mundane is charming by comparison, filtered as it is through the sensitivity of the painter.

But it is within this human sensitivity that we may begin to understand the desire towards exactitude and the purpose of these works. The paintings are made with remarkable care. To invest such care into the painting of an object, figure or landscape is indicative of a compulsion to pursue an ideal. The act of painting is invested with a morality. It is a desire to substantiate the integrity of the artist through a measured process of achieving an uncompromised level of resolution. Any less would be false. We have moved on from mere picture making to a quest to reveal how the world should be through the meticulous rendition of a subject, irrespective of how arduous this task might be.

The meanings of these works may well elude narrative explanation. For the viewer, this art is about connecting to the human significance with which the subject becomes imbued. So much personal history has been invested through the making process that these paintings take on a special human density. Beyond any social or political symbolism the subjects have a wonderment that they never possessed before. To realise such meaning in the seemingly mundane reinstates the viewing of art as an act of belief. Intellectual deconstruction will offer fewer rewards. The critical tools of Post-Modernism have helped us to recognise the conceit of these works and the fallacy of the innocent eye, but this does not make the art nihilistic and there is more to be gained from its viewing than post-modern game play. Although knowing in its artifice, this is an art that invites our total engagement and our suspension of disbelief for a greater reward of spiritual wellbeing. Its totality transcends an intellectual position; it takes on an

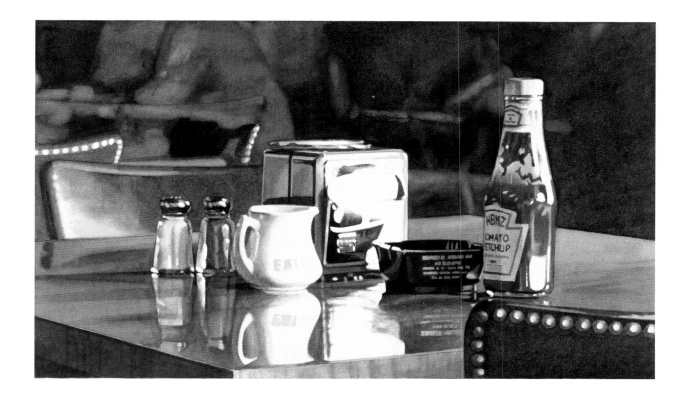

Ralph Goings
Coffee Shop Still Life
1979
Watercolour on paper
24 x 37 cm

altogether more important role. We haven't journeyed that far from John Ruskin's belief in exactitude as an image of heaven on earth.

For the artists, painting becomes a process of understanding themselves through the selection and description of the subject. Often exhaustive, these paintings undeniably charge their subjects with an aesthetic significance that entirely transposes meaning. The subject celebrates a new definition, as the painting reconfigures its details into relationships of space, colour, tone and pictorial language.

All art draws from its history and this is no less apparent within Exactitude in its aesthetic and linguistic references. Far from holding a mirror to the world, these paintings draw upon a rich legacy of painting. Much of what we find in them has already been painted by earlier artists and has already achieved an aesthetic meaning.

Nowhere is this more apparent than in the younger generation of Photorealists as they rework the subjects of Americana. Such works are a palimpsest of new and remembered meanings. Tjalf Sparnaay's ketchup bottle achieves a new iconic status not solely through its monumental size but through its re-presentation of a subject made aesthetically significant by the master Photorealist Ralph Goings.

Beyond this living memory is our collective Western history of Apollonian and Dionysian classicism. It is not surprising that Exactitude is inclined towards the former, drawing upon its sense of order and stability. At times there is a tendency for the subject to reiterate this concern for classicism, but this is far less overt now than within the neoclassical revival of the 1980s. Timeless subjects, such as still lifes, are more commonly presented in aesthetic frameworks that continue to bring clarity and focus to our lives.

So we have many visions. The skills of the representational artist endow such visions with credibility. Some artists would test this credibility against the actual world; others have no such interest. But all these artists share a desire to convince the viewer of the totality and coherency of their worlds. They do not ask for the viewer's adulation for their palpable skill but to suspend any disbelief in the artifice and to enter these worlds.

In many respects this art demands an approach both to its making and its viewing which might be regarded as traditional. Skills and values have been reinstated in an era when the mainstream has moved the practice of art out of the privacy of the studio and into the public realm of entertainment. This is not an art that raises issues but finds a universal voice for a personal vision. It is an art that does not remind us of the problems and banalities of our existence but sets out to uplift our spirits and give us meaning. It is an art that puts the work of art above the personality of the artist. In all these respects it shares much with the greatest art of the past. So to what extent can we see Exactitude as a truly contemporary movement?

When I first exhibited my large urban landscapes in the heart of London's West End there was very little such painting to be seen. It was only really visible in America. Ten years later and there is more art of this kind on show in the UK, and it has developed in other countries such as Spain and Italy. Coloured by a European sensibility and depth of art history, this art has different qualities to much that has been made in America. The scene has become more diverse in both where it is exhibited and in style, and its increased visibility in the art market is proving to be influential on younger artists. There is an international dialogue and followers of leading artists, all of which adds to the momentum, and the notion of a movement.

There have always been representational artists, because there will always be individuals who have a natural inclination to draw and paint the world around them (in the same way that there are people who will sing or dance). But art movements are dependent on there being an identifiable collective within the machinery of the art world and this is certainly now more definable.

Exactitude occupies a very particular stance within the contemporary scene. Undeniably rooted in their own personal creativity, these artists nevertheless present a collective position against the philosophical underpinning of the mainstream. What might be seen as a conventional pursuit in another era could be regarded as radical in today's context. The failure of the media and large art institutions to embrace this art only intensifies its outsider status, consolidating it as an avant-garde movement.

But isn't this just realist painting? Possibly, but we now know that realism is not a viable pursuit. For too long the philosophical legacies of realism have struggled to define representational painting. 'Exactitude' enables us to focus on what remains in the aftermath of Realism, Photorealism, Superrealism. These were issues for Modernists, not Post-Modernists. Exactitude presents a particular intensity of vision in a contemporary framework that is finally liberated from a troubled relationship with objective reality. We are now at the beginnings of recognising what such art is truly addressing and this understanding will strengthen its directions and identity in the future.

The art historian Michael Paraskos affirms this position:

> Exactitude is not the final statement, but a testing ground for new directions in figurative painting, and in that sense it can perhaps be likened to a science laboratory. In time, some of the experiments we see in Exactitude will undoubtedly fail and fall by the wayside. But some will succeed and those that do hold out the promise of a new start in painting, rooted not only in Photo-realism, but earlier aesthetic art. It will be a new start that acknowledges the implications of modernism, photographic reproduction and even conceptualism, but will at the same time be very much concerned with the nature of being human in our own age.

Exactitude is a very particular response to the here and now. The mainstream of contemporary art has been dominated by adman-style declarations on life and death that fail to further our understanding of the human condition, divorced, as they surely are, from any real experience. Exactitude, by contrast, is founded in the details of existence, and its meaning is all the more profound for being rooted in truthfulness. It is a contemporary art of invention, specificity and timelessness. The *Exactitude* exhibitions and the present publication connect this art to an audience. Beyond this, they may well prove to be integral to its very stylistic and theoretical evolution. We have embarked upon a thrilling journey – a journey with an unknown destination.

INTRODUCTION

John Russell Taylor

REALISM IS A HOUSE with many mansions. In 1981 the Centre Pompidou staged a huge exhibition, *Les Réalismes* (note the plural), which sought successfully to re-place the realistic tradition at the heart of twentieth-century art, after years of its being theoretically sidelined. And what was true in the last quarter of the twentieth century is equally true at the beginning of the twenty-first. The movement, or at least grouping of artists, that has become known as Exactitude is essentially vowed to realism. Of course it is only one kind of realism, but a kind of realism that seems particularly pertinent to the times we live in. At least, at the moment of its emergence, people had ceased for some while (importantly because of the Centre Pompidou exhibition) to question whether anything painted, let alone painted in a firmly representational style, could possibly be relevant in an age when the Conceptual seems to rule.

Any journalist will tell you that the one unforgivable folly is to state in print that anything happened for the first time at any given moment: immediately somebody comes up with a sensibly earlier instance. But one thing that can be said without fear of argument is that, ever since the first stirrings of the Renaissance, virtually every style and aesthetic subsequently prominent in art was, at the very least, implicit in what was already being done by artists. Symbolism? Of course it is everywhere in evidence. Impressionism? Look closely at Velázquez or Frans Hals. Expressionism? Look at Hieronymus Bosch or Matthias Grünewald. Even the fact that everything calling itself painting was essentially representational does not exclude the possibility of abstraction, either for religious reasons (in the forms of faiths which banned the making of graven images) or simply in decorative trappings within subject paintings.

Consequently, we should not be too surprised to find that exactitude with a small 'e' plays an important part in art history, ever since the discovery of perspective at least. With the advent of the Renaissance, concern for truth to the imagination was supplemented with a new concern for truth to observation. Perhaps one should say truth to the observable, since obviously not everything the sixteenth-century painter painted was necessarily something he had directly observed, except perhaps in a vision of Christian heaven or pagan Olympus and

OPPOSITE:
Clive Head
Fresno (detail)
2001
Oil on canvas
132 × 190.5 cm

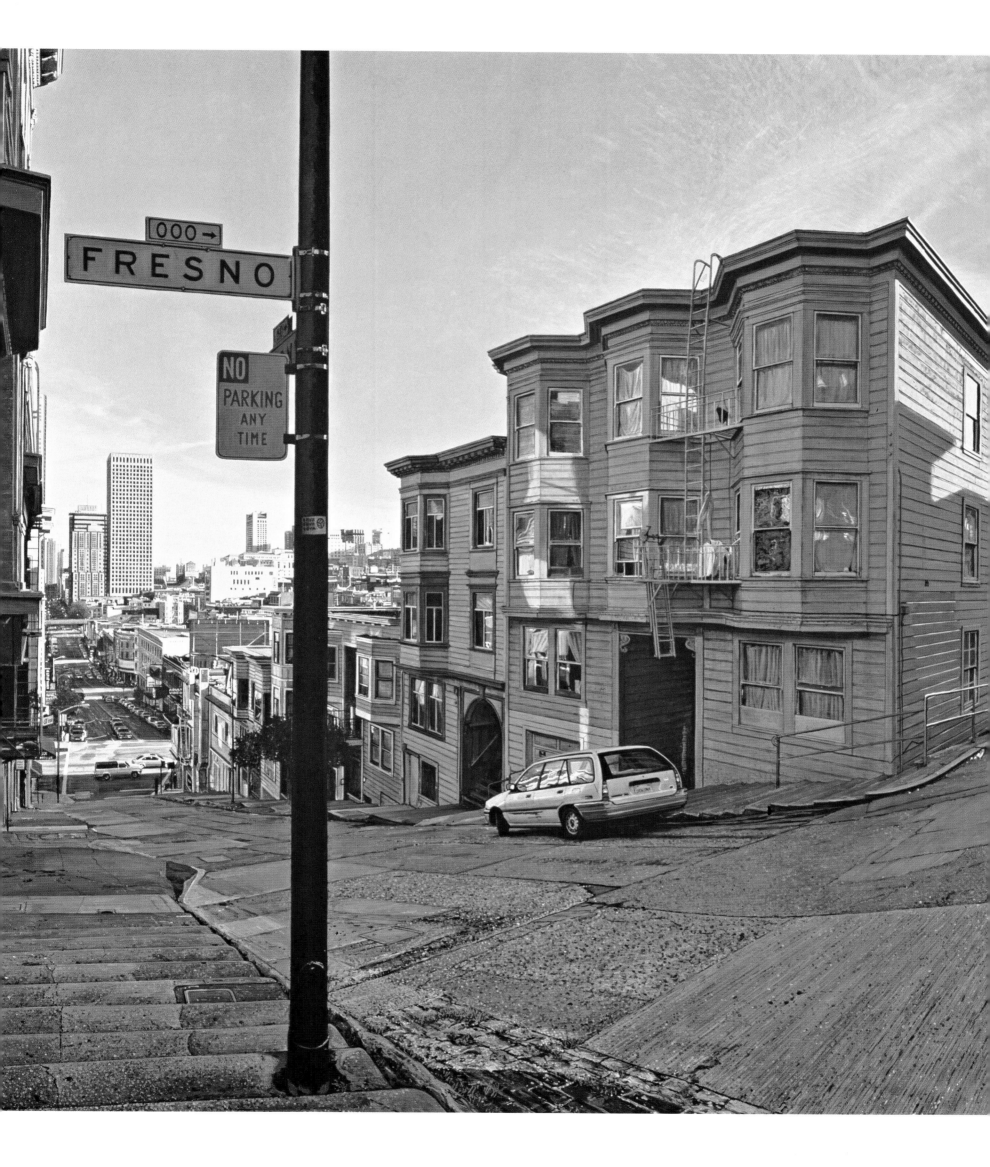

their respective denizens. But it gradually became de rigueur to make the wildest artist's imaginings look as if they had been directly observed, or anyway could have been.

In all this, perspective was a powerful weapon. Heaven could look likely enough to be round the next corner; the buildings attributed to ancient Athens or Rome as backgrounds to mythological goings-on could seem to be as solid and real as the buildings in which the artist himself lived or worshipped. Was this because the artists themselves consciously wished it so, or was it merely a visual expression of the tone of the times? Probably a bit of both, for few in any age are wholly immune to the forces of fashion. At any rate, verisimilitude was clearly more important in some contexts than in others. As the classic genres gradually separated and defined themselves, the landscape and the still life, and to a lesser extent the portrait, seemed to demand a particular concern on the artist's part for painstakingly accurate detail.

And then these genres divided into sub-genres, each with its own special requirements and built-in expectations. The landscape spawned the townscape; the still life spawned the trompe-l'oeil painting: and these required the painter not only to look closely at what was before him, but to devote more care and attention to its exact rendition. In the process of reducing three dimensions to two – the condition of all painting – he (or occasionally she) had to elaborate a more extreme form of illusionism. This meant that in the trompe-l'oeil still life, for instance, he had to re-create in paint the smallest detail, lest the illusion that one did see an actual fly which might easily detach itself from the peach in the painting before one and fly off to another equally believable picture were lost, and his artistic expertise therefore found wanting.

The painting itself, in other words, had become from some points of view an elaborate game, from others an invaluable piece of documentation. If it was always folly to fall, in much later days, for the claim that the camera could not lie, it was even more foolish back then to believe that any solid judgment (except, of course, judgment of the painting itself as a work of art) could be based on the artist's view of anything. Every school child remembers how Henry VIII was

lured into marrying Anne of Cleves on the basis of an outrageously flattering miniature by Hans Holbein. When, after the wholesale destruction of the Second World War, a model was required for the exact reconstruction of Warsaw and Dresden in particular, it was assumed that the townscape paintings Bernardo Bellotto had made there in the later eighteenth century were accurate enough to provide a template. This was probably correct, though it is worth remembering that his uncle and mentor Canaletto was not above rearranging the buildings in his preferred stamping-ground, Venice, entirely for artistic effect.

However, this is to anticipate. Renaissance painters, and indeed many Gothic painters, such as the Master of the *Wilton Diptych*, before them, might have subscribed to the child-artist's definition of what he was doing: 'I think, and then I draw a line round my thinks.' The line around the forms, the hard edge that gave substance to the loosest of imaginings, was to begin with crucial. Not necessarily in the portrait, where a good deal of generalisation could be tolerated, so long as the commissioner or the subject, or preferably both, felt satisfied that a comfortable likeness had been achieved. But a sketchy still life might well not still carry conviction, even if it was intended to stop well short of total trompe l'oeil. The painter of townscapes could be sure that anyone who wanted his wares would want also to see every single roof tile carefully depicted, if only because the buyer of the painting might well be a builder, an architect or a mere patron of such, and require that the painter clearly demonstrate what good value he had got (or given) in the transaction.

Obviously, for centuries before the invention of photography, the functions of the painter had to include pure documentation, and documentation required, and presumably received, as great a degree of accuracy as was humanly possible. Technical advances played their part: the proper understanding of perspective first of all, then the invention of devices such as the camera obscura. Perspective was first analysed in any way recognisable to modern understanding around the year 1000 by the Islamic polymath Alhazen, but since he was interested only in the mathematics, not the visual applications, and anyway he was writing in Arabic, this had little or no effect on European artistic practice. Around the

beginning of the fourteenth century, Giotto experimented, not especially success-fully, with applying a formulation based on algebra, though in some of his later works, probably by intuition rather than theory, an effect of recession is definite-ly achieved.

That was largely in the architectural backgrounds and foregrounds, and in any case resulted in creating a quite convincing distinction between the two. It was probably significant that the crucial figure in the definition of perspective for European artists was essentially an architect: Filippo Brunelleschi, who around 1415 used a geometrical approach for his painting of the Florence Baptistery, then exhibited it at the entrance to the Duomo, inviting the public to look at the real thing and a reflection of his painting of it through the same pinhole viewer and try to determine which was which. This experience, if not the theory behind it, had a sensational effect on artists' practice in Florence, and then in the whole of Italy, even before another, lesser architect, Leon Battista Alberti, put it all into verbal form in his tract *Della Pittura* in 1435 to 1436.

As for the camera obscura, Aristotle knew all about it in fourth-century BC Athens; Alhazen in Cairo understood it by the first millennium AD; the Song Dynasty Chinese scientist Shen Kuo discusses it in detail in his *Dream Pool Essays* (1088). In Renaissance Europe Leonardo da Vinci wrote about the cam-era obscura in the *Codex Atlanticus*, and Johann Zahn in 1685 elaborated its theory and practice, with diagrams, in his *Oculus Artificialis Teledioptricus Sive Telescopium*. That was ten years after the death of Vermeer, so the Dutch artist could not possibly have been directly influenced by Zahn's definitions or instruc-tions. Nevertheless there has been extensive controversy of late on the question of whether Vermeer himself (and presumably other contemporaries specialising in minutely detailed townscapes and interiors) used a camera obscura, a camera lucida or some similar device.

All this may well seem remote from any modern practice. But not so. Its relevance to the present resides in what has come to be known as the Hockney–Falco thesis, after the writings of the painter David Hockney and the physicist Charles M. Falco, working separately and in collaboration, and in scholarly and

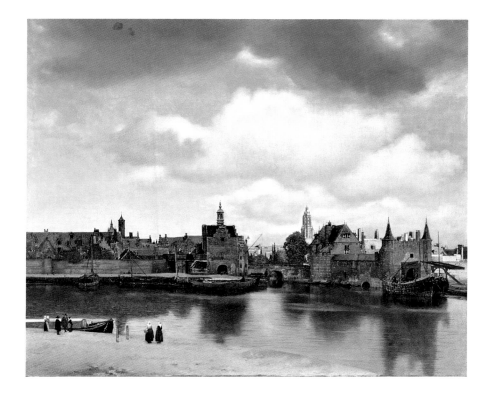

Johannes Vermeer
View of Delft
c. 1660–61
Oil on canvas
98.5 x 117.5 cm
Royal Cabinet of Paintings
Mauritshuis, The Hague

less scholarly reactions to them. The theory sees evidence in the paintings of Vermeer, and indeed in those of earlier artists such as Jan van Eyck and Lorenzo Lotto, that they used some sort of optical device – most probably curved mirrors – in the observation and translation of their subjects. The point of the frequently violent opposition that this idea has occasioned is that this is construed by many as accusing great artists, indeed some of the very greatest, of 'cheating', or at least using an illegitimate short cut.

So the debate becomes, rather bizarrely, a matter of artistic morality, almost exactly as in the twentieth and twenty-first centuries the use of photographs in painting has been bitterly questioned. Whether the Hockney–Falco theory is correct or not, many of the arguments based on it are surely misdirected. Who says it is inscribed in stone that all painting should be based solely on what the artist's eye sees unaided? Well, a lot of people do, but they and their motives for doing so are something we shall come to in due course. For the moment, all that matters is the quest for minute accuracy, or at least the illusion of minute accuracy, in the way the artist's vision is conveyed to his audience. Clearly this started relatively early in Western art, and remains as much of concern today as it has ever done.

Whatever Giotto's motivation, it is clear that Brunelleschi sought an illusion: he wanted his painting of one of Florence's most familiar buildings to be so convincing that, when viewed in carefully controlled conditions, one could not be distinguished from the other. It is curious that in this area of art, the quest for verisimilitude cannot be separated from the desire to deceive. The right application of the rules of perspective and the precise delineation of fruit and flowers seem like curious subjects for moral judgment, but so, almost since the beginnings of modern art, it has proved. If a restaurant owner were to place, say, a painting by Richard Estes in a space which might otherwise be occupied by a window, with the intention of making patrons feel that they were in lower Manhattan instead of freshly fashionable Hoxton, the suggested deception would seem harmless enough. After all, no one is going to be genuinely deceived – at least not to the extent that the Lumières' first audiences were put to flight by the illusion created by the film of a train apparently bearing down on them.

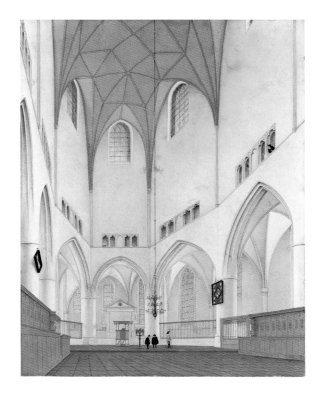

Pieter Jansz. Saenredam
*Interior of the Choir of
St Bavo at Haarlem*
1660
Oil on panel
70.4 x 54.8 cm
Worcester Art Museum,
Worcester, Massachusetts,
Charlotte E. W. Buffington Fund,
1951.29

The ground, of course, has changed somewhat since the fifteenth century. Back then the worry concerned the deception involved, which might almost be regarded as amounting to a lie, and therefore reprehensible. Now the illusion is not regarded as objectionable in itself: what is in question is rather the means by which the illusion is achieved. Can the painter legitimately call upon whatever aids he chooses – more probably by projecting a photograph and tracing the outlines from it than by the use of a camera obscura or a close glass – or is this in some way cheating? Does any use of a photograph in the creation of a painting amount to deception or outright fraud? To some it may seem strange that a practice which goes right back to Jean-Auguste-Dominique Ingres and Eugène Delacroix should still, a century and a half later, be a subject of concern.

However, back in the days of Vermeer these questions remained largely theoretical. If Vermeer and his contemporaries used optical devices to pull their compositions together, they did not bother to tell anybody – probably not because it was considered to be ethically dubious, but simply because every artist cheerfully used any device that might prove in some ways to be helpful, and did not think it worth commenting on. Nor did many people, apparently, think there was any question that fidelity to the observable facts of a scene or an arrangement of objects was a desideratum, or indeed a requirement, of any painting.

Vermeer is exceptional in his era only by virtue of the subtlety and intensity of his oeuvre, the exquisite finish without any concomitant chilling of effect, the compelling creation of atmosphere. In other words, he does much the same as many of his contemporaries, only with transcendent genius. But we should remember also that among his contemporaries was Rembrandt, whose ideas and ideals in art were very different. It is not that Rembrandt believed any less than Vermeer that every artwork should carry a certain sort of conviction, should demand recognition and belief. But his way of going about it was very different. Vermeer achieved his kind of conviction by way of extreme particularity, while Rembrandt created it by lavish use of what the Germans call *Stimmung*: atmosphere evoked by light and shade (mostly shade) and a haziness of outline.

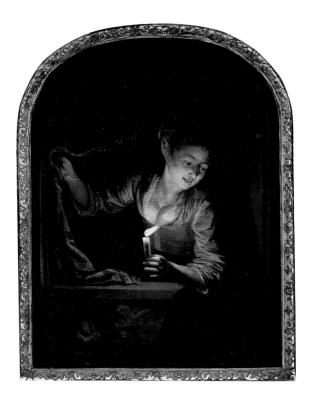

Gerrit Dou
*Young Woman at the Window
with a Candle*
c. 1658–65
Oil on panel
26.7 x 19.5 cm

Vermeer is therefore normally characterised as an artistic quietist, Rembrandt as a dramatist in paint. This, if not totally true, is true enough of the rival (or parallel) traditions they represent. The effect of Vermeer's kind of hard-edged realism is generally to lower the temperature: this is cool painting in every sense, ancient and modern. The effect of Rembrandt's brand of restless brush-work is usually to pump up the drama. Of course the cooling effect is often only superficial. The result of fierce precision may well be that of a pressure cooker: keeping drama under such tight control calls up visions of a caged tiger, burning all the brighter for the bars that only just constrain him.

What may be called, through a convenient shorthand if nothing else, the Vermeer tradition has concerned mainly the townscape and its close relation, the architectural interior, as practised by such as Pieter Jansz. Saenredam (1567–1665), a specialist in the bare and silvery church interiors of seventeenth-century Protestant Holland. But a vast number of still lifes and flower pieces that aspire to the same degree of minutely accurate detail were produced, both in the Low Countries and in Spain, from the mid-seventeenth-century Juan Sánchez Cotán to the mid-eighteenth-century Luis Egidio Meléndez. All of these, but especially such Netherlandish painters of flower pieces as Gerrit Dou and Cornelis de Heem, were strongly insistent on the meticulous accuracy of their depictions.

Dou (1613–75) in particular, though ironically an early pupil of the still teenage Rembrandt, was revered for his dazzlingly illusionistic style, which allegedly made his paintings of fruit and flowers indistinguishable from the genuine article, and convinced the viewer that such details as an insect on a fruit or a drop of water on a petal had in fact deposited themselves on the surface of the painting rather than being an integral part of the composition. His mature works, such as *Young Woman at the Window with a Candle*, always hovered on the edge of being so many trompe l'oeil tricks, in the days when such tricks were not yet seen as being frivolous deviations from the serious body of painting.

Very elaborate flower pieces faded from popularity in the eighteenth century, at much the same time that trompe l'oeil started to be regarded as a genre

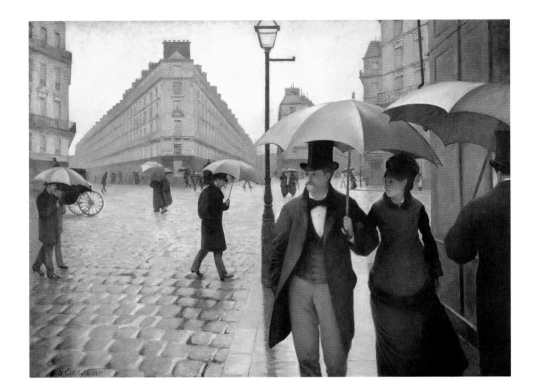

Gustave Caillebotte
Paris Street, Rainy Day
1877
Oil on canvas
212.2 x 276.2 cm
The Art Institute of Chicago,
Charles H. and Mary F. S.
Worcester Collection
1964.336

on its own, little more than an amusing caprice on the part of an artist with perhaps more technique than personal probity. The more staid still life of fruit and vegetables, set off by the occasional pot or glass, lingered on in Spain, with Meléndez as its last devoted master, while in France Jean Siméon Chardin brought evocations of the secret life of pots and pans to an unprecedented peak of perfection. But the search for believable documentary accuracy was concentrated in the townscape, which took on new life and popularity in the hands of Canaletto, and his nephew/pupil Bernardo Bellotto.

The approach of both was very matter of fact: they would go wherever the market was – in Canaletto's case mainly Venice and England, in Bellotto's the whole of central and eastern Europe – and paint whatever they were commissioned to do, or at any rate had reason to believe would sell. Probably there was some element of personal choice involved too. I remember once talking to John Piper about his commissioned 'portraits' of country houses. He said that he was so besieged by landowners wanting their own homes recorded and preferably glorified a little that he could afford to do only those he found personally tempting. 'The rest I suggest try Felix Kelly. Ooh, I shouldn't have said that!'

No doubt in the same way Canaletto made his own pick of his recurrent Venetian subjects, and having chosen them, did not scruple to rearrange them a little for artistic effect. Later generations have been so struck, nevertheless, by the proto-photographic qualities of his larger canvases – including as they do distortions which are bound to exist in images pulled together by the camera obscura but are virtually impossible for the unaided human eye – that it is generally believed Canaletto must have relied to some extent on such optical aids. Certainly no witness of his own time ever complained that his depictions of architecture were inaccurate, and speculations about his use of supposedly dubious devices all long postdate the invention of photography.

Despite the enormous international success of Canaletto and Bellotto, their practice was not pointing in the direction that painting was headed. When the *Encyclopaedia Britannica* refers to the 'cool precision' of their work, the description is not entirely complimentary: if we are looking towards the future of

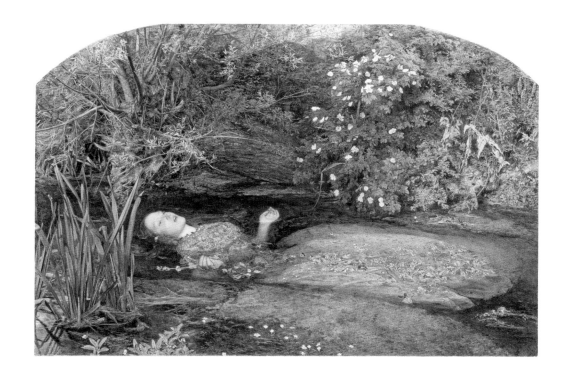

John Everett Millais
Ophelia
1851–52
Oil on canvas
76.2 x 111.8 cm

landscape we have to look rather at Francesco Guardi (1712–93), who superficially appears to be doing the same sort of thing as Canaletto. But Guardi is a Rococo artist, and fancy plays a large part in his painting. Often explicitly, in the *capricci*, which advertise their distance from external reality. But even the paintings of real scenes and existing buildings are invaded by a similar spirit: the touch is lighter, the outlines hazier, the whole impression is one of fantastic invention, where reliance on convincing documentary evidence is replaced by the willing suspension of disbelief.

Rococo fantasy is soon replaced by the Romantic Movement in all its tempestuous agitation, and eighteenth-century precision is succeeded by Sturm und Drang. The sober townscape, the poised and scientifically accurate flower piece are too tame, too limited to appeal to Romantic taste. Precision goes out of the window. When the townscape and the flower piece reappear, it is close to the heart of a yet newer school, Impressionism. And whatever the Impressionists and their satellites were about it was not hard-edged exactitude. Realism, and a sort of accuracy, were certainly involved, but it was accuracy to a certain kind of emotional reality – the reality of what one feels as one sees something, and how one sees it, rather than any kind of 'objective' reality. A Claude Monet street scene, a Henri Fantin-Latour flower piece creates, rightly enough, an 'impression' based on light and motion rather than a detailed record.

There was, however, one Impressionist who was deeply concerned with minute accuracy, and was obsessed with perspective. That was Gustave Caillebotte (1848–94), whose most famous painting, *Paris Street, Rainy Day* (1877) is not only intensely atmospheric, but an absolute model in the manipulation of perspective. And, probably, a comparatively early example of the influence of photography on art, if not actually of the use of photography in the creation of art.

Already modern Photorealism seems only a few steps away. But before we come on to that we need to go back a bit, to look at another kind of minute realism. The medievalising Pre-Raphaelite Brotherhood, founded in London in 1848, seems at first an unlikely place to find it. But part of the quasi-religious

Richard Dadd
Flight out of Egypt
1849–50 (detail)
Oil on canvas
101 × 126.4 cm

teaching of the first 'brothers' concerned absolute accuracy and truth to nature. Paradoxically, while Impressionism undoubtedly took art closer to the accurate depiction of the way things looked and struck people in everyday life, Pre-Raphaelite minuteness, however intended, took art further away from normal human observation.

For one of the facts about human observation is that it cannot see everything at once with the same clarity. If you look closely at the vegetation in the background of a typical early Pre-Raphaelite painting such as John Everett Millais's *Ophelia* (1851–52) it is all so accurately, sharply delineated that the excess of naturalism becomes unnatural and even rather nightmarish. The human eye simply cannot focus on so many things at one time. The camera's eye of course can, and the existence of photographic exemplars has a lot to do with painting's progression from realism to super-realism to surrealism.

But not everything. It may be noted, for instance, that the officially mad painter Richard Dadd (1817–86) was able somehow to observe the way that water flung into the air would follow a trajectory and re-form into droplets some time before photographic technology was sufficiently advanced to demonstrate conclusively that this was so. This special vision of Dadd's may be attributable to his mental state, or to whatever medication he was receiving. There may be some explanation for the Pre-Raphaelites' frenzied particularity in their alleged use, in a quasi-medical context, of laudanum. We know that many twentieth-century Hyperrealists have used mind-modifying drugs, from opium to LSD, for recreational or experimental purposes, and that this is unarguably relevant to the distinctive expansion of their artistic vision.

Along the way from realism to surrealism another element comes into play. Surely, one might say, the essence of Symbolism in painting lies in its non-realist elements, the scope it offers for fantastic glimpses of another world, a world that but for the artwork would exist exclusively in the artist's imagination? Edvard Munch, painter of *The Scream* (1893), fits neatly into the Symbolist framework, but many of his typical works, such as *Weeping Woman* (1913), prove on examination to be based quite closely on his own photographs. And the more

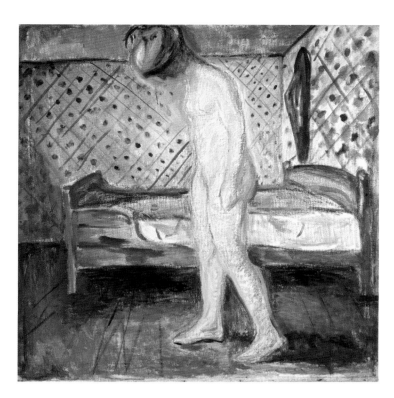

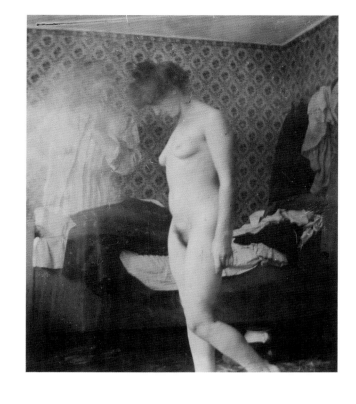

Edvard Munch
Weeping Woman
1907
Oil on canvas
121 x 119 cm
Munch Museum, Oslo

Edvard Munch
*Rosa Meissner at the Hotel
Rohne, Warnemünde*
1907
Photograph on toned
gelatin printing paper
8.7 x 7.3 cm

fantastic the subject, the more it needs detailed precision in its representation to carry conviction. Admittedly there are more than enough Symbolist artists with an unfortunate penchant for depicting their human characters, fairy-folk or angels as boneless wonders, but the majority nevertheless see the illusion of exact delineation as a requirement, and determinedly provide it.

In this combination of imaginative illusion and documentary exactitude the Symbolists are the direct ancestors of the Surrealists. Salvador Dalí was not the only Surrealist to acknowledge the connection. If he was to live up to Lord Berners's little poem,

> On the pale yellow sands
> There's a pair of clasped hands
> And an eyeball entangled in string
> And a piece of raw meat
> And a bicycle seat
> And a thing that is almost a Thing

he would make sure that every object mentioned would be as three-dimensionally convincing as possible, the perspective perfect, the texture evoked with maximum vividness.

Meanwhile, in another part of the forest…. Part of the reaction against the academic straitjacket which had constrained so many nineteenth-century artists was the appearance, around 1907, of abstract art. At the same time, coincidentally (or maybe not), Picasso was painting *Les Demoiselles d'Avignon* (1907), which carried representational art in a different direction with its infusion of what was then known, unselfconsciously, as 'Primitive' art. In consequence, little by little the idea spread abroad that the detailed representation of real places or objects in a minutely realistic style was somehow outdated and beyond the pale of serious art. While there were artists in Britain, like Algernon Newton with townscapes and Meredith Frampton with still lifes, who continued to observe the old faith, no one outside Royal Academy circles took them very seriously.

What then of other countries? The lingua franca of painting practically everywhere in the early twentieth century was some sort of modified or extended Impressionism, short on naturalistic detail and long on colour and atmosphere. Of course, in the wake of Pablo Picasso and Georges Braque, and through them of Paul Cézanne, there were various derivatives of Analytical Cubism, where the reality referred to was that of volume rather than superficial appearance. In America there was a school of painters who called themselves Precisionists, though what they dealt in primarily was bold geometrical simplification of forms (admittedly often of industrial buildings that were themselves geometrical) that owed more to Cubism than to Canaletto.

All the same, realism (or realisms, as the Pompidou Centre exhibition had it) kept raising its unfashionable head. In France Jean Cocteau advocated a 'rappel à l'ordre', which brought even Picasso back to a species of neoclassicism in which massive female nudes reclined, nursed babies, or thundered along Mediterranean beaches. In Germany the favoured mode for painting in the Weimar Republic, replacing pre-Great War Expressionism, was something called Neue Sachlichkeit (New Objectivity), in which people appeared in microscopic detail, warts and all, against starkly simplified backgrounds. The advent of Nazi rule did not change this excessively: the Expressionists were still condemned, now explicitly, for producing *Entartete Kunst* ('degenerate art'), and realism was still overwhelmingly approved – so much so that some Neue Sachlichkeit painters, those at least who were not Jewish or too left-wing, continued to work relatively undisturbed throughout the Nazi period. In Russia the first joyous revolutionary heyday of Constructivism was soon replaced by the dreary subservience of Socialist Realism.

These various realist art movements were, by and large, deprecated, or even sneered at, by serious people. The Surrealists nurtured by Spain, Belgium and Germany, though generally most active in Paris, were a different matter. They, after all, were defiantly experimental and avant-garde, and not, for the time being, appreciated by the general populace. (That came later, in the Forties, when Surrealism was taken up in a big way by Hollywood, and Dalí himself was to be

observed working for Hitchcock and Disney.) The precision of Surrealist draughtsmanship was much appreciated, because it had been irrevocably removed from academic associations by means of the subject matter to which it was applied. And no one could accuse a manner of depicting something that existed only in the artist's imagination of being a cheat on the grounds that it appeared to be based too slavishly on photographs.

Not that this possibility was much commented upon, adversely or otherwise, before 1940. No one worried much, for instance, if Edward Hopper's paintings of urban isolation or the discreetly homoerotic advertising illustrations of J. C. Leyendecker looked 'photographic' or 'cinematic', since this was judged to be a legitimate influence on the artist's way of visualising things, rather than a literal dependence on a photographic source. The direct use of photographic materials in anything but collage (as practised by Max Ernst or John Heartfield) did not really become an issue until the early 1960s, with the appearance on the scene of Pop Art, followed shortly afterwards by the advent of Hyper- or Photo-Realism.

The two new schools raised rather different issues, but both were connected with the use of photographic documentation in painting. Pop artists such as Peter Blake or R. B. Kitaj unashamedly based their paintings and prints on photographs, and David Hockney was suspected of doing the same, though his explanation of his creative block working on *A Bigger Splash*, 1967 (that he had quite simply got the perspective of the side of the pool wrong, and it took time for him to realise his error) strongly suggests that he did not. At least these artists, if they did make use of photographs, as a rule totally transformed them in the process of painting.

But the Photorealists were a different matter. It has frequently been observed at international art festivals such as the Venice Biennale, that in the arts things can happen simultaneously, with no apparent connection, all over the world, and suddenly everyone seems to be carving wood or painting in watercolour. Thus it was with Photorealism in America during the early Sixties: two groups of artists came forward at the same time on the East Coast and the West, quite independently of each other, and each very diverse in itself, but all linked together by the fact

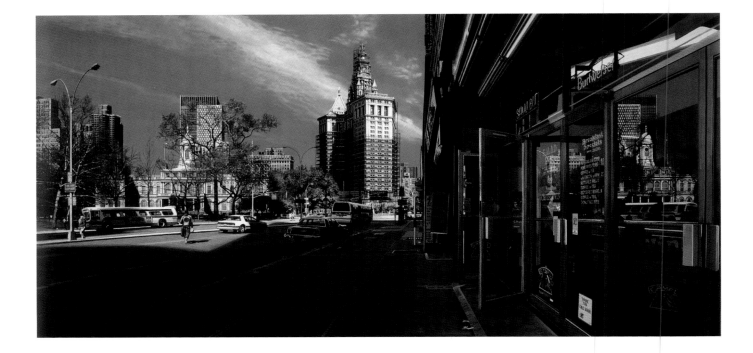

Richard Estes
*Park Row Looking Towards
City Hall*
1992
Oil on canvas
91.5 x 183 cm
Marlborough Gallery,
New York

that they not only made general use of photographs as background documentation, but also actually transcribed photographic images directly on to canvas.

To many critics this meant that their works were not real paintings at all, in that their hard-edged forms owed nothing to their creators' draughtsmanship skills (if any), coming with all their details of composition and perspective ready-made. The paintings did not even look as if they were the product of human observation, adopting as they did, wholesale, the distortions inherent in the workings of a camera lens.

Naturally this technique manifested itself in all sorts of ways, and with all sorts of subject matter. On the East Coast Richard Estes painted minutely accurate (accurate, that is, in relation to his photographic models) views of New York street scenes, while Chuck Close did the same thing in portraits of gigantic proportions. (Close also experimented with 'scientifically' fragmented photographic images, bringing to mind, unexpectedly, the brief flirtations of certain Impressionists with Pointillisme.) Others, such as Charles Bell and Tom Blackwell, were interested in using photographs to suggest the veiled quality of memory, and this is where the temporarily resident Brit John Salt also came in.

On the West Coast Ralph Goings was subjecting the streets of Los Angeles to the same kind of scrupulous examination that Estes brought to New York, while Ed Ruscha used photographs with as much fidelity, but to the rather different end of glorifying the legendary aspect of Tinseltown/Hollywood (and to such a degree that his photo-based paintings and prints are sometimes classified as Pop Art). Yet others, such as Richard McClean and Robert Bechtle, boldly mingled memory and desire to create their own individual fusions without ever moving noticeably, at any rate at this period, from the security of the photographic.

Against doubters as to the legitimacy of this form of photographic input into the act of creating a painting, it could be, and was, argued that the mere act of making over a photograph into a painting transformed its essence and made it into something fundamentally different. Such assertions ventured too far into metaphysics for most observers, whose main concern was with whether they liked the resultant effect or not.

Many did, however it was achieved, and suddenly minute representation was acceptable again in serious art, and could even again be accounted fashionable. Not only that, but in the immediately following age of Conceptual Art, when a one-sentence description of a potential concrete work might be posted on a wall and obviate the necessity of doing anything more palpable, even such basic theoretical considerations could not but seem totally beside the point, an unbelievable finicking with matters that no one cared about any more anyway.

Despite the prevalence of this attitude, however, there were intermittent attempts to counter it, notably in Britain: in 1981, the now long-defunct London gallery Fischer Fine Art presented *The Real British*, a show of paintings and drawings by artists who believed intensely in minutely detailed realism. Virtually all the artists involved – David Hepher, Brendan Neiland, Michael Leonard, Graham Dean, David Tindle, Ben Johnson – went on to achieve greater individual fame, but most of them by veering away from extreme specificity in a wide variety of different directions. The most obvious exception was Ben Johnson, and, intriguingly, Johnson was the only one from *The Real British* who appeared also in the first Exactitude show twenty-two years later.

And meanwhile a series of larger, more ambitiously titled, and in their time more influential international exhibitions, starting with *A New Spirit in Painting* at London's Royal Academy in 1981, closely followed by *Zeitgeist* in Berlin (1982), advocated a revival in painting, and even, more often than not, a revival in representational painting, but carrying it away towards a violent kind of Neo-Expressionism, as exemplified in the work of, for instance, Anselm Kiefer, Georg Baselitz, Markus Lüpertz and Reiner Fetting from Germany, Francesco Clemente, Sandro Chia and Mimmo Paladino from Italy. Again, most of these artists still register, though their time basking in the blaze of high fashion has long gone. And none of them at any stage had anything to do with the merely photographic.

In any case, our own period, as we move all too rapidly into the twenty-first century, is shaping up, or has declared itself already to be, one of unparalleled eclecticism and multiplicity. The very idea of pontificating on what is

fashionable and what is not hardly seems possible in circumstances when a group of young men of the same age and background may be seen out together sporting haircuts ranging from the close-shaven to the shoulder length or pony-tail, and a comparable group of young women may be wearing skirts (those that are wearing skirts at all) ranging from those that barely cover the crotch to those that sweep the floor, all in the name of fashion.

In the same way, I encountered an art graduate recently, an adherent himself of minutely realistic painting, who dismissed a contemporary as doing installations, 'you know, that old-fashioned sort of stuff which wins Turner Prizes', while the aforementioned contemporary held him up to ridicule for doing 'that old-fashioned stuff, the sort of thing you would put in for the Royal Academy Summer Show.' Needless to say, the two of them were the best of friends.

Obviously, this might be the best of times, or the worst, for launching a new art movement. I doubt whether such considerations weighed heavily, or at all, with painter Clive Head in 2003 when he was asked by Plus One Plus Two Gallery to curate an exhibition reflecting the gallery's established interest in rep-resentational art. Head, as a practitioner of artistic exactitude himself, was well aware of the problems created by following such an aesthetic in what was by then generally regarded as the Post-Modernist era.

Clearly the situation was not entirely negative. Implicit in the concept of Post-Modernism was, if not a total rejection of the avant-garde, at least a recog-nition that other attitudes to art were not only viable, but actually permissible. So, the Photorealist approach to painting was acceptable, but so was the view that painting based too closely on photography was improper. And, because those who rejected Photorealism combined the avant-garde, who probably did not care for painting at all, and the ultra-conservative, who cared only for paint-ing which followed certain restrictive rules, more were against than for Head's approach, and by extension that of the like-minded artists he found for the first *Exactitude* exhibition.

Nevertheless, they were there to be found. They were already believers in Exactitude, if not yet with a capital 'e': that was Head's contribution,

remembered from an exhibition he had seen at the Metropolitan Museum of Art, New York, in 1988. The first gathering of artists under the heading of Exactitude consisted of three well-established painters, Clive Head, Ben Johnson and Steve Whitehead, and one sculptor, Steve West, along with three lesser-known painters, David Finnigan, Sharon Tiernan and Nathan Walsh. *Exactitude II* in 2004 added six more artists, ranging in age from Gus Heinze (b. 1926) to Andrew Holmes and Cesar Santander (both b. 1947) – a demonstration, if any were needed, that Exactitude, even if regarded as a new movement, went back some way into pre-existing tradition, in Britain and elsewhere. *Exactitude III* (2006) added another seven, three from America, two from Britain, one from Canada and one from Holland. And Plus One Gallery, which had presented all three exhibitions, continued to give kindred artists, mostly American, solo exhibitions, among them John Baeder, David Ligare and Carl Laubin.

The diversity in age and national background of these, ultimately, twenty-five artists reveals something of the tenacity with which this tradition of intense, meticulous realism has survived in the twentieth century, despite the vicissitudes of fashion and politics. I have mentioned some of the reasons that intense naturalism in painting fell into desuetude after 1900. Political prejudice certainly had something to do with it, in particular the official dedication of the Nazi regime to the sort of conservative, realist art that Hitler had been taught in his earlier days at art school and continued to practise in rare leisure moments throughout his life.

Consequently, the Nazi version of super- (and often heroic) realism was universally despised, and its connections with Neue Sachlichkeit ignored: in the Paris *Réalismes* show visitors arrived virtually at the door of Nazi realism, and then were diverted through a long succession of international political posters before entering the Nazi section, where they found, for the first time in the exhibition, extensive wall texts explaining exactly why the paintings were anachronistic and distasteful. One could only conclude that the organisers, having presumed that the inferiority and irrelevance of Nazi art would be self-evident, discovered that once it was on the walls it seemed to fit very well with the revised history of twentieth-century art that the exhibition proposed.

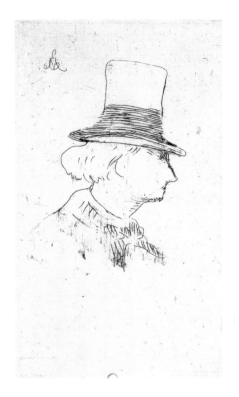

Edouard Manet
Charles Baudelaire
1862
Bibliothèque nationale
de France, Paris

Nadar
Portrait of Charles Baudelaire
1862
Bibliothèque nationale
de France, Paris

Much the same would probably have gone for Soviet Socialist Realism, had it not been totally excluded from the Paris show. Russia's official rejection of what was regarded as modernist music by the Zhdanov decrees of 1948, which set great, serious composers such as Shostakovich and Prokofiev abandoning the symphony and the string quartet to write jolly, 'accessible' cantatas in praise of re-afforestation and the like, caused a major uproar in the West, partly because the Cold War was already looming large. The equivalent exclusion of modernist art caused much less fuss, happening as it did in the late Twenties, when the left-wing intellectuals of the West were still in the middle of their honeymoon with Soviet Communism, and did not question too much whether the return of such revolutionary (and Revolutionary) artists as Kazimir Malevich from the outer edges of abstraction to a cosier form of peasant-like representation was willing or motivated by fear of an oppressive authority.

All the same, it remains necessary to take into account the matter of artistic talent. Though no doubt Malevich did not welcome being coerced into a return to representation, his later works, done under the new artistic regime, are full of life and vigour. Though representational, they are far from being photographic in their realism, relying instead on their bright folk art-like simplifications to ensure that they look popular and not over the heads of Russian art's new masters. Soviet landscape generally tends, under the new dispensation, to the Impressionistic, or slightly Post-, but in the more official reaches, the vast compositions with happy peasants crowding round a beneficent Uncle Joe Stalin are definitely photographic, and often based unmistakably on actual photographs. It was not necessarily what the artists responsible wanted to do either: the great expert in such things, Yekaterina Zernova, made an official trip to India in 1966, and I have one of the works she painted there. It is a jewel-like panel evoking dusk on a river, verging on the abstract in its bands of exquisitely graded colour. Did she occasionally manage in this way to work off her frustration at being normally confined to official set pieces? We can only guess.

In any case, Soviet realism, like Nazi realism, has been tarred for years with the reputation of serving only totalitarian philistinism. It hardly helped,

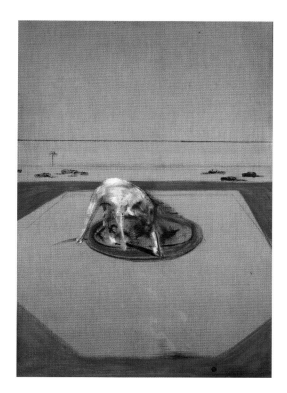

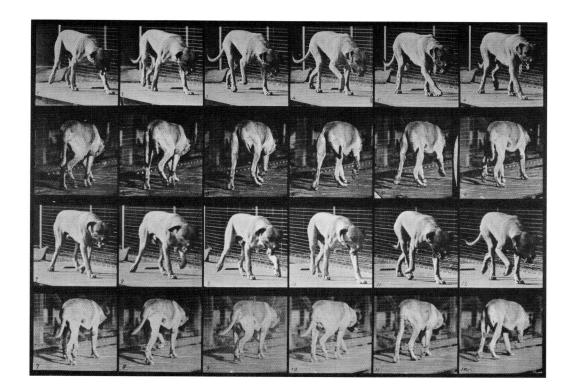

Francis Bacon
Study of a Dog
1952
Oil on canvas
198.1 × 137.2 cm

Eadweard Muybridge
Mastiff 'Dread'
c. 1884–87
From 'Animal Locomotion',
plate 704
Collotype print
23.2 × 32 cm
George Eastman House,
Rochester, New York

therefore, in the cause of continuing, or rehabilitating, the realist tradition in modern painting. Nor, apparently, did the parallel existence of the photograph. It is well known (though possibly apocryphal) that when he first saw daguerreotypes exhibited in 1839, the French academic painter Paul Delaroche exclaimed 'From today, painting is dead!' It should also be remembered that this, if he ever actually said it, did not prevent him from heading a French government commission into the value of the daguerreotype process, and continuing to paint his grand historical set pieces until his death in 1856. He quite possibly realised that the photographer, rather than proving a dangerous competitor, could well become an aid to the painter, obviating the necessity for extended sittings with live models.

Even if he did not, many other painters did. We know, for example, that such great masters of the day as Ingres and Delacroix made use of photographs in their figure compositions, Delacroix indeed getting his friend Eugène Durieux to make photographs expressly for that purpose, much as, somewhat later, Edouard Manet used his photographer friend Felix Nadar's pictures as a basis for his portraits, painted as well as etched (*Charles Baudelaire*, 1862). Already, by Manet's time, painters were tending to be more secretive about their use of photographs, as though it was regarded as slightly infra dig, a disreputable shortcut. Edgar Degas, for instance, certainly used Eadweard Muybridge's consecutive pictures demonstrating exactly how a horse's legs moved in motion in his own pictures of horses, and even such an enthusiastic proponent of on-the-spot *plein-air* painting as Cézanne demonstrably made use of photographs as documentation, at least occasionally, in his landscapes, as did Maurice Utrillo a generation later. Incidentally, at least one important twentieth-century artist has been inspired by Muybridge: several of Francis Bacon's paintings of a dog or a pair of wrestlers are clearly based on Muybridge photographs.

By the end of the nineteenth century the general attitude to painters' use of photographs as documentation or inspiration, in Europe at least, had become one of, to twist slightly the famous film publicity line, 'Do it, and talk about it in whispers.' When Walter Sickert openly based several of his paintings in the

late Thirties on pictures he had seen in the press, this was received with universal horror, as a sad demonstration of the artist's deteriorating talents now that he was approaching his eighties. And it was not as though Sickert was indulging in slavish imitation of a photographic original in, say, his famous *Portrait of Edward VIII* (*c*. 1937), which if anything boldly anticipates Pop Art's gleeful appropriation of mass media images. Any more than Cézanne was a slave to his photographic original in *Melting Snow, Fontainebleau* (1879), which is transformed into a piece of classic Impressionism. It was not the effect, but the very idea, which scandalised.

Interestingly, the categorical rejection of photography as a legitimate artist's aid never seems to have been quite so much an article of faith in America. Possibly because, even though most prominent American artists of the later nineteenth and early twentieth centuries studied and/or painted in Europe at some stage in their career, America as a nation, regarding itself as still young and open to innovation, had a different attitude to photography itself, and consequently to the various uses to which it might be put. No doubt a crucial figure in all this was the painter/photographer Thomas Eakins (1844–1916). While it is known that another American classic, Winslow Homer (1836–1910), consistently used photographs as the basis for his prolific output of magazine illustrations during the 1860s, it is not so certain that he continued with this practice in his mature paintings. Eakins, however, who called himself a 'scientific realist', took his own photographs, and is indeed rated today as a photographer almost more than as a painter, made no bones about working the two media together, and openly based his landscapes as well as his figure compositions on photographs he had taken.

I suppose that a 'scientific realist' is not necessarily quite the same thing as a 'photo-realist', but the implication is certainly there that photographs are in some way more 'real' than paintings, and therefore, perhaps, that a painting based on a photograph may then be more 'real' than one based on the observation of the artist's own unaided eye. In any case, it all depends on how 'real' the the artist intends his painting to be – not to mention in what sense, if any, he intends it to look 'real'. In spite of everything, Eakins's own paintings end up

looking more like conventional Victorian paintings – the later work of, say, Millais – than like the photographs they are based on.

When he first became aware of photography, the art critic John Ruskin began by valuing the objectivity of the photograph, but then rejected it as too literal. It lacked the soul that a true artist's image necessarily possessed, and indeed his Pre-Raphaelite disciples aimed beyond the literal towards the hallucinatory. Clearly the Impressionists on the whole sought their reality in the way that light and colours flickered and transformed themselves, rather than in the hard lines photography depicted in the objects the light played upon. The Cubists found their reality in re-creating the volume of the place or thing depicted. The Expressionists dumped that kind of reality in favour of truth to the subjective responses of the artist to what he sees. All of these are seekers after truth, of one kind or another, but none of those kinds has much to do with the particular truth laid bare in a photograph.

To complicate matters, influences between painting and photography began to flow, at times quite strongly, in the opposite direction. The Pictorialist movement in later Victorian photography, for instance, set out to make photographs look more like paintings. Not only would pictures be taken deliberately in very soft focus, but all sorts of techniques involving retouching, cropping, tinting and 'framing' photographic images were employed the more closely to approach a painterly effect in the finished print. The prevailing tone of the times (the phrase is Henry James's) also had its inevitable effect, so that a photographer such as Edward Steichen, who used none of these devices, inevitably though unconsciously strikes us in his early work as a Symbolist artist in his choice of subject and the angle from which he observes it.

When we realise that Steichen was also a painter, a gallery director, and a friend of the leading American artists of his day, that makes perfect sense. It also helps to explain why photography, both in itself and as an adjunct to painting and other fine arts, was much more respected in America than elsewhere in the world. As the twentieth century progressed, American art produced more prominent figures who upheld the claims of photography and themselves combined the

Charles Sheeler
Cactus
1931
Oil on canvas
114.6 x 76.4 cm
Philadelphia Museum
of Art: The Louise and
Walter Arensberg
Collection, 1950

Charles Sheeler
*Cactus and
Photographer's Lamp*
1931
Gelatin silver print
23.5 x 16.6 cm
Museum of Modern Art
(MoMA), New York, Gift of
Samuel M. Kootz, 404.1942

practice of photography with that of painting. Of all the group known as Precisionists, Charles Sheeler is the perfect role model. His typical paintings were of urban and industrial buildings and of rather stark, bare interiors. Few of them depicted subjects which would have struck earlier generations of painters as interesting (the interiors might, at best, be compared with those of the great turn-of-the-century Danish painter Vilhelm Hammershøi), though they might well have caught the photographer's eye. The simple lines and angularities which came readymade in such subjects already looked like Cubist reductions or Art Deco streamlining, and when they led to painting with the same characteristics no one was excessively taken aback. After all, they could be readily placed in some recognised artistic tradition which did not require any specific reference to photography – even though Sheeler was also known as a photographer and filmmaker.

Though none of this back-history brings us really close to Photorealism properly so called, it is already looming on the horizon. The real, epoch-making change came instead from a chic, rather camp illustrator in New York named Andy Warhol. Although not in the form of true Photorealism; rather the reverse. Warhol was not so much interested in realism per se. But he was fascinated by celebrity, whether the celebrity of Marilyn Monroe or that of Mao Tse-tung. And he recognised that celebrity's best primary vehicle was photography. Not so much the photograph of myth that allegedly cannot lie, but rather the reality of photography which says that, with a bit of manhandling, it can do anything you want it to do. And it is, if true to anything, true to one particular moment, which is desirable if, in Warhol's famous dictum, we are all going to be famous for fifteen minutes.

Warhol, after a decade of success with his own highly idiosyncratic draughtsmanship, seems to have wished to become, as George Meredith puts it, 'seraphically free of taint of personality', and developed his own cult of impersonality, redefining the artwork as a mechanical product. This meant that he was willing to state that 'Anyone can make a Warhol, not just me' – and later, when I queried the logic of his suing two inmates of his Factory, Brigid Polk and Gerard Malanga, for doing just that, he replied mildly 'Ah, that was art, and this is

money.' Warhol's own later graphics and paintings were all based on photographs, sometimes Polaroids taken by himself, but more often found or acquired images of famous people or notorious events, silkscreened on paper or canvas and then worked on.

That is not to say that he was in any sense a Photorealist. His vision entailed starting from what was unmistakably a photographic image and then transforming it. A portrait photograph of, say, Elizabeth Taylor or Elvis Presley would be fantastically coloured to take on extraordinary abstract qualities. An image of an horrendous road accident or an electric chair awaiting its occupant would be twinned or multiplied to emphasise the horror. A black-and-white self-portrait would be overlaid with a range of different colours or with an elaborate camouflage design. Nothing particularly real about those, obviously – except, perhaps, in an Expressionist sense of what reality is all about.

It must be remembered that Warhol emerged to public acclaim (and sometimes obloquy) during the heyday of the American painters known as the Abstract Expressionists, and it may not be too fanciful to see a touch of Abstract Expressionism in the famous early Warhols. Certainly their use of photography is not part of a reaction, let alone a rebellion, against the prevailing aesthetic in American art. But such a reaction – or rebellion – is certainly about to appear. And not before time, many thought. The ancestry of Abstract Expressionism was curious. Almost all of the principal figures – Jackson Pollock, Mark Rothko, Arshile Gorky, Franz Kline – had some Surrealism in their background, along with, even more improbably, in Pollock's case a sort of Regionalist realism akin to Socialist Realism and derived from his teacher Thomas Hart Benton.

They had all toyed with representation and deliberately turned their backs on it. Therefore a return to representation in any form was inevitably going to be seen as a retrograde step. It was certainly considered thus in Europe, where Avigdor Arika, a painter known to us for his representational work, tells me that when he turned away from abstraction to detailed representation in Sixties Paris he was literally spat on in the streets by outraged fellow artists, who regarded him as a traitor to the cause of Modernism. If there is any truth in this rather

sensational assertion, perhaps the emergent American school of Photorealists have to be seen as the first Post-Modernists. It is difficult now to know for sure how they then regarded themselves, or if they had any sort of unified, coherent programme in mind.

Probably not, for the unexpected return to, not only a kind of realism, but the extreme form represented by the photograph, seems to have been totally uncoordinated, happening simultaneously among groups of unconnected artists, who did not even necessarily know one another, let alone that the same sort of thing was happening on the East and West Coasts at the same time. The movement, such as it initially was, certainly did not arise, except chronologically, in the wake of Warhol. Nevertheless, Warhol's example must have had something to do with it. What the Photorealists had in common with Warhol was the pervasive use of photographic images in their painting, and the psychological importance of impersonality as an ideal of art.

In some of this Photorealism was in parallel with another movement which, at much the same moment, was advocating a recultivation of representation. In New York, and even more in London at the outset of the Sixties, there were many young artists who, a few moments before the idea of Swinging London had even germinated, were fascinated by the visual attributes of what was coming to be called 'Pop Culture'. In London David Hockney, Peter Blake, the American R. B. Kitaj (then studying in London), Richard Hamilton and others began using newspaper and advertising photographs, flags, posters and such in their art. In America a group of ex-Abstract Expressionists including Roy Lichtenstein, Robert Rauschenberg, Jasper Johns and Claes Oldenburg, who at least all knew one another (in some cases intimately), were taking much the same line, with some specifically American variations: Lichtenstein's blown-up frames from comic strips and Johns's flags and targets figured prominently.

Pop Art seems to be in a pretty direct line from Warhol. The artists' use of their Pop materials was more evidently whimsical, ironic, even camp, than Warhol's, but the preoccupation with the material was very similar. And clearly, as with Warhol, reality had little to do with it. Photographs were extensively

used as raw material, but in a way their use, even if not literally in collages (and quite often it is), was very much in the line of satirical and surreal collages from the interwar years, as in the work of artists such as Max Ernst, Hannah Höch and John Heartfield. There are some artists who in certain respects form a bridge between Pop Art and Photorealism. Ed Ruscha, for example, makes photographic works himself, like his Los Angeles panoramas, most extraordinary among them *Pico*, which strings together a complete record of the least glamorous of Los Angeles boulevards, both sides, from Downtown to the sea. Even that is in some ways whimsical (only a fantasist would choose Pico Boulevard for this treatment in the first place), and much of Ruscha's graphic art based on photographs permits the intrusion of fantasy, like the print of the 20th Century Fox sign erected like the Hollywood sign on top of a hill.

But most of the famous Photorealists are deadly serious in their use of photography. To allow whimsy in is to let in the personality of the artist, showing what sort of thing he personally finds funny and, by extension, what strikes him as tragic, what interests him and what bores him. You might say we must at least know what interests him by his choice of subject: he is surely, after all, hardly likely to pick a subject that bores him. Well, yes and no. Photorealism is essentially noncommittal. The impression created by it is that any subject is as good as any other. One could simply drop a camera anywhere, take the picture, and then render it exactly in paint. In that case, no hint of the artist's personality would intrude.

But of course, that is only an impression created, more or less deliberately, by the artworks. We might suppose from his apparent nonchalance that Richard Estes has no particular preference in his choice of New York street scenes, except perhaps that they should not be too remarkable, not picturesque or even distinctive in any way. But look more closely, and one sees that he is fascinated by the reflections in store-front windows, and enjoys angles rather than flat surfaces presented directly to the camera. At any rate, Estes is the quintessential pioneer Photorealist in the most significant respect: all his pictures are deliberately calculated to look as much as possible like photographs.

So are those of John Baeder, another classic American proponent of the Photorealist aesthetic in his own painting, as well as in such writings as his book *Sign Language: Street Signs as Folk Art*. In his case he manifests a particular, personal obsession: with that uniquely American phenomenon, the roadside diner. He had this interest when he first appeared on the art horizon at the beginning of the Seventies, at which time the diner already had a faintly nostalgic aura about it, associated with the earlier, simpler days of *American Graffiti*. He still has the interest today, when the diner has been virtually abolished, and then undergone a chic revival in even more than its original gleaming-chrome splendour. More bizarre still, Baeder's vivid delight in the diner appears to have had more than a little to do with the diner's renaissance – an interesting case of life taking its cue from art.

Baeder is not the only early Photorealist to be possessed by a particular subject. Taken one at a time, John Salt's subjects (virtually all of them American, though he is British and generally resident in Britain) might seem quite casually selected and unpremeditated. Taken together, they give a very different impression: most obviously, that he is obsessed with old American cars, the more derelict the better, and that he has definite ideas as to how his pictures should be composed. Once the subject is chosen, he deliberately paints them as though by numbers, filling in the outlines traced from photographic originals. But even at that stage, the choice of colours, all very subdued and delicately coordinated, is unmistakably his own.

Though landscape, and specifically townscape, is the main preoccupation of Photorealists, it is not the only one. Some Photorealists seem to belong to a different tradition, not necessarily connected with photography at all. For all through time, even, if we are to believe the frescoes of Pompeii, before the systematisation of perspective at the Renaissance, the trompe l'oeil has existed. It reflects, no doubt, the perennial mischief of mankind, the desire to deceive for no other reason than the sheer pleasure of pulling the wool over somebody else's eyes. And while most Photorealism has no desire to deceive in that particular way – one is not expected, even for a moment, to suppose that one is

Ben Schonzeit
Roses Les Halles
2005
Acrylic on linen
100 x 100 cm

contemplating a real street scene through a real window – some Photorealist still lifes could definitely be mistaken for the real thing, if appropriately placed and lit.

Largely it is a matter of scale. The main reason one would not mistake a painted townscape for the real thing is because it is not big enough. After Alfred Hitchcock felt that he and his wife Alma were too old to travel to St Moritz in winter every year to relive their honeymoon, he remarked to me that since all he had done at St Moritz in recent years was sit by a hotel window and look out at the ice and snow, he thought he could procure the same effect at home in Bel Air by getting some scene-painters from Universal Studios to make a snowy back-drop to hang outside his study window there. Now that would be an illusionist piece of Photorealism, because it was big enough to be so. Otherwise, it does not work that way.

But the deceptive side of trompe l'oeil is clearly not incompatible with Photorealism on a smaller scale. The classic trompe l'oeil painting nearly always depicts a collection of objects hanging on a wall or door: the requirements of per-spective are minimal, and if the placing of shadows is consistent the effect can be complete, whether it is making us believe we are looking at a group of more or less crumpled letters in a paper rack, or a dead bird hung up to mature.

Various artists who are by no means Photorealists – such as Michael Leonard in his so-called *Transpositions*, where a contemporary sitter is drawn in the style of another era – enjoy, and make us enjoy, the technique involved in simulating the crumples and folds of old paper. Some artists who were not excessively wor-ried in the early days to be called Photorealists, Stephen Posen for one, strenu-ously resented being associated with trompe l'oeil. But one has only to look at the still lifes and flower pieces of Posen or Ben Schonzeit to gauge the possibili-ties of Photorealism in small-scale deception of the eye.

Trompe l'oeil, as noted, has never been entirely respectable in art apprecia-tion. Like the architectural *capriccio*, it is tarred with frivolity: all very well in its way, and undeniably fun, but is fun to be regarded as a proper product of seri-ous art? At least in that respect most works of Photorealism are unimpeachable: one feels that if they were not unmistakably serious, they would come in for

much more flack from the art establishment even than they do now. Surprisingly, Photorealism still remains controversial.

Why should we be surprised? Well, up to the golden age of Abstract Expressionism, whatever form the kind of painting most in vogue took, it was always expected to be, at the very least, painterly. Early in the twentieth century it was expected also to be based on expert draughtsmanship, learnt in a life class, even if this solid basis was heavily disguised, as it often was from the dawn of Impressionism on. Later, with the ascendancy of abstraction, attention turned more to the free-ranging expression of the artist's emotions and aesthetics in paint. But always personal expression was the painter's sine qua non.

That was then. But matters have changed radically since 1960. First, there was the acceptance of phenomena such as Performance Art, Video Art, Assemblage and Installation as legitimate forms of Fine Art. I remember taking part around 1980 in a public debate on the subject of 'Craft: Is It Different from Art?' I thought then (and I have been proved right) that this must surely be one of the last of its kind, for how could we solemnly be discussing, in the light of all these newly legitimate art-forms, whether ceramic sculpture was automatically inferior as a form to stone carving, or whether a book-binder needed to describe himself as a 'book sculptor' in order to receive respect.

And yet, there are still many critics who look askance at Photorealism, or indeed any use of photographs, in the creation of a painting or print. Some of those critics, admittedly, have trained as painters along traditional lines, and retain a sort of personal resentment that other painters exhibiting in respectable West End galleries are somehow getting away with murder, never having spent years of effort learning the hard way how to draw. Consequently, Photorealism has never achieved total acceptance in Britain. But at least, accepted or not – and indeed perhaps partly because it has not always been – it has continued to be practised by younger and younger artists.

It was into this climate that Exactitude was born. It seems to have been the brainchild of the English painter Clive Head, who curated an exhibition under that title at Plus One Plus Two Gallery, London, in March 2003. The show

John Salt
Falcon
1971
Oil on canvas
117 x 162.5 cm

brought together seven artists of similar tastes and techniques: six painters and one sculptor. At the time of the exhibition, Clive Head was thirty-seven, and of his three established artist-colleagues Ben Johnson was fifty-six, Steve West fifty-four, and Steve Whitehead forty-two, while the three new 'discoveries' were thirty-eight (David Finnigan), thirty (Nathan Walsh) and twenty-three (Sharon Tiernan). The nationality of all seven is given in the catalogue as British, though it is also noted that Ben Johnson was born in North Wales.

Thus Exactitude began life as a specifically British movement, though probably not perceived as a movement at all until Head christened it and in the process defined it. This seems to be significant, for Photorealism has been seen primarily as an American form of art. The very word 'Photorealism' summons up for British connoisseurs a selection of New York or Los Angeles street scenes and American rubbish dumps, the streets and the dumps not always being clearly distinguishable from one another – indeed most American Photorealists are particularly drawn to the sleazier side of urban life, as though this sort of detailed realism must inevitably confront the grim and the sordid, as a possibly painful duty.

Given this bias, we should not be surprised that one of the earliest and best-known British Photorealists, John Salt, who had been painting in that way since 1968, has all along been totally besotted with squalid America, and particularly with the American automobile at various stages on its way to total disintegration. When he lived for a while in America he lived in Baltimore, the home and inspiration, be it noted, of that specialist in kitsch and grunge John Waters. And since his return to Britain, he has remained true to this primal vision. Even if not every American Photorealist has concentrated on the dark side, they have nearly all steered clear of the conventionally beautiful or picturesque.

How, then, could Photorealism be acclimatised to 'this precious stone set in the silver sea'? Not all Brits share the normal American view that Britain is unremittingly cute, with something beautiful or quaint round every corner. But you still have to look further and longer in Britain to find the sort of urban disaster area that regularly abides cheek by jowl with the hyper-glamour of

Ben Johnson
Through Marble Halls
1994
Acrylic on canvas
139 x 183 cm

new-minted America. So British Photorealism could easily have been seen as something of a contradiction in terms.

In this respect, the main thing that the first *Exactitude* exhibition demonstrated to British art lovers, if they had the sort of preconceptions we uncharitably suppose they would have had, was that grunge and Photorealism do not necessarily go together like a horse and carriage. The very first picture in the catalogue instantly breaks the mould: it is undeniably a prime piece of Photorealism, but as for the subject.... Clive Head has chosen, of all things, a *Paris, Morning Light* (2002), and while Head's panorama does not centre upon any obvious Paris tourist magnet, no one could deny the glamour of the Seine-side scene he has selected, all bright and glistening in the morning air. Even when he turns his attention to East Side New York, in a view of the rather bare, but meticulously tidy river end of 42nd Street, he is definitely flying in the face of conventional wisdom about what Photorealism is and should be.

Ben Johnson moves in a slightly different direction by turning to the interior, and in the case of *A Place of Reflection* (2002), also to the edge of abstraction, depicting a bare white interior (the range of beiges presumably comes from the light) which defies the viewer to know for sure which divisions are really there and which are reflections or reflections of reflections. It comes as no surprise that one of Johnson's other pictures in the show depicts, in of course meticulous detail, the country house grandeur of the entrance hall at Syon House. Steve Whitehead carries the same technique into the open country and to the seaside – reminding us momentarily of a half-forgotten, recently revalued British realist of the Thirties, Tristram Hillier. The fourth established artist, Steve West, is the odd man out, a sculptor whose key piece, *Ancestral Guardians and Other Useful Objects* (1999), uses white plaster to reproduce – sometimes in miniature – domestic vessels along with musical and scientific instruments, and encases them in glass-fronted white cases to disquieting and illusionistic effect.

Two of the three newcomers on show are slightly nearer to convention, David Finnigan with *Alameda* (2002), a nondescript street crossing with a group of nondescript people waiting to cross, and Nathan Walsh with *View from*

Gus Heinze
Mission San Louis Obispo
2003
Acrylic on gessoed panel
81.3 x 97.8 cm

Platform 13, which is evidently an industrial (railway) scene, but gleaming smartly in the sunshine under a brilliant blue sky. And the third, Sharon Tiernan, reverts to that different, if remotely related tradition, trompe l'oeil: her *Untitled* (2000) is a patchwork of postcards reproduced with minute accuracy, very much as some eighteenth-century sophisticate or nineteenth-century primitive might set out in paint to convince us that we are looking at a real, crowded letter rack.

The suspicion might arise that with this first *Exactitude* show Head and his collaborators were trying to establish a specifically British slant on the whole idea of Photorealism. The fact that the nationality of each artist is carefully noted in the catalogue might be read that way, in that they are all British. On the other hand, it could be read quite differently, as implying that being British has to be specified, since adherents to the movement might well hold other nationalities, though in these particular instances they do not. Significantly, the catalogue for the second *Exactitude* show eighteen months later applies the nationality tag only intermittently, though it does tell us where the artists were born as well as when, and leaves us to infer the rest.

Inferences made, this is the picture presented: of the seven artists included in *Exactitude II*, three are British, two American, one German/American, and one Spanish; their ages range from seventy-eight (Gus Heinze) to forty (David Finnigan). The group is evidently not young-British any more. *Exactitude III*, two years later, extends things still further: of the seven new artists, apparently three are American, two British, one Canadian and one Dutch; the ages specified (some are not) range from sixty-nine (Jack Mendenhall) to thirty-three (Simon Hennessey). Given this variety of age and background over the three *Exactitude* shows, one might question whether these fairly disparate artists can seriously be held to constitute a coherent movement at all.

For all the variety in their works as shown, there is enough in common to make the idea that they might constitute one movement not totally inadmissible. But the informing idea of Exactitude seems to me to be more one of managing responses. Despite the great fame of certain American Photorealists, most notably Richard Estes – not to mention the high prices currently paid for the

Clive Head
Canary Wharf
2008
Oil on canvas
152.5 x 307 cm

works of Estes and some of his fellows – the whole idea of Photorealism remains faintly disreputable in Britain. This is tiresome, not only to artists who choose to follow a generally Photorealist line, but also to many serious scholars of Post-Modernism, who are irritated by those on the other side who accuse them of being not merely wrong-headed – most art historians are inured to that in relation to some part of their intellectual structures – but quite simply gullible, deceived by the cynical tricks of these artists, masquerading as accomplished draughtsmen when all they know how to do is to trace the outlines of a photograph.

The public that rejects Photorealism is unlikely to read a volume of Post-Modernist theory in order to learn the rationale of finding freedom by submitting totally to the authority of a pre-existing image – and if it did, might well dismiss such devious arguments as casuistry. Such people, however, might perhaps feel differently if required to make no intellectual effort, but merely respond to something before their eyes. The work of the Exactitude group of artists exerts a variable but undeniable appeal to the senses. Few of these artists – with the possible exception of John Salt, with his gangrenous cars in their maximal dilapidation – recoil from any idea of sensuous delight. Clive Head's sweeping panoramic views of London or Rome, Moscow or Prague are uncomplicatedly beautiful in a quite traditional style. Though they may betray some elements of distortion peculiar to photography, they do not insist on them, and thereby do not alienate those who insist on everything's being drawn from life.

Others deviate even further from the severity widely associated with classic Photorealism, which is often thought of as necessarily puritanical and self-denying. What could be more alluring than Tjalf Sparnaay's glowing images of a lollypop or a one-third-empty ketchup bottle, or Simon Hennessey's close-ups of beautiful young women, which may be trompe l'oeil renderings of glamour photographs, but if so, who cares? In these cases, some rebranding was surely in order. Not the sort of rebranding so common in Britain – which apparently assumes that if you start calling British Railways British Rail, or the Post Office Consignia, any grudges against the old version will be totally eliminated from

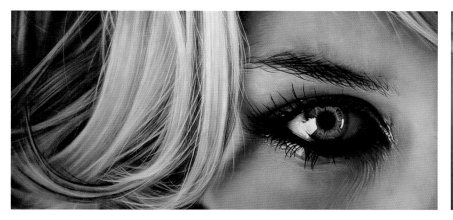 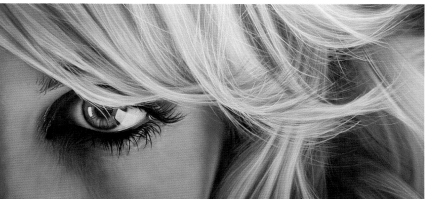

Simon Hennessey
Gaze
2008
Acrylic on board
60 x 246 cm

people's minds by the change – but rather, a recognition that a genuine change has taken place, and needs a new term to encompass it.

In fact, Photorealism has not essentially changed since it was first identified and embraced or reviled in the early Sixties. It has, however, developed and modified itself, rather as, say, feminism has developed and modified itself in the same period. Just as a core feminist looks, talks and behaves very differently from a core feminist forty-some years ago, without essentially changing her stance or ultimate objectives, so Photorealism has moved away from its original self-denying ordinances without negating its original raison d'être.

It still insists on a clear separation between the artist and the artwork. It still depends heavily for its effect on a mechanical quality in its execution, as though the creator is almost denying that he had any essential role in his own creation. It still likes on occasion to advertise its photographic origins, embracing the distortions born in the camera instead of trying to compensate for or disguise them. It still loves the hard outlines sought out by the merciless lighting of the sort of photograph generally used by Photorealist painters.

But it has ceased to be so prudish about the pleasure principle. The subjects most beloved of Photorealists have moved away from, if not totally deserted, the slum and the garbage dump: Photorealism has recognised that it can afford to turn its attention to the picturesque and the beautiful, losing none of its intellectual integrity thereby. It can even afford to link up again with its long-lost, disreputable twin trompe l'oeil, accepting that a hint of frivolity, a touch of humour is an inalienable part of life, and so can find its way into the most serious contexts. It does not even have to be set somewhere in urban America.

But what shall we call these newly developed manifestations of the old principle? It is clearly desirable to call them something different, so as to avoid confusion and misapprehension. What's it all about Alfie?, as modish observers in the Swinging Sixties might have enquired. Well, above all else it is, now as then, whatever form it takes, about exactitude. Clive Head's memory of MoMA in the Eighties hits the nail on the head, and so Exactitude it is.

JOHN BAEDER

IMMEDIACY IS THE QUALITY most regularly attributed to the photograph: it captures the instant, it puts you right there with something that happened this morning the other side of the world. And, indeed, that is the feeling most often sought by Photorealist painters in their art. But it is not invariably the case. The other great, distinctive function of the photograph is to stimulate the memory, to bring back with its full quota of nostalgia something that has seemed lost forever.

So it is with John Baeder. His name is immediately associated with one single, if almost infinitely varied, subject: the American roadside diner. This is usually understood as being a thing of the past – albeit regrettably. But obviously, many of them are still there, where Baeder photographed them, and the country is scattered with brand new examples, the result of a wave of revivalism fuelled to a large extent by the popularity of Baeder's images, as endlessly reproduced in prints, postcards, calendars, not to mention four best-selling books. (Who says that life does not ever take its cue from art?)

In his devotion to a single subject, all shaded with nostalgia, Baeder is unusual, but not unique, among classic Photorealists. For almost as long, John Salt has been paying visual tribute to period American cars in varying states of decay, lying unloved (except by Salt) in almost equally derelict urban backwaters. The difference is that while Salt's photographic originals give the impression (artfully contrived) that they are already fading and curling round the edges, Baeder's paintings themselves appear to be spankingly new and fresh, showing off his diners of choice in all their glory.

Whether this is the way they looked when he found and photographed them, we will never know. The suspicion is that the paintings are sometimes at least efforts of conscious reconstruction, like Alan Sorrel's reconstructions of how primeval stone circles or medieval monasteries must have looked in their heyday. Significantly, Baeder says that he sees his diners as 'temples from lost civilisations'. While the previous generation of American artists, the Abstract Expressionists, mostly began as Surrealists, Baeder's generation started out as Abstract Expressionists before veering into Pop Art or Photorealism. Baeder (born 1938) sees it this way: 'Basically, I'm an Abstract Expressionist, that's where I started. Deep in my heart I still am. Except when I finish a painting, it looks photographic.'

Between Baeder's beginnings as an Abstract Expressionist and his maturity as a Photorealist he spent sixteen years as an art director in the New York advertising and publicity industry. During that time he commissioned a lot of photography from others, although his own interest in photography arose quite independently. His fascination with diners went back much further, right to his childhood, and as he himself says:

> I am concerned with process: the revelation of a particular and poignant part of the urban landscape, and thus the preservation of a unique and rapidly disappearing icon of American roadside culture.

Baeder's art, then, is a hymn to America's past, as he readily admits. But also, because of the insidious effect of art, a hymn to a small but vital part of its present and future as well.

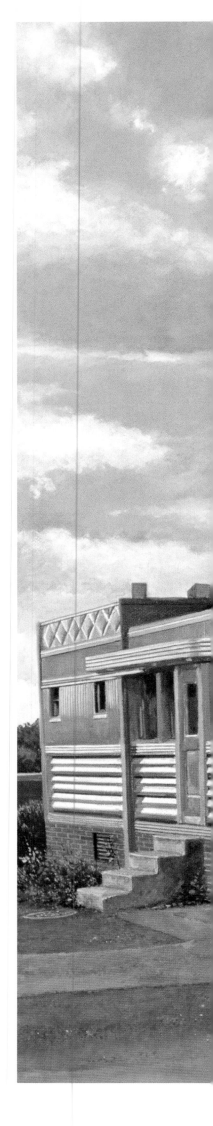

Olympia Diner (detail)
2005
Oil on canvas
76 x 122 cm

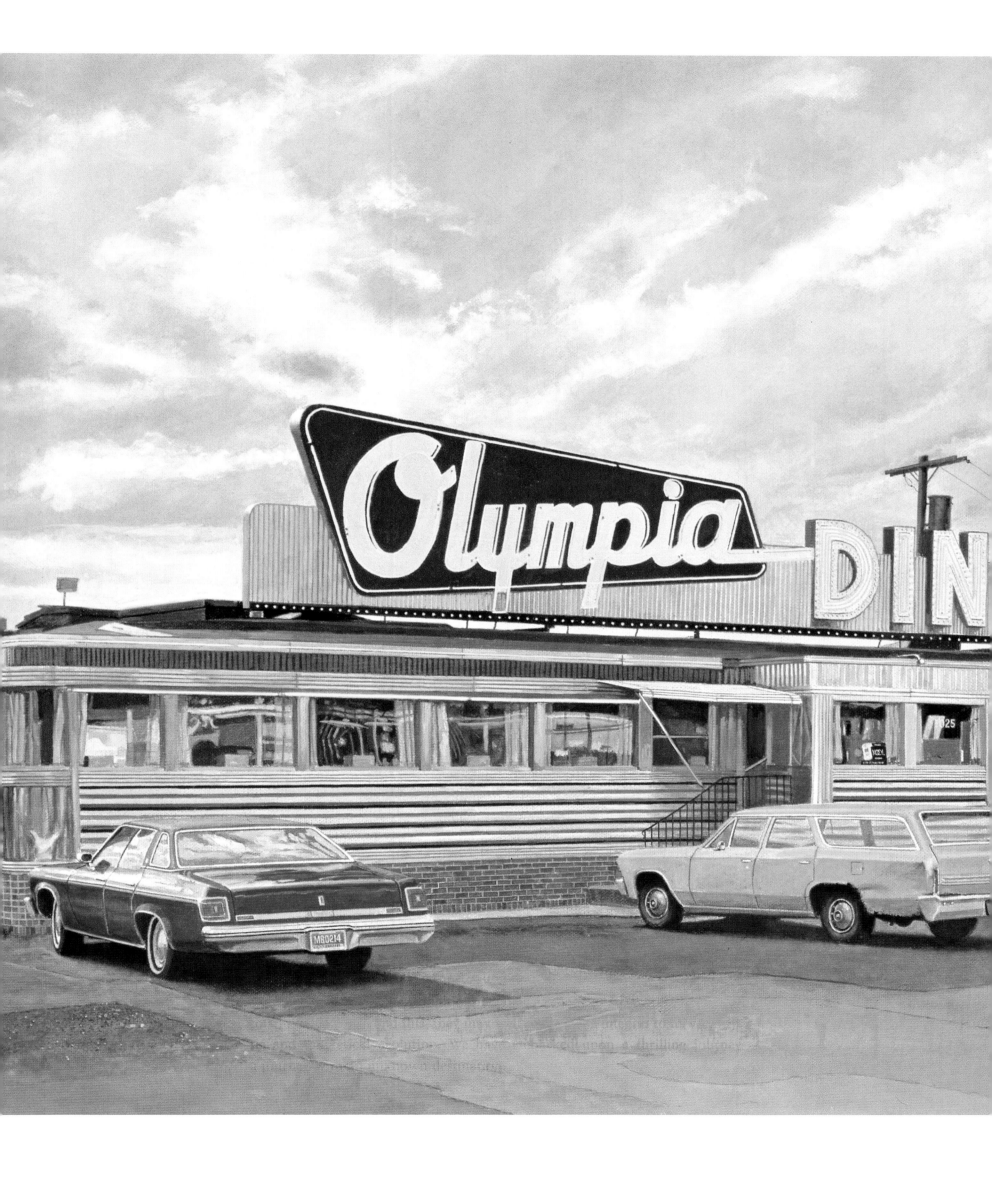

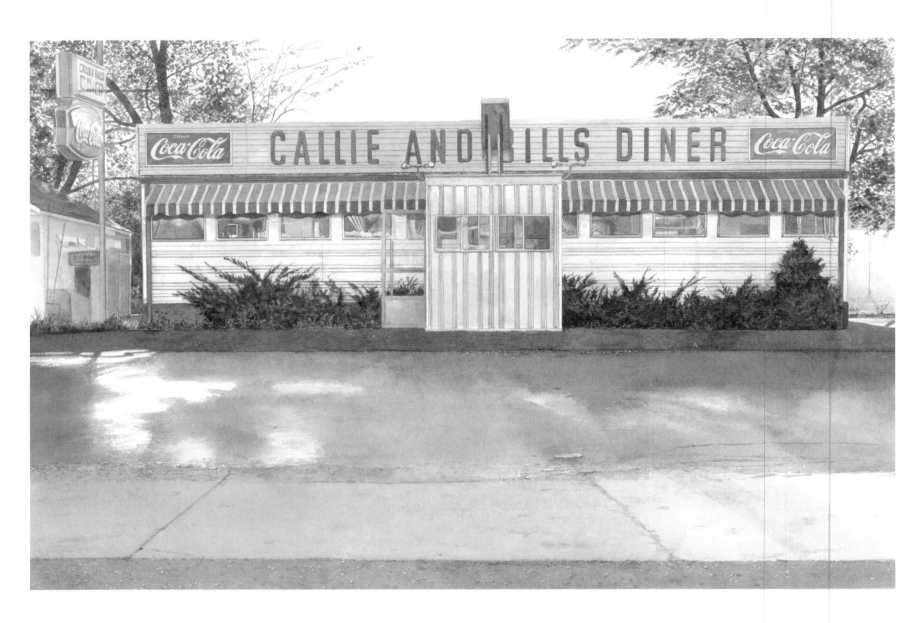

Callie and Bill's, Newburg, NY
1984
Watercolour on paper
77 x 122 cm

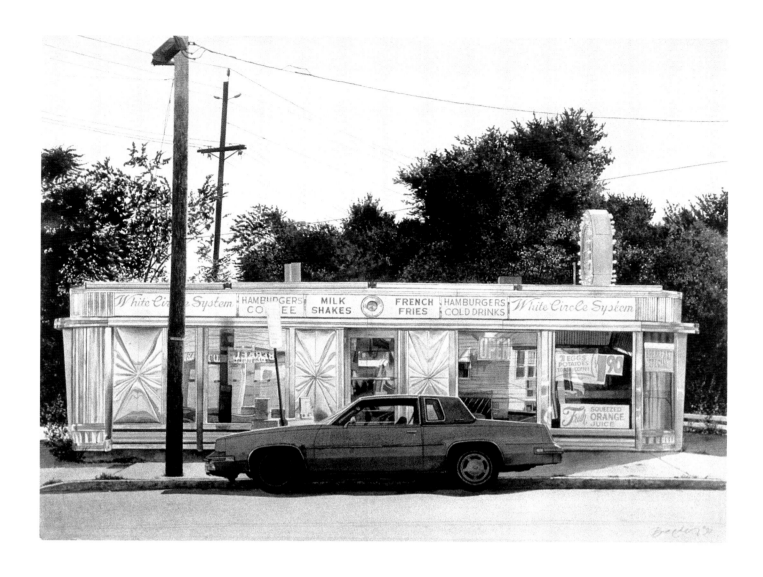

White Circle System, Bloomfield, NJ
1984
Watercolour on paper
58 x 76 cm

Olympia Diner
2005
Oil on canvas
76 x 122 cm

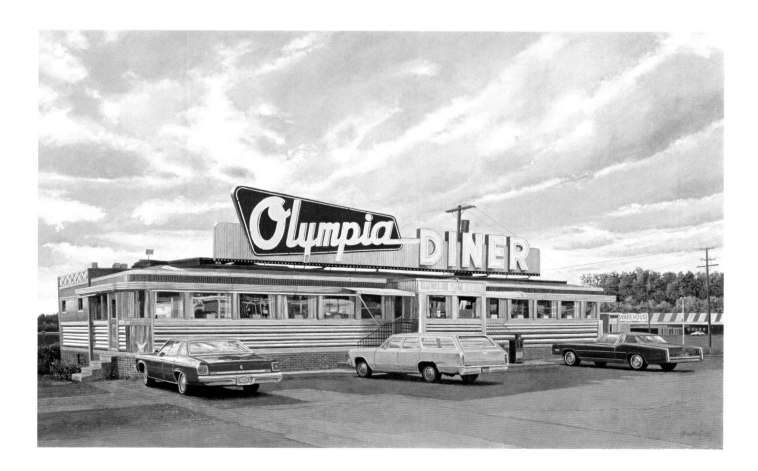

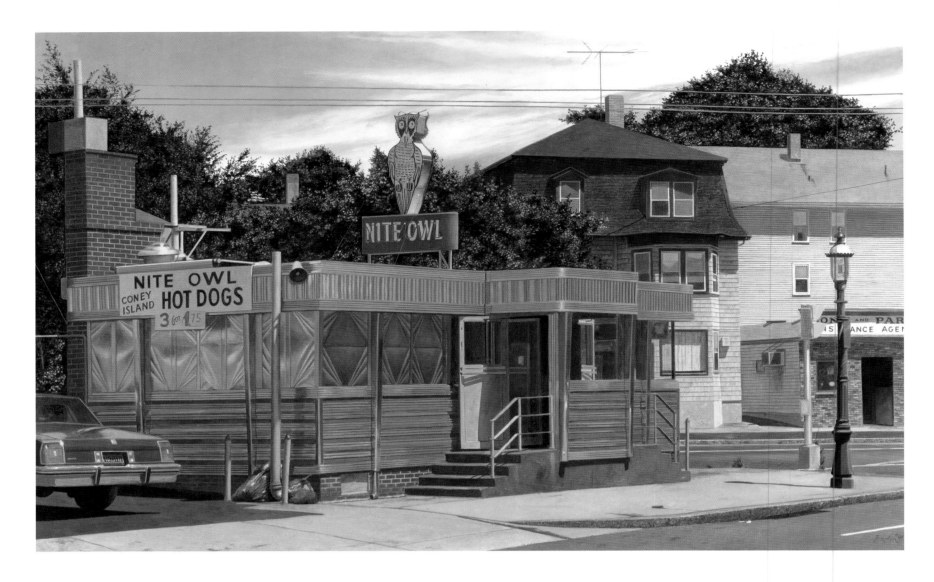

Nite Owl
2000
Oil on canvas
76 x 122 cm

Pappy's Diner
2005
Watercolour on paper
76 x 122 cm

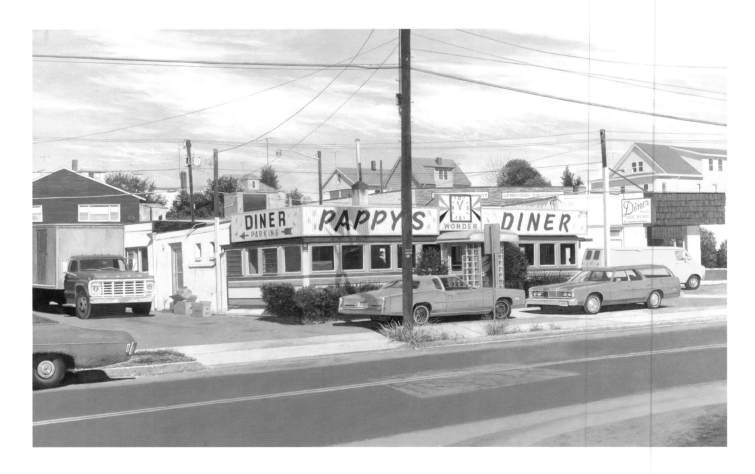

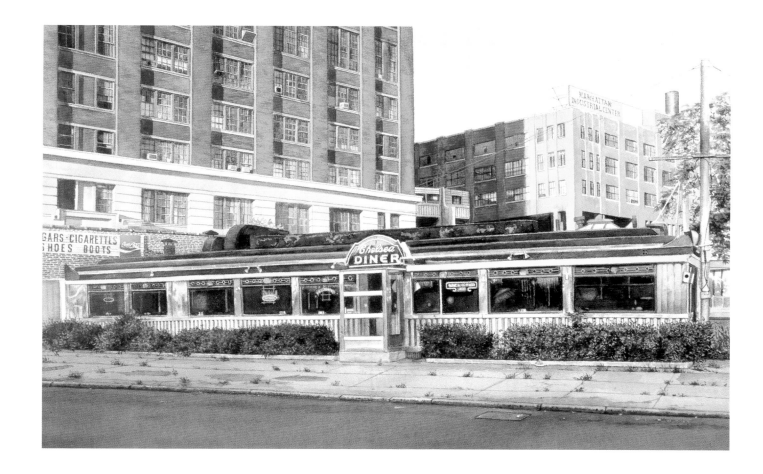

Chelsea Diner
2003
Watercolour on paper
39 x 61 cm

Rosebud
2004
Oil on canvas
76 x 101.5 cm

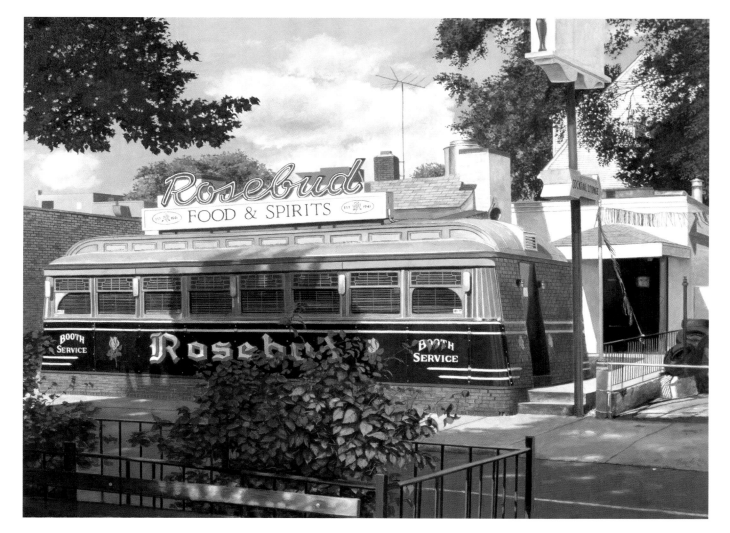

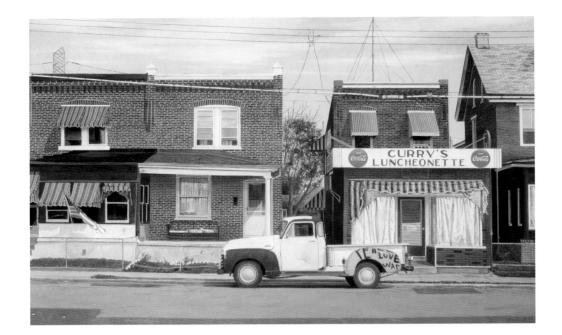

Curry's Luncheonette
2007
Oil on canvas
76 x 122 cm

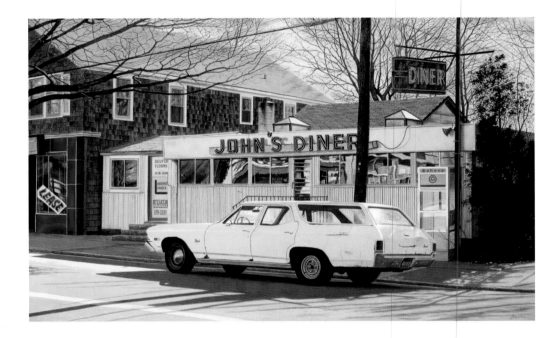

John's Diner
1990
Oil on canvas
61 x 91.5 cm

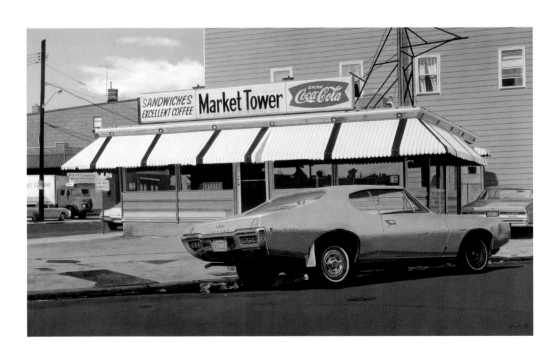

Market Tower
2007
Oil on canvas
76 x 122 cm

Short Stop
2006
Oil on canvas
76 x 122 cm

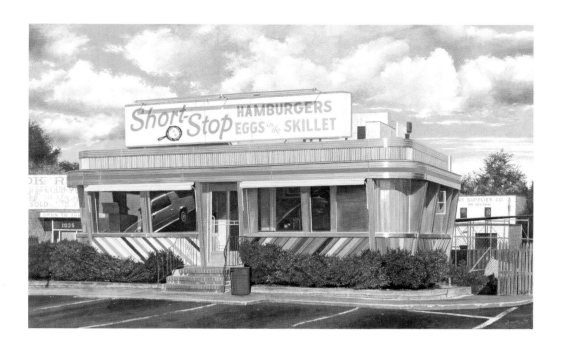

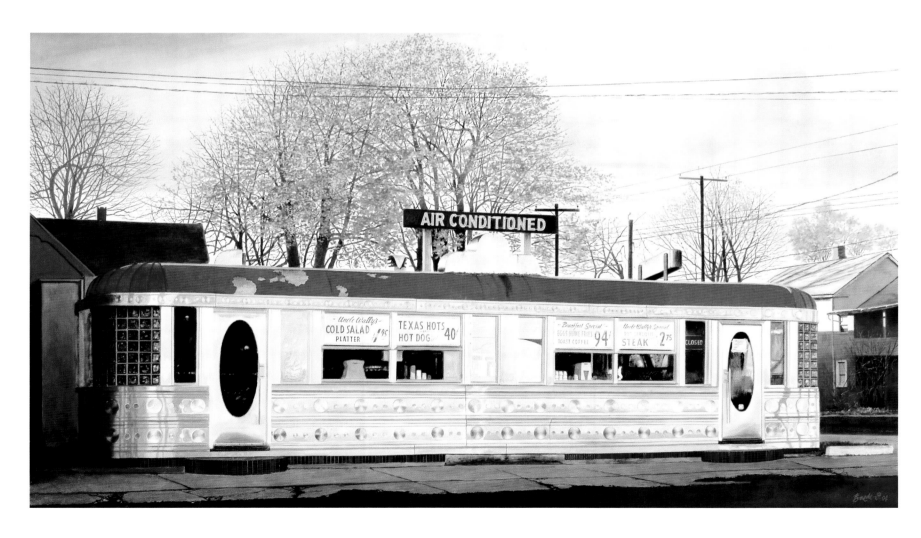

Uncle Wally's
1975
Watercolour
33 x 47 cm

Shorty's Short Stop
1984
Oil on canvas
86.5 x 122 cm

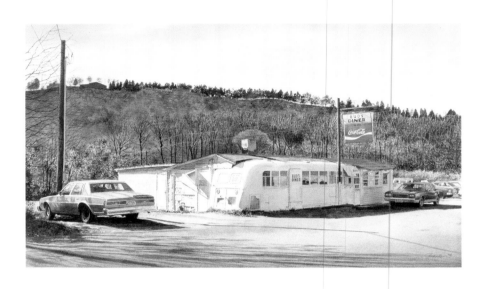

Bud's Diner
1994
Watercolour on paper
43 x 63.5 cm

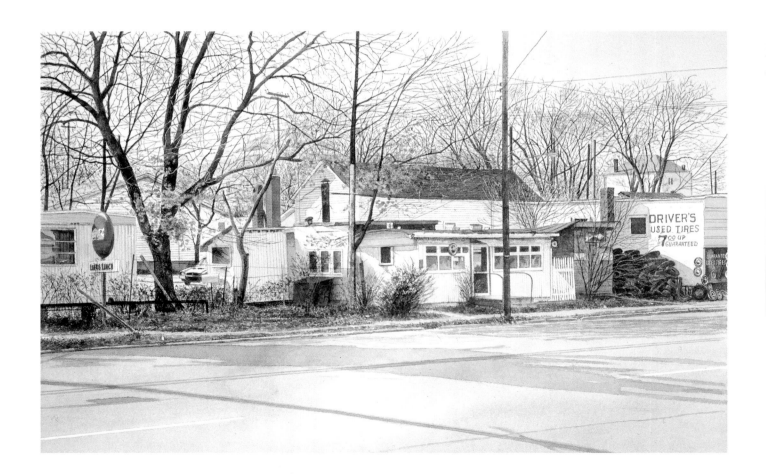

Loftis Lunch
2004
Watercolour on paper
46 x 63.5 cm

Hot Dogs
2003
Oil on canvas
76 x 122 cm

Super Duper Weenie
2000
Watercolour
76 x 122 cm

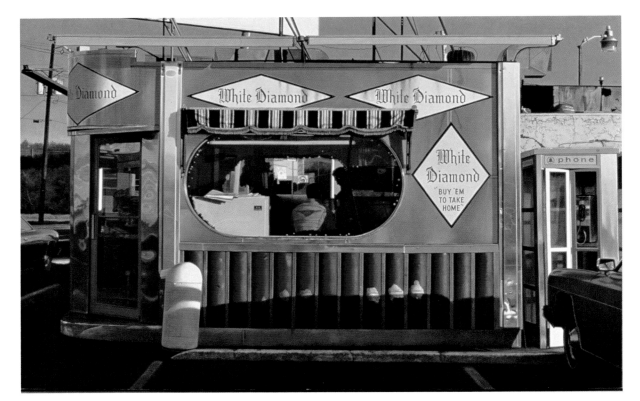

White Diamond
1982
Oil on canvas
106.7 x 165 cm

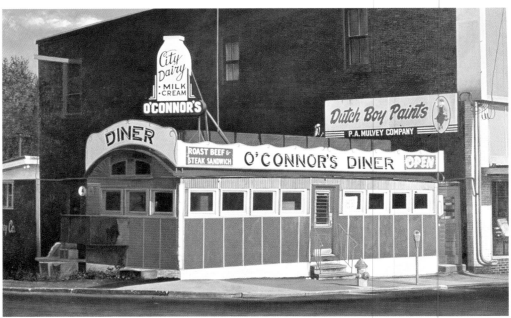

O'Connor's Diner
1976
Oil on canvas
122 x 168 cm

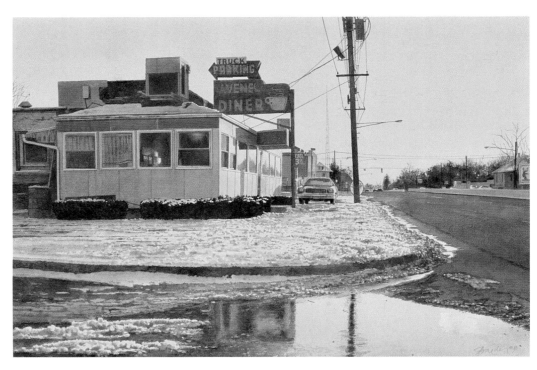

Avenel Diner
1993
Watercolour
30.5 x 45.7 cm

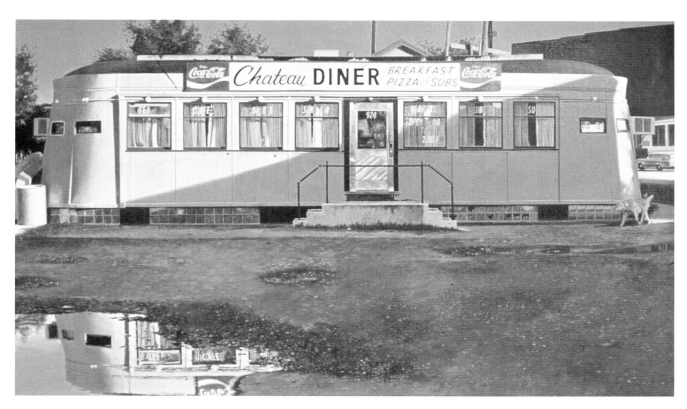

Chateau Diner
1976
Oil on canvas
68.5 x 112 cm

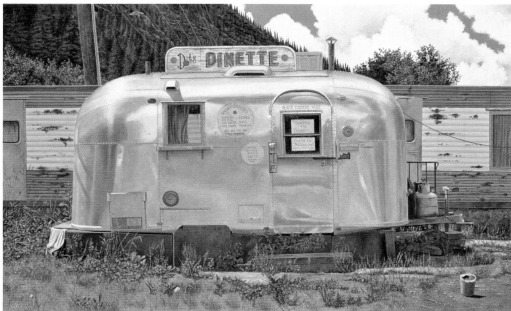

Dot's Dinette
1986
Oil on canvas
76 x 122 cm

Bound Brook Diner
1995
Oil on canvas
76 x 122 cm

PAUL BELIVEAU

IF PHOTOREALISTS divide into two categories, those who see photographs as emblematic of the now-ness of now, and those who regard them as the key to memory, French-Canadian painter Paul Béliveau clearly belongs to the second. Though he has in the past evinced an interest in architecture, his prime obsession for many years has been with books.

That could mean all sorts of things. It could mean that he is a highly literary artist. It could mean that he is taken with the physical aspect of books, as with those decorators who love to sprinkle their interiors with old books in old bindings – the sort of books that no one would dream of reading but whose appearance alone is deemed to impart a touch of class. It might even imply a more basic view of books as physical objects, as in the works of sculptor/installationist John Latham, which all entail burning and otherwise destroying the books themselves.

Mercifully for the booklover, destruction is not part of Béliveau's strategy. He is certainly impassioned by the sight and physicality of books, but also, it seems, by what the books contain. Béliveau links his passion for books to his early childhood, and, rather curiously, to his childish delight in fly-fishing, a delight he shared with his uncle and father. Mostly they enjoyed the experience together, but when his uncle could not come for some reason he made it up to the young Béliveau by lending him books on the great artists from the Time Life collection, thus sparking his parallel interest in art. To this day he remains a devoted reader, surrounded by books and with a particular preference for history and biography, plus the classics of French literature such as Rimbaud, Baudelaire and Proust.

My interest in books goes beyond their content. I collect them, I pile them up, I photograph them, I paint them, I even invent them.... In fact, it is the whole book itself – its essence – that I love. I consider this object to be exceedingly meaningful.... I get a great amount of pleasure from occasionally browsing through libraries or bookstores, touching the worn leather, examining the yellowed pages, the faded covers and the inscriptions and the first few pages.... When I hold an old book in my hands, I feel I am holding a piece of history.... I also find the scent of ink absolutely intoxicating, and I love the sight of letters time is erasing bit by bit.

That does sound a bit like obsession. It emerges also that among many other occupations, including accountant, inspector, plumber, even butcher, Béliveau's father was something of a typographer, and got him hooked on typography at an early age – to such an extent that his mother thought he should become a graphic designer rather than a painter, because at least graphic designers were likely to earn more money.

This may be taken to indicate that Béliveau's artistic devotion to books is not purely passive, just a case of photographing and painting books. His relationship with photography is in itself very complex. He first selects, arranges and photographs his books. Then the photograph is digitised, and the painting executed from the digital version of the photograph of the actual books. This gives at once a remoteness which has often been noted as a positive quality of Photorealism, and a fluidity which suggests that, far from looking at something inscribed in stone, we are snatching at just one instant in the unending process of becoming.

Les humanités CXLIII (143)
(detail)
2005
Acrylic on canvas
122 x 183 cm

KIN

ME
LES
IS

RAPHAEL

SPRING
BOOKS

LEROY

INGRES

The Art of Describing

Les humanités CXLIII (143)
2005
Acrylic on canvas
122 x 183 cm

Les humanités CXCIV (194)
2006
Acrylic on canvas
102 x 152 cm

Les humanités CCLIV (254)
2007
Acrylic on canvas
122 x 183 cm

Les humanités CCCXCIV (394)
2008
Acrylic on canvas
102 x 152 cm

Les humanités CCLVI (256)
2007
Acrylic on canvas
76 x 76 cm

Les humanités CCLXIII (263)
2007
Acrylic on canvas
102 x 152 cm

Les humanités CCLXII (262)
2007
Acrylic on canvas
102 x 152 cm

Les humanités CCLXIX (269)
2007
Acrylic on wood panel
61 x 122 cm

Les humanités CCLXIV (264)
2007
Acrylic on canvas
122 x 183 cm

Les humanités CCLXVI (266)
2007
Acrylic on canvas
122 x 183 cm

Les humanités CCLXXXII (282)
2007
Acrylic on canvas
91 x 122 cm

Les humanités CCXCIV (294)
2007
Acrylic on canvas
66 x 203 cm

Les humanités CCCII (302)
2007
Acrylic on canvas
66 x 203 cm

**Les humanités CCCXCIX
(399)**
2008
Acrylic on canvas
61 x 76 cm

**Les humanités CCCXXXIX
(339)**
2007
Acrylic on canvas
91 x 122 cm

**Les humanités CCCXXV
(325)**
2007
Acrylic on canvas
183 x 46 cm

PEDRO CAMPOS

MOST PHOTOREALISTS pass as super-modernists, largely because photography, even though it has been around now for nearly two centuries, is perceived as the new, shiny, boldly contemporary thing for an artist to be engaged in. But, as we have seen, a concern for extreme realism, subscription to a concept of quasi-scientific precision in painting, goes right back at least to the Renaissance. This must surely imply that photography is not necessarily the only way to approach Exactitude. It might equally well be possible to arrive by a more traditional route: the minute study of the right Old Masters and their work.

It is therefore significant that at least two Hispanic Photorealists, Francisco Rangel and Pedro Campos, have been closely associated, at early stages in their careers, with analysis of the ways and means of the great masters of the past. As a result, both painters have a particular, special access to the techniques of the Old Masters, having practised them personally, Rangel as an official maker of facsimiles at the Prado, and Campos as a professional picture restorer, backed by a diploma from the Official School of Conservation and Restoration of Works of Art in Madrid.

This means that Campos could probably produce the same effect in his hyperrealist paintings without any support or inspiration from photography at all. However, given that photography exists, it would seem perverse to neglect its possibilities for painting altogether. And Campos sees the advantages of using every conceivable support that life offers him, recognising that his individual style and approach will shine out, whatever his precise way of arriving at them.

As indeed they do. Campos, born in 1966 in Madrid, did not have his first solo exhibition until 1998, when he had a showing in Salamanca and A Coruña. The results of this were so encouraging that the following year he determined to give up all other activities and become a full-time painter. Up to now he has exhibited only in Spain, where he has achieved considerable success with his meticulously executed snatches of the real world executed with the minute precision of higher mathematics.

Not for him symbolic overtones: his images might seem icy in their precision if he did not carry that precision to such extremes that his paintings end up being similar in effect to the hyper-intense (possibly drug-fuelled?) images of the first Pre-Raphaelites. Thus, ironically, what seem to be very cool, unemotional artworks, embracing a quietist aesthetic, turn out to set off an intensely emotional experience. What begins in mathematics ends in subtle and virtually indefinable magic.

Coloured Pencils and Torn Paper (detail)
2004
Oil on canvas
100 x 100 cm

Summer Fruit
2006
Oil on canvas
100 x 100 cm

Apple and Cherries
2006
Oil on canvas
100 x 100 cm

Apples and Oranges
2005
Oil on canvas
100 x 100 cm

Apple and Grapes
2007
Oil on canvas
81 x 116 cm

Red Apples
2005
Oil on canvas
100 x 100 cm

Lemons
2007
Oil on canvas
100 x 100 cm

**Coloured Pencils and
Torn Paper**
2004
Oil on canvas
100 x 100 cm

Pencils and Freud
2007
Oil on canvas
89 x 116 cm

Pencils
2007
Oil on canvas
100 x 100 cm

Rhapsody in Red
2008
Oil on canvas
150 x 150 cm

Cornflakes
2007
Oil on canvas
81 x 116 cm

Exactitude Marbles
2007
Oil on canvas
81 x 116 cm

Silver Marble
2008
Oil on canvas
81 x 116 cm

Glass and Marbles
2007
Oil on canvas
100 x 100 cm

Solitude
2008
Oil on canvas
40 x 80 cm

Blue Solitude
2008
Oil on canvas
40 x 80 cm

Jellybeans
2008
Oil on canvas
97 x 195 cm

A Hot Day II
2008
Oil on canvas
97 x 195 cm

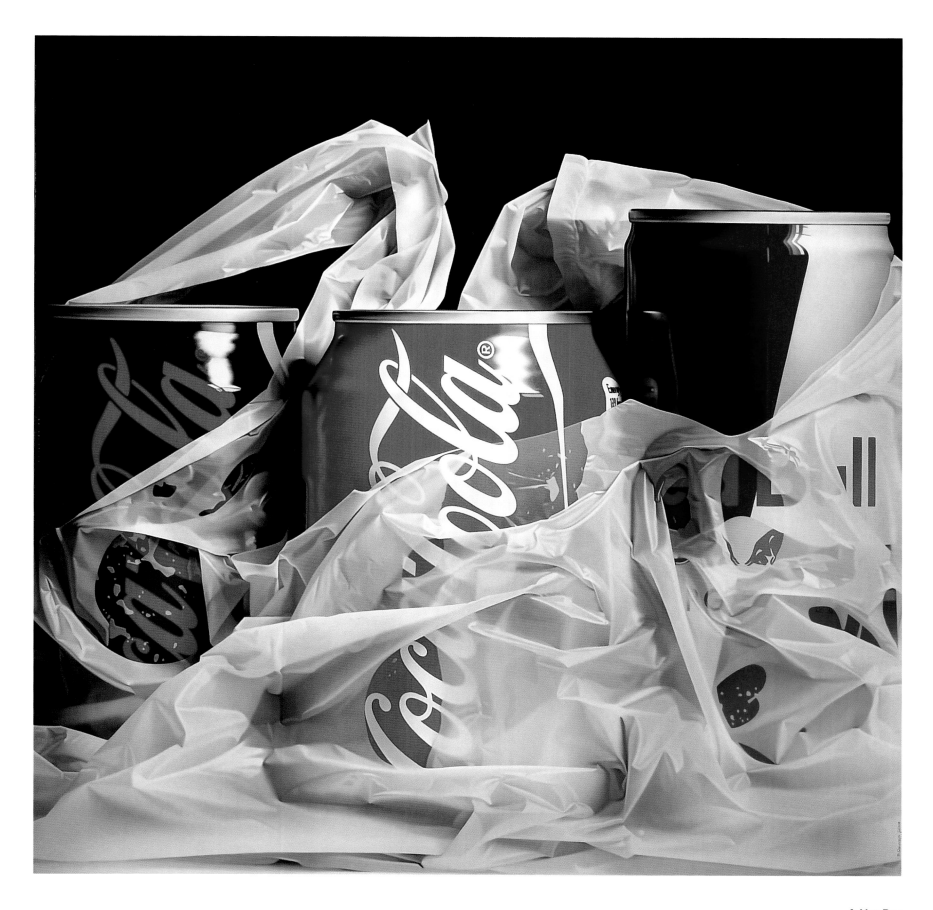

A Hot Day
2008
Oil on canvas
150 x 150 cm

RANDY DUDLEY

MOST OF THE ARTISTS associated with Exactitude are very importantly, if not exclusively, interested in technique. Some use photographs as a tool in the elaboration of their painted work, much as they would use a sketchbook. Others seek to depersonalise their painted work by making it as indistinguishable as possible from the photograph on which it is based. Yet others are inspired to new heights of minutely detailed realism by the general example of photography, rather than producing a detailed imitation of a specific photograph.

None of these statements, however, seems particularly relevant in the case of Randy Dudley. We may presume that he makes some use of photographs in the elaboration of his art. But however far that goes, Dudley does not seem to be much concerned with ways and means. The connection with photography lies rather in his choice of subject matter, which he approaches as an artist of course, but also, crucially, as an historian. His particular area of study is what are nowadays called brownfield sites: those areas, usually on the derelict fringes of inner cities, where the heavy industry that supported and activated the community not so long ago has since given way to smaller, lighter industries, or indeed to nothing at all.

What fascinates Dudley is the way that this history manifests itself in telltale details of the landscape:

This landscape suggests, through its layering and overlapping of debris, structures, and accumulated rubble, a visual record of the past and present. This synthesis of histories is what gives

the landscape its vitality. Gone are the stockyards, tanneries, steel mills, and gas works: replaced by numerous smaller concerns, all of which leave their trace to the historic mix. The industrial landscape, by virtue of its isolation, seems to resist change. This same isolation creates a menacing and alien landscape to some. But the inherent beauty of reflected light and local colour combine with a stillness that permeates everything, creating a unique and inspired environment.

In all this, improbably on the face of it, Dudley belongs to a whole tradition of industrial romanticism, stretching from de Loutherbourg in the eighteenth century at least until Prunella Clough in our own day. One or two other adherents of Exactitude share Dudley's romantic feelings about industrial decay, although usually in a strictly limited field, as with John Salt's devotion to mouldering motors. Dudley, however, arrives at the expression of his feelings by way of topographical precision: he is an artist and an historian in equal measures.

And out of this possibly explosive combination comes an unpredictably affecting art, distinctively American in its expression as well as its subject matter. For Dudley, born in Peoria, an industrial town not so far from Chicago, in 1950, the decay of heavy industry in his own area, in his own lifetime, is part of his personal history, and felt to be so. This is no fantasised view from a distance by readers of James M. Cain and Mickey Spillane, but autobiography in paint.

Sand Barge – Chicago River
(detail)
2004
Oil on canvas
31 x 34 cm

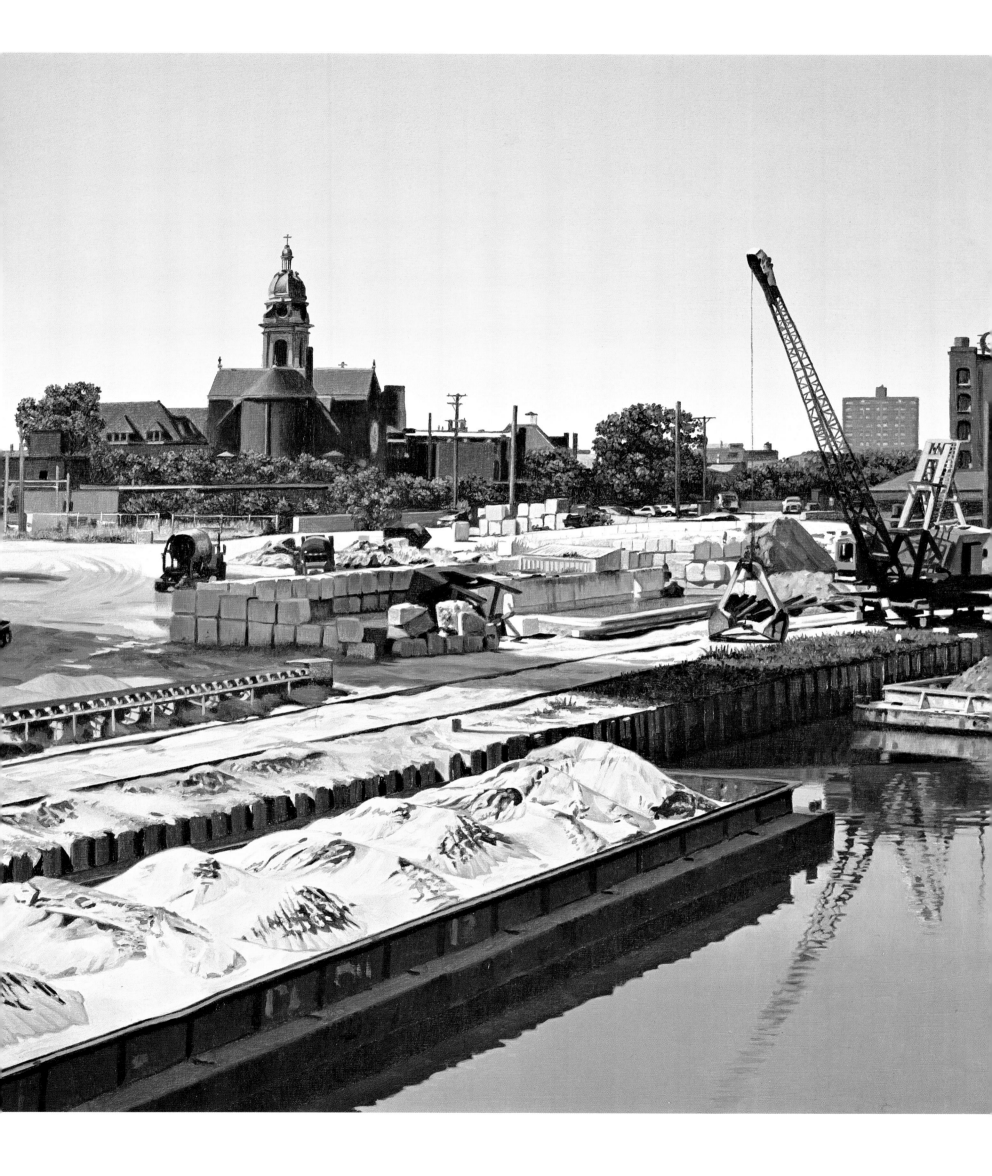

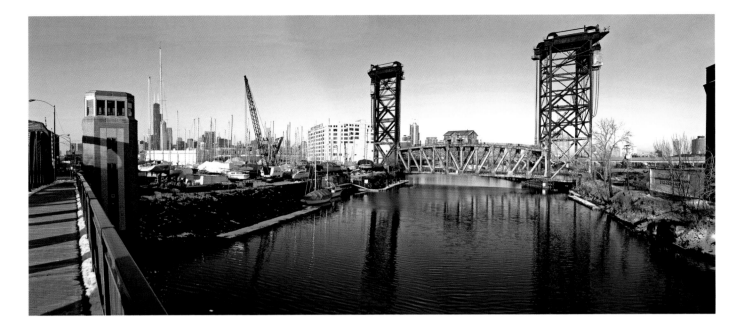

Lift Bridge
2008
Oil on canvas
76 × 122 cm

Little Rock Bridge
2008
Oil on canvas
127 × 203 cm

**Illinois and Michigan Canal –
Marseilles, IL**
1991
Oil on canvas
72.5 × 136.5 cm

Sand Barge – Chicago River
2004
Oil on canvas
31 x 34 cm

**Ruined Building on South
Canal, Chicago**
2005
Oil on canvas
54.5 x 95 cm

DUDLEY 91

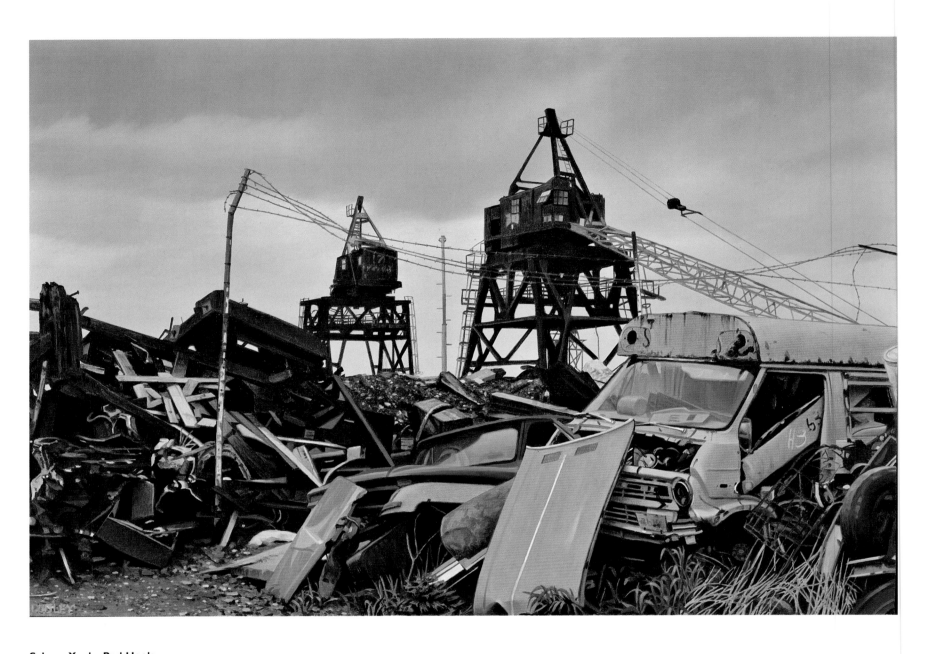

Salvage Yard – Red Hook
2004
Oil on canvas
23 x 33 cm

South Canal Street Bridge, Chicago, IL
2005
Oil on canvas
53 x 144.5 cm

Salvage Yard Near 130th Street, Chicago
1998–2002
Oil on canvas
37 x 61 cm

Barge Terminal – Hennipen, IL
2000
Oil on canvas
84 x 122 cm

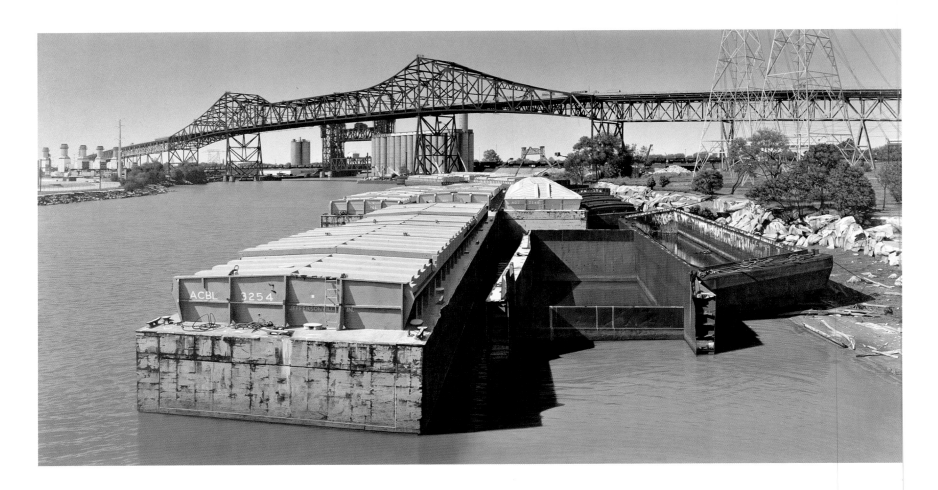

**Calumet River from 100th
Ave – Chicago, IL**
2004
Oil on canvas
106.5 x 203 cm

Coal Bunker from 6th Street
1991
Oil on canvas
45.7 x 76 cm

Ruined Bridge Piers
2007
Oil on canvas
38 x 132 cm

**Bridge Construction –
Marseilles, IL**
2003
Oil on canvas
23 x 33.5 cm

Calumet RIver
2007
Oil on canvas
38 x 145 cm

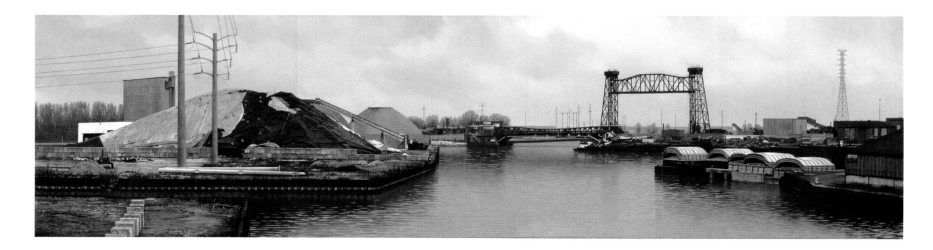

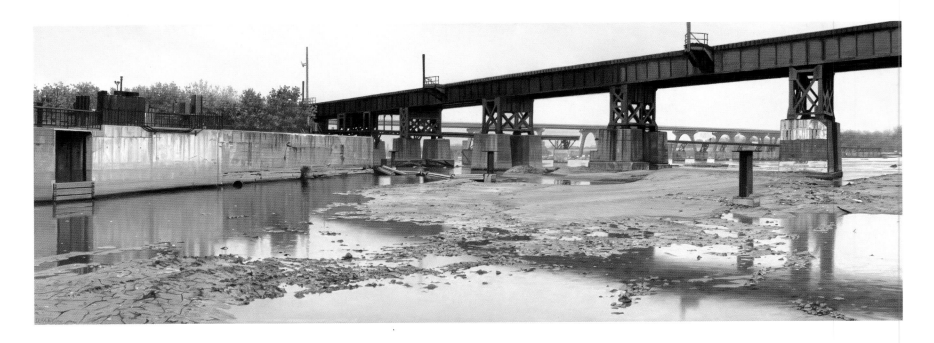

**Several Bridges Across the
James River, Richmond**
2006
Oil on canvas
25.5 x 71 cm

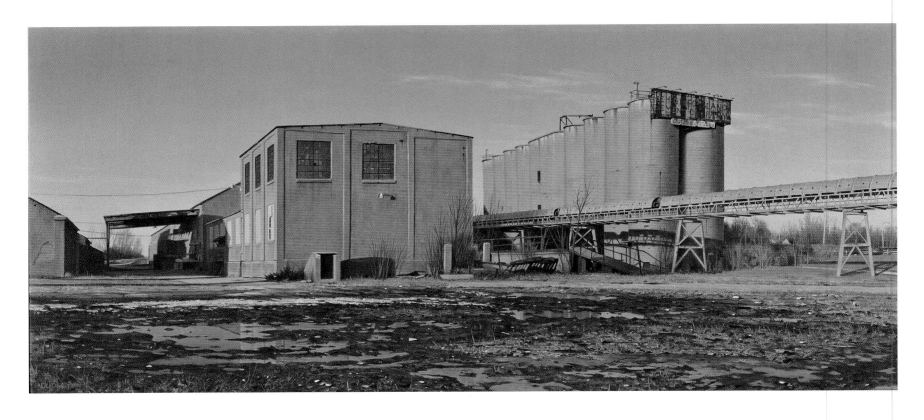

**Sand Storage Bunkers
– Oglesby, IL**
2004
Oil on canvas
29 x 66 cm

Empty Barge – Utica, IL
2002
Oil on panel
23 x 34.3 cm

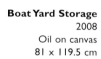

Boat Yard Storage
2008
Oil on canvas
81 x 119.5 cm

Restoration of South Canal Street, Chicago
2005
Oil on canvas
58.5 x 129 cm

DAVID FINNIGAN

ONE OF THE 'NEW' artists to emerge in the first Exactitude exhibition in 2003, David Finnigan was at the time already thirty-eight. He is, one might divine, a slow worker, one who thinks carefully about everything he does. His credo might well be that of any Photorealist – or at least constitute the basic minimum of a Photorealist's credo, being purely practical, unencumbered by anything highfalutin and theoretical:

My approach is to try and find vignettes of the world in which we live and try to portray what I have seen in a photorealist style. I am a painter who is fascinated by photography and my work reflects that. I like to search out images which may have a slightly reflective or melancholy feel. I am very keen on using colour in a way which contributes to the success of a painting. I believe the finished work should have an overall consistency and believability.

What Photorealist painter could say less, or would need to say more? Actually there is, even here, one possibly extraneous element: Finnigan does admit to a personal inclination towards a certain range of mood in the pictures he uses, the 'reflective and melancholy'. I would suspect that Photorealist artists, like any others, must have their subjective preferences, whether or not they are aware of the unconscious impulses that dictate the choice of one picture over another for translation into paint. But of course there are those who would deny it, insisting on the objective nature of their paintings, the mechanical, depersonalising effect of deriving their art directly from a photographic original.

In this context, Finnigan is, relatively speaking, a romantic. He responds emotionally to possible subjects, and admits that, even when working as a professional photographer, 'occasionally while on a shoot I just take a picture of something just because it seems to have a quality about it, even though it is at odds with all the other images I had been taking.' He does not explain whether, from the start, he takes such a picture with the intention, or at least the good possibility, of basing a painting on it, but it seems a reasonable assumption that this may be so.

In other words, for Finnigan the photographic originals most likely occupy the position of substitute sketchbook, taken specifically as a painter's aide-mémoire. Finnigan's description of how his painting *Maggiore* evolved seems to support this: apparently in the summer of 2004 he was doing a straightforward professional photo shoot on and around Lake Maggiore when he noticed an unconnected but decorative view, neither, to my eye, reflective or melancholic, from Isola Bella looking across the water towards the town of Stresa. 'There is a market running on one side of the island and some traditional boats were moored nearby. The composition appealed to me because of its "classical" feel.'

This makes Finnigan a much more traditional kind of artist than we might otherwise suppose: a landscape, or townscape, artist who picks his subjects carefully, on the evidence of the eye, and carefully prepares to paint with the aid of on-the-spot notation – which just happens to be a photograph rather than a drawing. Since his style calls for hard-edged precision, he still fits in with the ideals of Exactitude, demonstrating that if one final result is desirable, there are endless ways of reaching it, all equally legitimate.

Zoo (detail)
2004
Oil on canvas
81 x 117 cm

Gala Special
2003
Oil on linen
86 x 117 cm

Moda
2005
Oil on linen
76 x 152.5 cm

Saint Denis
2003
Oil on linen
122 x 92 cm

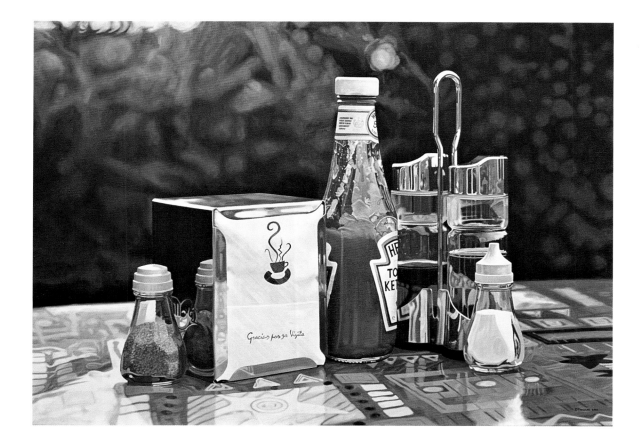

Visita
2001
Oil on linen
76 x 101 cm

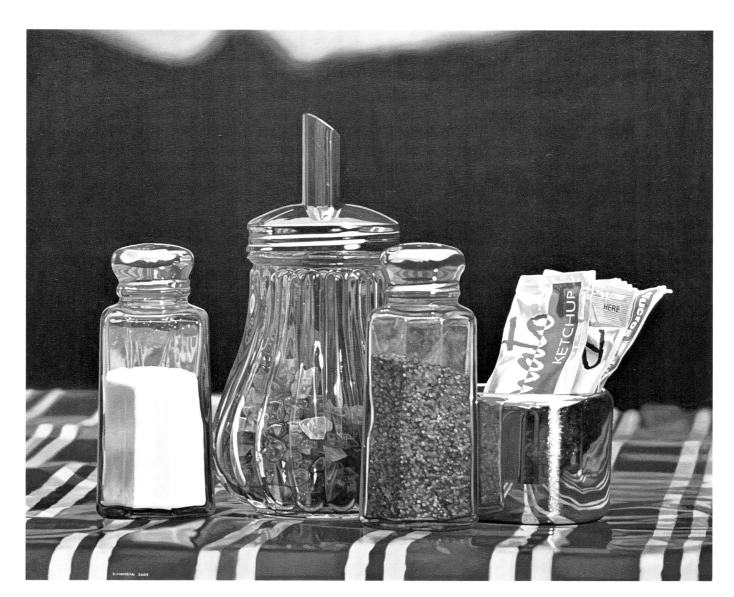

USA
2003
Oil on linen
90 x 110 cm

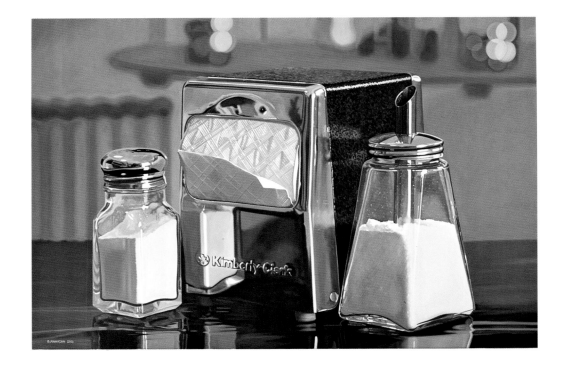

High Noon
2006
Oil on linen
87 x 130 cm

Samurai
2006
Oil on linen
91.5 x 122 cm

Evening Bell
2007
Oil on canvas
81 x 107 cm

Afternoon
2005
Oil on linen
96.5 x 147.5 cm

Far to Go
2006
Oil on linen
91 x 137 cm

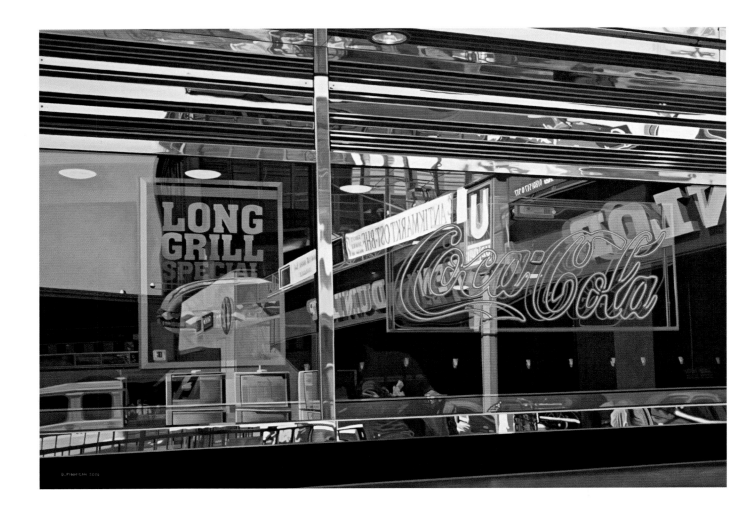

Zoo
2004
Oil on canvas
81 x 117 cm

Palace
2005
Oil on linen
86.5 x 132 cm

The Morning was Cold
2007
Oil on linen
86.5 x 112 cm

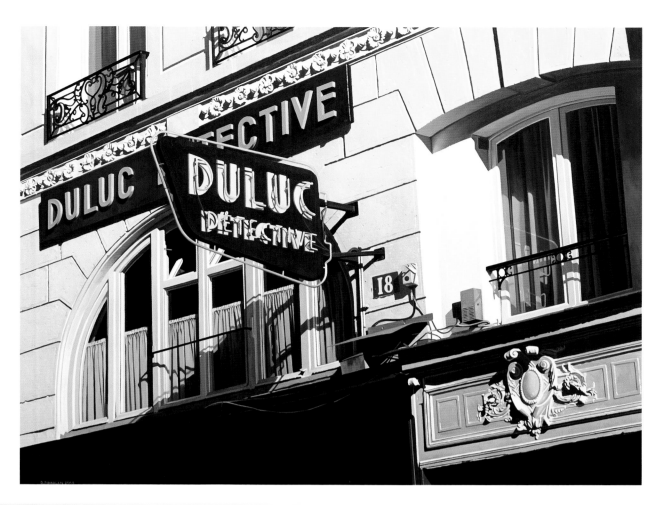

City of Lights
2006
Oil on linen
122 x 91.5 cm

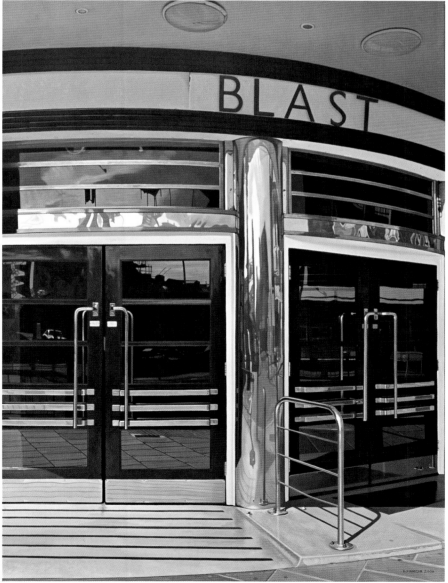

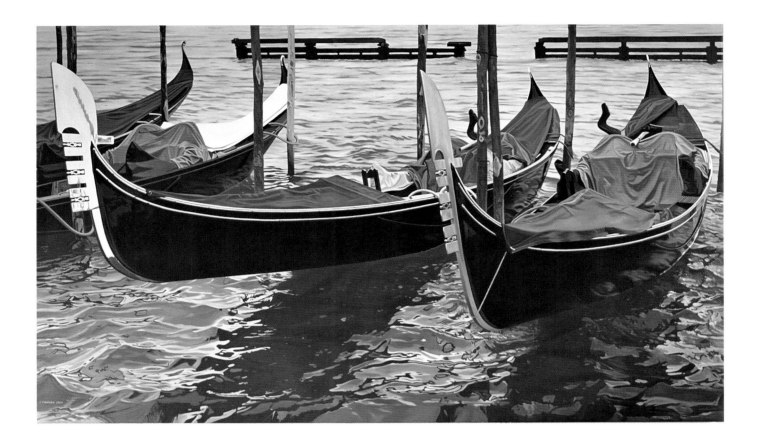

Presence
2007
Oil on linen
71 x 137 cm

Reuss
2007
Oil on linen
91 x 152 cm

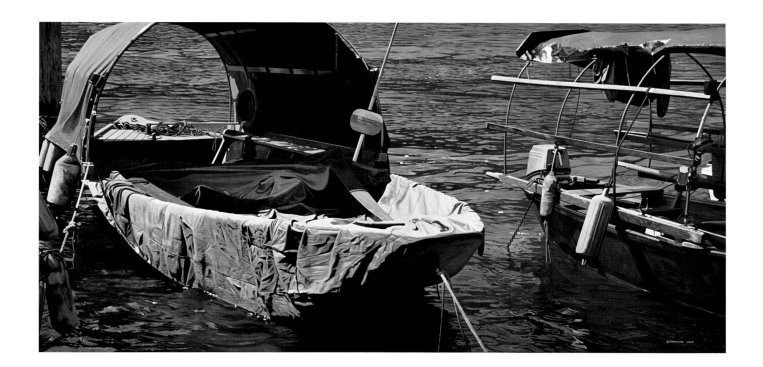

Maggiore
2007
Oil on canvas
73.5 x 150 cm

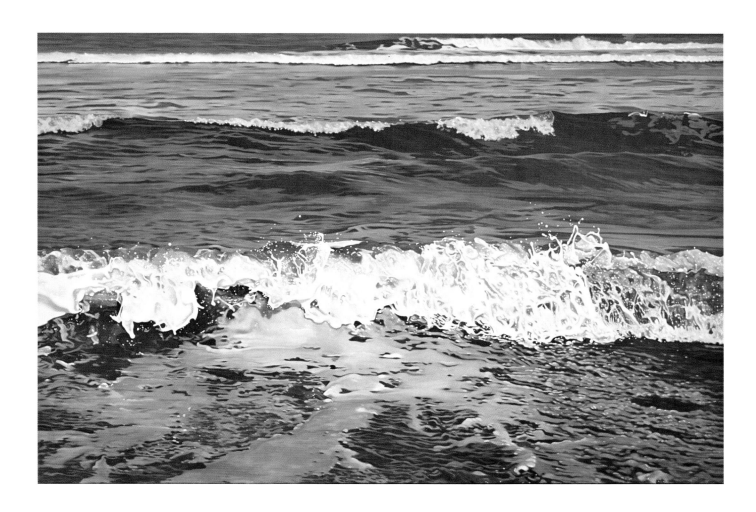

Transition # 2
2007
Oil on linen
86 x 127 cm

SIMON HARLING

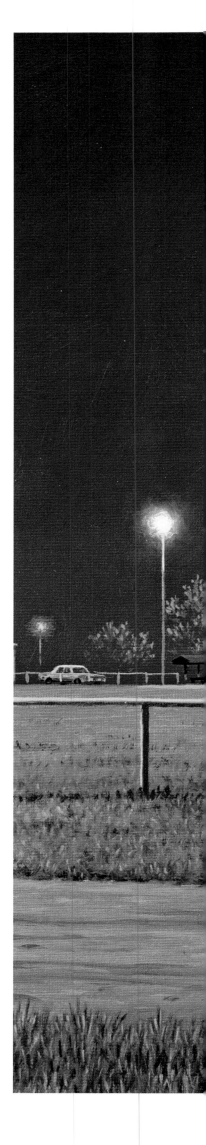

SIMON HARLING is yet another British artist obsessed with the American scene and American cars. Born somewhere as quintessentially English as Colchester (in 1950), and owing his professional training to the London College of Printing, of all places, he has at least spent a considerable amount of time in America. He has also exhibited extensively there – indeed, between 1990 and 2005 he hardly exhibited anywhere else – and an impressive number of corporate collections in the States have added work by him to their holdings.

While his view of America is therefore presumably based on more direct observation than that of most of his fellows in Exactitude who romanticise the wastelands of urban America, there is still no doubt something irreducibly foreign about the way Harling sees things there. That may, indeed, be precisely what Americans like about his work. Even taking into account the way David Hockney has revolutionised the way Angelenos see Los Angeles, the 'foreign eye' effect has tended to be most evident in films. Think of America through the eyes of, say, John Schlesinger in *Midnight Cowboy*, Milos Forman in *Taking Off*, Jacques Demy in *Model Shop*. In each case there is no doubting the personal devotion of the filmmaker, and yet there is no mistaking the way each involuntarily remakes America in the image of

his own origins, thereby offering an angle of vision from which Americans would otherwise never see themselves.

So may it well be with Harling. At the moment he is engaged in an ongoing series of paintings that originate in an Eighties picture book called *The Red Couch* by two American makers of photographic installations. The idea is that its authors took a dilapidated red couch round America, photographing it in various locations, likely and unlikely, in order to observe it bouncing off, as it were, its various environments. Fine, thought Harling, but wouldn't it be better to take as inspiration a real embodiment of American culture, like an Eighties General Motors Cadillac Fleetwood Brougham? So, around 2004, he set out to drive around America in just such a vehicle, and immortalise it in landscape wherever he went.

The paintings that resulted from this road trip are minutely accurate, and at the same time intensely atmospheric and evocative. You might expect them to belong to the world of Edward Hopper, but instead they belong to the world of Algernon Newton: American landscapes painted with an English eye. Did he take the photographs first, and then base the paintings on them? Hard to know without going to Harling himself – and harder still to think that his answer would make any difference....

Nite Game, Gas City (detail)
2006
Oil on canvas
41 x 51 cm

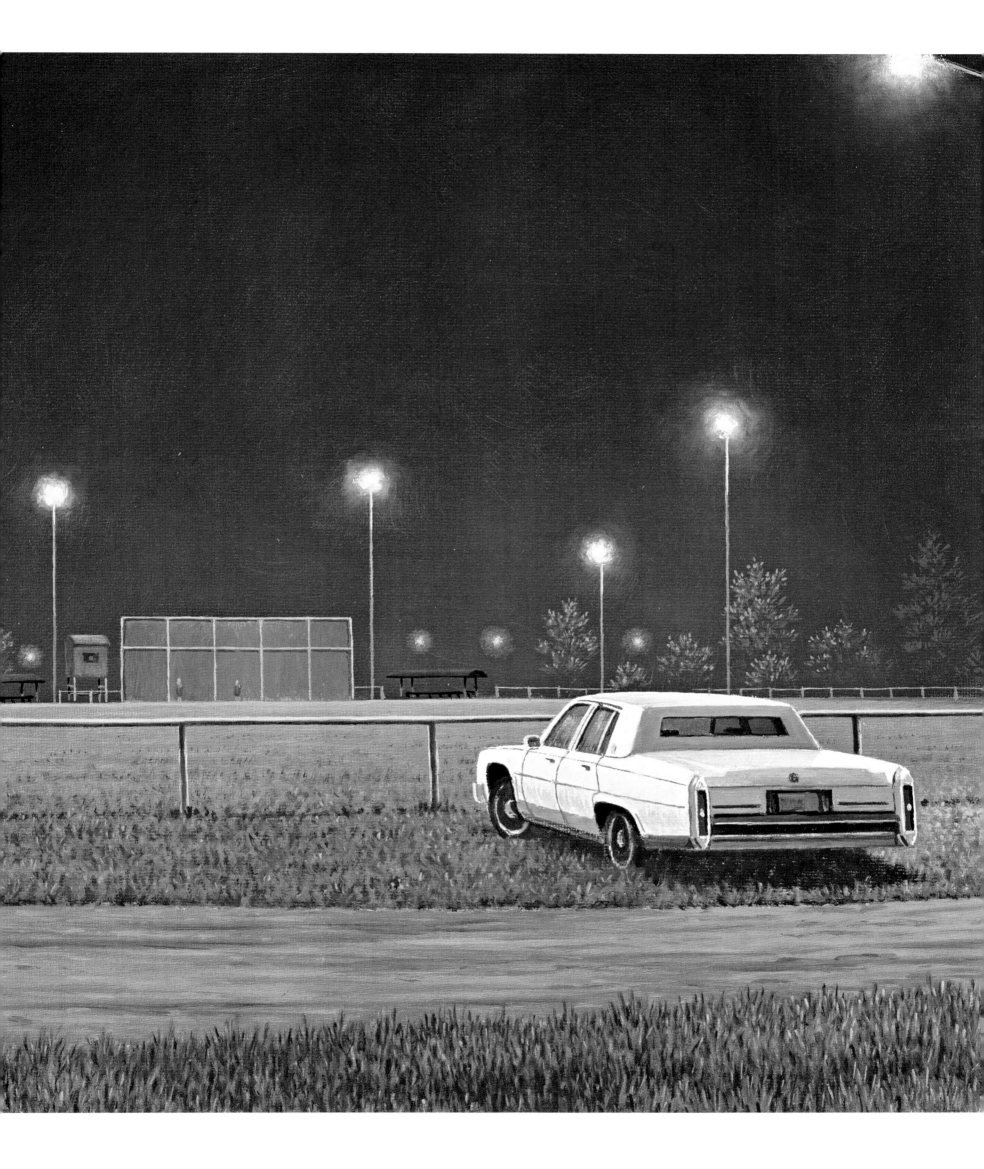

**Evening Light, Lake
Newfound**
1996
Oil on linen
259 x 259 cm

Gulf
2003
Oil on canvas
38 x 76 cm

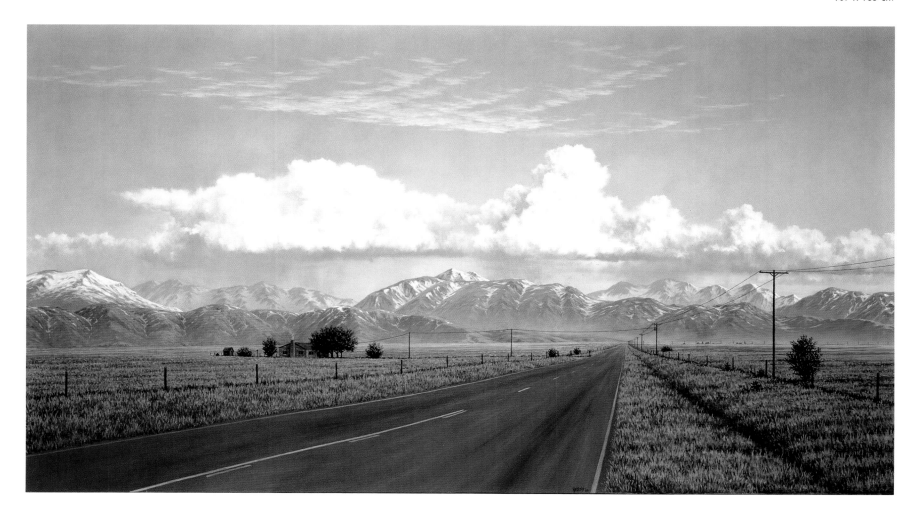

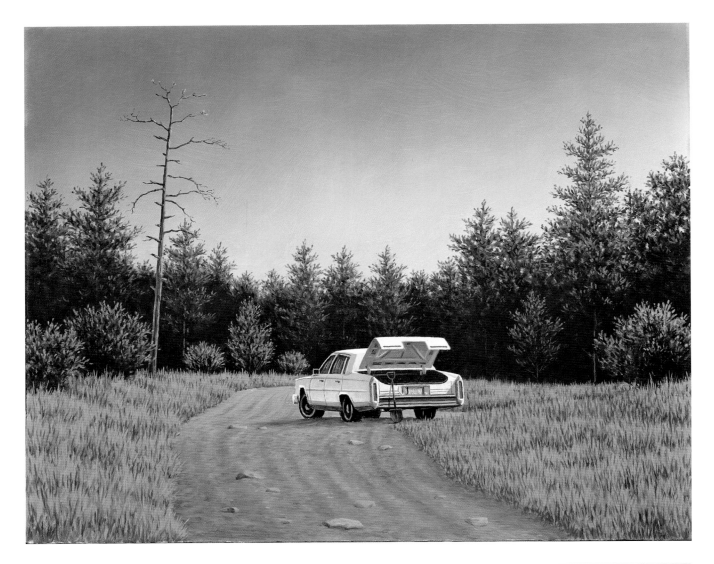

Blood Simple Cadillac
2006
Oil on canvas
41 x 51 cm

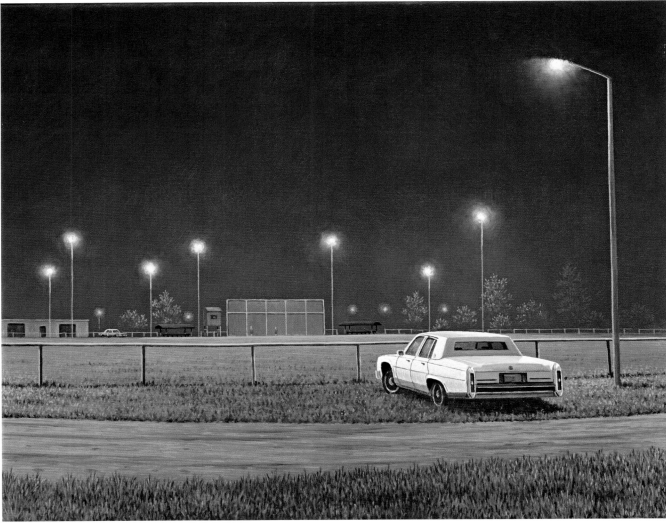

Nite Game, Gas City
2006
Oil on canvas
41 x 51 cm

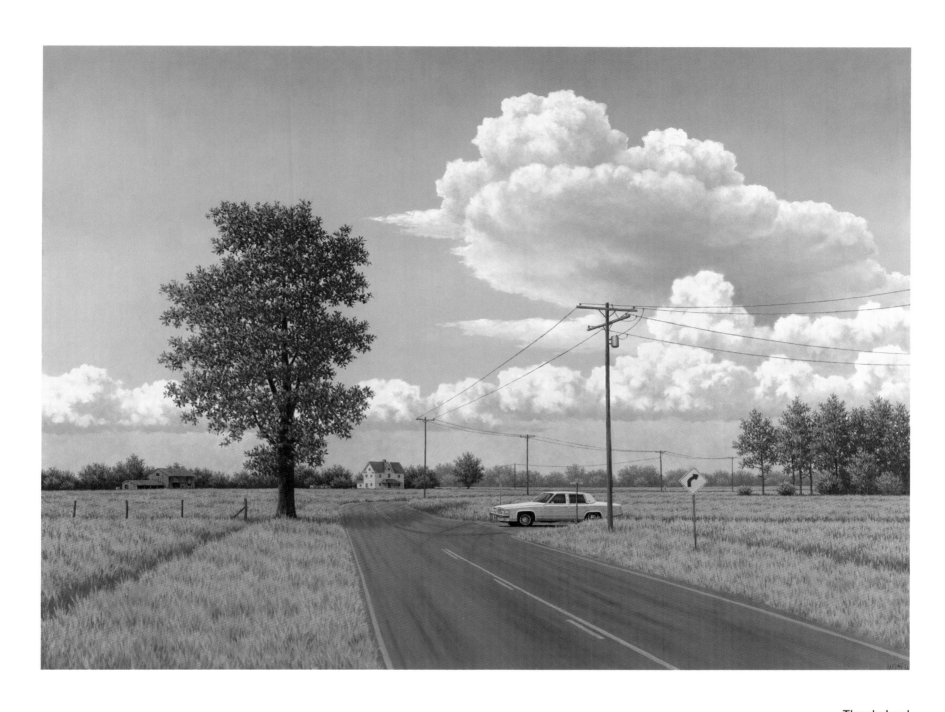

Thunderhead
2006
Oil on canvas
91 x 122 cm

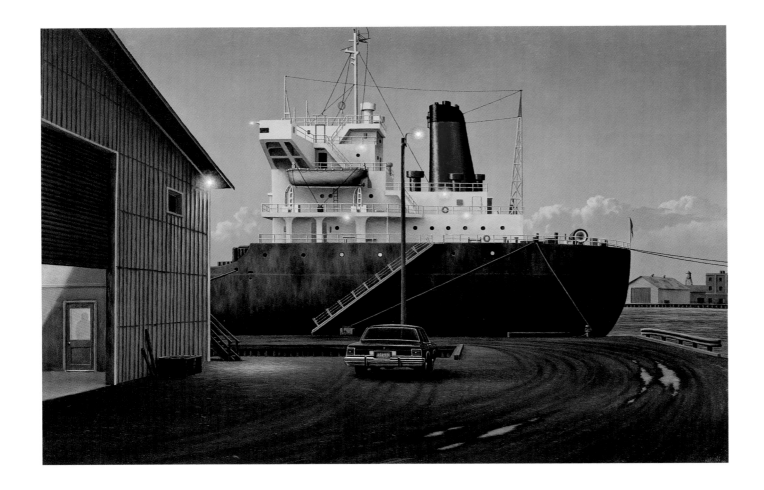

**Loading Scrap, State
Pier, Portsmouth**
1993
Oil on linen
61 x 91.5 cm

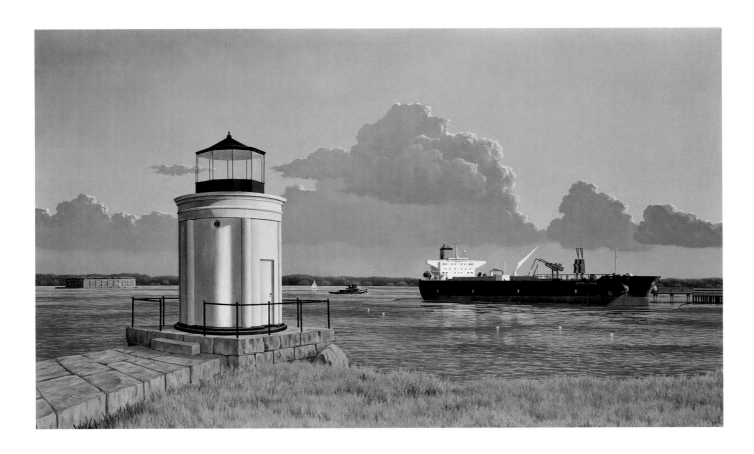

Casco Bay from Bug Light
1999
Oil on canvas
91.5 x 152.5 cm

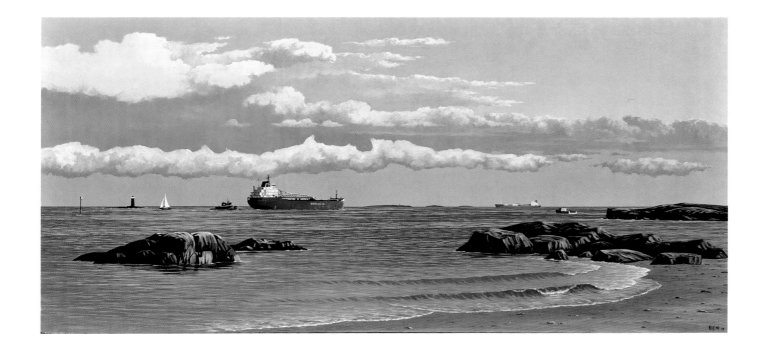

**Departure of 'Atlantic Erie'
off Portsmouth**
1999
Oil on linen
51 x 106 cm

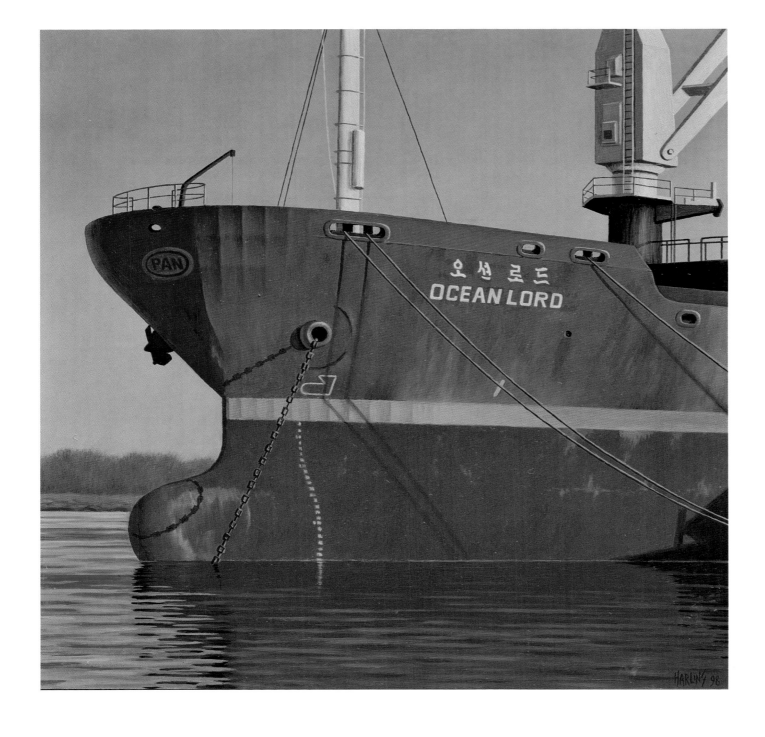

Ocean Lord
1998
Oil on gesso panel
30.5 x 30.5 cm

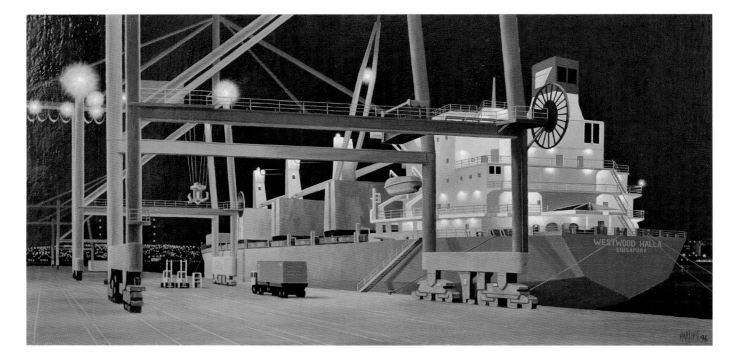

Nightloading
1996
Oil on gesso panel
30.5 x 61 cm

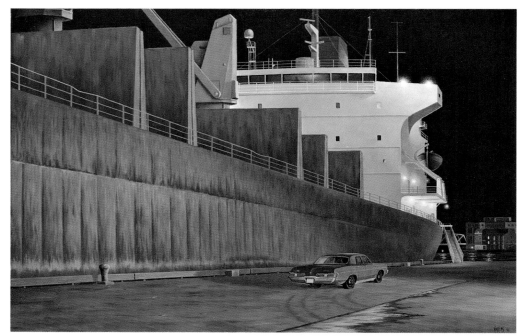

Night on the Dock
1995
Oil on linen
61 x 91.5 cm

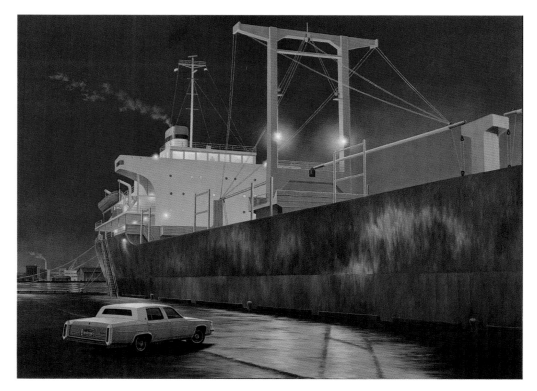

**'Hollandic Confidence'
Loading Scrap**
2006
Oil on linen
91.5 x 122 cm

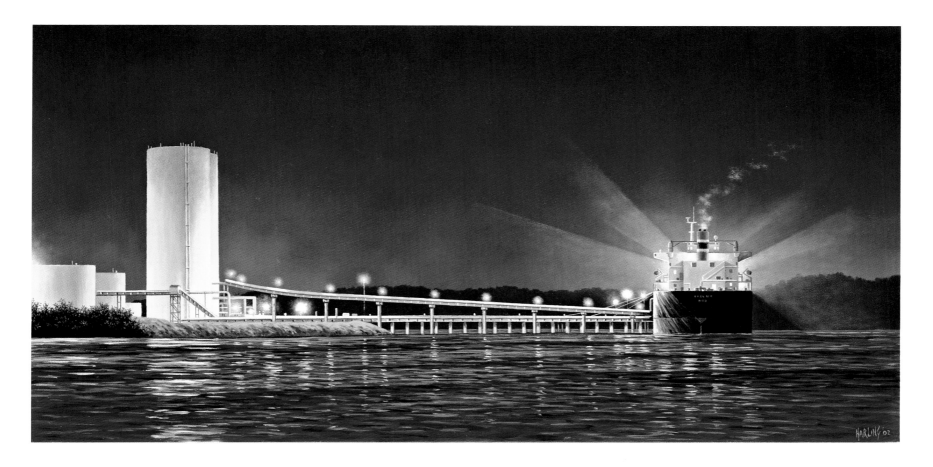

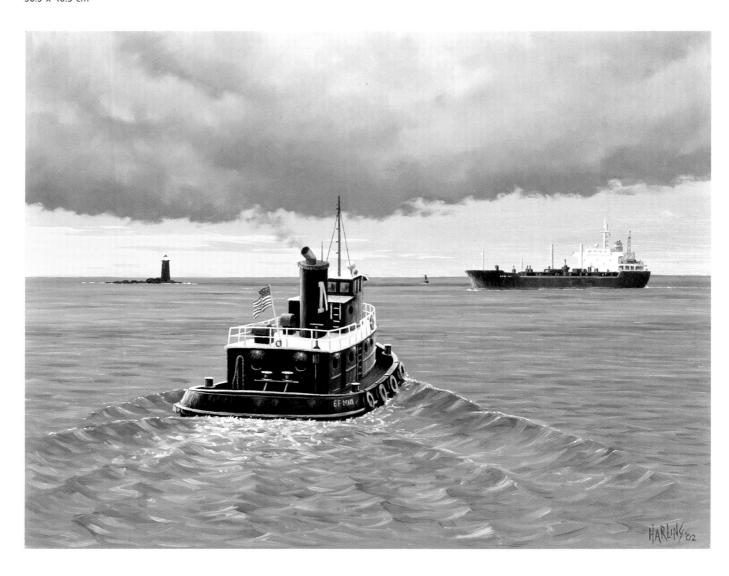

Night on the Piscataqua
2002
Oil on canvas
38 x 76 cm

Moran Tug off Portsmouth
2002
Oil on gesso panel
30.5 x 40.5 cm

Twister
1988
Oil on linen
56 x 152.5 cm

Okay Gas
1994
Oil on gesso panel
30.5 x 61 cm

Home by the Road
1988
Oil on linen
56 x 152.5 cm

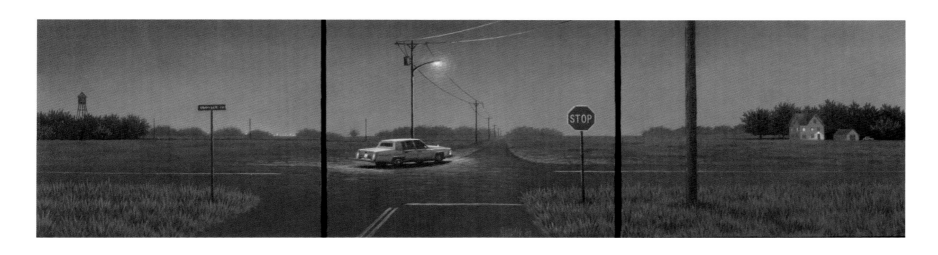

Indiana Crossroad, Night
2007
Oil on board
20.5 x 76 cm

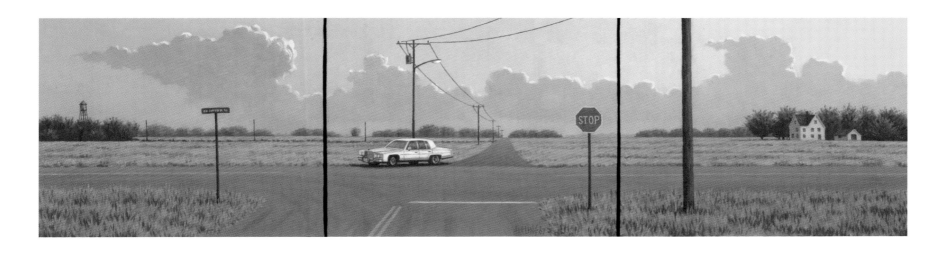

Indiana Crossroad, Morning
2007
Oil on board
20.5 x 76 cm

CLIVE HEAD

MOST LEADERS, promoters or inventors of art movements are inclined to be didactic, and possibly dictatorial. Though he may be credited with inventing, or at least discovering and defining, Exactitude, Clive Head does not fit into that particular template at all. As an artist, he knows exactly what he wants (or needs) to do, and does it with the utmost conviction. He also recognises those with similar goals and urges, and takes positive pleasure in bringing them together. His New York-based friend and fellow artist Robert Neffson has observed:

> On a personal level, Clive is one of the most generous artists I know. He has the ability to share what he has learned and truly believes in the cooperation of artists.… He has a fine, rare collegial spirit and a deep love of all art.

This no doubt explains what he senses he has in common with other Exactitude artists, as well as what we notice as setting him apart. What he has in common, of course, is his concern with the precise rendering of whatever is before him, or at any rate before his camera. What sets him apart from at least some of them is the way he does it. He is above all a very painterly painter, not of course if you understand 'painterly' to signify a lot of obvious frenzy, slapdash or wildly improvisatory brushstrokes. But as we know, there have been many others ways to paint landscapes than the way Turner did in his later days, as well as before.

No, what can be disconcerting about Head's work is that he sometimes appears to be painting exactly as he might have done a century at least before the camera was ever invented. In many ways he has more in common with Canaletto than he does with Estes. Naturally he uses photographs, as they are an available resource and why should he not, but never it seems does he indulge in slavish reproduction of just one photographic image. In relation to one of his recent paintings, *Cliff Lift*, we learn from his published correspondence with Neffson that, as he began work on it,

Everything is being tied down through my usual layout drawing which subjects everything, whether based on life drawings or transparencies, to the same linear precision. At this point I am able to work with quite diverse sources, and I am hopeful that my work methods are sufficiently independent from photographic rendering to maintain this continuity.

In other words, he does not, like the classic American Photorealists, want his paintings to look like photographs. He wants them to look like the paintings that they are: personal responses to what he has seen, maybe through the lens of a camera, maybe not. No matter what his sources are for the various elements of the composition, the ultimate form of the composition is his responsibility alone, and significantly that responsibility is invested not in one photographic source, but in his own execution of the layout drawing which establishes the 'linear precision' of the whole.

'The result', he writes of *Cliff Lift*, 'is quite obviously not a photorealist painting. But it is true to my ambitions towards revealing some kind of truth, is honest to the art of painting, and reveals my aesthetic identity.' The same could be said of all his paintings, even those that appear incidentally to involve human figures, like the huge panorama *Prague, Early Morning* (2004–2006). Here there is only one figure, a solitary runner seen from behind. But she proves to be central to the whole conception of the work, the fulcrum on which turns the whole conceit of thrusting and receding perspectives. 'The great thing with paintings is that they do develop their own logic and tell us what to do as they come to completion. I go with my instincts at the beginning until the painting takes over and almost paints itself …. My painting is so much stronger now than when I allowed aspects of copying the photograph to enter my work.'

Mutatis mutandis, Canaletto, had it ever occurred to him to examine his own artistic navel in such detail, might have said the same.

St Paul's from Blackfriars Bridge (detail)
2006
Oil on canvas
95 × 168 cm

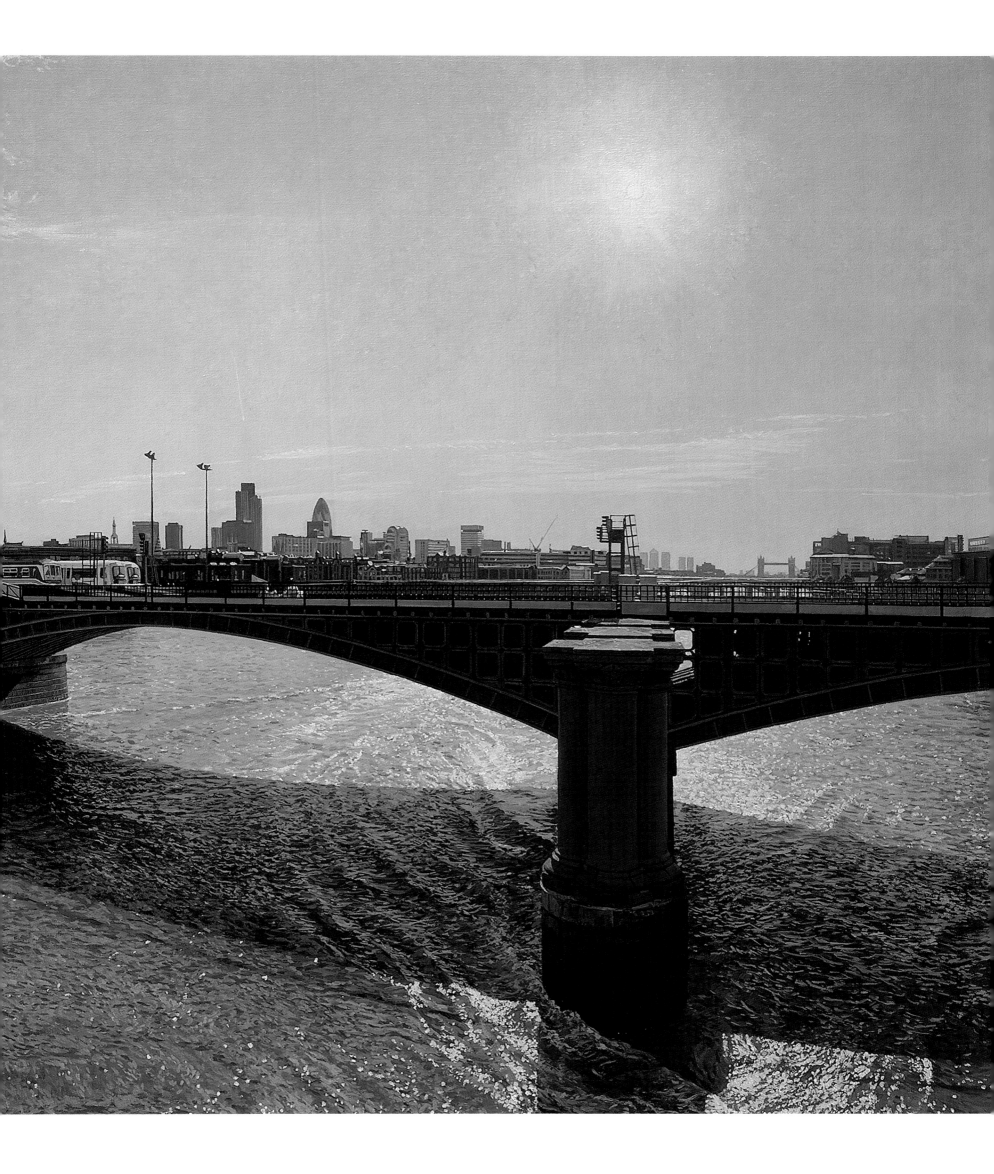

Paris, Morning Light
2002
Oil on canvas
135 x 256.5 cm

Observatory
1998
Oil on canvas
117 x 198 cm

Paris, Sunrise
2003
Oil on canvas
175.3 × 307.3 cm

East River
1999
Oil on canvas
140 × 193 cm

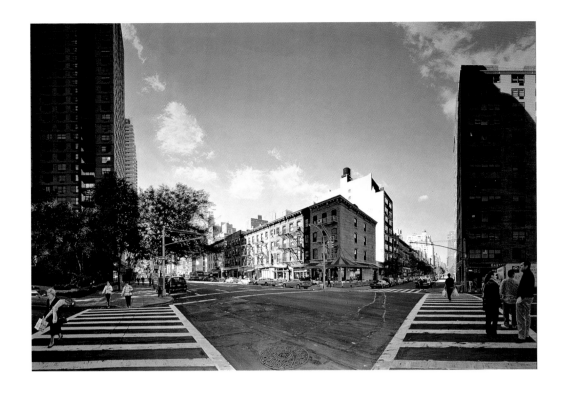

New York, October 2001
2002
Oil on canvas
190.5 x 267 cm

**42nd Street, Sunday
Morning**
2001
Oil on canvas
170 x 292 cm

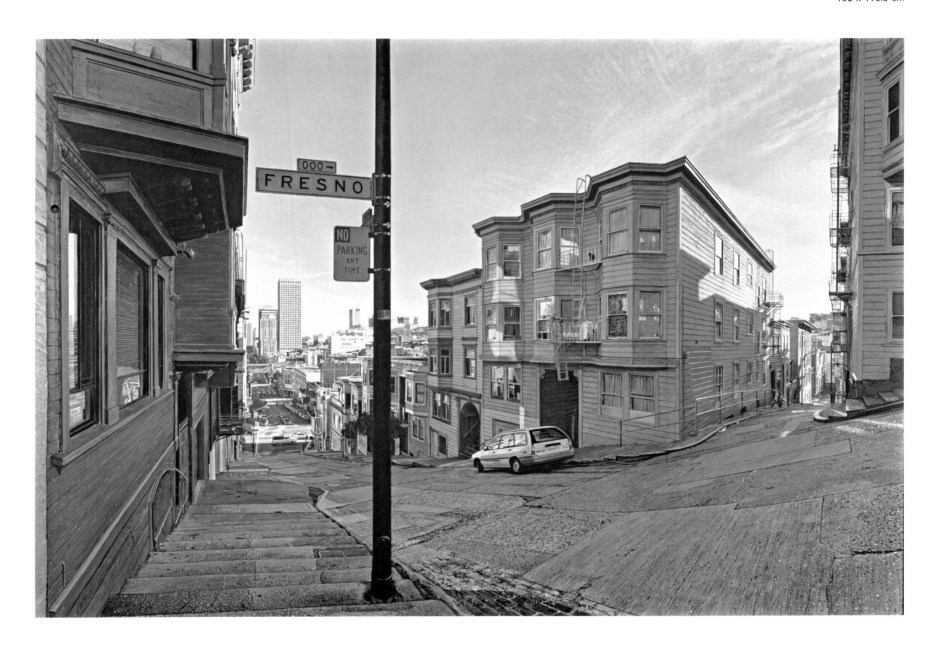

Valley Bridge
1998
Oil on canvas
140 x 200 cm

Waterloo
1999
Oil on canvas
140 x 295 cm

Santa Maria in Via, Rome
2005
Oil on canvas
118 x 124 cm

Città del Vaticano
2005
Oil on canvas
109 x 193 cm

Prague, Early Morning
2004–2006
Oil on canvas
132 x 249 cm

Spring Blossom, Geneva
2005
Oil on canvas
98 x 158 cm

St Paul's from Blackfriars Bridge
2006
Oil on canvas
95 x 168 cm

Tracks
1997
Oil on canvas
127 x 163 cm

Marylebone Road
2007
Oil on canvas
114 x 132 cm

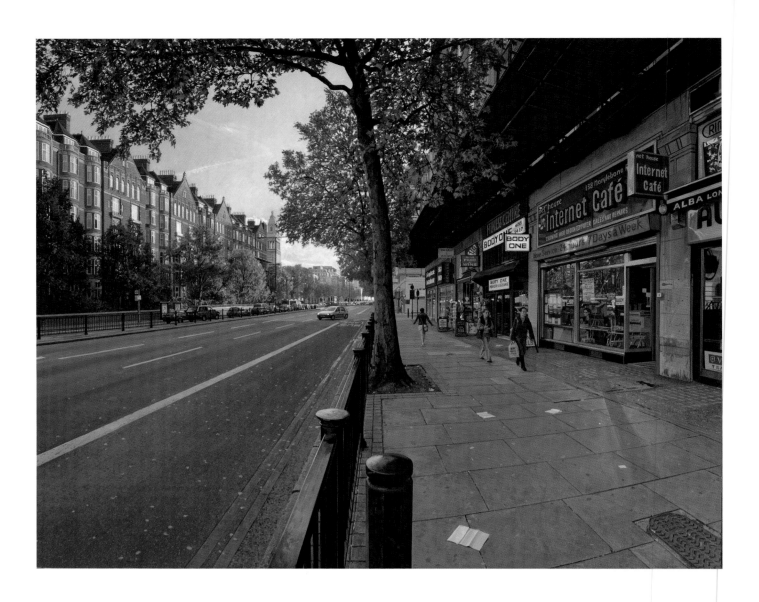

Canary Wharf
2008
Oil on canvas
152.5 x 307 cm

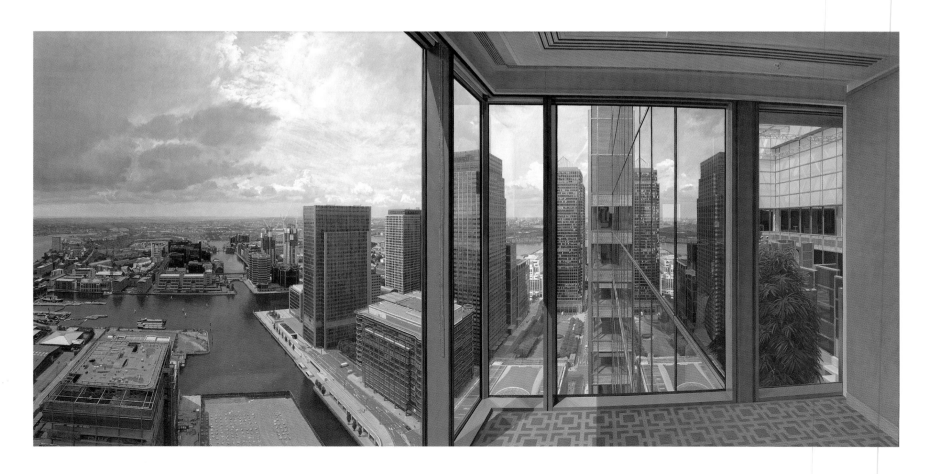

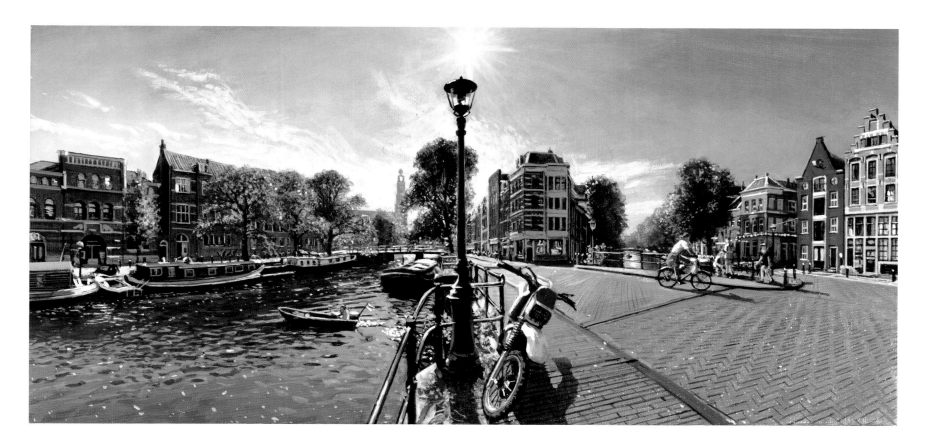

Study for Pansemertbrug
2002
Acrylic on canvas
24 x 51 cm

Piccadilly
2007
Oil on canvas
154 x 232 cm

Study for Pansemertbrug
2002
Acrylic on canvas
24 x 51 cm

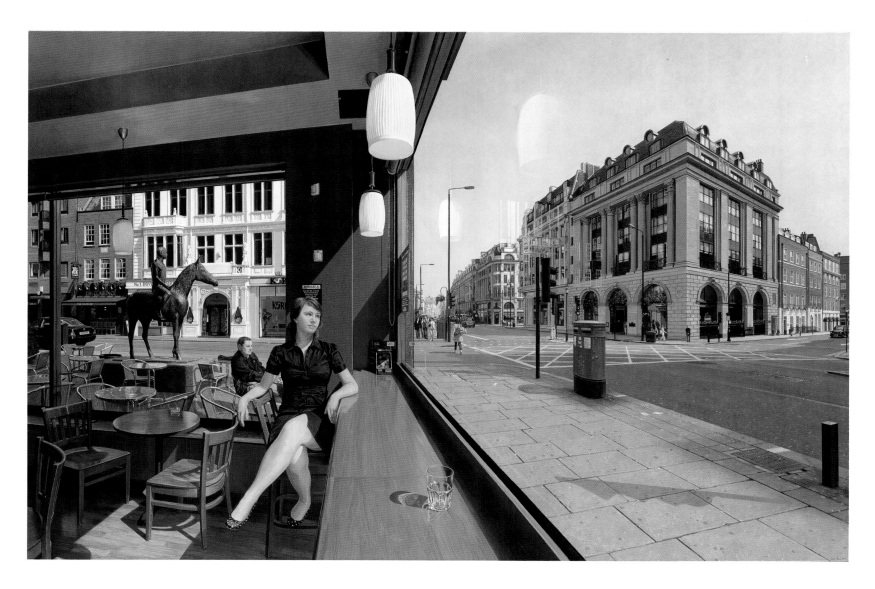

GUS HEINZE

PHOTOREALISM, so called, goes back already more than half a century, but even then it is not really one of the new kids on the block. In various guises, under various names, it has been appearing and fading and reappearing at least since Gus Heinze, the oldest of the painters associated with Exactitude, was born. Which is saying something, since he was born in Bremen, Germany, in 1928.

Despite his German origins, Heinze is really in effect an American artist, like so many who left Hitler's Germany and never looked back. On the other hand, one could never describe him as a typical American artist, or indeed typical of anything except himself. Heinze is clearly a Photorealist, yet he himself talks largely of the abstract elements in his work. How does he square the one with the other?

Well, in most of his paintings the 'subject' is clearly discernible. Heinze is fascinated by decaying machinery left behind as the detritus of the Industrial Revolution. The forms are powerful, if inscrutable, I suspect, to any except those who have worked in the industries that have left these wheels and drums and pulleys behind. That being the case, the basic materials of Heinze's visual world are already tending towards abstraction, since few viewers of his paintings will recognise what they are or how they fit into any other world but his. But Heinze carries the process of abstraction further:

It is quite evident that in most of my paintings the suggestion and visual appearance imply an abstract intent. The cropping of the subject enforces a tight composition, the subject thus becomes ambiguous. The finished painting will consciously

remain objective, eliminating subjective qualities such as identifiable techniques and any suggestions of the narrative.

Thus, in his words, his painting 'appears to be just composition, colour and shapes'. And yet, because his rendering of the physical details, 'how the sun over time can change a paint colour and the various colours of rust', is so unsparingly precise, he views his work as both abstract and intensely realistic: 'If I imagined or made up these inadvertencies of nature, I think it would be subjective, something of me would then remove mostly the image of my painting from an abstract awareness.' He therefore sees his work as 'a total oxymoron, abstract-realism'.

This may well be true, but it is not so extraordinary. In British art particularly, but also in American, there is a long and distinguished tradition of industrial romanticism. The artists did not, of course, necessarily know the mechanical background of the scenes and machines that they found so visually stimulating. But they knew what they liked, and why they liked it: because it looked spectacular and mysterious in almost equal measure.

When Turner is evoking *Rain, Steam and Speed*, the hard outlines are lost in an iridescent display of virtuoso painting. But when Wright of Derby depicts a scientific experiment, absolute precision is the order of the day. If we were to place Heinze's magnificent ruins of industry somewhere between the two we might not be too far wrong. And if we compared a typical Heinze with a typical abstracted industrial scene from the early work of the British Neo-Romantic Prunella Clough, we would be almost spot on.

Green Reaper (detail)
1999
Acrylic on gessoed panel
86.5 x 96.5 cm

Elegant Confusion
1999
Acrylic on gessoed panel
66 x 76 cm

Green Machine
2000
Acrylic on gessoed panel
61 x 71 cm

Green Reaper
1999
Acrylic on gessoed panel
86.5 x 96.5 cm

Blue Starter Engine
2001
Acrylic on gessoed panel
61 x 71 cm

Red Machine
2000
Acrylic on gessoed panel
61 x 71 cm

Blue Carburretor
2001
Acrylic on gessoed panel
61 x 71 cm

Rolling Yellow
2003
Acrylic on gessoed panel
81 x 91.5 cm

Yard Engine
2003
Acrylic on gessoed panel
81 x 91.5 cm

Observation Coach
1998
Acrylic on gessoed panel
106.7 x 127 cm

Static Trio
2002
Acrylic on gessoed panel
81 x 91.5 cm

Retired Power
2000
Acrylic on gessoed panel
94 x 112 cm

No. 494
1997
Acrylic on gessoed panel
106.7 x 129.5 cm

No. 707
2003
Acrylic on gessoed panel
81 x 98 cm

Out of Service
2003
Acrylic on gessoed panel
81 x 91.5 cm

Tender Access
1999
Acrylic on gessoed panel
71 x 78.5 cm

Scenic Drive
2004
Acrylic on gessoed panel
71 x 84 cm

875
2006
Acrylic on gessoed panel
71 x 76 cm

Sam's Café
2005
Acrylic on gessoed panel
71 x 76 cm

Mission San Louis Obispo
2003
Acrylic on gessoed panel
81.3 x 97.8 cm

Town House
1999
Acrylic on gessoed panel
81 x 91.5 cm

Pike River
1999
Acrylic on gessoed panel
91.5 x 112 cm

Early Autumn
1998
Oil on canvas
86 x 105.5 cm

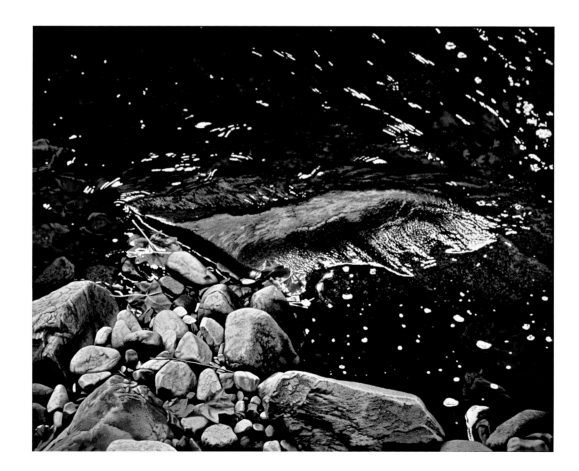

SIMON HENNESSEY

SIMON HENNESSEY is in certain ways unique among the adherents of Exactitude. Most obviously, in his views on the relationship between photography and painting. His painting, at least. Whereas most Photorealists regard the photograph as possibly a kind of sketchbook, or anyway as a means to the end of precise depiction, Hennessey regards it as itself the object to be depicted.

This is somewhat different from the ideas of those who want their paintings to look as much like photographs as possible, eliminating all evidence, such as brushstrokes or the texture of a canvas, which indicate that it is after all a painting we are looking at. Hennessey, instead, is not interested in superficial impressions that may impart a feeling of impersonality, a suggestion that the entire process of making a picture is mechanical. Rather, he is fascinated by the mechanism of depicting exactly the photograph and what it shows us that the unassisted human eye almost certainly could not see.

I concentrate on accurately portraying a photographic source. This involves a meticulous calculation of the process of change from photographic image into a painted language.… There are certain qualities produced by the camera that do not exist in reality; they are only ever present in the hyper-realist world of photography. These assets I judge heighten our visual perceptions of an image through distorting focus, colour, tonality, depth and focal points; as a result presenting us with a false sense of reality, a photoreality.

So, does this mean that Hennessey is not interested in reality? Or that the order of reality he is interested in has more in common with that of the late nineteenth-century Symbolist painters than with that of their twentieth-century successors, the Surrealists? Certainly one of his artistic interests goes back even further than the *fin de siècle*, right back indeed to the *fin* of the previous *siècle*, and the quasi-scientific absorption of the early nineteenth century in physiognomy, the reading of a human's inborn character from the shape of his head and the details of his facial features.

It should be noted that all Hennessey's work reproduces images of facial features in extreme close-up. In a way it is like those television programmes in which we see only the eyes or the lips of some informant, in order to obscure their identity. Except that Hennessey is not trying to obscure identity so much as to depersonalise the people in his pictures. He wants us somehow to assess their characteristics entirely from a few physical clues.

One recent work is a diptych, *Anna* (2007), which suggests a question of meaning. A similar painting, *Angelina: Saint or Sinner?* (2006), poses the question more directly. In both paintings the left half of the face is in colour, the right in black and white. Do we think colour is the Devil's work, while black and white implies documentary purity? A lot of people see it that way. But is not black and white more artificial in our everyday experience than colour? And in any case, do not both of them partake here of that 'false sense of reality, a photo-reality'? Hennessey wants us to consider such questions, and leaves the answers up to us.

Under Surveillance (detail)
2005
Oil on canvas
53 × 140 cm

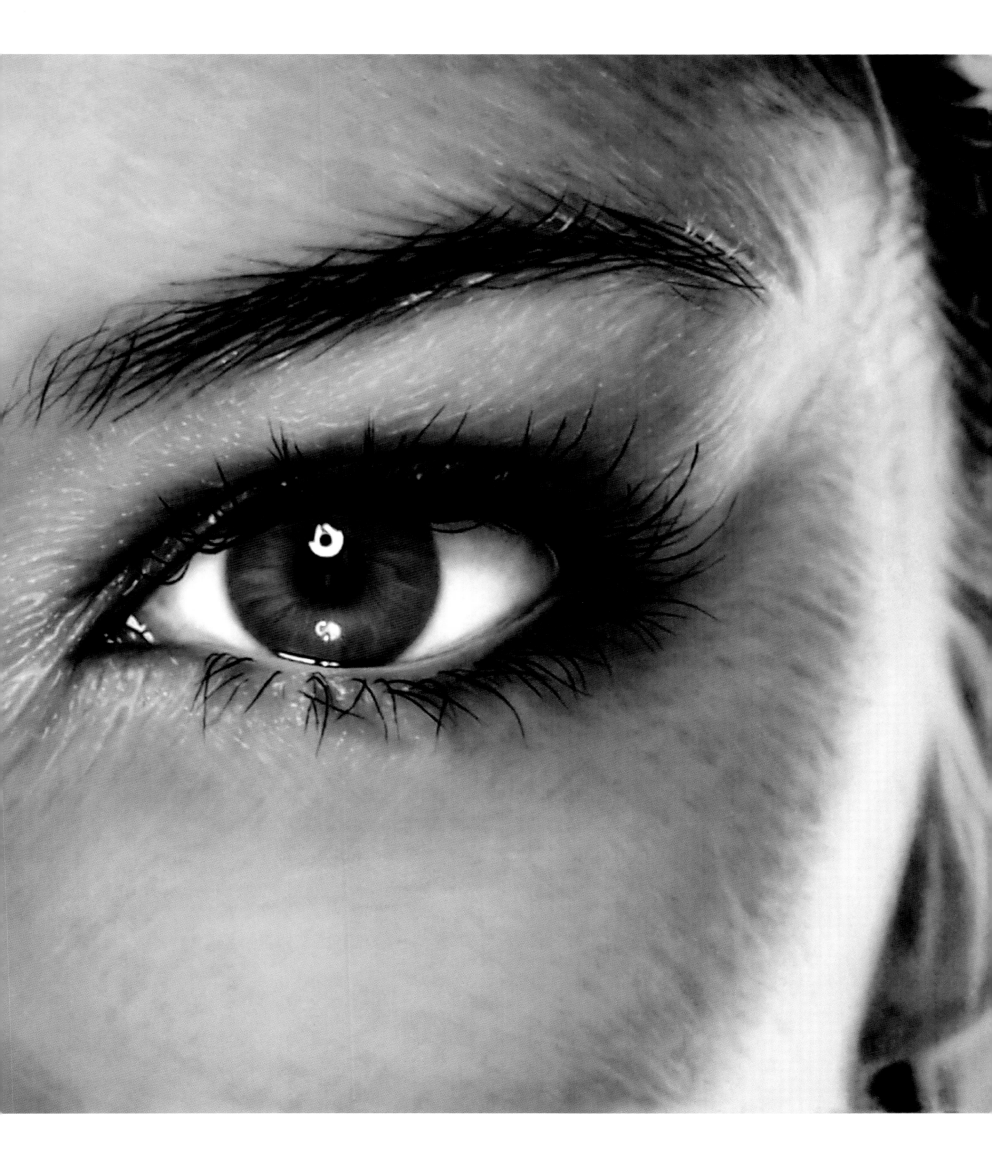

Blue Eye
2005
Oil on canvas
60 x 116 cm

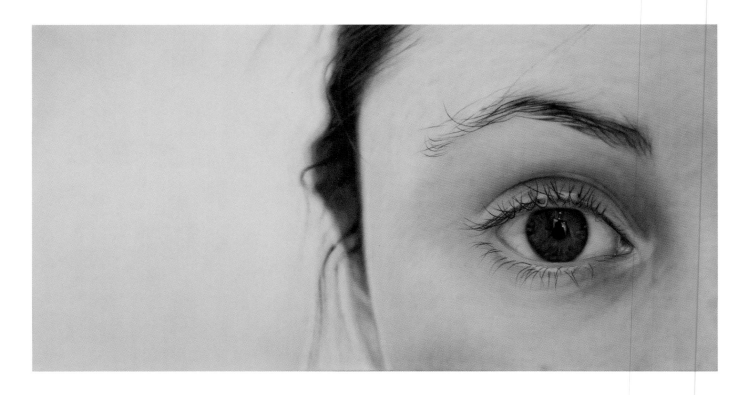

Charlie's Eye with Reflection
2007
Oil on canvas
60 x 116 cm

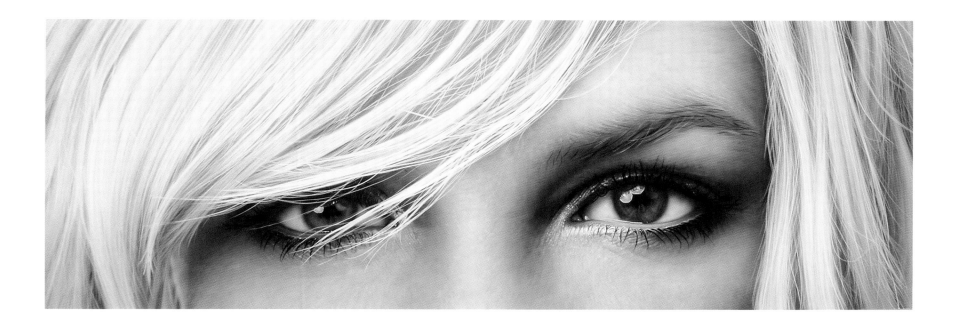

Blond Hair Green Eyes
2007
Acrylic on board
51 x 145 cm

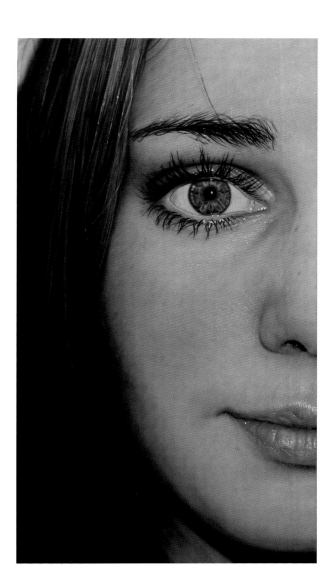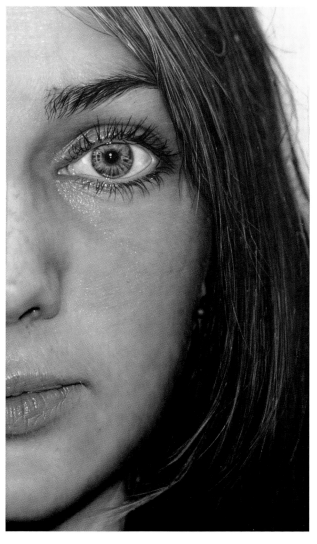

Anna
2007
Oil on canvas
73.5 x 80 cm

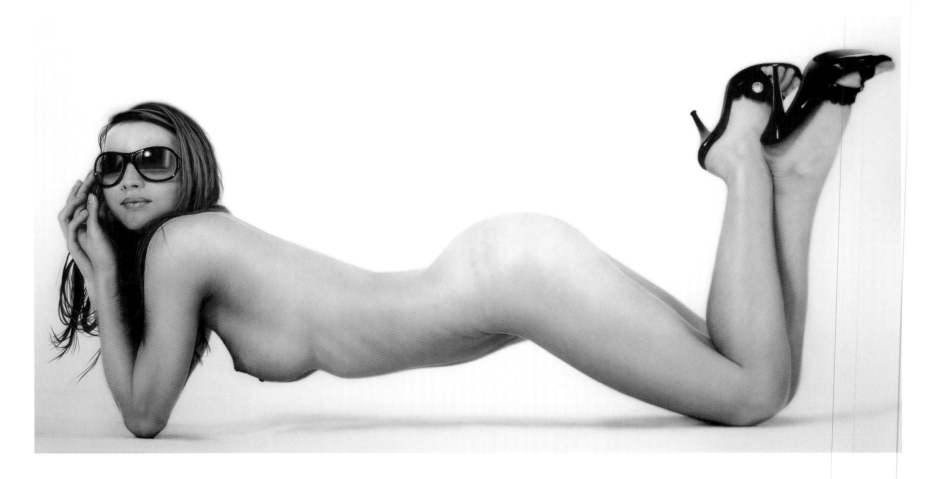

Heels and Glasses
2008
Acrylic on canvas
81 x 155 cm

Shades Chic
2008
Acrylic on board
84 x 122 cm

Glimmer in her Eye
2008
Acrylic on board
150 x 97.5 cm
© A Solovyou

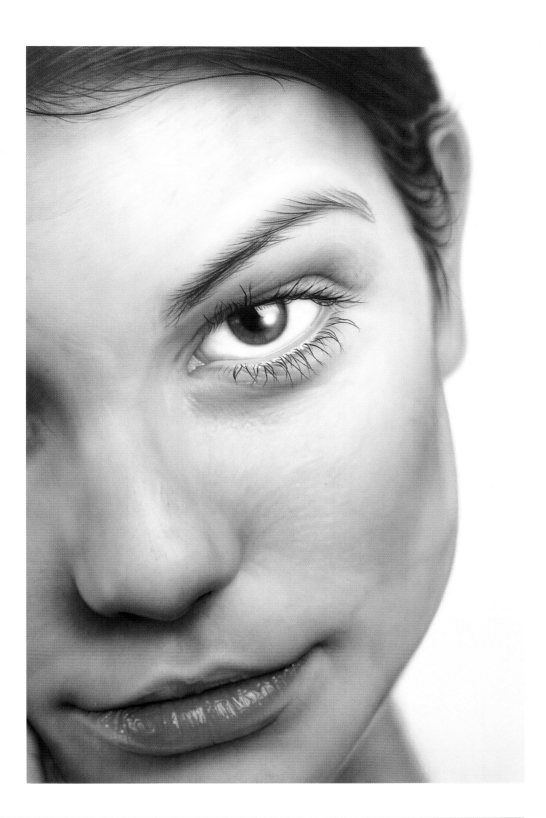

Au Naturel
2008
Acrylic on board
56 x 160 cm
© M J Ranum

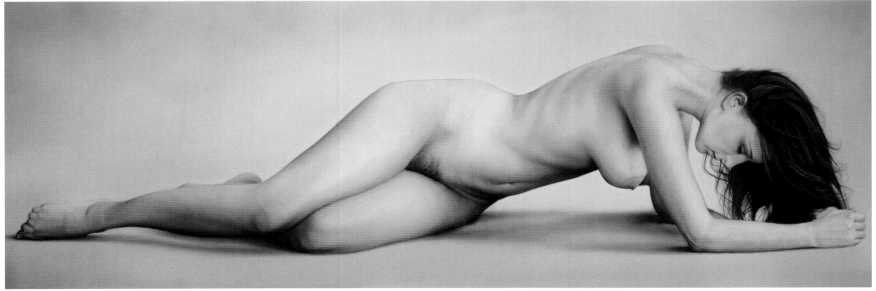

The Duality of Colin
2008
Acrylic on board
60 x 160 cm

Female Face (positive & negative)
2007
Oil on board
60.5 x 68 cm

Self Portrait (positive & negative)
2007
Oil on board
60.5 x 68 cm

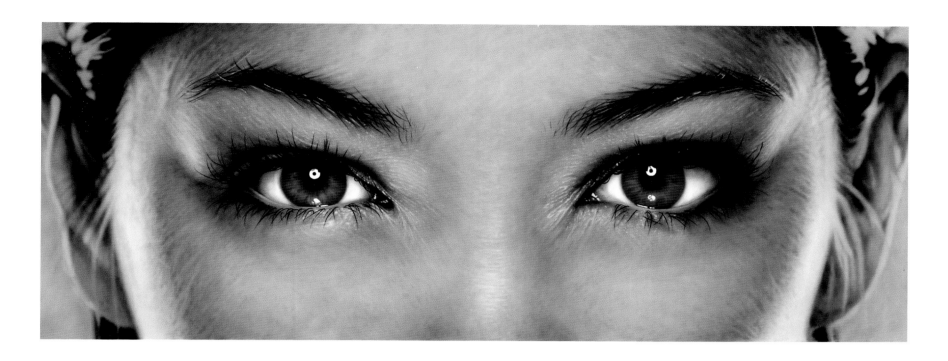

Under Surveillance
2005
Oil on canvas
53 x 140 cm

Enigmatic Gaze
2006
Oil on canvas
50 x 140 cm

Gaze
2008
Acrylic on board
60 x 246 cm

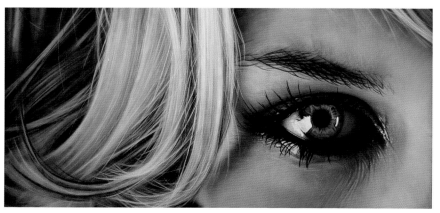

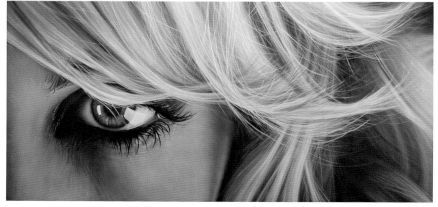

ANDREW HOLMES

Andrew Holmes is not the only British artist to be interested in America. He was a student at the Architectural Association in London and is a professor of architecture. His ideas are concerned with the infrastructures that create cities. His subject is the Interstate Highway system, the largest structure in the world, at 43,00 miles, conceived and designed as a single entity. Its objective was military, to transport tanks anywhere in the US, in the event of an airborne invasion. Its secondary function is for the transportation of goods, most importantly oil products. Almost incidentally it is a social network, giving rise to auto cults and snow-bird migrations. These ideas he sees clearly in the city of Los Angeles and its surrounding deserts. Through photographs, films and drawings he has documented, analysed and classified the machines driven by the men and women who ride and maintain this armature. He exposes the illusion of freedom of an individual tied to this compelling, restrictive system, and the fragility of a society dependent on a supply of cheap oil. The titles of the works indicate they are history and portrait at one and the same time.

There is an elusive character to the images he depicts that are photographic in feel and general appearance, but have a distinctive poetry that lifts them far above the literal documentary quality frequently associated with Photorealism. Many men get very romantic about motor vehicles and everything connected with them. There would seem therefore to be nothing unusual about Holmes's artistic preoccupation with American cars and garages. Indeed another adherent of Exactitude, John Salt, appears to share a similar passion. The similarity is only superficial, however. Salt is clearly enchanted by the idea of old American cars rotting quietly away in nondescript backwaters. His colours are muted, as though everything is seen through a veil of nostalgic memory, or in the light of faded period colour photographs. Holmes's images, on the other hand, are bang up to date, immediate, and often brilliantly coloured. If photographs lie at the basis of these pictures, the subjects must be very recent and in excellent physical condition.

Holmes's species of clear-eyed analysis ultimately resides not so much in the raw materials he uses, but in the abstract qualities he imparts to them. We know we are looking at a piece of machinery, or a general prospect of a sunlit filling station, and what we see has been first seen through the lens of a camera. But from the first we know also that we are looking at a very elaborate drawing that in some ways is designed to tease our perceptions.

While it is clear what we are looking at, it is far from clear how we are looking at it. Take an image like *Oil Change*. Obviously, we are being shown a gas station somewhere, to judge from the radiant blue sky and sunlight, in southern California. But it is not that simple. There are distortions that we are irresistibly tempted to try and resolve. Some of them can be explained perhaps because at first glance we appear to be viewing the scene through a wide-angle lens. Others might be explained by heat haze. But there are yet others that must indicate that we are looking at the rendering of a reflection in a somewhat uneven convex stainless steel mirror, the back of an oil tanker. There seems to be something missing. For where are the photographer and the camera? They should be visible in the interstices of the bright metal framework at the centre of the composition.

All these things indicate that Holmes is looking away from photographic origins rather than aiming at a closer and closer, more and more exact reproduction of his photographic inspiration. Perhaps it's his background in architecture that makes him so expert at the subtle, balanced compositions that are such a prominent feature of his work. Throughout his work there is a delight in details of construction, not just the obvious add-on design of exhaust stacks, air coolers, headlights, aerials, radiator grills and gas tanks of a semi, but the precise but awkward placing of an electric conduit and switch on a steel column in a gas station.

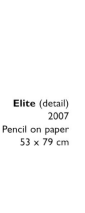

Elite (detail)
2007
Pencil on paper
53 x 79 cm

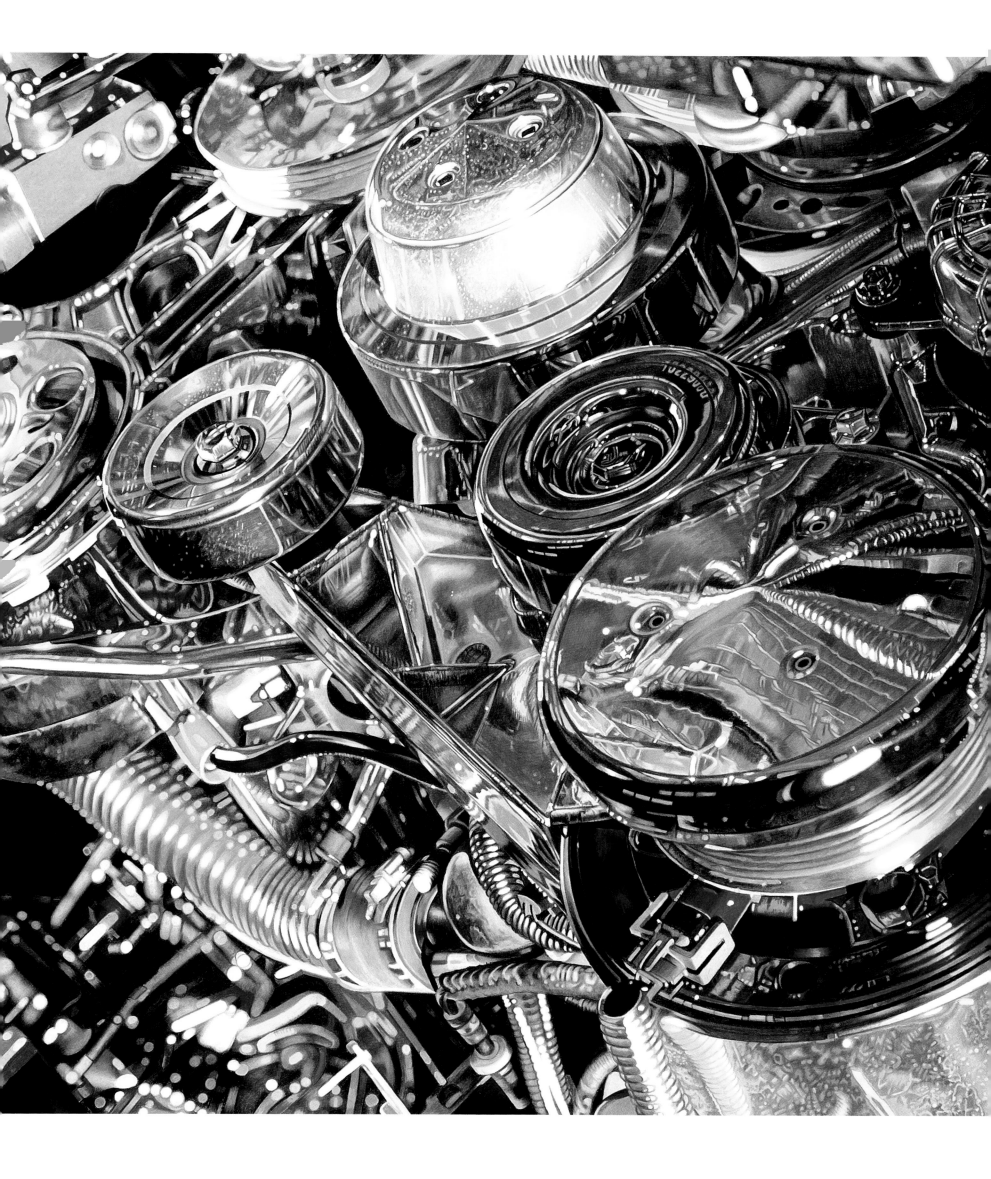

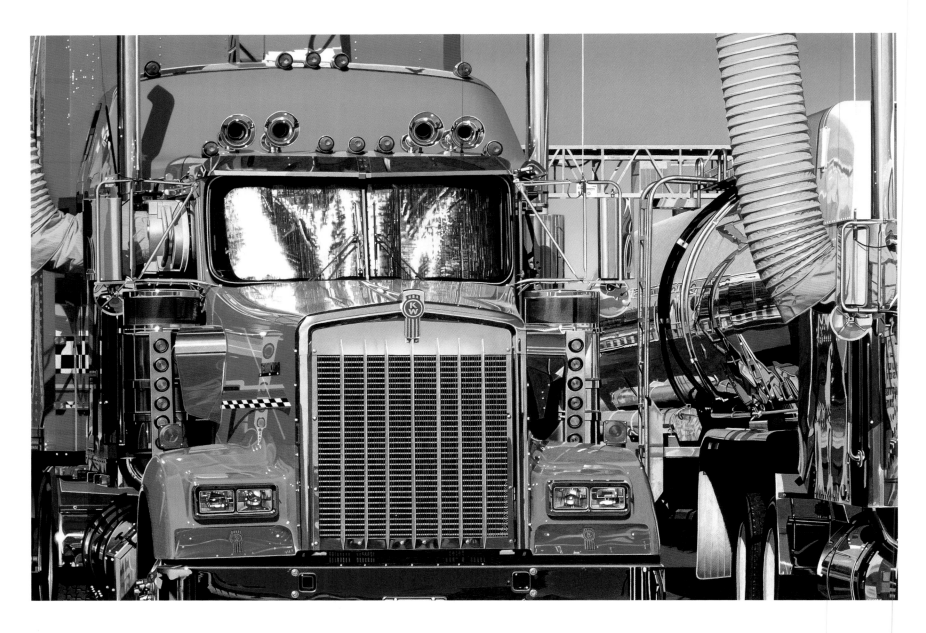

One Too
2006
Pencil on paper
53 x 79 cm

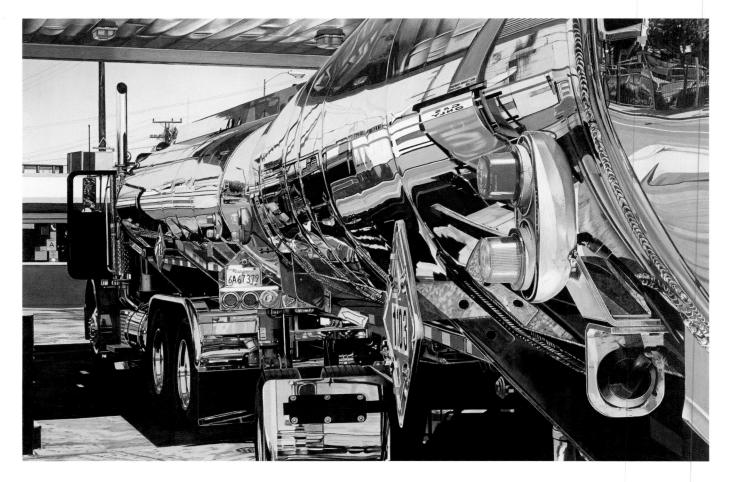

Gas Only
2008
Pencil on paper
53 x 79 cm

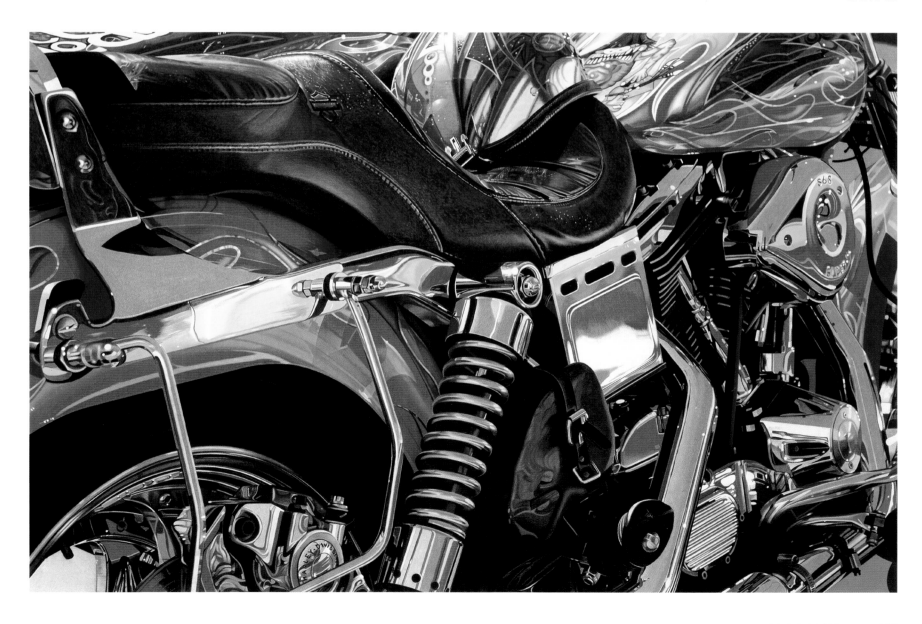

Vegas
2005
Pencil on paper
53 x 79 cm

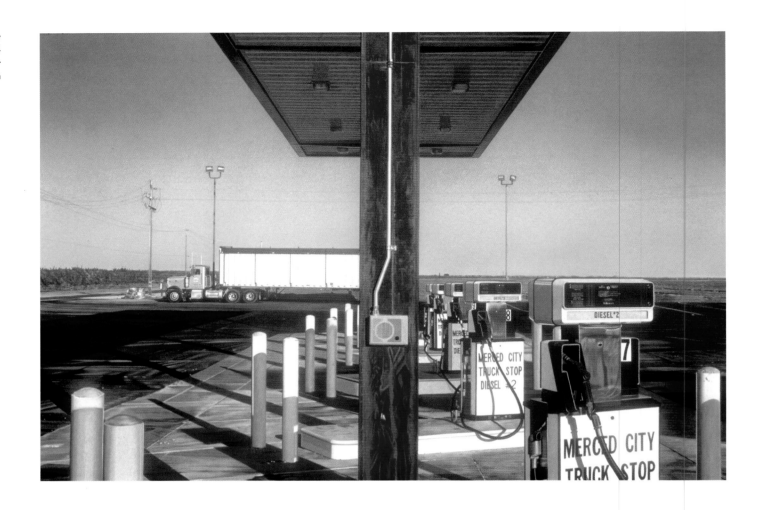

Merced City
2004
Pencil on paper
53 x 79 cm

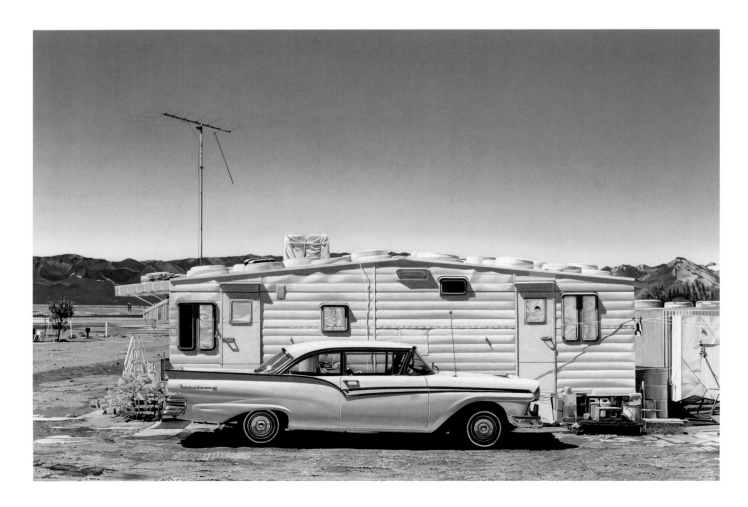

Fairlane
2005
Pencil on paper
53 x 79 cm

J & L Tank
2004
Pencil on paper
53 x 79 cm

Sugartrux
2006
Pencil on paper
53 x 79 cm

L
1999
Pencil on paper
53 x 79 cm

Elite
2007
Pencil on paper
53 x 79 cm

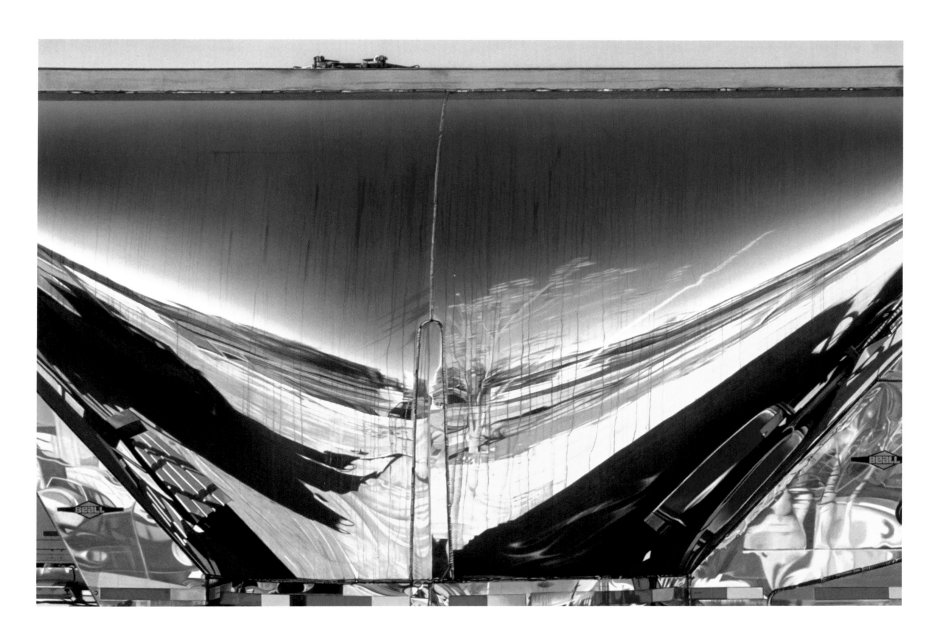

B
1999
Pencil on paper
53 x 79 cm

Now
2007
Pencil on paper
53 x 79 cm

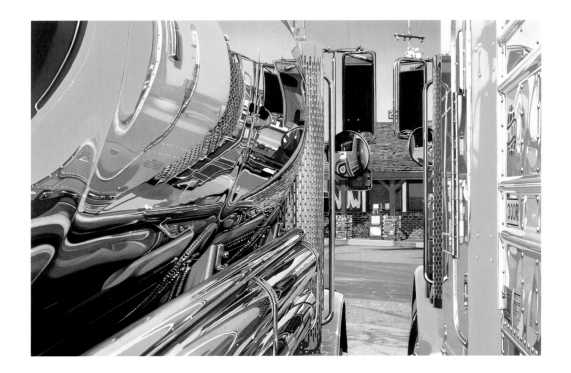

Power Vibe
2007
Pencil on paper
53 x 79 cm

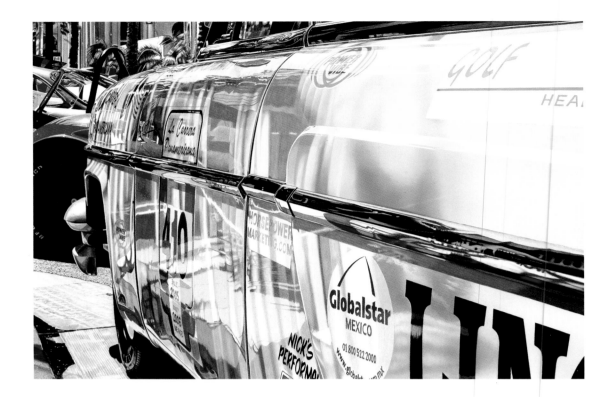

US Mail
1996
Pencil on paper
53 x 79 cm

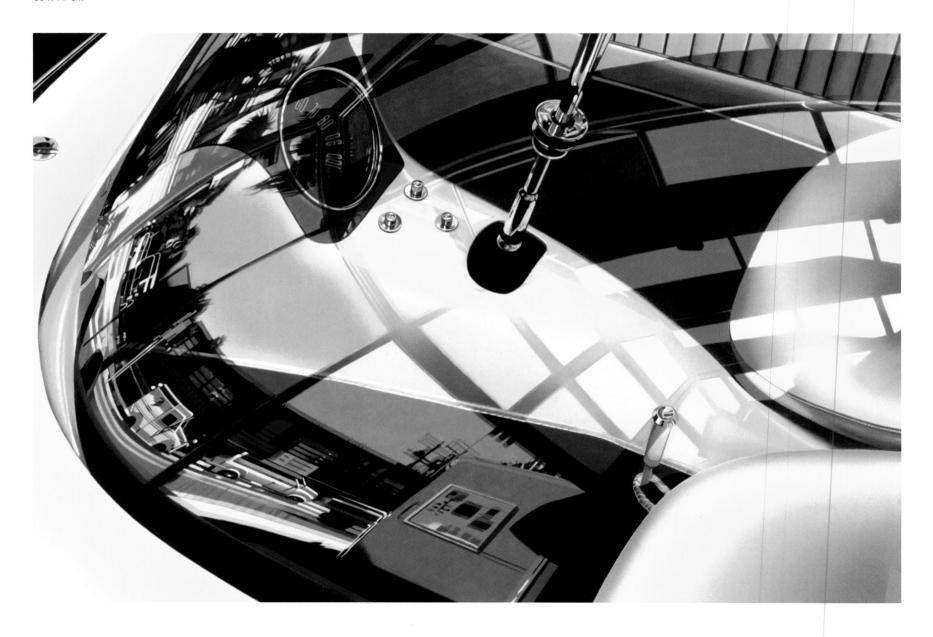

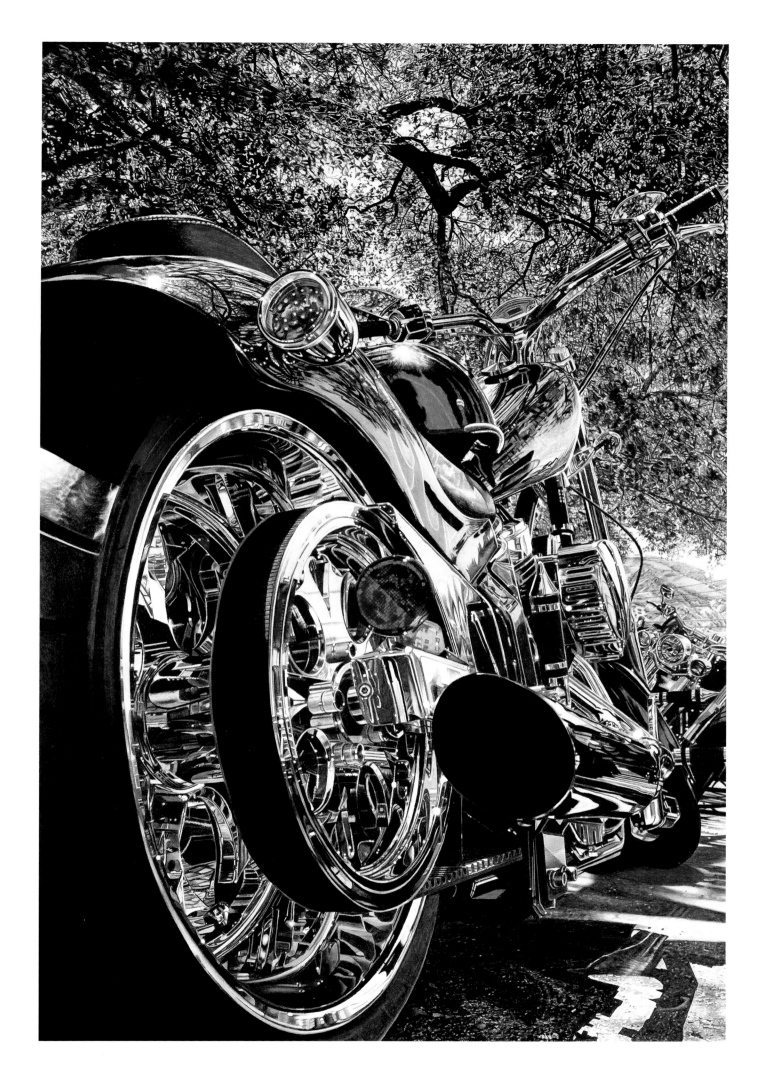

Mulholland
2007
Pencil on paper
79 x 53 cm

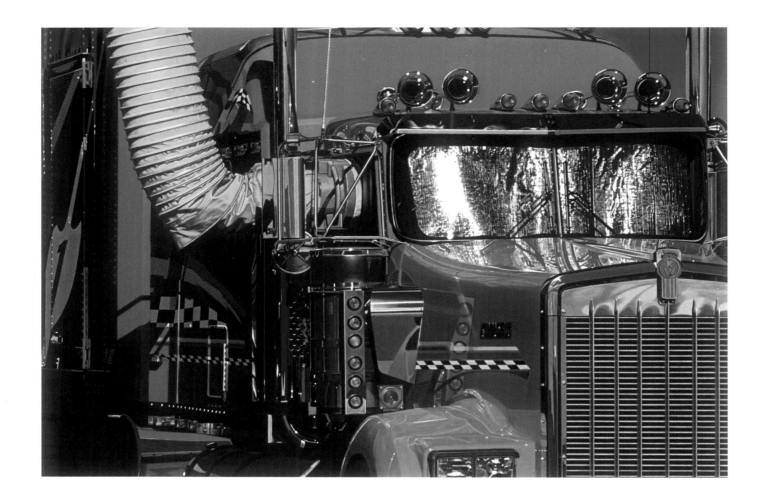

One
2004
Pencil on paper
53 x 79 cm

Vice
1991
Pencil on paper
53 x 79 cm

Lord
1987
Pencil on paper
80 x 120 cm

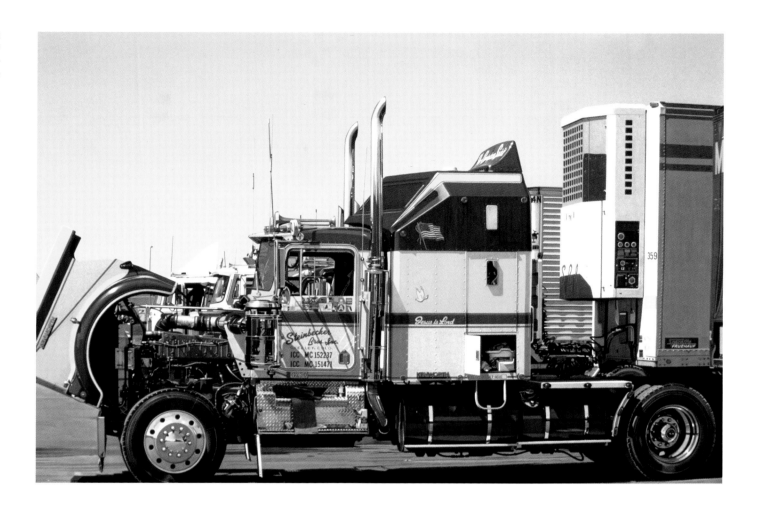

Ideal
1991
Pencil on paper
53 x 79 cm

Steel
1992
Pencil on paper
79 x 53 cm

CT
2003
Pencil on paper
53 x 79 cm

Dane
1991
Pencil on paper
79 x 53 cm

Ex
2003
Pencil on paper
53 x 79 cm

BEN JOHNSON

REALISM, ESPECIALLY IN EXTREME FORMS such as Photorealism, has not been fashionable in Britain for many years. Indeed, despite a few stray exponents in the Thirties, such as Tristram Hillier and Meredith Frampton, it can claim to have been intensely unfashionable, even before the advent of Conceptual Art and a widespread rejection of painting altogether. In this context the first *Exactitude* show, curated by Clive Head, was genuinely revolutionary, seeking to bring a long-submerged tradition up to the surface again.

Though much the most successful attempt at outing realists, it was not the first, however: in 1981, the now-defunct London gallery Fischer Fine Art presented *The Real British*, a show of paintings and drawings by artists who believed intensely in minutely detailed realism. Ben Johnson was one of them, and, intriguingly, he was the only one from *The Real British* who also appeared in the first *Exactitude* show twenty-two years later. Of course he has not stood still in the interim. If some of the *Real British* painters forsook realism altogether in favour of out and out abstraction, others like, notably, Brendan Neiland and Ben Johnson went a few steps along the road to abstraction without in any way relinquishing their devotion to exactitude with a small 'e'. They simply chose their subject matter from things that in themselves look abstract: reflections in sheets of plain glass; interiors full of transparent glass which, the more precisely they are rendered in paint, the more difficult they become to read in realistic terms.

Reassuringly, Johnson has not meanwhile abandoned full-on Hyperrealism, or Photorealism as we may now fairly call it. In the last few years he has carried out a number of major commissions involving a very detailed depiction of real places, such as his series of major works reflecting the ever-changing face of urban Hong Kong and, most spectacularly, the enormous panorama, commissioned by the Khalili Family Trust, representing *Jerusalem, The Eternal City*, which has been touring the world prior to its final installation.

In *Exactitude I* itself Johnson showed a mixture of his two sub-genres – the separation is mine, not his. On the one hand there were pictures like *A Place of Reflection* (2002), which we accept must represent an actual interior space, but beyond that is almost impossible to read realistically; we struggle to work out what is where, what is real and what reflection, how its designer has bolstered himself and us against the void. On the other hand, there were the meticulously detailed depictions of spaces like the entrance hall of Syon House (called evasively *Through Marble Halls*, 1994) or single architectural features such as *Double Doors, France* (1979).

And what is the intention behind these immaculately clean and tidy paintings? The titling is a clear indicator that they have nothing to do with the inevitable but not very lofty impulse to buy postcards of memorable places we visit. What Johnson wants to capture is not the accidentals of Syon, but the essence. He understands perfectly the lesson of most Photorealism: the more minutely particular a painting is, the more universal it is likely to prove.

Tokyo Pool (detail)
2006
Acrylic on canvas
137 x 206 cm

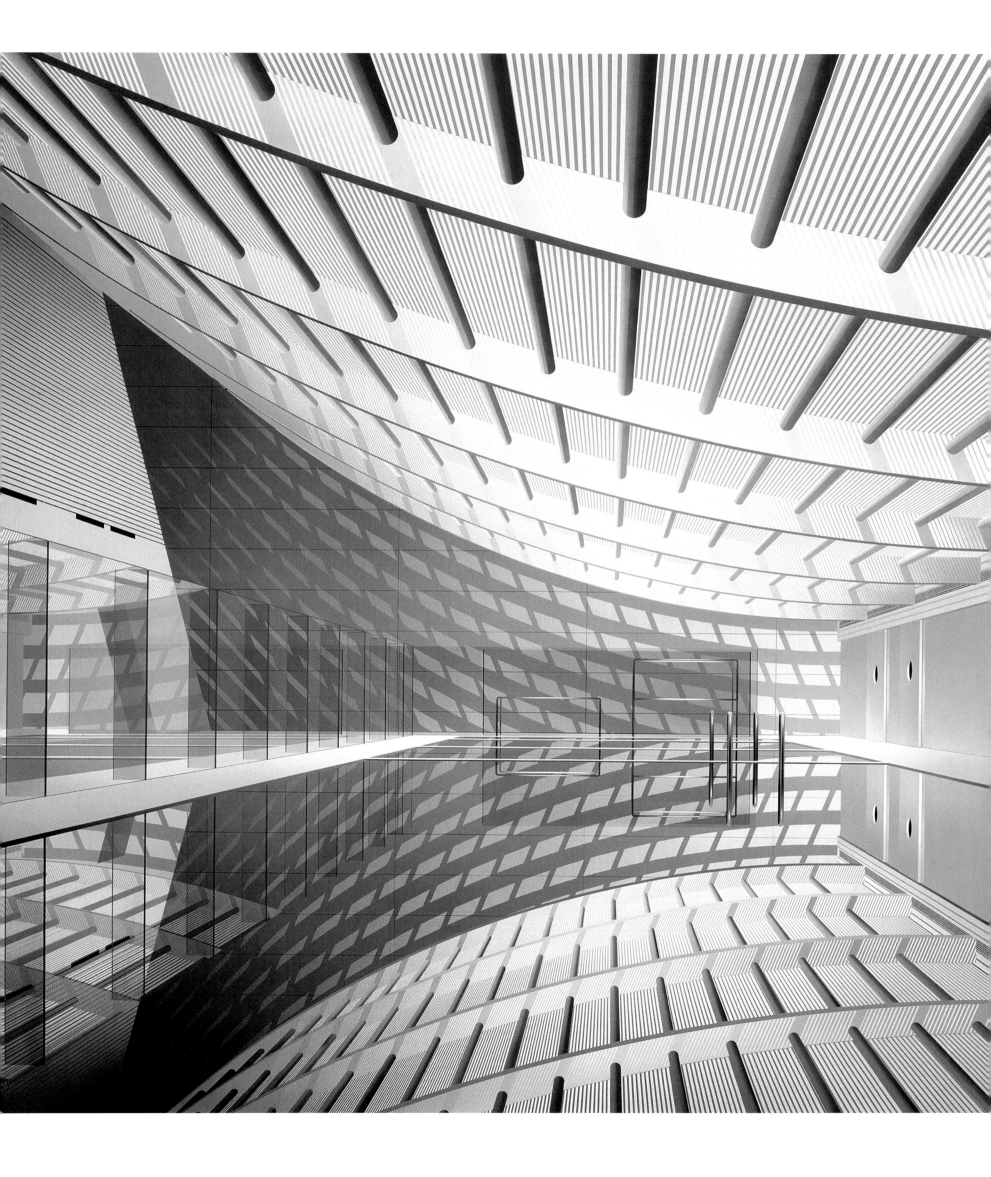

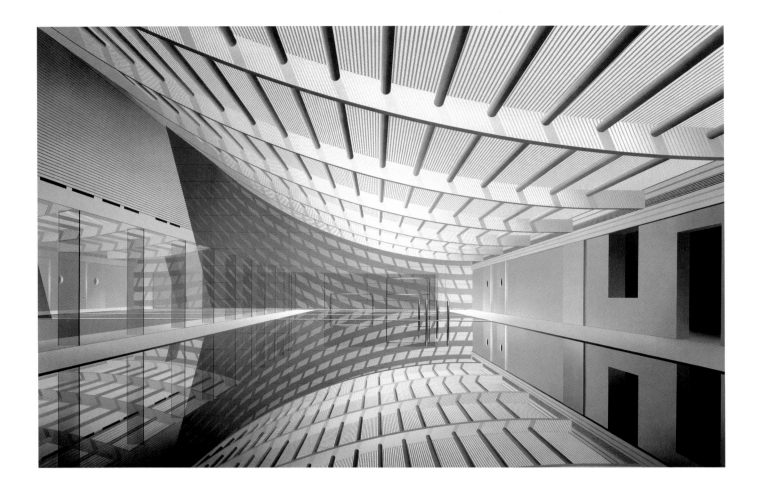

**British Museum
Great Court**
2002
Acrylic on canvas
150 x 200 cm

A Place of Reflection
2002
Acrylic on linen
183 x 183 cm

Leading Light
2001
Acrylic on canvas
183 x 242 cm

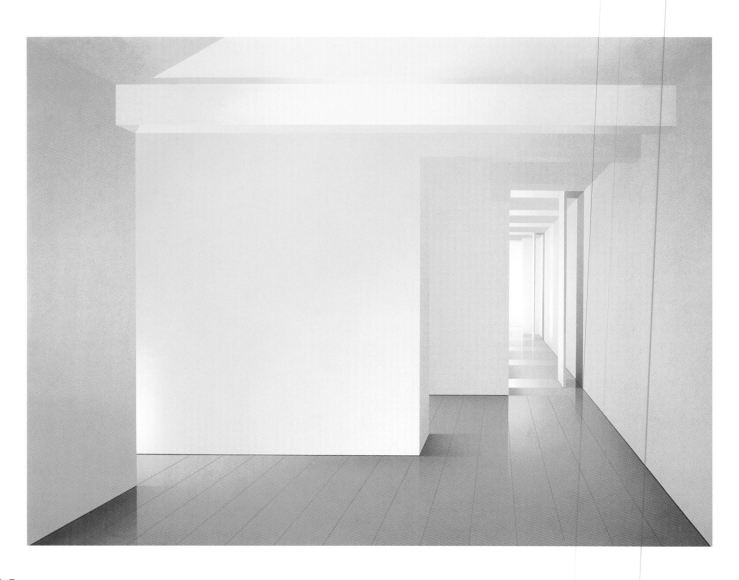

Unseen Space
2007
Acrylic on canvas
183 x 158 cm

Through Marble Halls
1994
Acrylic on canvas
139 x 183 cm

Corridor of Benediction
2000
Acrylic on canvas
140 x 193 cm

The Inner Space
2001
Acrylic on linen
102 x 152 cm

Reading between the Lines
1997
Acrylic on canvas
152 x 229 cm

Art and Illusion
1989
Acrylic on canvas
193 x 193 cm

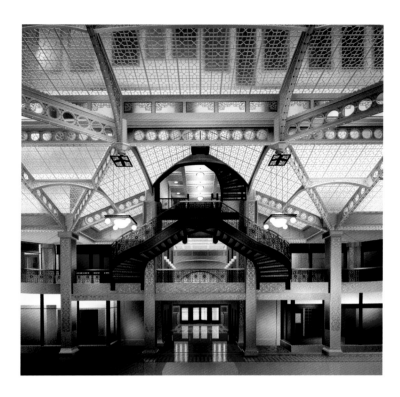

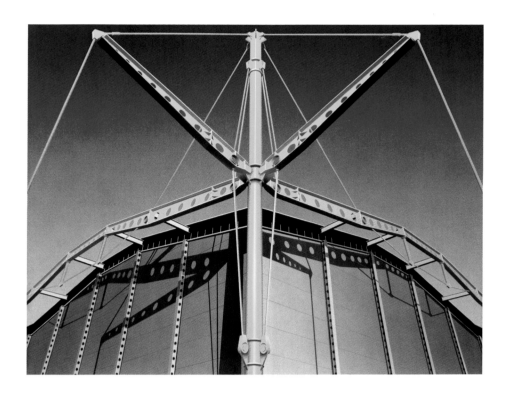

The Rookery, Chicago
1995
Acrylic on canvas
231 x 231 cm

Outriggers East Mast
1986
Acrylic on canvas
95.5 x 119 cm

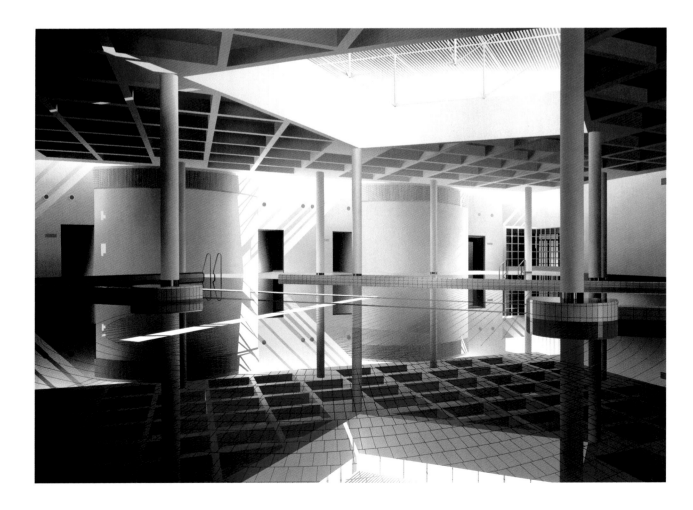

The Unattended Moment
1993
Acrylic on canvas
184 x 243 cm

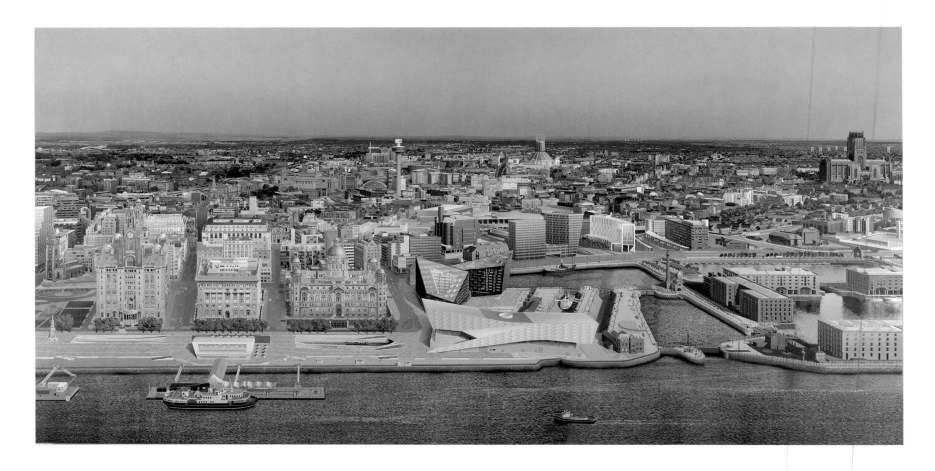

The Liverpool Cityscape
2008
Acrylic on canvas
244 x 488 cm

Jerusalem, The Eternal City
2008
Acrylic on canvas
229 x 457 cm

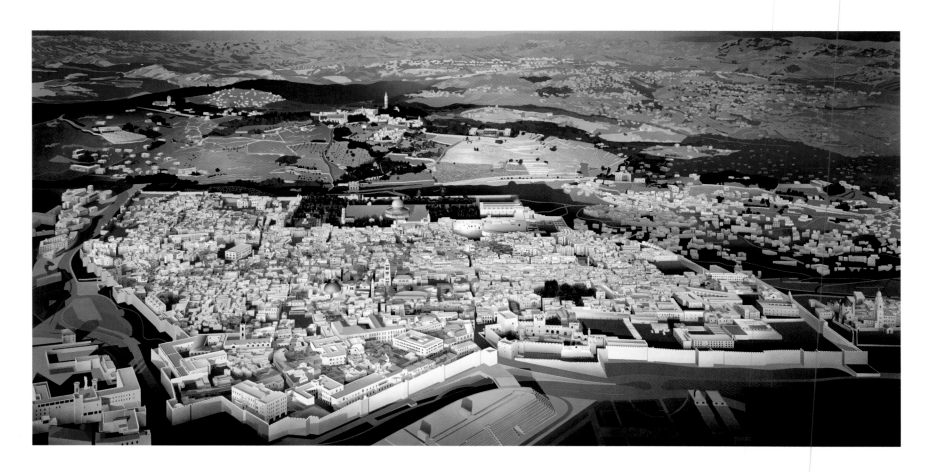

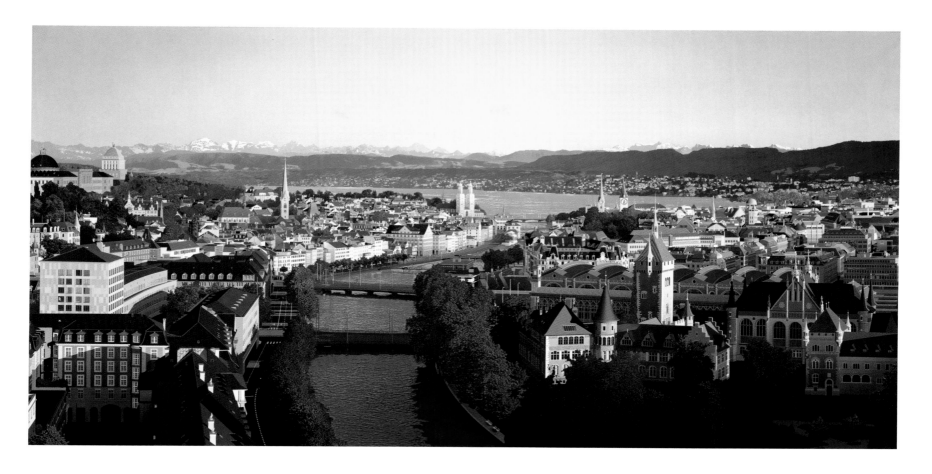

Zurich
2003
Acrylic on linen
200 x 400 cm

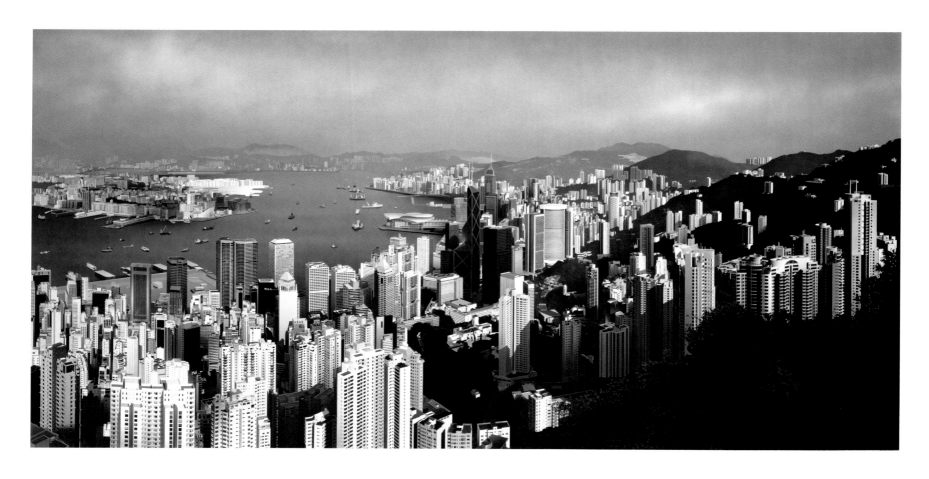

CARL LAUBIN

ARL LAUBIN IS NOT A PHOTOREALIST. It is arguable whether he is even a realist. And yet the label Exactitude fits him immaculately. How can this be? Well, we must bear in mind where he has come from, and what exactly he does. He was trained, and even qualified, as an architect, and he paints primarily architecture. All the same, the architecture in his training was virtually coincidental to his true desire and lifelong determination to be a painter and, even more important, to paint. (The two desires are not, of course, necessarily synonymous.)

Laubin always wanted, indeed needed, to paint. Though he let his father persuade him to train as an architect (so that he would have a 'real job' to fall back on), his own feeling seems to have been that at least it kept him in the realm of art, and couldn't do any harm. He came to Europe at the age of twenty-six, intending to take up a job in a Lugano architect's office, and ended up in a London architect's office instead. There, he continued to paint for himself in his spare time, and his boss soon discovered that he had a special talent for producing vivid drawings – or paintings, as they often turned out to be – of the office's major projects. These were inevitably imaginative realisations of other people's ideas, which might or might not reach a realisation in bricks and mortar as well as in paint. And the more life-like and convincing the paintings were, the more likely they were to persuade potential patrons that the project should be pursued.

Soon enough these paintings took on a life of their own. First Laubin found that this was all he was doing for his architect's office, then, once he had broken free of it, that it was what he wanted to do, with a more and more free-soaring imagination, for himself as an independent painter. So the origin of his taste for exactitude becomes clear. Evidently his work for architects, though based initially on something which existed only in someone's head, needed first and foremost to carry conviction: it did not yet exist, but the painting gave an amazingly accurate idea of how it might. Thus, even if Laubin was painting a fantasy completely out of his own imagination, to make it work as he wanted he had to have mastered everything there was to know about perspective and proportion, and, like Dalí and his Surrealist followers, to produce an overwhelming impression of precision in the delineation of 'a thing that is almost a Thing'.

Since so many of Laubin's architectural paintings are of buildings that do not exist, or at least not yet, at the time of painting, literal Photorealism is hardly something that is open to him. Photographs might possibly be of use for those elaborate compositions in which he brings together in a single painting all the works of Sir Christopher Wren or Nicholas Hawksmoor, but their usefulness would be very limited, and certainly do little to ease the intense brainwork that must go into such pieces. It is here that the obsession with getting everything that can be verified absolutely right, and, moreover, getting it to look right, comes into play.

Laubin parts company with most key Photorealists in other ways than in his choice of subject matter. Many of them want their paintings to look as much like photographs as possible, while he prefers his paintings to look like paintings. Indeed, one may suspect that he has made no deliberate choice in the matter, but just can't help himself. He is a painter through and through, and a very painterly one at that. Painterly, it must be added, rather in the way that Ingres was painterly: no flashy brushwork, no obtrusive effects to say 'Look at me, look at me! Trust me, I'm a painter....' but instead a personal angle of vision, a skilfully summoned-up atmosphere, a justice and delicacy in the choice of colour that proclaims a master painter at work. A painter who is at once intensely modern, and at the same time proud to belong to a classic tradition. If Canaletto were to be reborn, Laubin gives us a very fair idea of what a Canaletto for the twenty-first century would be doing right now.

Si Monumentum Requiris
(detail)
1995
Oil on canvas
122 x 183 cm

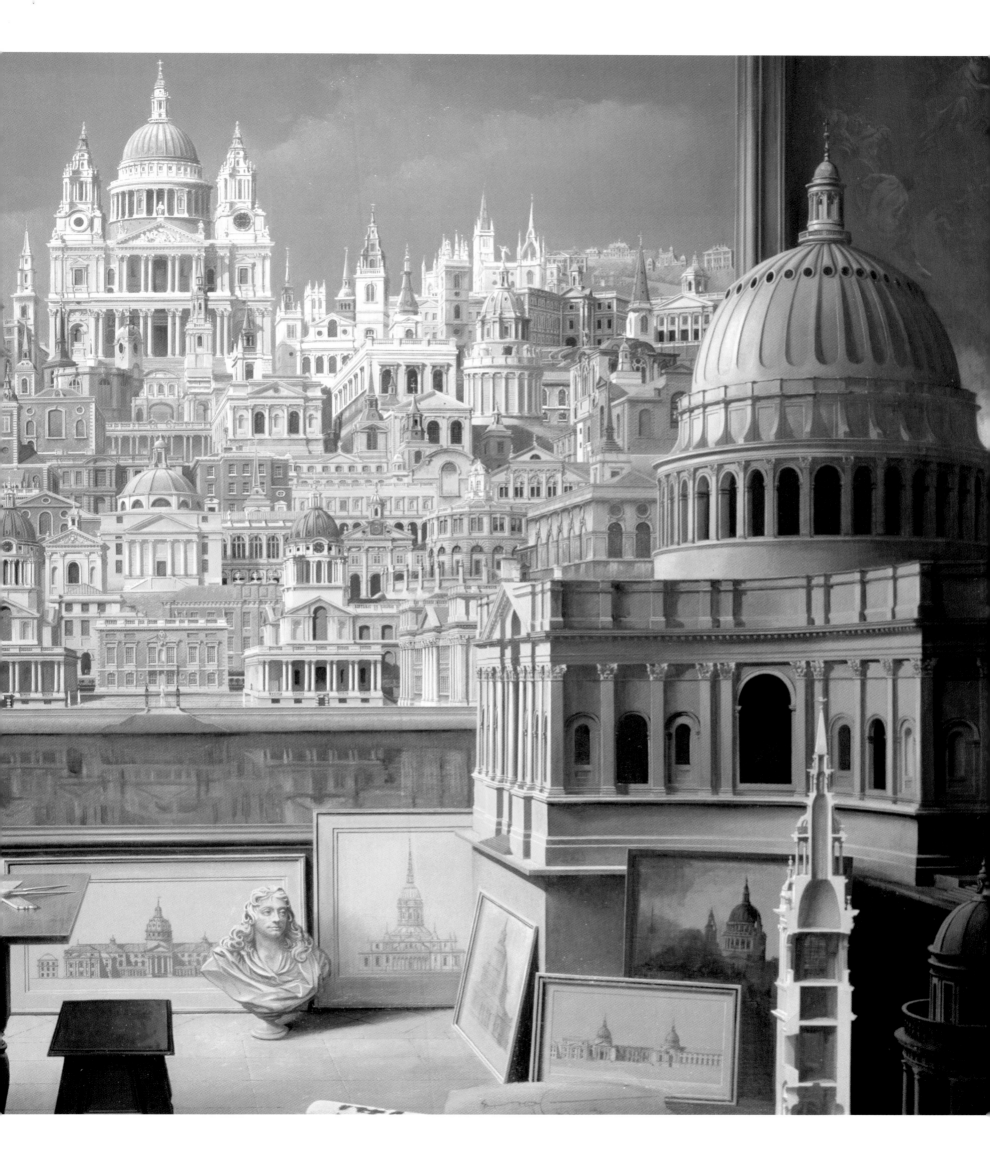

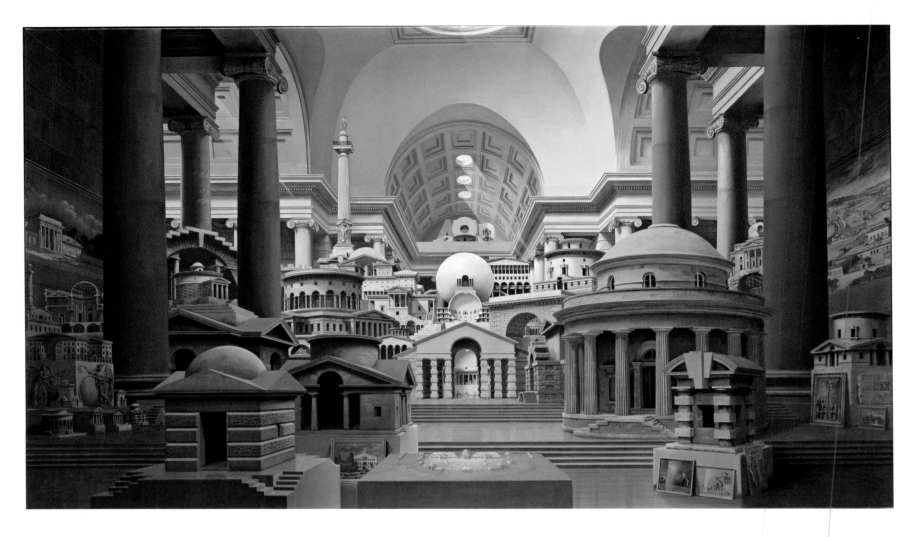

Architecture Parlante
2006
Oil on canvas
117 x 204 cm

**Tivoli Corner, Bank
of England**
1999
Oil on canvas
71 x 51 cm

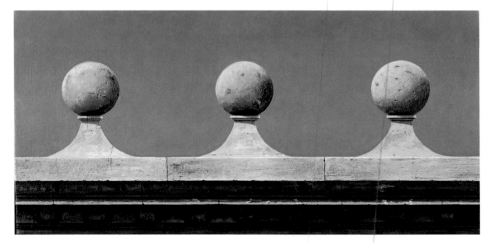

Palladian Machicolation
2008
Oil on canvas
30 x 61 cm

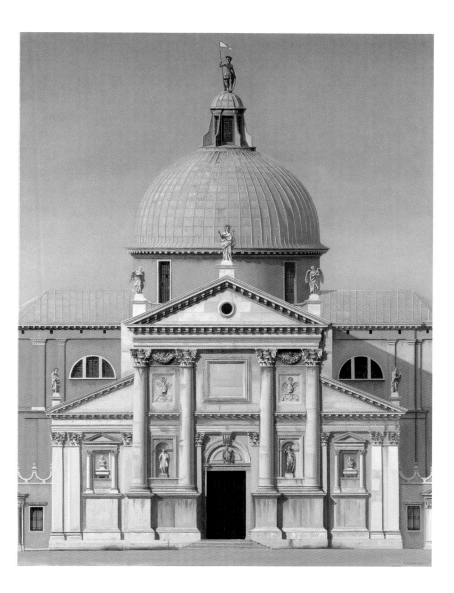

San Giorgio Maggiore
2004
Oil on canvas
114 x 87 cm

**Strong Reason and
Good Fancy**
2004
Oil on canvas
107 x 183 cm

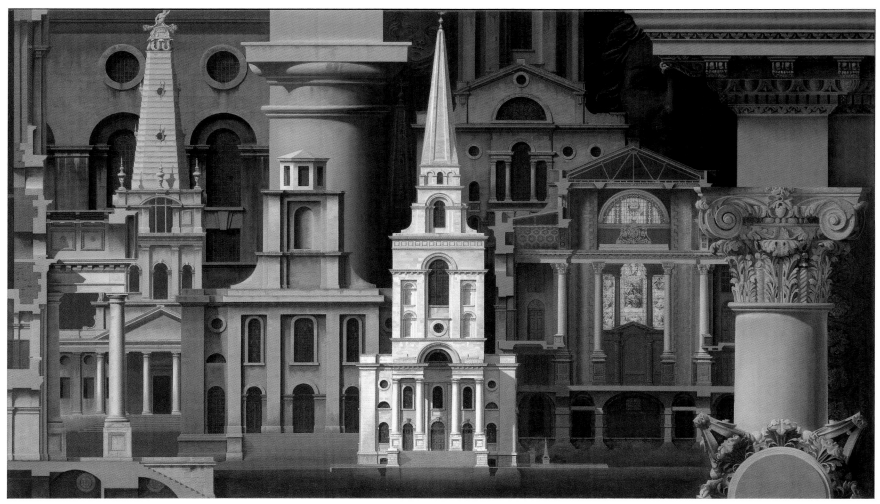

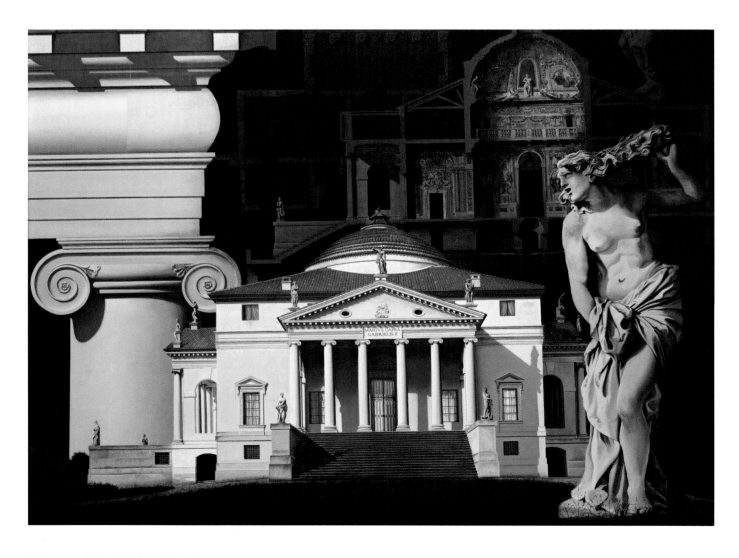

Villa Rotunda
1992
Oil on canvas
80 x 107 cm

Villa Rotunda
2004
Oil on canvas
110 x 137 cm

Burnham Lighthouse
1992
Oil on canvas
36 x 26 cm

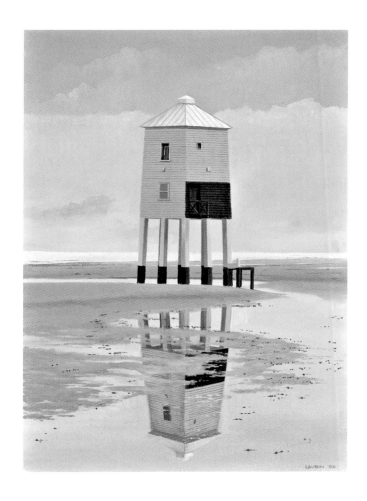

**No. 9 Rue du Docteur
Blanche**
2005
Oil on canvas
122 x 91 cm

**The Thames at Cannon
Street**
1999
Oil on canvas
61 x 122 cm

White Drapery
2004
Oil on canvas
152 x 152 cm

Castle Howard Capriccio
1996
Oil on canvas
122 x 183 cm

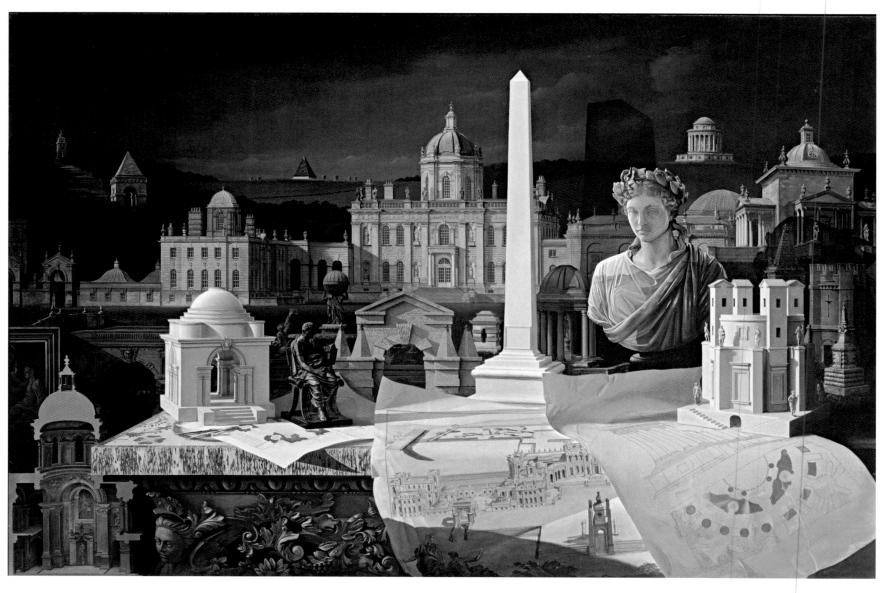

Venere Italica
2004
Oil on canvas
152 x 121 cm

**Un Rêve d'Architecte
à Bordeaux**
1988
Oil on canvas
105 x 153 cm

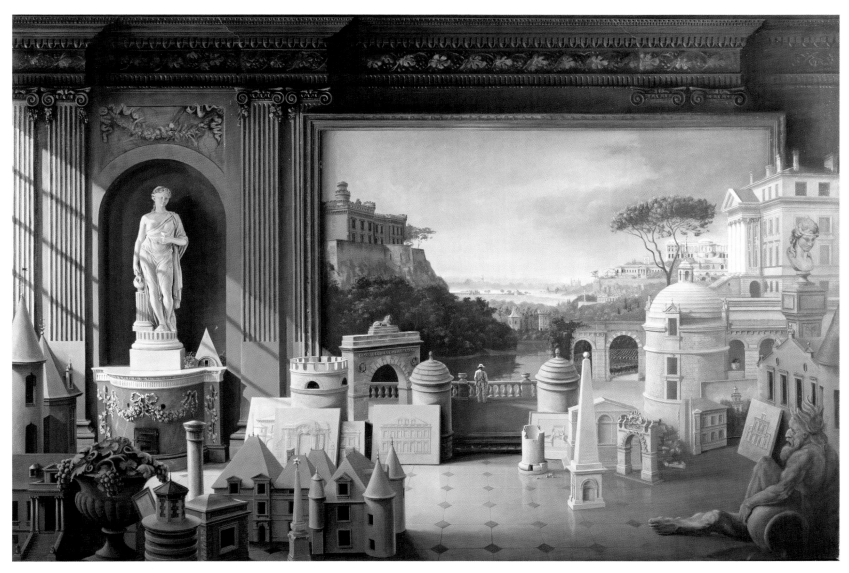

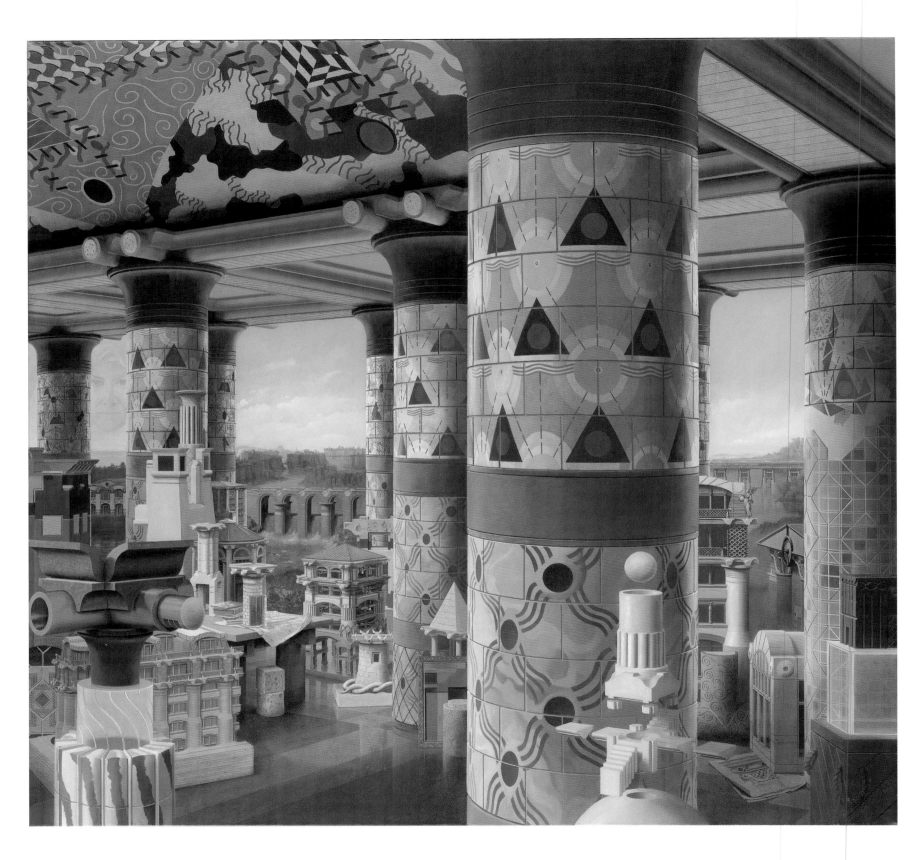

**Cloaked in an Ancient
Disguise**
2004
Oil on canvas
142 x 152 cm

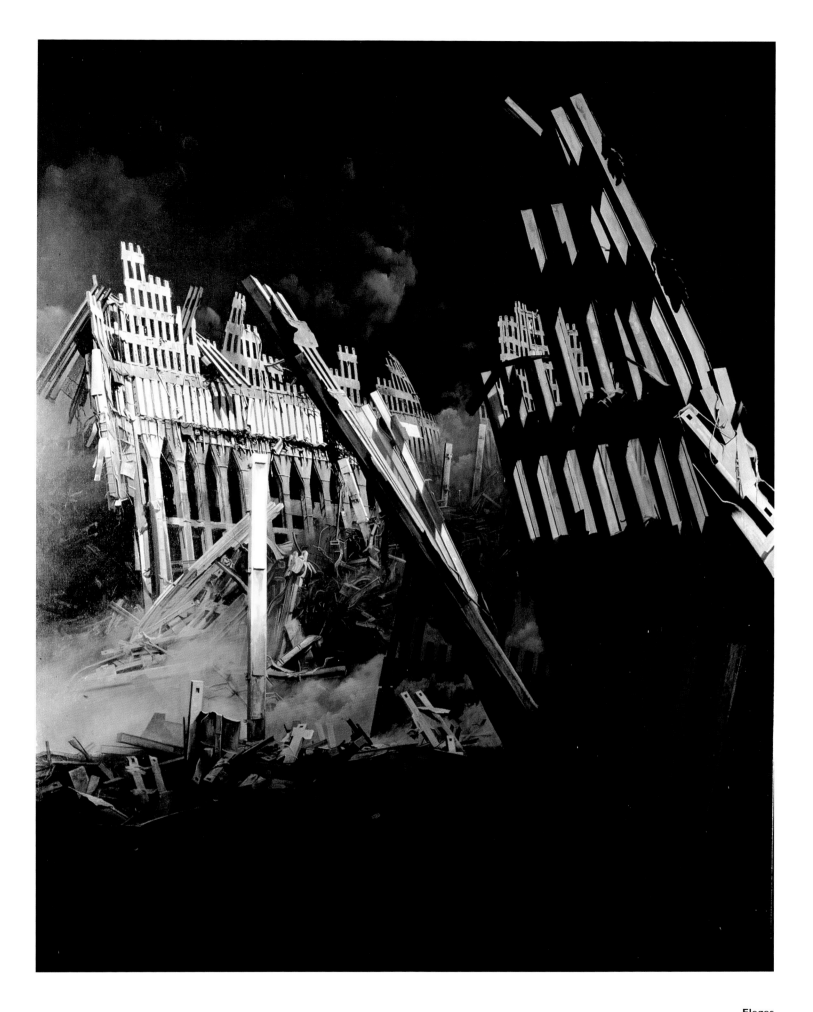

Elegos
2001
Oil on canvas
183 x 152 cm

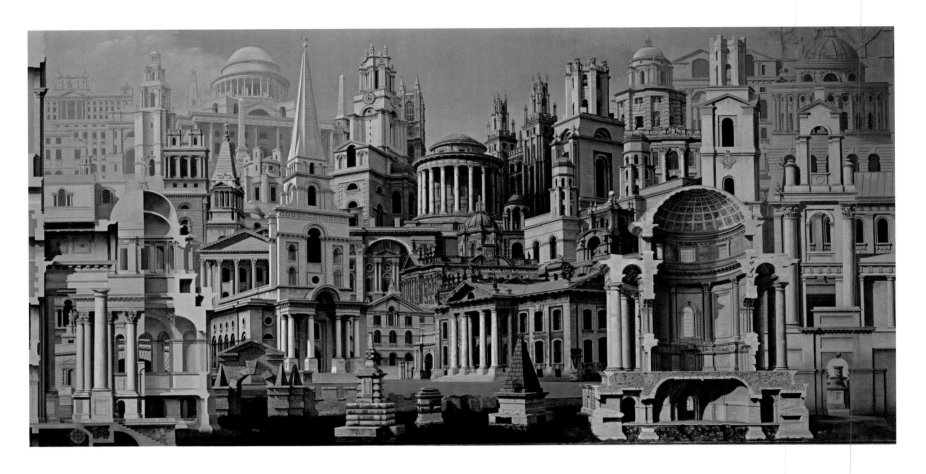

Hawksmoor
1996–2000
Oil on canvas
102 x 203 cm

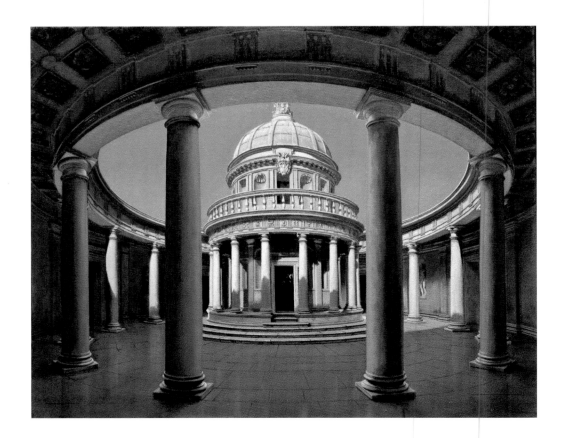

**Tempietto, an Interpretation
of Bramante's Circular
Cloister**
2002
Oil on canvas
41 x 51 cm

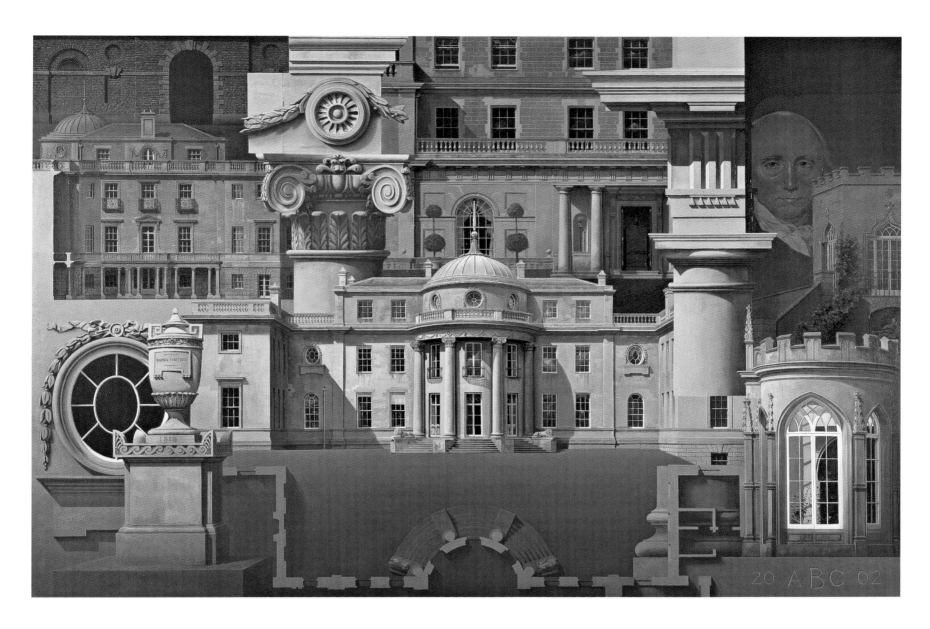

Daylesford House
2003
Oil on canvas
122 x 183 cm

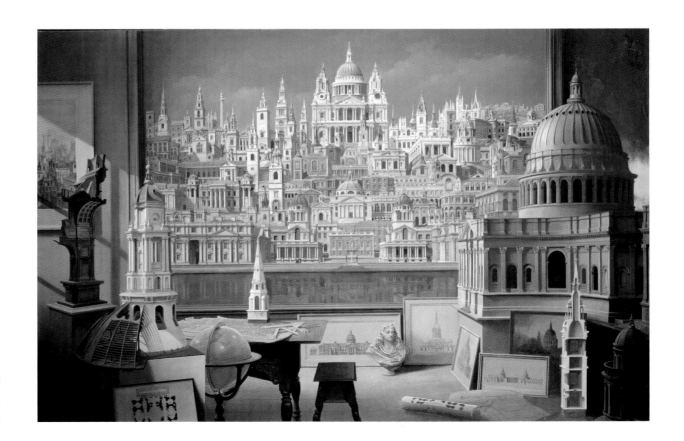

Si Monumentum Requiris
1995
Oil on canvas
122 x 183 cm

Twentieth-Century Order
2005
Oil on canvas
137 x 102 cm

Cinquecentenario
2008
Oil on canvas
117 x 203 cm

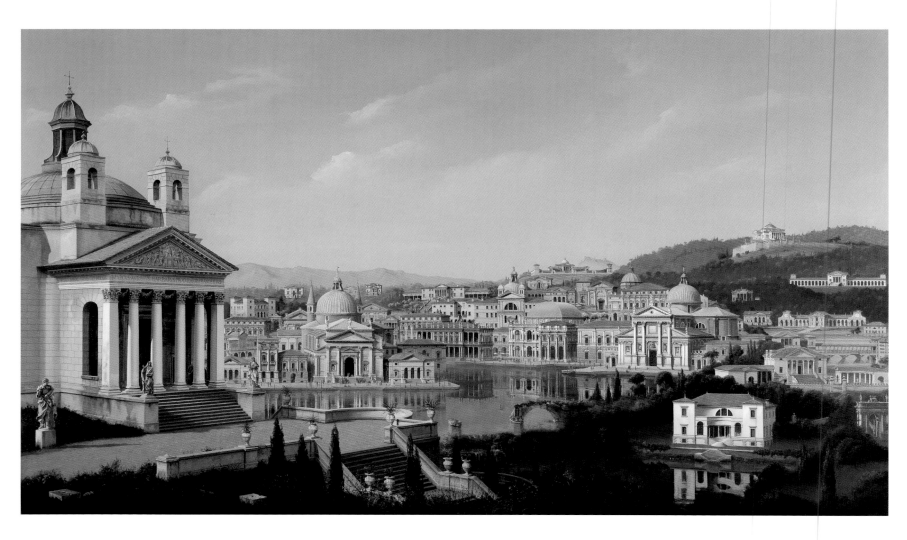

**Literal and Phenomenal
Transparency**
2006
Oil on canvas
152 x 152 cm

Palladius Britannicus
2008
Oil on canvas
117 x 203 cm

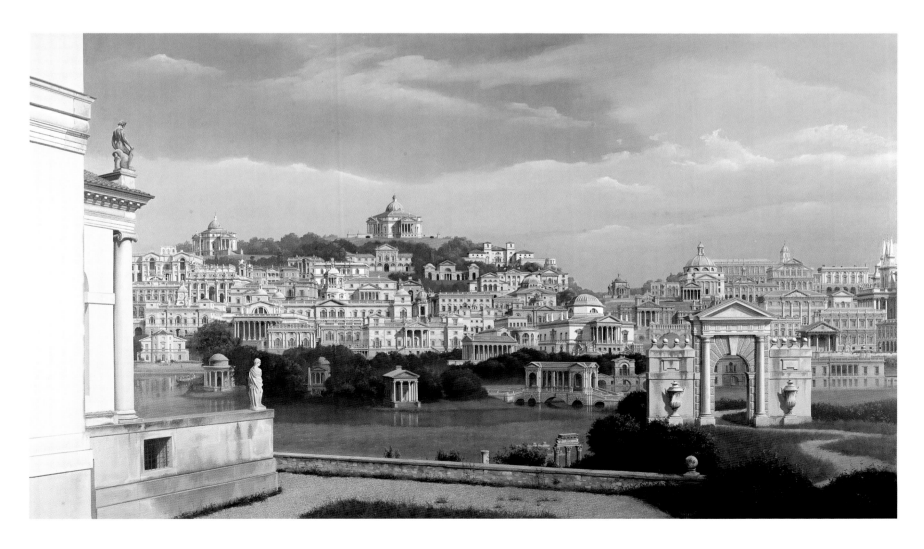

DAVID LIGARE

THE STILL-LIFE TRADITION dates back as far as ancient Egypt where images of foodstuffs in the tombs were meant to accompany the deceased into the afterlife. Later Greek and Roman paintings often included images of ritual offerings (*aparchai*) intended to propitiate the gods. In his still-life paintings, California artist David Ligare has reached back to these ancient traditions. He has also looked carefully at the great flowering of Italian, Spanish and Dutch still-life painting of the seventeenth century that may have evolved from isolated details in Renaissance and Baroque figure paintings. A notable example of this is Caravaggio's isolated basket of fruit probably painted as a commission after his *Supper at Emmaus* (1601) with its prominent hyperrealist basket of fruit. The still lifes of the seventeenth century often referred symbolically to the shallowness of earthly life (*vanitas*) or served to remind viewers of their own mortality (*memento mori*). None of these paintings could have been influenced by ancient art because the wall paintings of Pompeii and Herculaneum were only discovered in the late eighteenth century.

David Ligare acknowledges artists such as Caravaggio, Juan Sánchez Cotán and Francisco de Zurbarán but has returned in recent years to ancient Greek and Roman still lifes for inspiration. Through diligent research, Ligare discovered what has long been overlooked by other artists and scholars: that many of the paintings from Pompeii and Herculaneum are, in fact, depictions of what were called first-fruit offerings of thanks laid out on altars or offering tables. Ligare calls his approach 'the literate picture', because the paintings are based on investigations into history and philosophy. As Michael Squire, research scholar in classics at Trinity College, Cambridge, wrote: 'David Ligare has turned to the still life to explore the intersection between his academic research and cultural poetics.'

Although the greater part of the artist's production over the past thirty years has been figure and landscape paintings, still lifes have occupied an important place in his oeuvre. His 2005 London exhibition, *Offerings: A New History*, marked the introduction of the *aparchai* elements carefully set in the same altar-like space that he has used for twenty years. This format affords Ligare the chance to present small essays in wholeness. Nothing is ambiguous or diffuse. The enclosure opens to the right revealing a view of a placid sea and allowing the sunlight to illuminate the objects and their cast shadows onto the left wall. The objects chosen – apples, peaches, figs, grapes, wheat, etc. – are not casually strewn about but, instead, are reverently placed onto blocks of stone as if they were, indeed, ritual offerings of the first fruits of the season. In that same London exhibition the artist also included several paintings, including *Georgic Landscape* (2005), depicting agriculture in the same late, Virgilian light.

David Ligare was born in the Chicago suburb of Oak Park, Illinois, but his family moved to Los Angeles, California, when he was five. He studied at the Art Center College of Design, now in Pasadena. After extended travel in Europe and two years of military service, the artist began exhibiting in New York in 1966 and has had over thirty-six solo exhibitions there and in Los Angeles, San Francisco, Rome, London and elsewhere. In addition he has participated in group shows all over the world. In an interview given in 2007 the artist said that 'no matter how carefully I have painted the objects and the light and so on, and no matter how much people want to say that this is "realism", the fact is that this is a world set apart from the real world. The greater the depictive quality of the image is, and without expressive paint-handling or style, the greater the tension between the viewer and the un-enterable "sacred" space. It is not a depiction of reality, or a deception, it's what has been called a "critical reconstruction".'

Still Life with Grapes and Apples (Aparchai)
(detail)
2005
Oil on canvas
51 x 61 cm

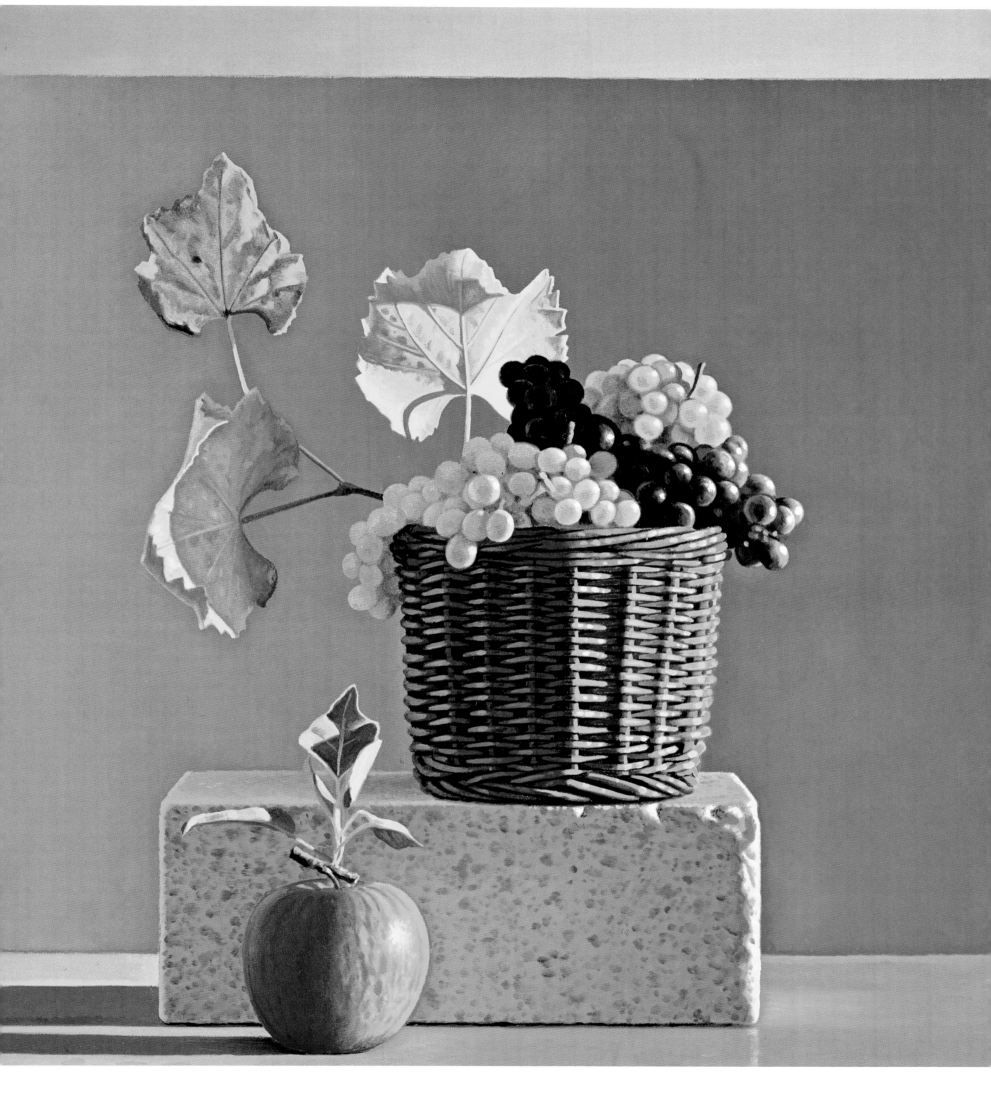

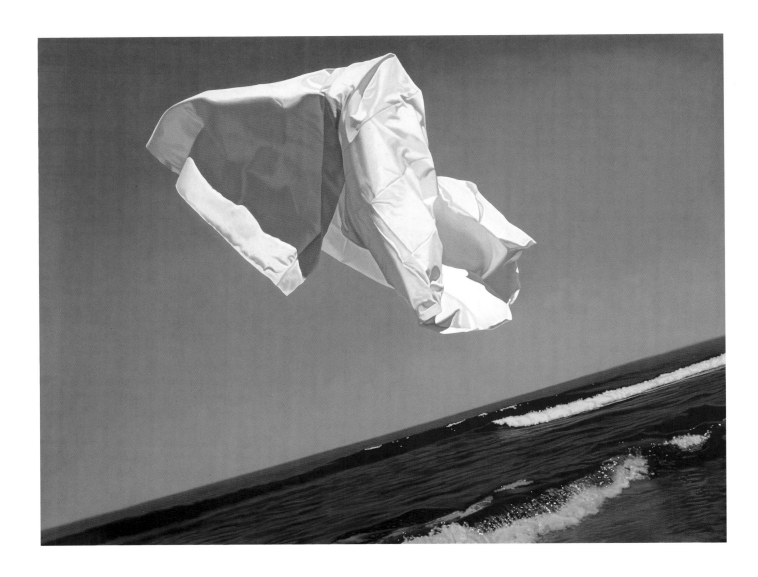

Naxos (Thrown Drapery)
1978
Oil on canvas
152.5 x 198 cm

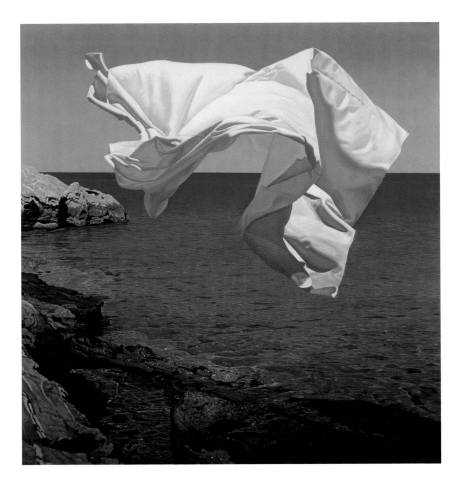

Symi (Thrown Drapery)
1979
Oil on canvas
152.5 x 127 cm

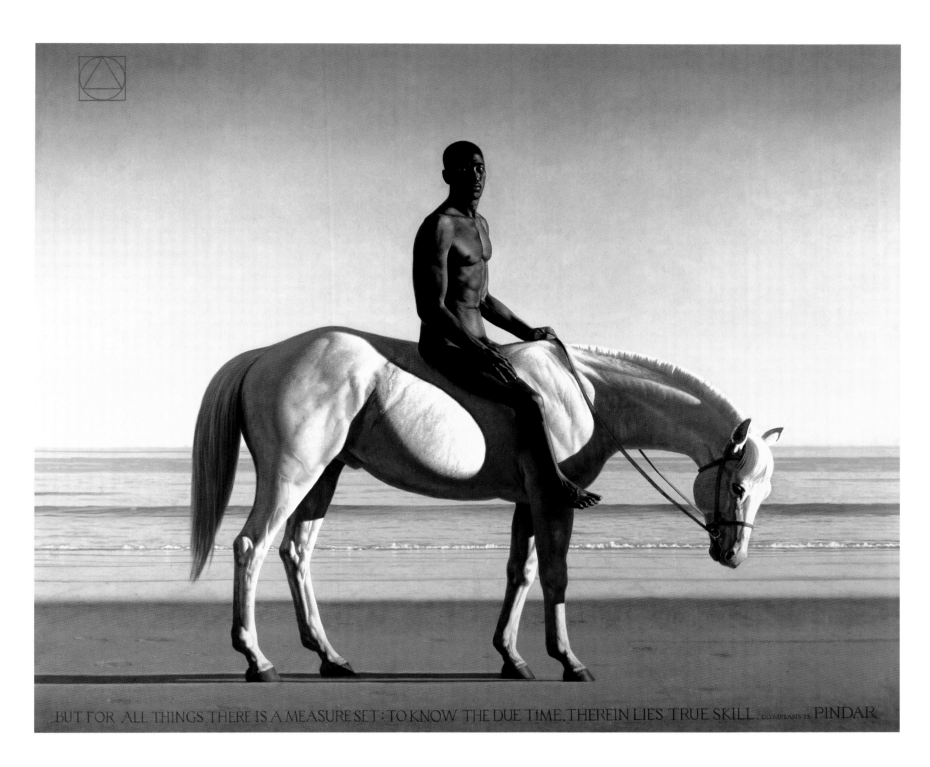

BUT FOR ALL THINGS THERE IS A MEASURE SET: TO KNOW THE DUE TIME, THEREIN LIES TRUE SKILL. OLYMPIANS 13 PINDAR

**Areta (Black Figure on
a White Horse)**
2000
Oil on canvas
244 x 295 cm

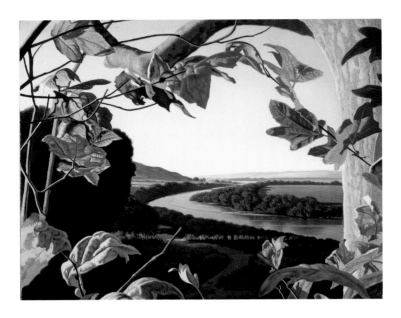

Landscape with Leaves
1999
Oil on canvas
41 x 51 cm

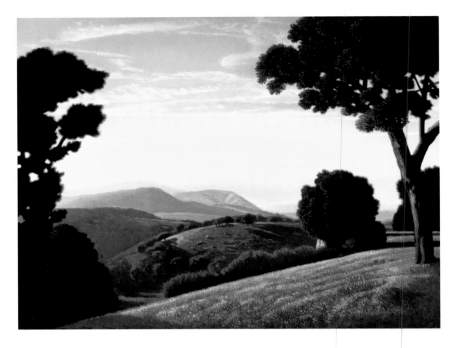

Corral de Tierra Landscape
1998
Oil on canvas
51 x 66 cm

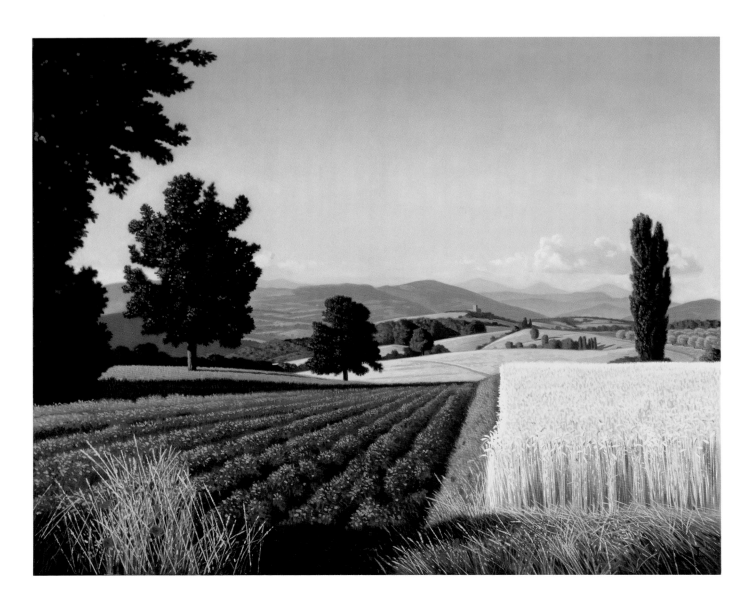

Georgic Landscape
2005
Oil on linen
66 x 81 cm

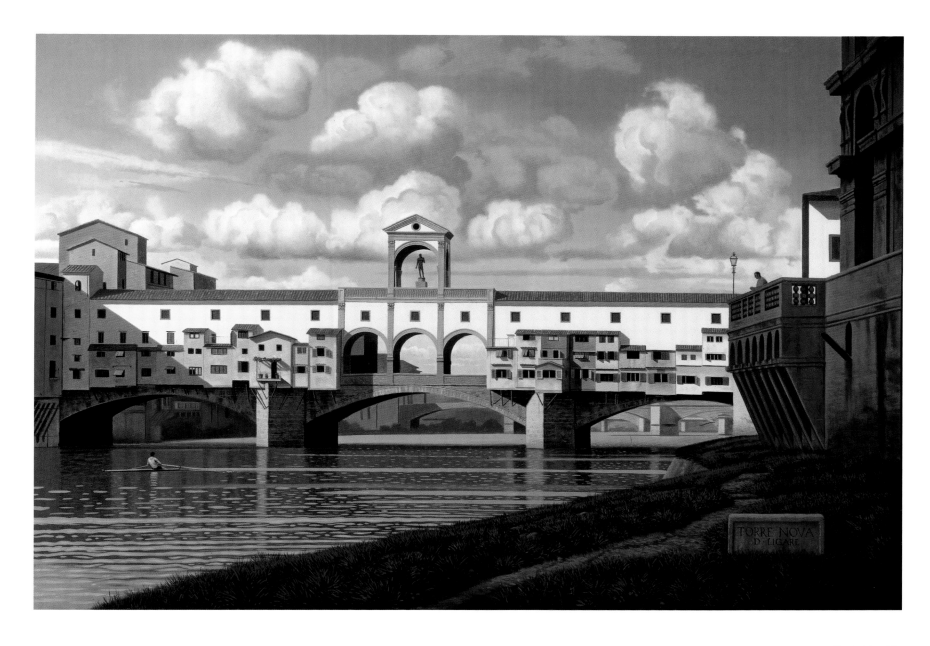

Ponte Vecchio
1996
Oil on canvas
101.5 x 147.5 cm

**Landscape for Baucis
and Philemon**
1984
Oil on canvas
81 x 122 cm

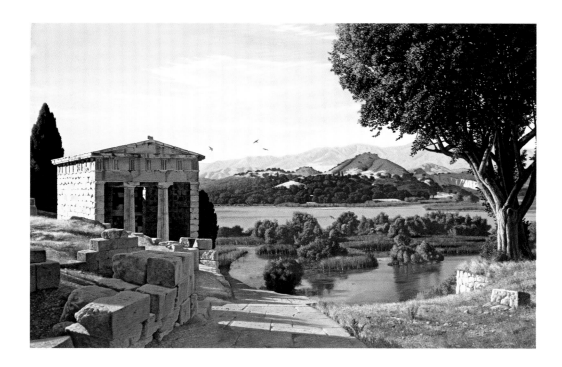

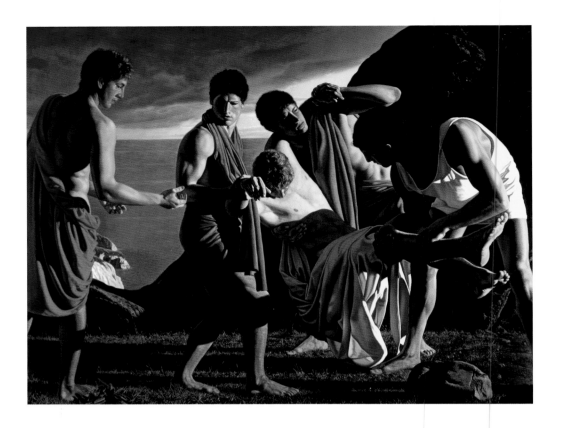

**Achilles and the Body
of Patroclus**
1986
Oil on canvas
152.5 x 198 cm

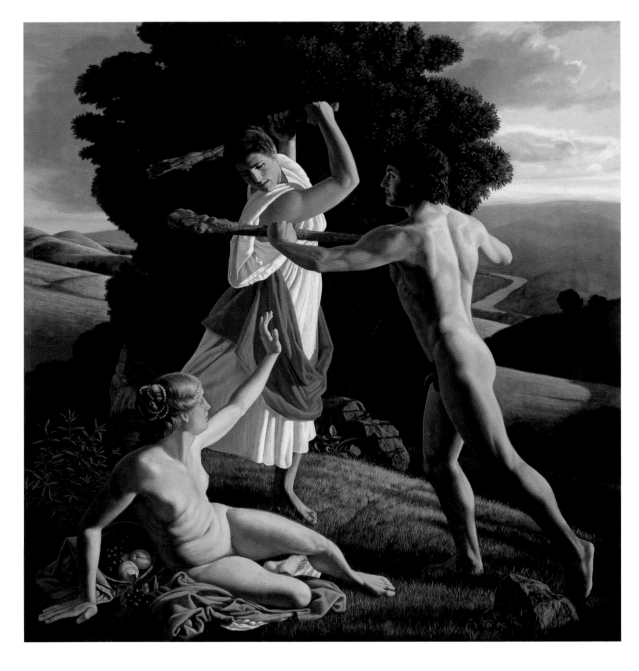

**Hercules Protecting the
Balance between Pleasure
and Virtue**
1993
Oil on canvas
152.5 x 142.5 cm

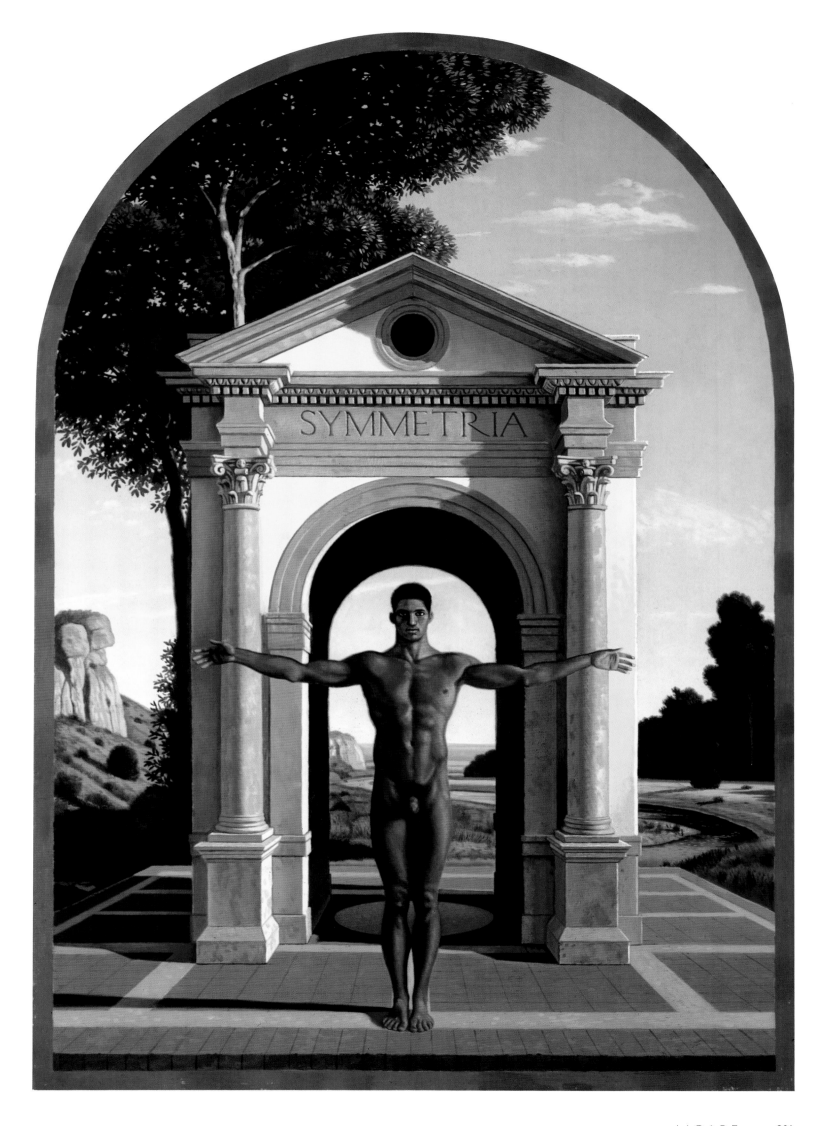

Symmetria
1997
Oil on panel
81 x 56 cm

Penelope
1980
Oil on canvas
102 x 122 cm

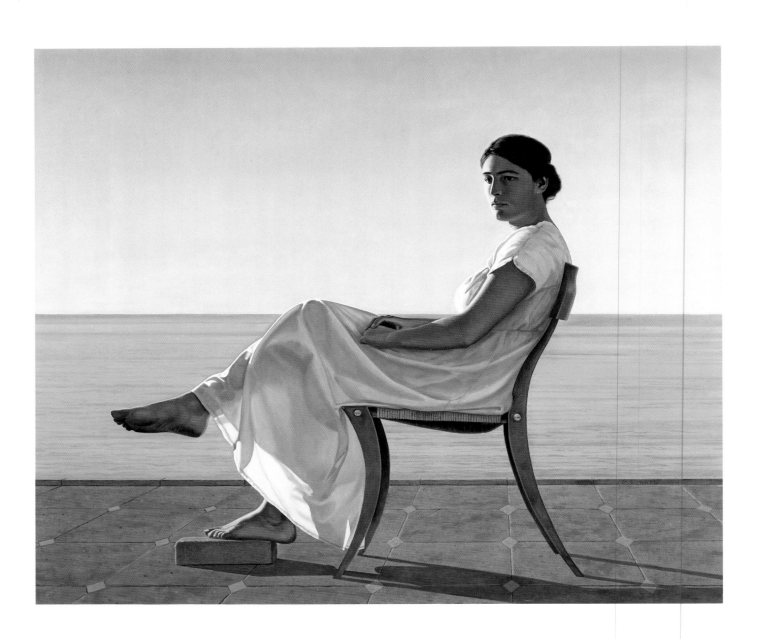

Landscape with Running Horse
1990
Oil on canvas
81 x 122 cm

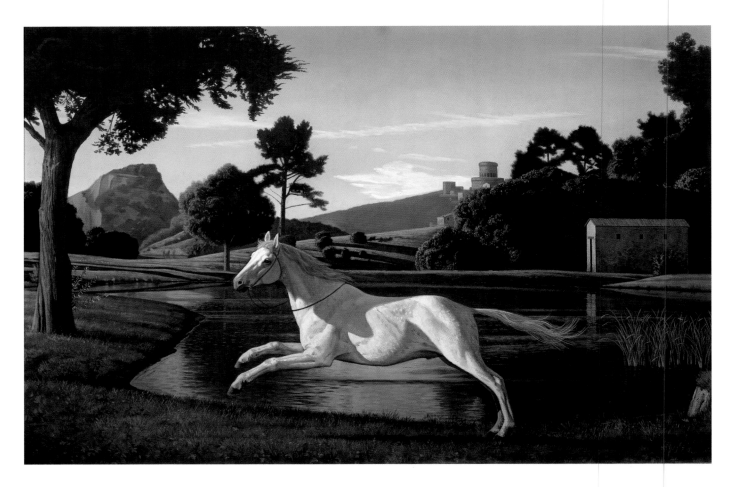

**Still Life with Torso
and Cactus**
2006
Oil on canvas
102 x 122 cm

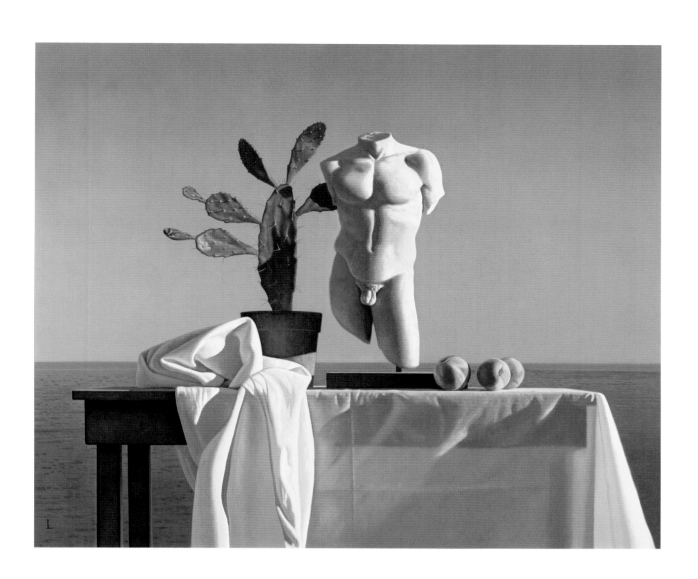

**Still Life with Peaches
and Grapes**
2006
Oil on canvas
102 x 122 cm

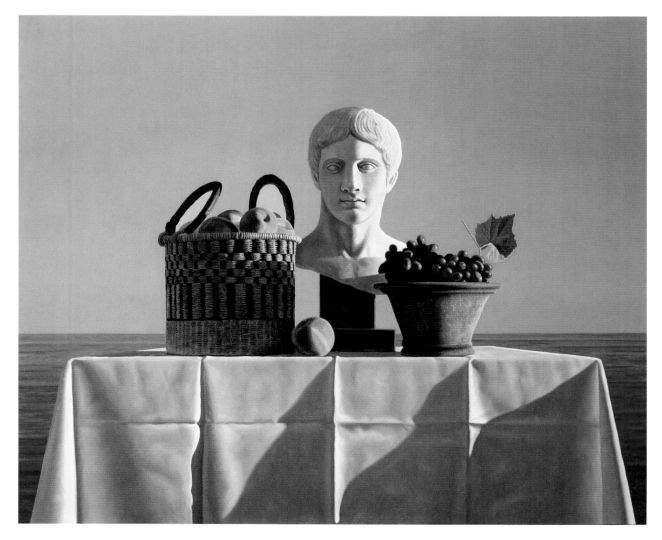

**Still Life with Lemons
and Honey**
1998
Oil on canvas
122 x 102 cm

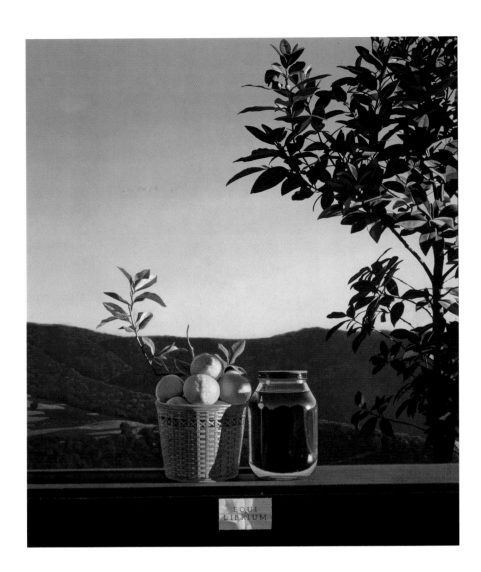

**Still Life with Peaches and
Water Jar (Aparchai)**
2005
Oil on canvas
51 x 61 cm

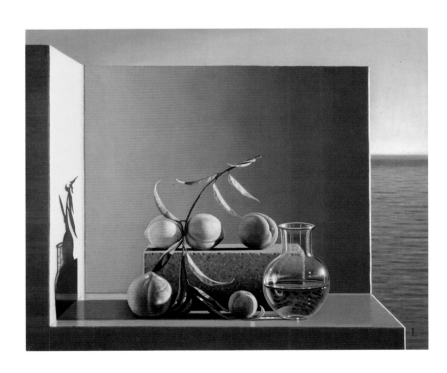

**Still Life with Grapes and
Apples (Aparchai)**
2005
Oil on canvas
51 x 61 cm

Still Life with Apples and Corn (Aparchai)
2006
Oil on canvas
51 x 61 cm

Still Life with Eggs and Cactus Pear (Aparchai)
2005
Oil on canvas
51 x 61 cm

**Still Life with Cherries and
Water (Aparchai)**
2005
Oil on canvas
51 x 61 cm

**Still Life with Fig and
Pear (Aparchai)**
2005
Oil on linen
51 x 61 cm

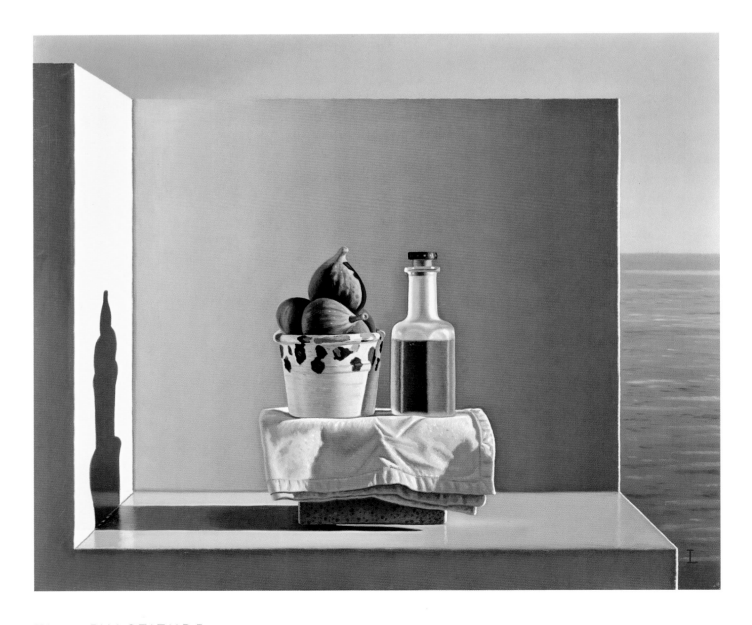

**Still Life with Figs and
Olive Oil (Aparchai)**
2005
Oil on canvas
51 x 61 cm

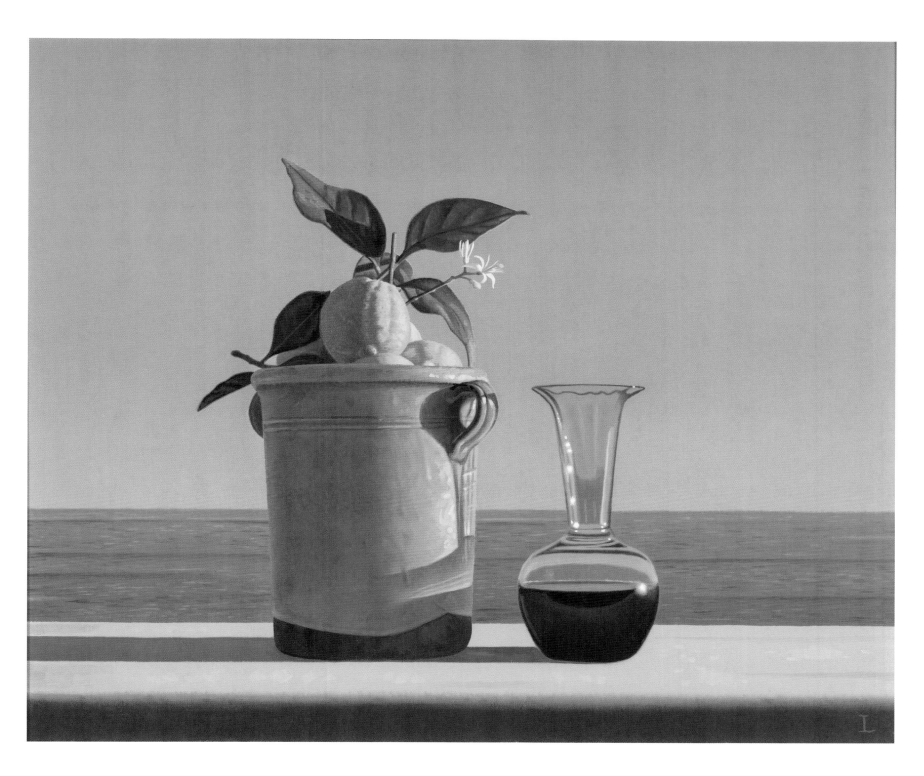

**Still Life with Lemon
and Wine**
2006
Oil on canvas
51 x 61 cm

CHRISTIAN MARSH

CHRISTIAN MARSH IS A YOUNG MAN from Wolverhampton who took his two degrees in illustration at Wolverhampton University and who still lives in Wolverhampton. So it is surprising to see that his paintings all seem to be of foreign parts, mostly American. Or is it? Despite the large number of British adherents to the idea and practice of hyperrealism in its various forms, somehow the natural, almost automatic association of the style(s) involved is still with America. Perhaps Marsh has simply succumbed to the zeitgeist.

But that is clearly to oversimplify. Obviously Marsh has travelled, and photographed the places that he has been to, especially the West Coast of America and Hawaii. Probably the romance Hawaii and California hold for most sun-starved Brits had a lot to do with his decision to travel there, but it is doubtful whether the glamour attached to American versions of Photorealism had anything much to do with it. Rather, the travel had its own raison d'être: the photographing of places visited is what all travellers do, and it was only after the fact that the photographs led to a remarkable outburst of painting.

Marsh himself remarks on the importance of photography in his painting. It enables him to freeze the moment as it flies, and then analyse what the photographs record and reveal at leisure. And clearly what he found in these images of a sunny Pacific was an amazing clarity and definition: 'The light was so pure, these places offered images that were flooded with detail of shadows and strong light reflections. The ever-changing intensity of light fascinated me, and advances in technology have allowed me to capture these striking moments.' Admirable though Wolverhampton may be, it seldom offers anything similar.

Marsh's artistic interests are not limited to bright sunlight; he also relishes night scenes and the effects of artificial light on otherwise dark streets. He notes that while he enjoys 'the challenge of the detailed architecture of urban life', he likes to mix solid architectural shapes with the curved and asymmetrical shapes of people and plants. The inclusion of human beings in a Photorealist composition has a purely technical advantage, in that it offers an important clarification of scale. But also, and it seems more importantly for Marsh, it brings in a narrative element.

Who are these people, and what are they doing here? It is the sort of question that few Photorealists seem particularly to want us to ask. Many Photorealist paintings eschew people altogether, or include them only as antlike, unpersonalised beings such as Harry Lime cheerfully wrote off from the height of the Viennese Ferris wheel. No Harry Lime he, Marsh emerges as one of the most human, humane of all the artists who embrace Exactitude.

View from Rialto Bridge,
Venice (detail)
2008
Oil on canvas
116 x 205 cm

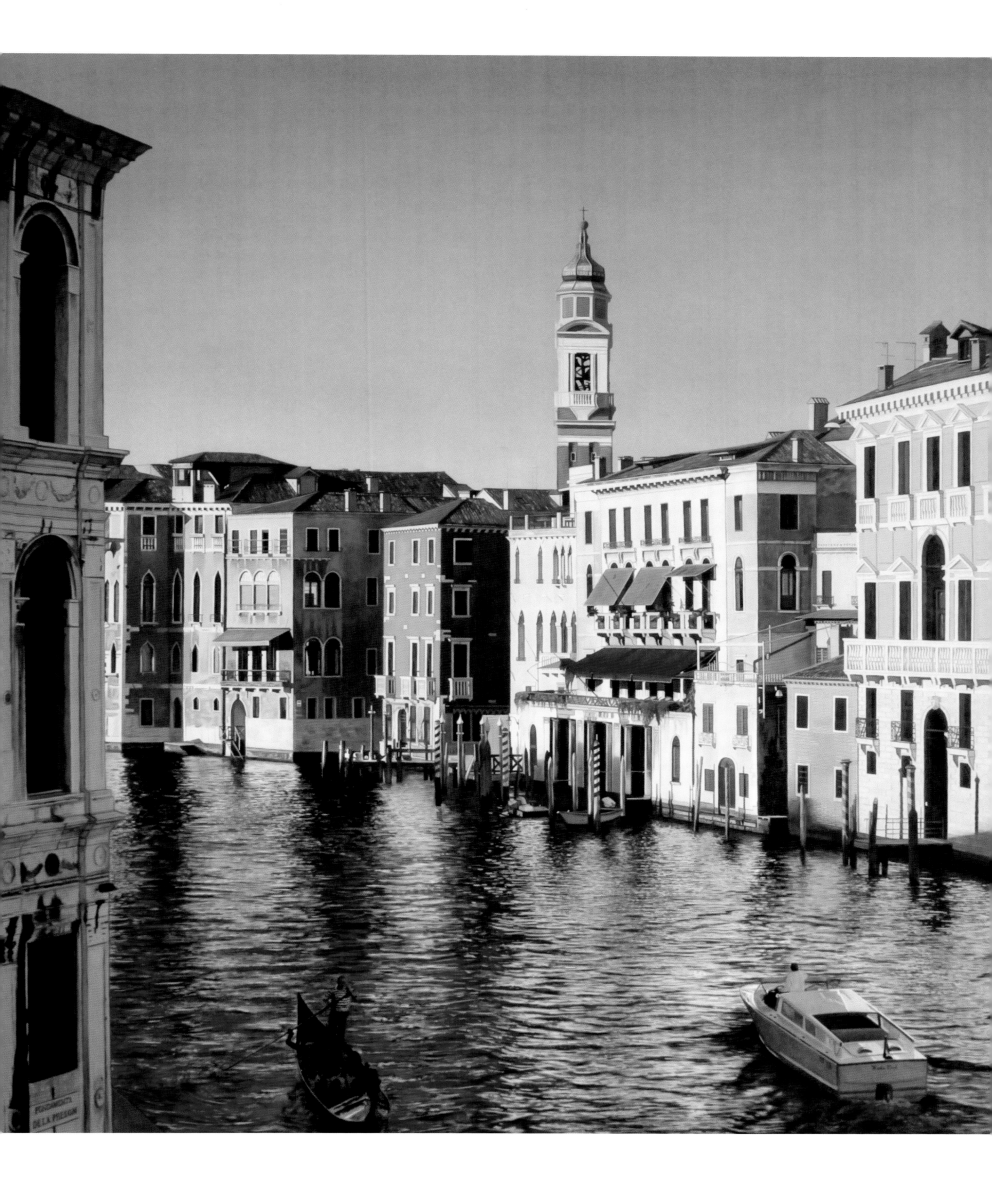

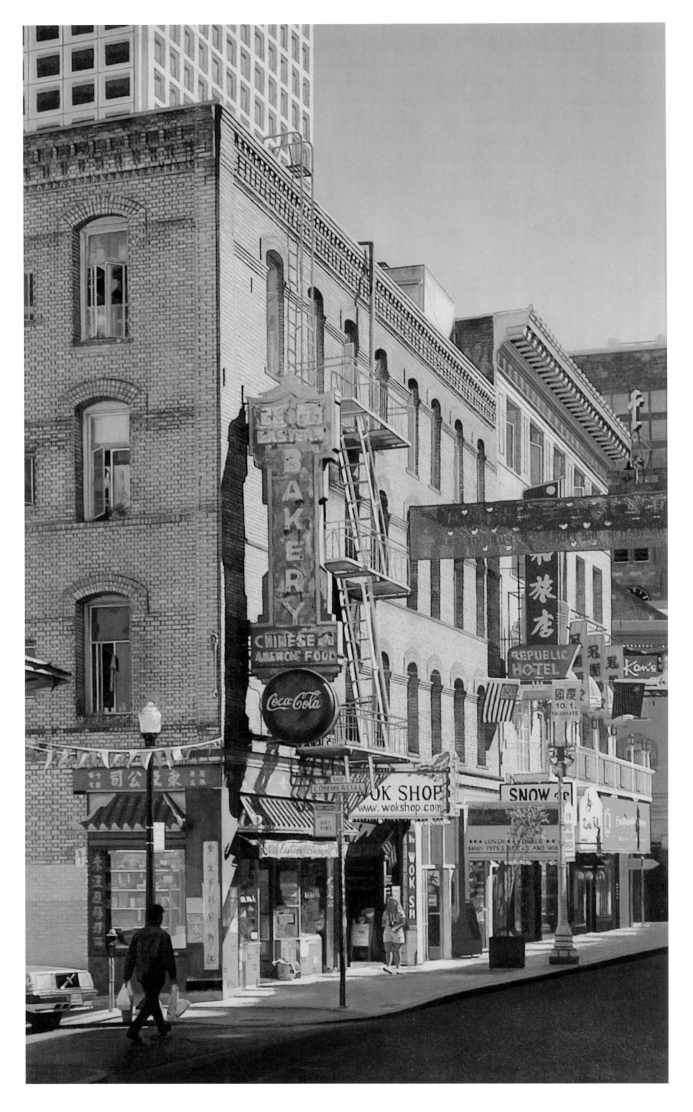

San Francisco, Chinatown
2005
Oil on canvas
66 x 39 cm

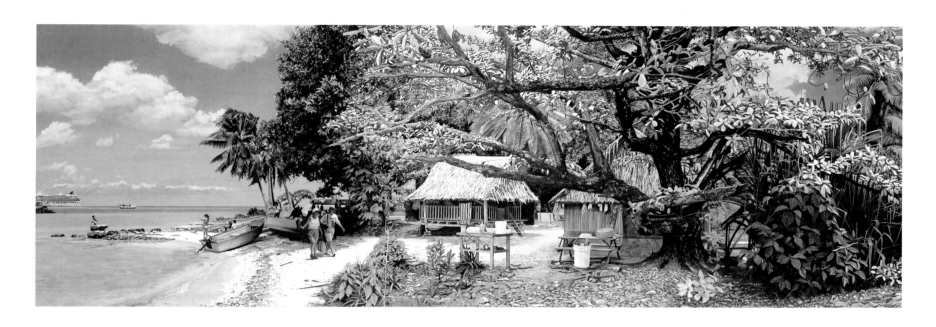

Fanning Island
2006
Oil on canvas
40 x 117 cm

Tree in the City
2006
Oil on canvas
38 x 73 cm

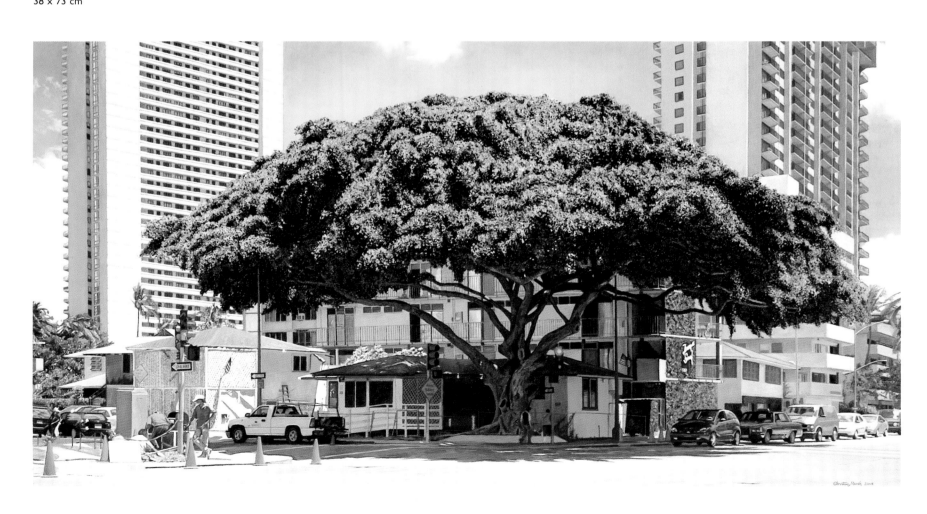

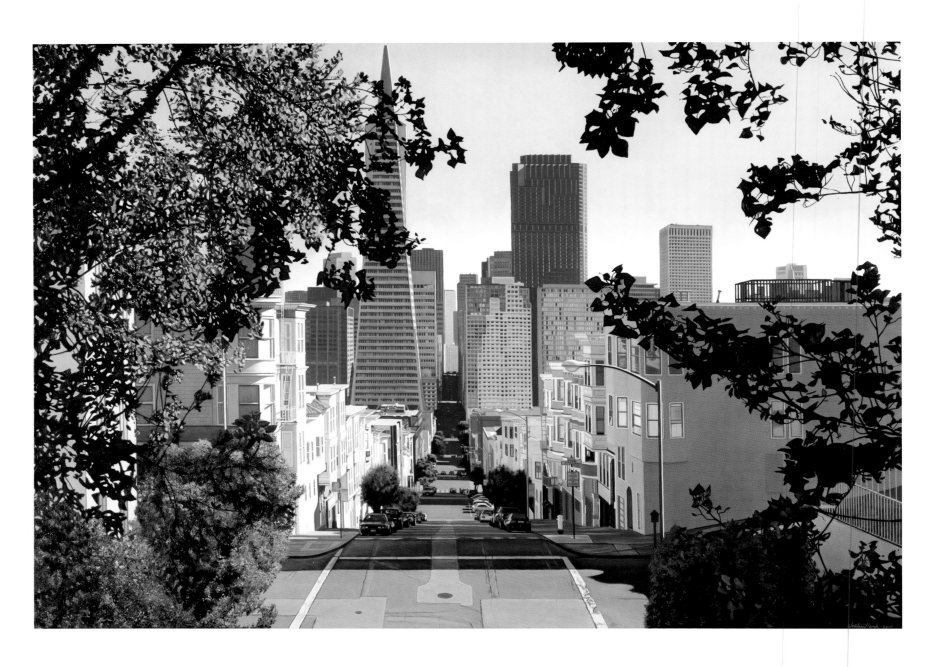

Transamerica Pyramid,
San Francisco
2007
Oil on canvas
82 x 115 cm

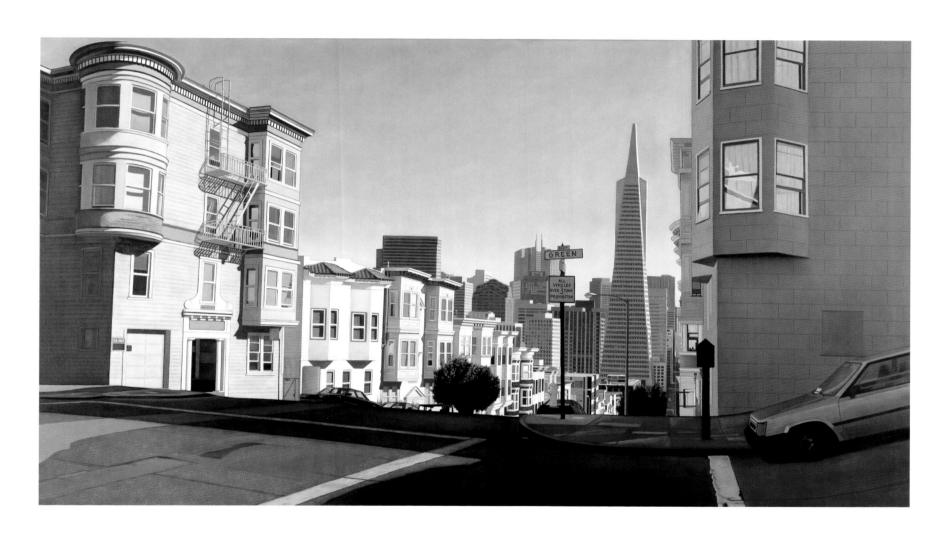

San Francisco
2007
Oil on canvas
95 × 170 cm

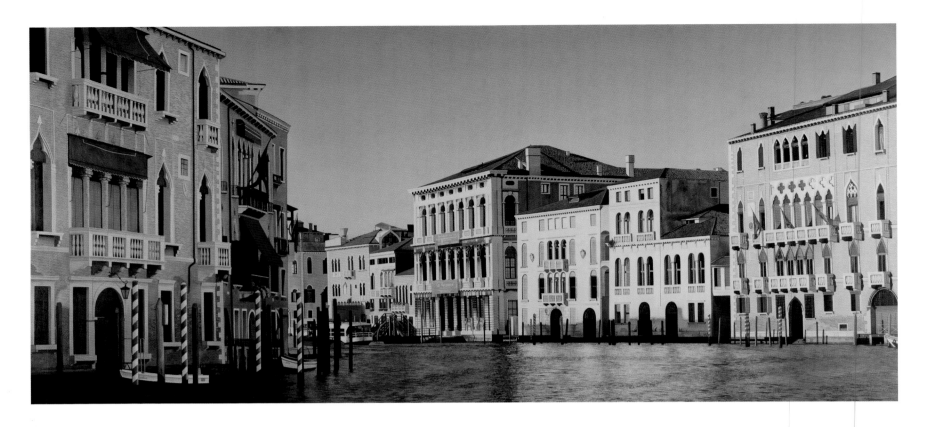

Ca' Rezzonico
2008
Oil on canvas
98 x 220 cm

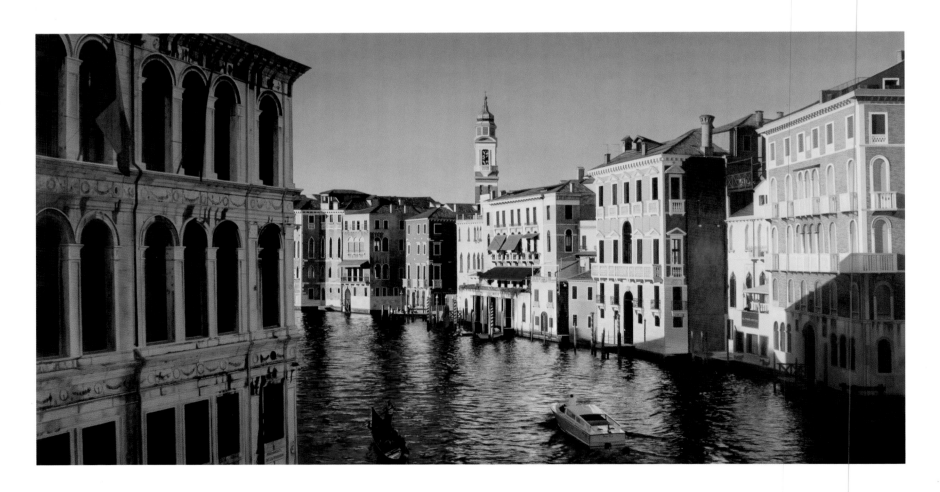

<div align="right">

**View from Rialto
Bridge, Venice**
2008
Oil on canvas
116 x 205 cm

</div>

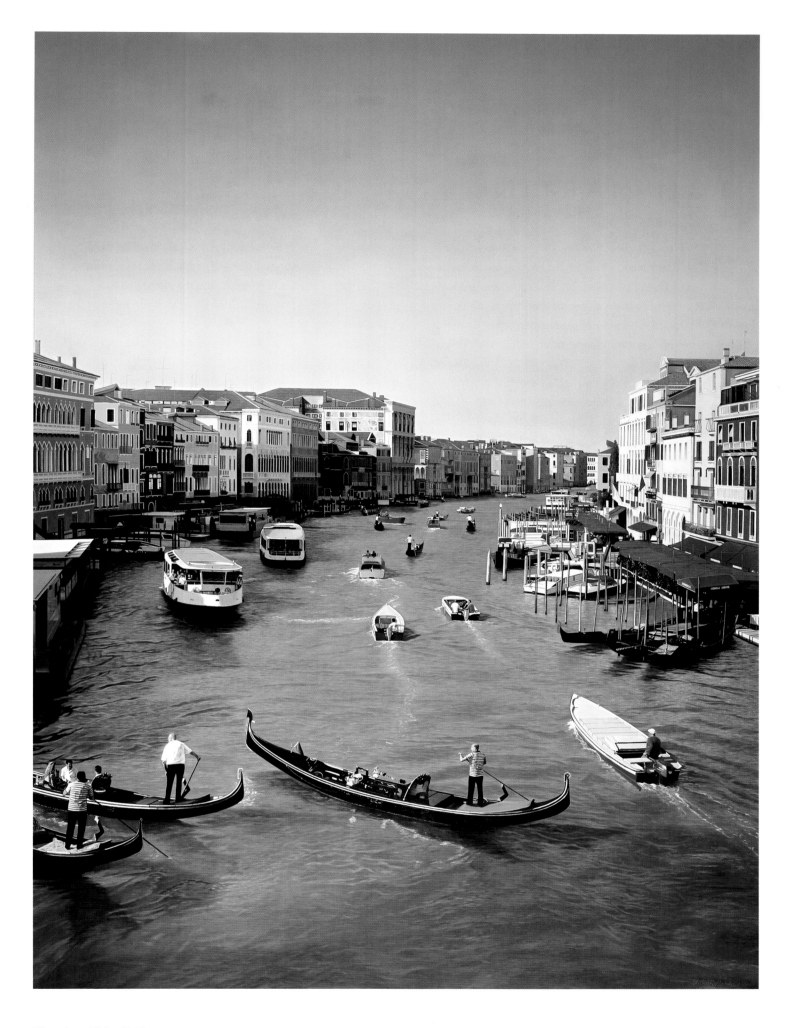

View from Rialto Bridge,
Venice
2008
Oil on canvas
190 x 140 cm

TOM MARTIN

Tom Martin is unique among adherents to Exactitude in his choice of subject matter and his approach to rendering it in paint. He makes no bones about being photographic in his approach, and depending on photographs for his raw material. But in practice his work is hyper-photographic, to coin a phrase: it carries photographic representation further than a mere camera could ever do.

What he paints, up to now exclusively, is details of everyday metal objects, shown in such intimate close-up that they are more likely than not to be unrecognisable. The general effect is unmistakably photographic in all the most generally accepted senses of the term: the frequent shiny surfaces are meticulously rendered, the colours and textures of anything unshiny clearly being the subject of Martin's closest attention. So, it might be supposed that these are simply reproductions in paint of vastly blown-up photographs.

But a moment's consideration tells us that this cannot be so. For one thing, many of the images are panoramic, giving the impression that we are seeing not only what is immediately in camera range, but also round corners and exploring depths which would be beyond the capabilities of any one camera to reach. Martin makes clear that his paintings are devised with the aid of many photographs, welded together and reimagined with considerable technical virtuosity and a constructive mastery of perspective remarkable in one so young. (Martin was born in 1986, and trained in art schools and university art departments in Rotherham and Huddersfield.)

As Martin explains it:

My aim primarily is to create an impossible existence, a hyper-reality itself. It is by emphasising a shallow depth of field and

panoramic view of the subject that I achieve this. I use these devices to bring forward elements of the composition, whilst pushing other areas back deeper into the painting. Using a panoramic view provides not only information about the object when looked at head on, but also about how the eye reacts when an object passes by us. I want the subject to appear to project further than the plane of the canvas, to have a presence, putting the viewer somewhere in the physical experience of the painting.

Consequently, surprisingly, this approach brings Martin closer to early Pre-Raphaelite practice than any other of the Exactitude group. Though his subject matter – the high-tech machine – could hardly be more remote in feeling from the leaves and flowers that preoccupied the Pre-Raphaelite painters, the ultimate hallucinatory effect of seeing more than the human eye – or now, than any camera lens – could ever see at one go is exactly the same.

It is not clear whether Martin is aware of this historical parallel. At the time of his first London exhibition he insisted that he made a point of visiting London at least once a month 'to see different shows and get different inspiration', but one gets the impression that he is essentially a loner, developing his own style and vision completely independently of London fashions, and that his alliance with Exactitude makes perfect sense for the movement, but is unlikely to compromise his rooted independence in any way.

GDA (detail)
2007
Acrylic on canvas
84 x 76 cm

D Ring
2008
Acrylic on canvas
63.5 x 152.5 cm

Déjà Vu
2008
Acrylic on board
68.5 x 114.5 cm

Clips
2008
Acrylic on canvas
95.5 x 114.5 cm

Barbell
2007
Acrylic on canvas
72 x 96 cm

Skull Crushers
2007
Acrylic on canvas
90 x 60 cm

Three Glasses
2008
Acrylic on canvas
152.5 x 114.5 cm

Typical Composition
2008
Acrylic on canvas
91.5 x 152.5 cm

GDA
2007
Acrylic on canvas
84 x 76 cm

Healthy Digestion
2008
Acrylic on board
80 x 80 cm

NON-GM
2008
Acrylic on board
100 x 100 cm

Wholewheat
2008
Acrylic on board
100 x 100 cm

JACK MENDENHALL

JACK MENDENHALL IS AS AMERICAN in his attitudes and background as Randy Dudley, but this allows him to be as different from Dudley as industrial Illinois is from laidback southern California. He did, admittedly, study further north than his Ventura birthplace, at the California College of Arts and Crafts in Oakland. While to Angelenos that sounds something like the Arctic, the Bay Area round San Francisco is sophisticated, dangerously relaxed California, not trend-obsessed, celebrity-focused California.

To most of us all this seems more than exotic enough as a source of subject matter, but clearly it is not sufficiently so for Mendenhall. He freely admitted in the later Nineties:

> In the last few years my interest has turned to painting the allure in an exotic environment. I have travelled to the Caribbean and areas in the Pacific Rim searching for seductive light, lush colour and gleam; all elements important to my painting style.

Benighted Brits might well wonder at Mendenhall's scale of exoticism, if feeling no qualms about the directions in which it carries him, despite the fact that Peoria would surely be more exotic to Mendenhall than Pogo Pogo. But then, to be sure, ex-industrial anywhere would hardy offer seductive light and lush colour, though Dudley might argue that it features more-than-sufficient gleam.

In any case, Mendenhall is quite right about what unmistakably turns him on as a painter. We may remember that John Salt began to express his passion for American motors by copying highly glamorous advertisements for Buick motors, and only later, as those up-to-the-minute images began themselves to retreat into history, started to see them through the veils of memory. Mendenhall, once

he had graduated, also began by copying glamorous images of domestic interiors and just exteriors from magazines such as *Architectural Digest* and *House Beautiful*. In this, in the early Seventies, he was allying himself with a group of San Francisco artists who gloried in their determination (and, let us not forget, ability) to copy in the most minute detail photographs such as these.

Mendenhall, at least, has not changed materially in the last thirty years. The main difference is that nowadays he takes his photographs for himself. Wherever taken, the photographs concentrate on the luxurious (or anyway luxuriant) and the glamorous. And therefore, so do Mendenhall's paintings. Convention would tell us that in consequence he cannot be accounted a social realist. But who decides that a tanned bikini-wearer by a sunny Californian pool is any less real or a part of society than, say, a disgruntled unemployed steelworker in Peoria?

Some have said that Mendenhall's painting embodies an ironic comment on society. I am not so sure. Mendenhall does not seem to claim any social intent for his work, though he agrees that the leisure activities depicted in so many of these poolside scenes do in their own way make leisure itself an issue. But he also admits to the enchantments of *luxe*, *calme* et *volupté*. Though labelling himself a Realist painter, he sees that

> ... at the heart of all this is the temptation to visual alchemy. When I paint water, sky, trees, chairs, etc., I must imagine touching them, convincing myself, as it were, that I am creating these things in the very real sense. The magic occurs when I believe that I have done this.

Phoenician Island (detail)
1999–2000
Oil on canvas
119.5 x 162.5 cm

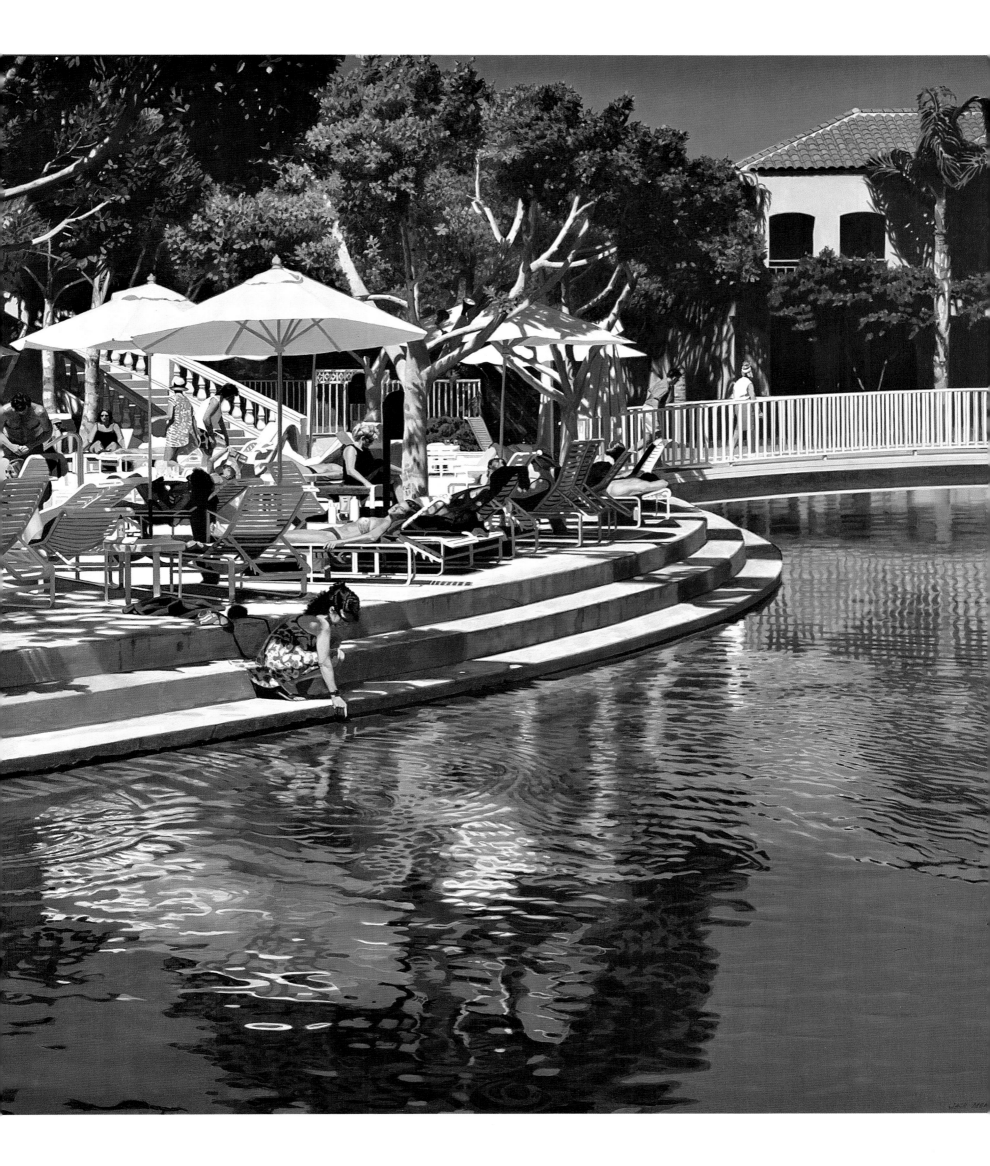

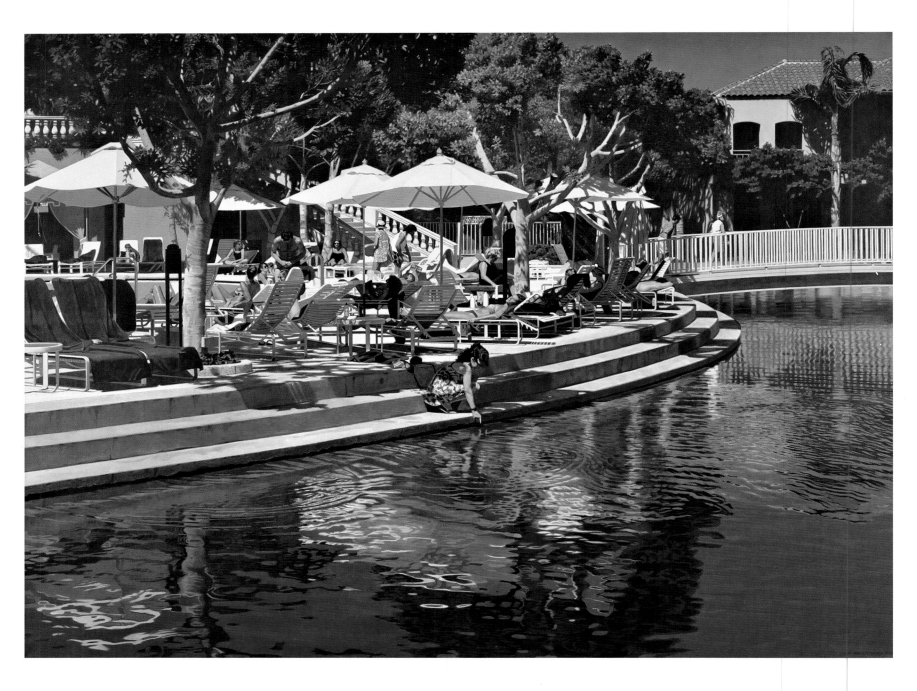

Phoenician Island
1999–2000
Oil on canvas
119.5 × 162.5 cm

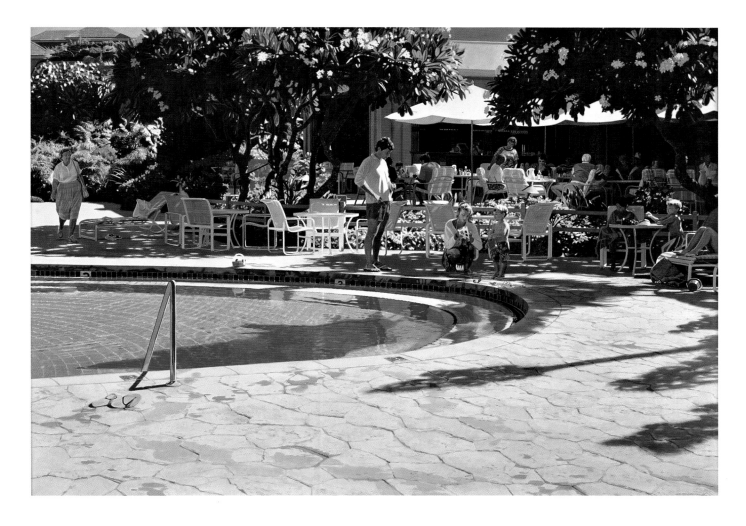

Pointe Hilton II
1996
Oil on linen
124.5 x 185.5 cm

Blue Pool at Kapalua
2001
Oil on linen
121.9 x 172.9 cm

Woman in Red Suit
1981
Oil on canvas
55 x 81 cm

Bellagio II
2007
Oil on linen
82 x 139.7 cm

Blue Umbrellas II
2007
Oil on linen
94 × 140 cm

Miami Beach
1993
Oil on linen
117.5 × 173.5 cm

Blue Umbrellas
2005
Oil on linen
71 x 105.5 cm

Pointe Hilton IV
1997
Oil on canvas
130 x 192 cm

**Yellow Tulips and
Dinner Setting**
1981
Oil on canvas
129.5 x 150 cm

Dining Room with Arbor
1983
Oil on canvas
129.5 x 155 cm

Interior with Heartlight
1987
Oil on canvas
147.5 x 184 cm

Interior with Zebra Rug
1973
Watercolour on paper
15 x 20 cm

White Breakfast Room
1978
Oil on canvas
159 x 165 cm

Kim on the Deck
1989
Oil on linen
132 x 189 cm

Yellow Sofa with Swan Vase
1972
Oil on canvas
213.5 x 188 cm

ROBERT NEFFSON

ROBERT NEFFSON IS PROBABLY BEST KNOWN in Britain as the other end of a fascinating published transatlantic dialogue with Clive Head about the ways, means and attitudes of Photorealism. In America, however, he is a well-known artist, exhibiting regularly with his New York gallery, Hammer Galleries (seven shows since 1998) and accepted now as one of the classic exponents of Photorealism.

From his obviously close rapport with Head and the clarity with which they discuss technical and even philosophical matters, it would seem reasonable to assume that their art might be very similar. Surprisingly, this turns out not to be the case: comparison between Neffson and Head clearly demonstrates that Photorealism is merely a technique, or even a nebula of related techniques, which can be used in a diversity of different ways, rather than a straitjacket which ensures that all those subscribing to the technique will turn out indistinguishable.

While Head is clearly a classicist, a depicter of a cool world where geometry is more important than mere human interest, Neffson emerges very much as a romantic humanist. His compositions are much more informal, suggesting a series of urban snapshots rather than sober topographical documentation. Human figures certainly play a more prominent part in the majority of Neffson's pictures, and usually appear to be having fun, while Head's people, if they are there at all, as a rule impress us chiefly with their structural function in the overall pattern of Head's creation.

Neffson seems to be aware of this; indeed, he seems to be aware of everything. How many artists do we know who, after listing academic experiences that include endless life drawing at the New York Art Students League, copying Old Masters at the Metropolitan Museum of Art, being let loose in the Rembrandt print collection of the Boston Museum of Fine Arts and spending a Fulbright year in Rome making himself at home with 'the sweep of world culture', can conclude with equanimity: 'When developing my own style, I tried to back it up by a rounded art historical and philosophical world view, formed though my omnivorous reading in all subjects.'?

It all sounds very conscious indeed, a style arrived at by ratiocination rather than instinct. So by rights Neffson should be a soul-brother of Head. And yet, his work manages to look and feel spontaneous, an instant reaction, as often as not, to the bounding joie de vivre in what he sees, or at least in what he chooses to photograph. Even the spontaneity appears to be the result of a conscious decision: 'I see my current project as trying to let the subject matter determine the aesthetic of each work, and I feel the individual painting should vary with the needs of the specific motif.'

One thing seems to be clear: Neffson is very far from the kind of Photorealist who just takes a photograph, then reproduces it slavishly in paint. He explains himself thus:

> The work is based on long hours of sketching, observing and photographing at the site. I take multiple photographs at various times of day and from numerous vanishing points. I study the motif in different weathers and seasons. All of this is to know the object intuitively, deconstruct it and have it remade. Merely copying one photo would never allow me to accomplish this. The paintings are made entirely by hand with no mechanical transfers.

Clearly Neffson is after all a classicist, and could almost certainly do everything he does without any photographic input whatever. But he doesn't. That is surely the point. Photorealists come to their art from many directions, and use photography in many different ways. And yet, in all their works, it is exactitude that finally rules.

Columbus Circle, Summer
(detail)
2006
Oil on linen
101.6 x 198.1 cm

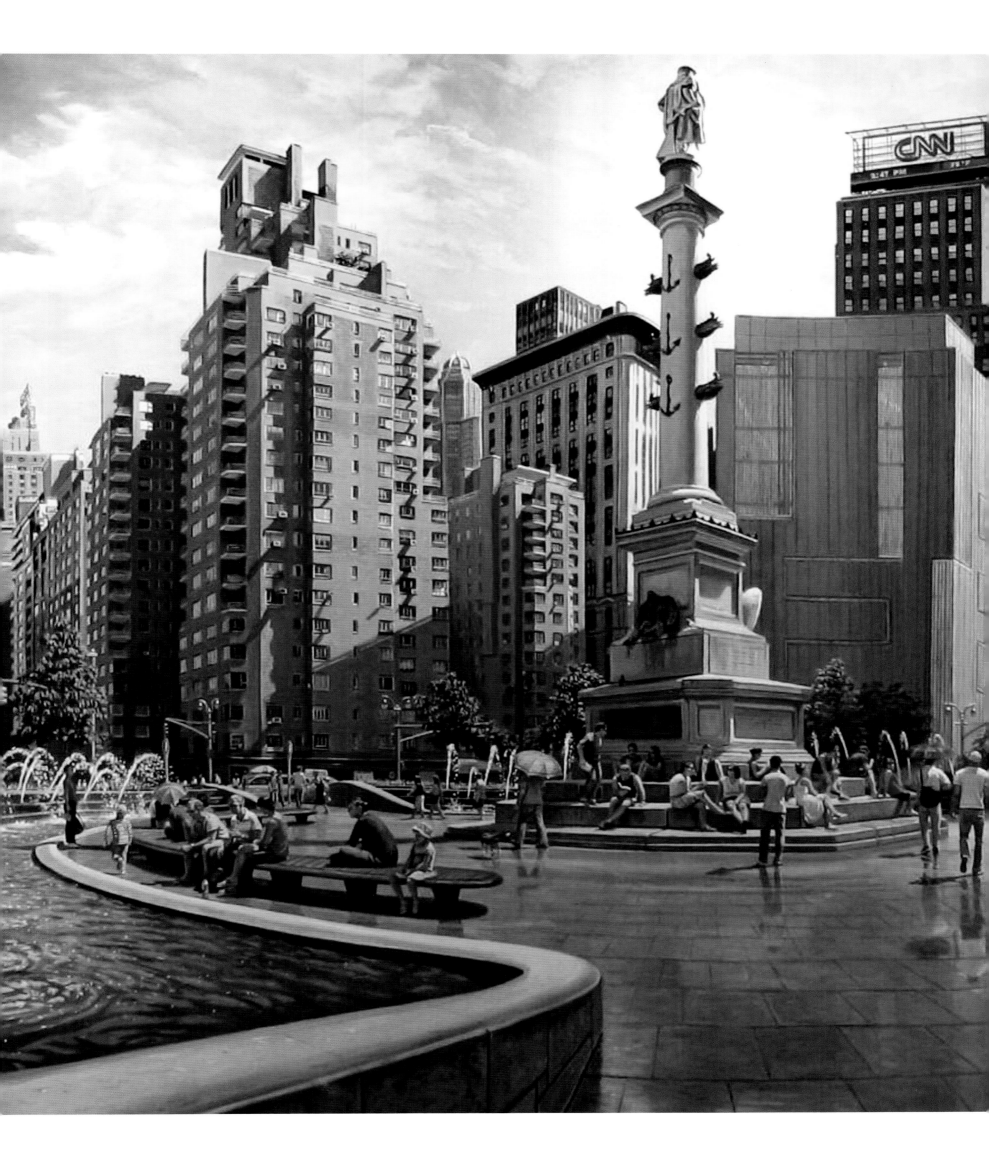

Broadway and Canal
1999–2005
Oil on linen
114 x 129.5 cm

55th and 5th Avenue
2002
Oil on canvas
43 x 71 cm

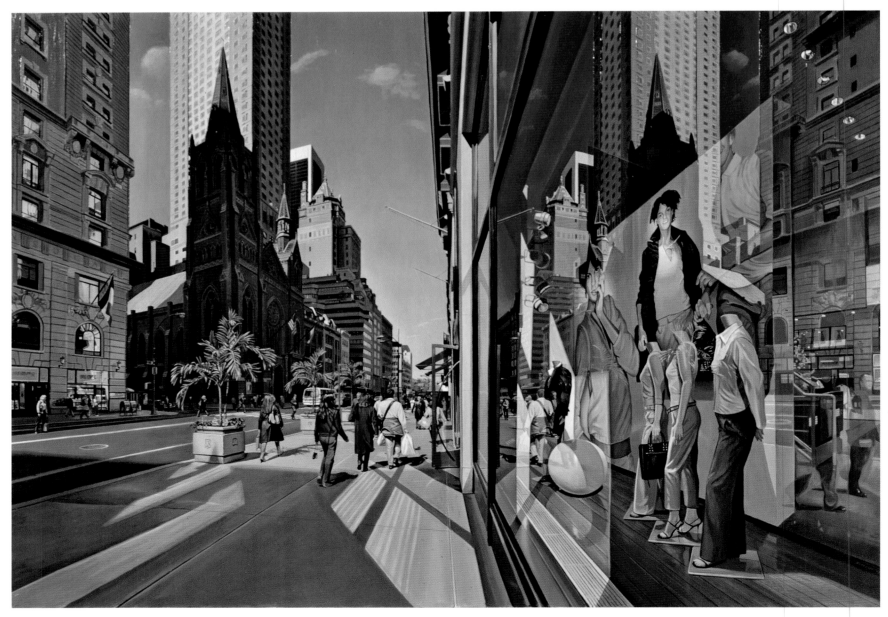

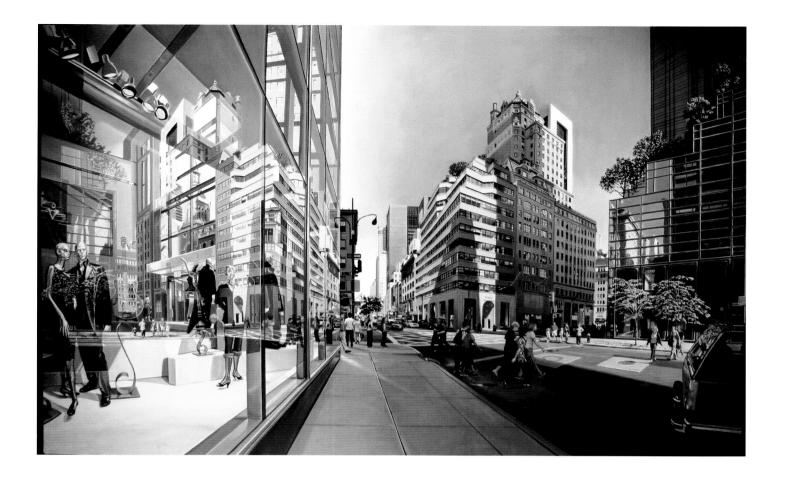

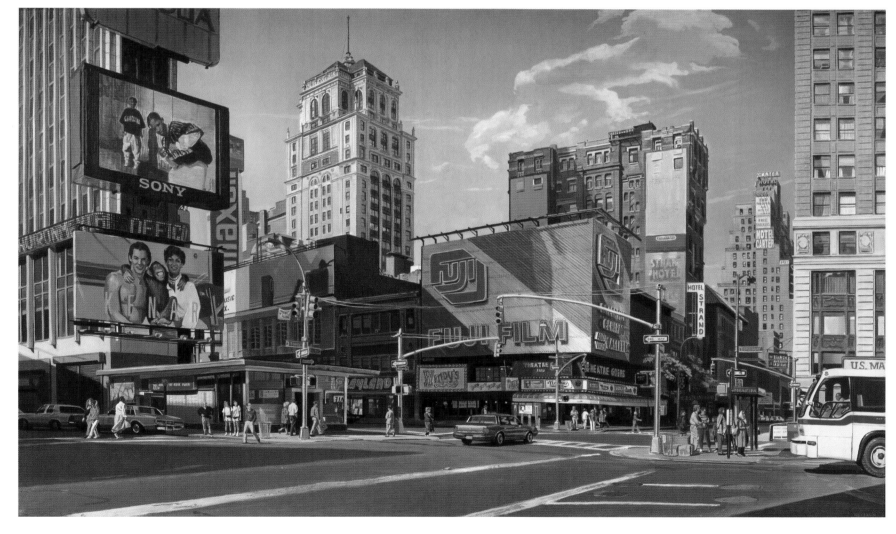

Broadway and 43rd Street
1990
Oil on linen
43 x 71 cm

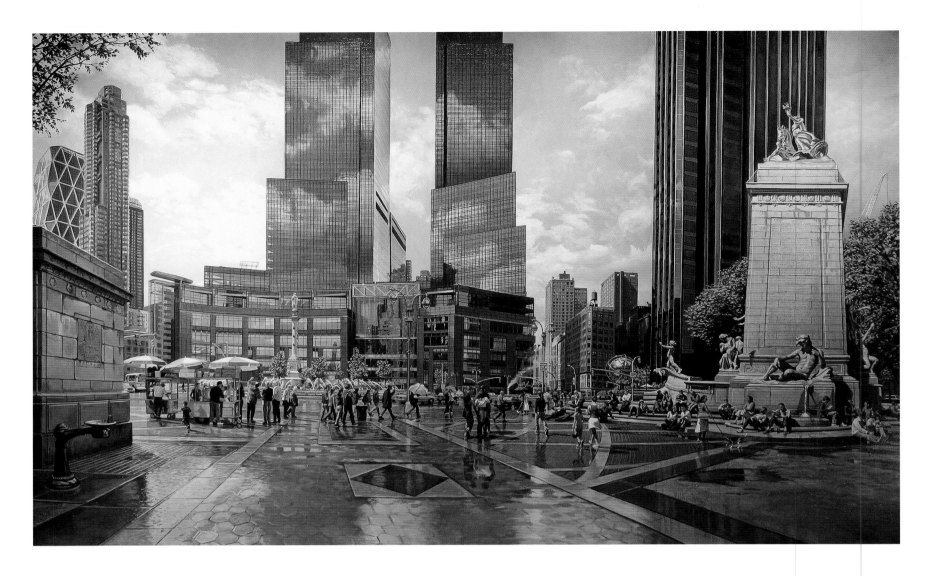

Columbus Circle, Spring
2005
Oil on linen
101.6 x 198 cm

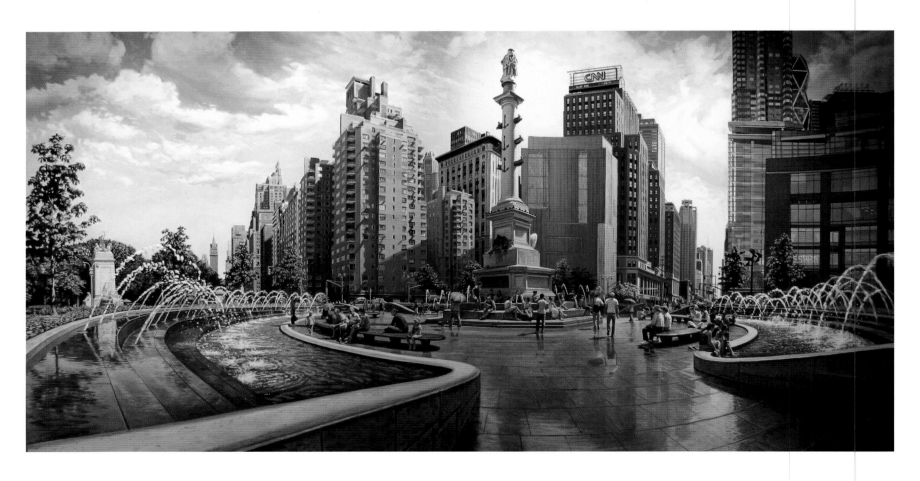

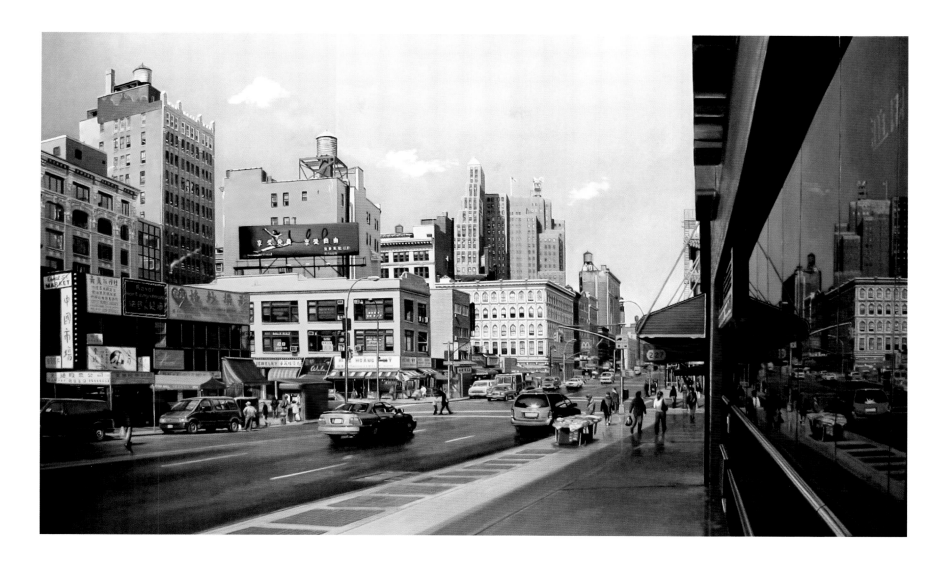

Chinatown
1995–2005
Oil on linen
89 x 147 cm

57th Street Galleries
2007
Oil on linen
106.7 x 137 cm

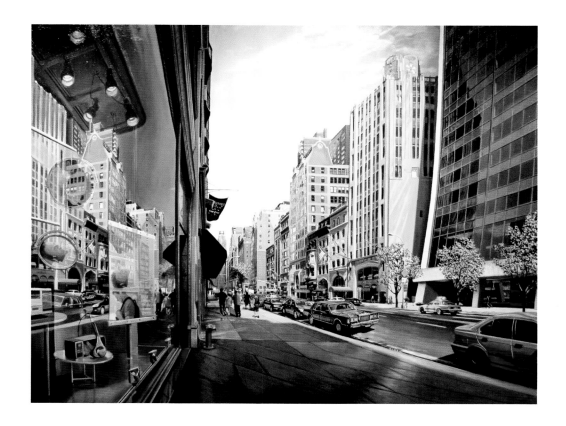

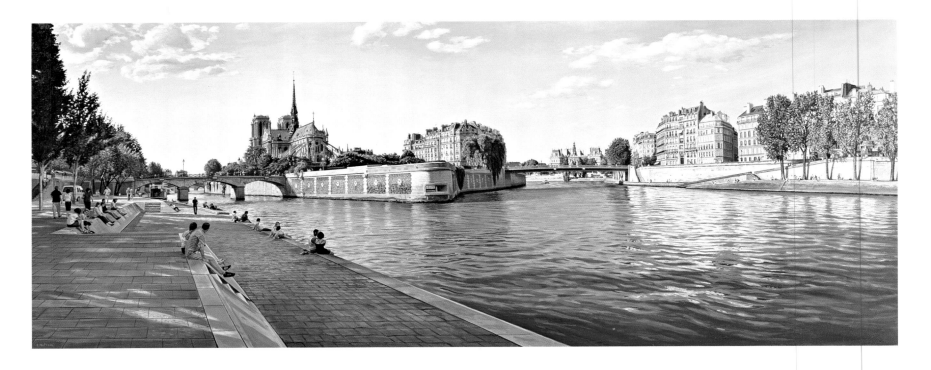

Paris, Seine
2006
Oil on linen
71 x 183 cm

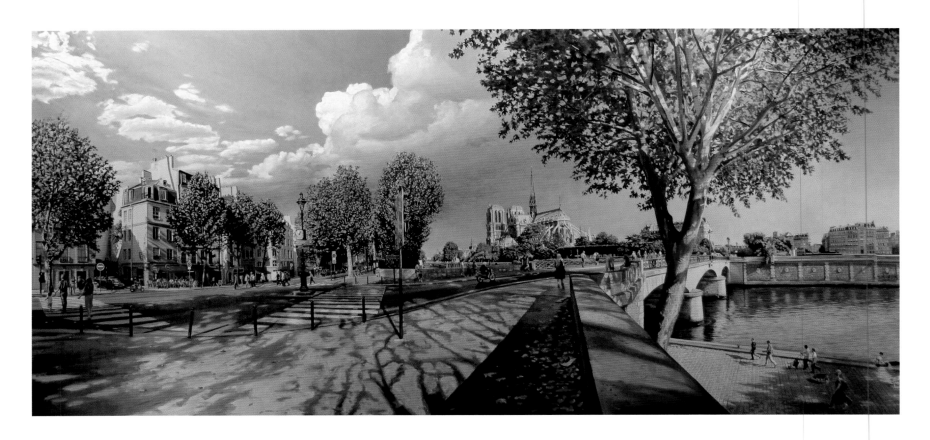

Rome, Spanish Steps
2004
Oil on linen
101.5 x 183 cm

CYNTHIA POOLE

CYNTHIA POOLE, like Carl Laubin and Francisco Rangel, began her professional life as an architect. She was born in Zimbabwe, where there was no prospect of earning a living as an artist, so she enrolled in the architecture course at the University of the Witwatersrand in Johannesburg.

After three years there, 'learning about the Gothic cathedrals of Europe and the great Victorian engineering structures of Brunel without ever seeing any of them', Poole headed for London, which seemed to her then, and still does now, like the centre of the world. She immediately got a job, mainly because of her drawing skills, she says, as architectural and landscape assistant with a large commercial practice. Meanwhile, she took a variety of art-related evening courses, and eventually completed her architectural studies at the University of Westminster, from which she emerged a registered architect.

It still took several years before Poole could return to her first love, painting. That was in 2000, and even then it was in her spare time. In the meantime she had become very skilled with graphic computer programmes, working for Richard Rogers in his computer section, mainly on conceptualising projects in terms of 3D models, and then freelancing in the same field for Norman Foster and Nicholas Grimshaw, among others.

While studying for the architectural diploma, she had become interested in the work and writings of Le Corbusier, and subsequently carried out a great deal of research centred on his 1928 book *Une Maison – Un Palais*. What caught her attention was the way he organised the façades of his early 'Purist' houses: an architecture of geometric relationships and fundamental solids (the cube, the cone, the sphere, the cylinder…), and how this approach to composition in architecture related to the way he organised his paintings. (Le Corbusier, she says, is much underrated as a painter of still life, and the little-known painting movement he founded with Amédée Ozenfant, 'Purism', at around the time of Cubism, repays study). The Purists were interested in *objets types* – objects stripped of extraneous frills, and capable in their pure geometries of standing in for all the objects of their kind, and in *méchanisme*. Given her architectural background, her familiarity with computer graphics and realistic architectural renderings, and her own environment of everyday London, Poole began to see how she might compose something with resonance, in paint on canvas.

In the return to painting, which by 2004 had become an all-consuming passion, Poole diverged sharply from the experience of Laubin and Rangel. While architecture remained central to their work as painters, for her the focus shifted to a very different genre: what she calls 'contemporary still life'. In this she approaches most closely the work of Cesar Santander, partly at least no doubt because she, like him, seems to be especially drawn to sweets and junk foods. She explains:

> I am mainly interested in the forms, surfaces and signage of everyday things in their normal context. I prefer objects which are plain and functional, their forms not obscured by decoration: 'type objects', in fact…. And where the subject is a food product – a tin of beans, a bottle of vinegar – I want it to be a mass-market, consumer item. I want the labels to be familiar, contemporary and, to a point, iconic…. Labels must not be too self-conscious, or too archaic, or too decorative. And some are too iconic…. The pictures I am trying to construct include objects which might or might not mean anything, arranged in a way that might or might not be significant.

> Many of the pictures are of chocolate bars and crisp packets, either in newsagents' displays or in vending machines. I like their vivid colour and strident competitiveness. Objects of this kind are normally only perceived as signage; their actual visual qualities, particularly in combination, are mostly unnoticed – yet they make up much of the visual fabric of contemporary life. And their unacknowledged beauty, and their 'evolutionary' success in the retail jungle, adds a carnival aspect to the quotidian world of the corner shop.

Poole's interest in packaging includes a fascination with stripes. In the *Danish Laundry* series, the blue and white stripes of the carelessly wrapped paper parcels describe the volumes of the packages with much more animation than any plain covering, and yet a certain austerity is retained. This theme has been expanded on recently: the painting *A View of St Mark's Square* (2007) is a close crop of the merchandise displayed on a t-shirt vendor's stall in Venice, where there is just enough detail to see what the items are. Again, these are everyday items in an urban context – this is what most travellers will take home, while their memories of La Serenissima fade away. Poole was pleased to paint the gondoliers' t-shirts rather than the grand canal, and happy to achieve something that looks at first glance rather like an Op Art painting, but is simultaneously figurative and Photo-real.

For this ex-architect, architecture is still there, but as a background to the close-ups of everyday life; and a feel for architectonic rules is used to structure many of the compositions of these paintings.

ToffeeCrisp (detail)
2005
Acrylic on canvas
100 x 122 cm

Bounty
2005
Acrylic on canvas
100 x 122 cm

ToffeeCrisp
2005
Acrylic on canvas
100 x 122 cm

Starburst Twix
2004
Acrylic on canvas
91 x 91 cm

Crisps
2004
Acrylic on canvas
76 x 76 cm

Triple X Mints
2007
Acrylic on canvas
100 x 120 cm

The Race
2006
Acrylic on canvas
76 x 76 cm

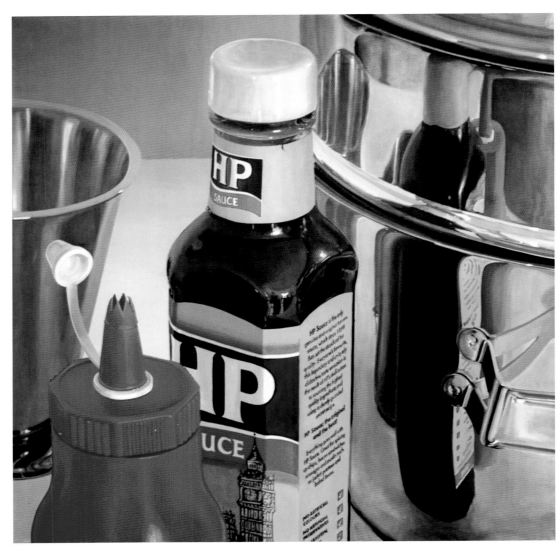

HP Sauce
2007
Acrylic on canvas
76 x 76 cm

Sarsons Pyrex I
2001
Acrylic on canvas
51 x 61 cm

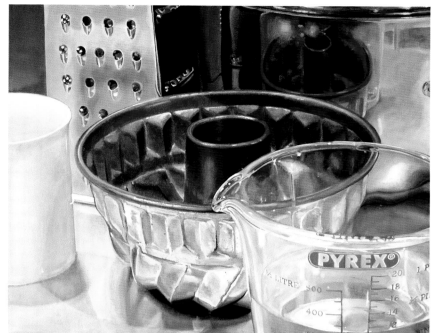

Jelly Mould
2003
Acrylic on canvas
51 x 61 cm

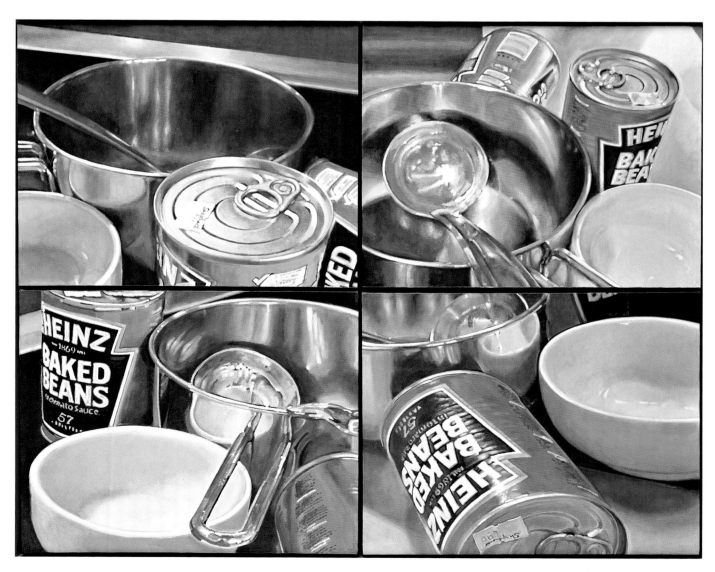

Heinz
2002
Acrylic on canvas
84 x 104 cm

Danish Laundry
2001
Acrylic on paper
30 x 35 cm

Danish Laundry IV
2006
Acrylic on canvas
76 x 76 cm

A View of St Mark's Square
2007
Acrylic on canvas
76 x 76 cm

Media Studies
2008
Acrylic on canvas
100 x 100 cm

Illy
2001
Acrylic on canvas
45 x 97 cm

Sarsons Pyrex III
2002
Acrylic on canvas
61 x 76 cm

Pyrex Pears II
2005
Acrylic on canvas
82 x 102.5 cm

Dishwasher
2008
Acrylic on canvas
120 x 120 cm

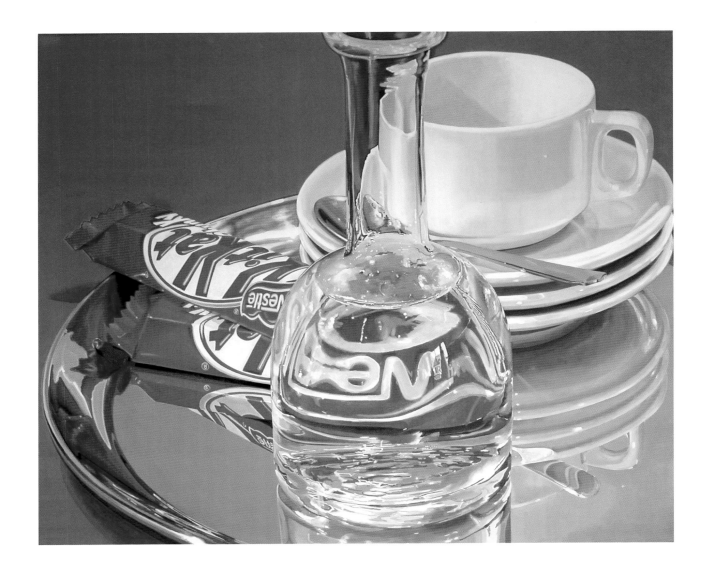

KitKat Chunky II
2005
Acrylic on canvas
102 × 122 cm

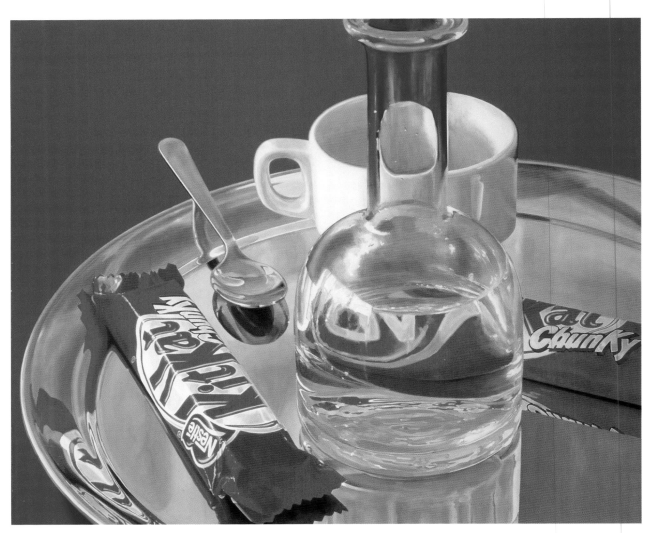

KitKat Chunky X
2008
Acrylic on canvas
100 × 120 cm

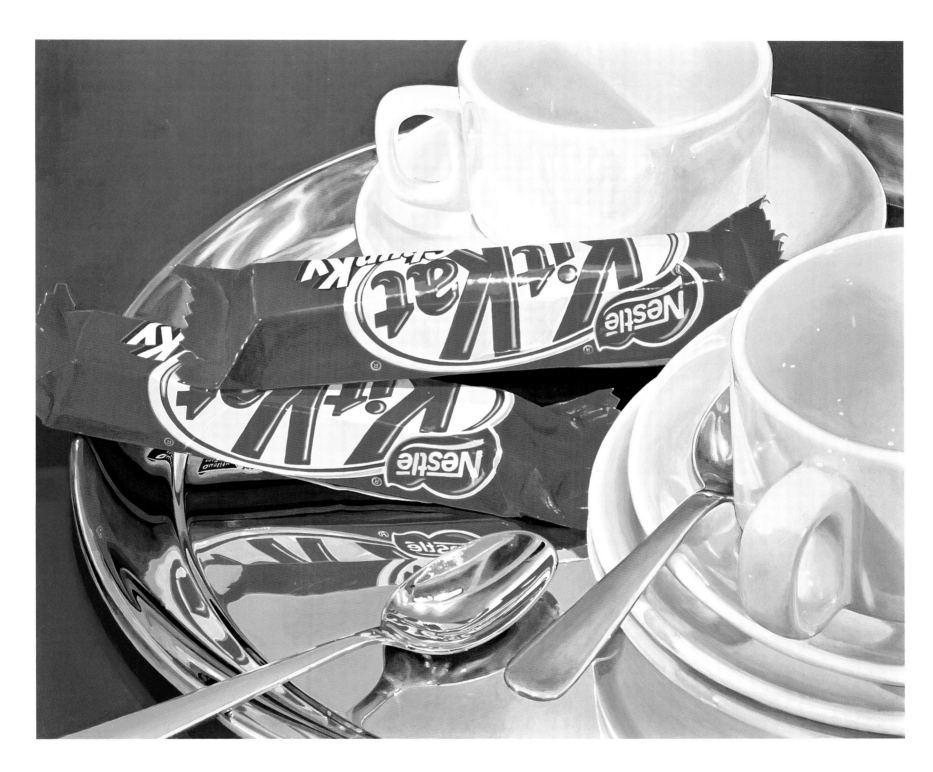

KitKat Chunky VIII
2007
Acrylic on canvas
100 x 120 cm

FRANCISCO RANGEL

FRANCISCO RANGEL HAS ONE THING IN COMMON with another Exactitude-connected artist, Carl Laubin: he was originally trained and began his professional career as an architect, and architecture remains his predominant interest in the subject matter of his painting. Very useful, one would imagine for a Photorealist painter, since architecture is so frequently an important element of the photographic material that forms the basis of the painter's work. An understanding of the logic behind the things being represented must surely be helpful in getting ever closer to a believable appearance of reality.

Also, in Rangel's case, a deeper understanding of the human background. He says of his London paintings:

> Being an architect, I am particularly aware of what the architecture of a city can reveal about its society. I feel this is particularly strong in London, which to me seems to be in constant evolution. London bridges are the fingerprints/witnesses of London's life, and this is what is very attractive to me.

It may well be that other Photorealists feel the same way about the human implications of their paintings, but none has been so eloquent, and some are definitely looking in the opposite direction, concentrating on the ability the use of photographs gives them to divest their works of all human, personal connotations.

Rangel has come to Exactitude only gradually: he points out that he has been painting for some twenty-five years (which means, since he was twelve), but regards himself as having been a realist for only the last ten. Originally Mexican, he began studying drawing, painting and – a very Mexican speciality – muralism in 1980, graduated as an architect in 1995, and worked for five years as an architect specialising in the restoration of traditional buildings. After undergoing a formidable academic training in Christian iconography and the fundamentals and techniques of oil painting, in 2000 he relocated to Spain, armed with a licence to paint exact reproductions of masters in the Prado.

From then on he has devoted himself completely to painting, while continuing his further education with intensive courses in photography and film-making. All of this learning is evidently in play in his art, though miraculously it does not stultify it. This must be partly because Rangel has generally painted (and before that photographed) his cities as an outsider, an explorer almost. He has painted urban landscapes in Madrid, Milan and London, none of them familiar to him when he launched the projects. Consequently, he has always brought a fresh eye and an enquiring mind to each place, the enquiring mind constantly enriching his human understanding of what the eye sees.

This means that what is appreciated most in his work is not primarily topographical precision – though that also exists – but the atmospheric qualities he imparts, the pattern of moods created by the way a sympathetic stranger sees something which, for natives, may well be muted by over familiarity.

Zebra (detail)
2005
Oil on linen
62 x 145.5 cm

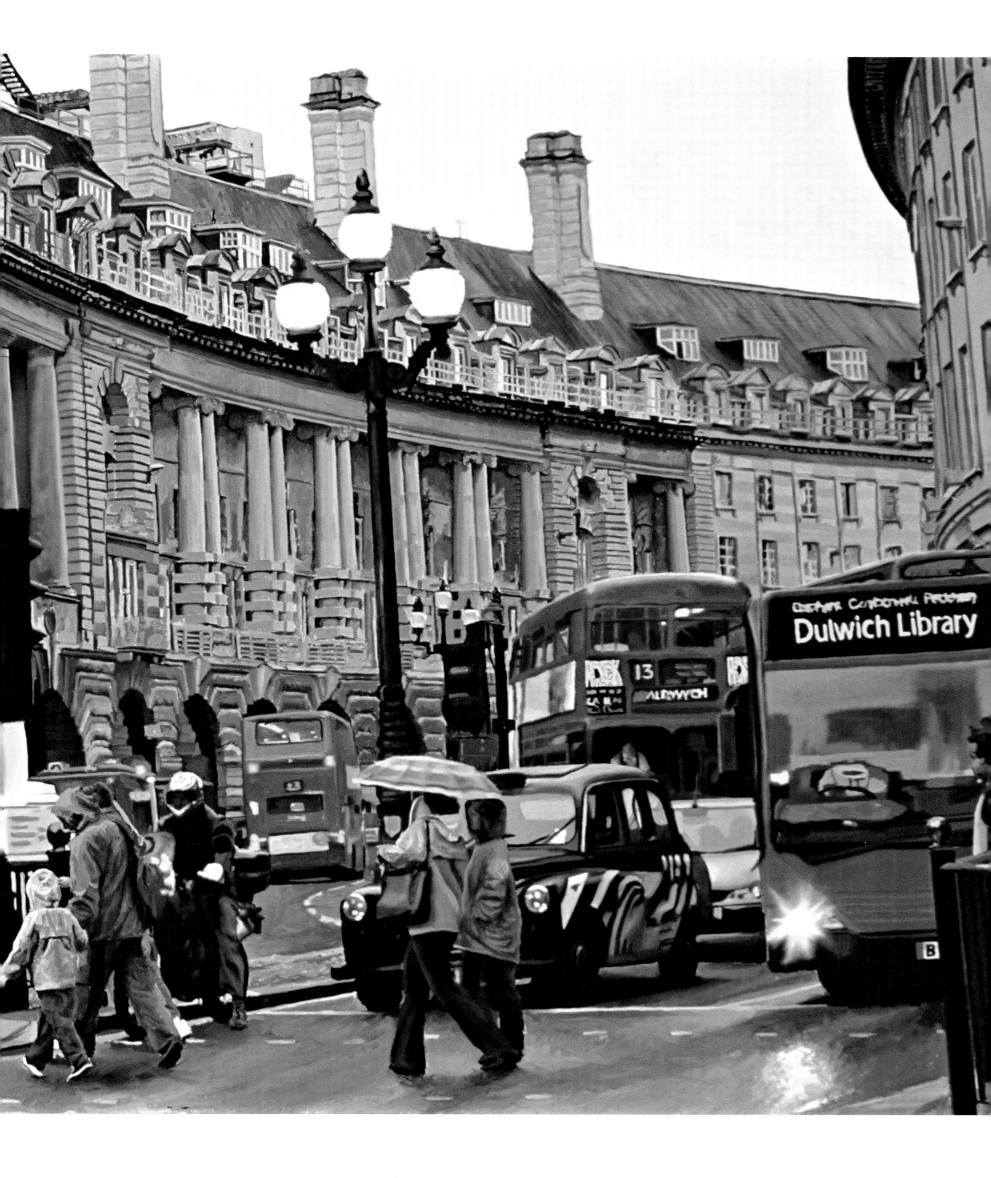

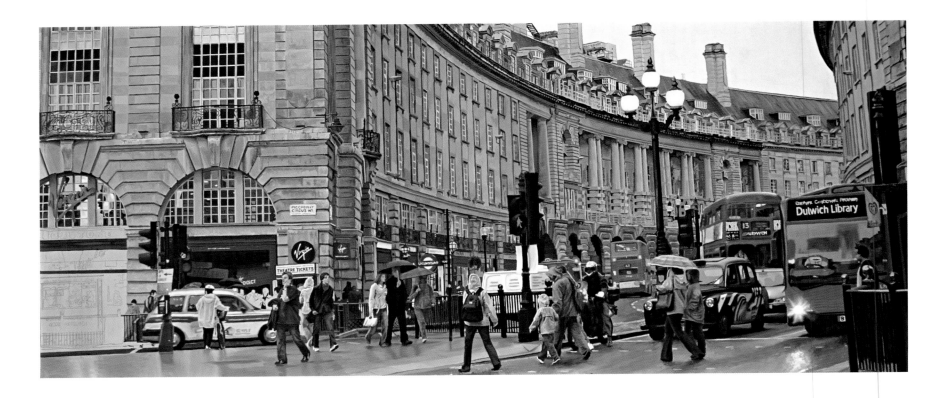

Zebra
2005
Oil on linen
62 x 145.5 cm

15:55 pm
2005
Oil on canvas
45 x 60 cm

Black Cab
2005
Oil on linen
62 x 145.5 cm

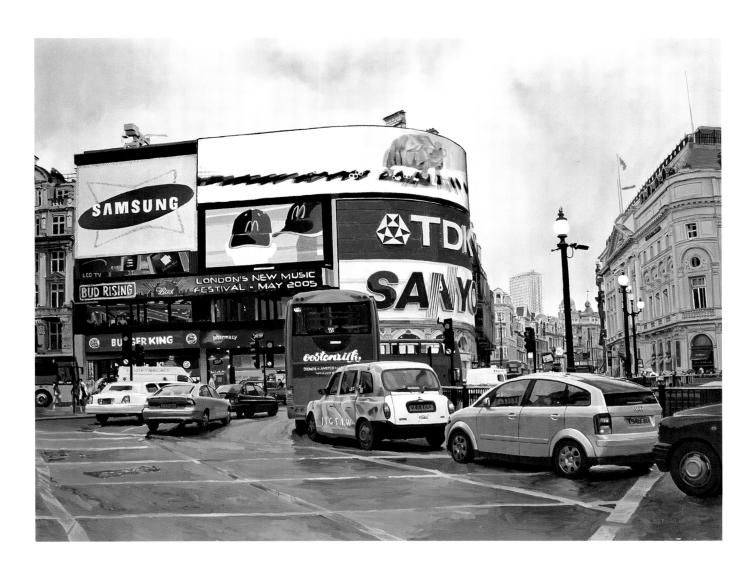

Apollo
2005
Oil on canvas
45 x 60 cm

Piazza Vittorio, Turin
2004
Oil on canvas
28 x 65 cm

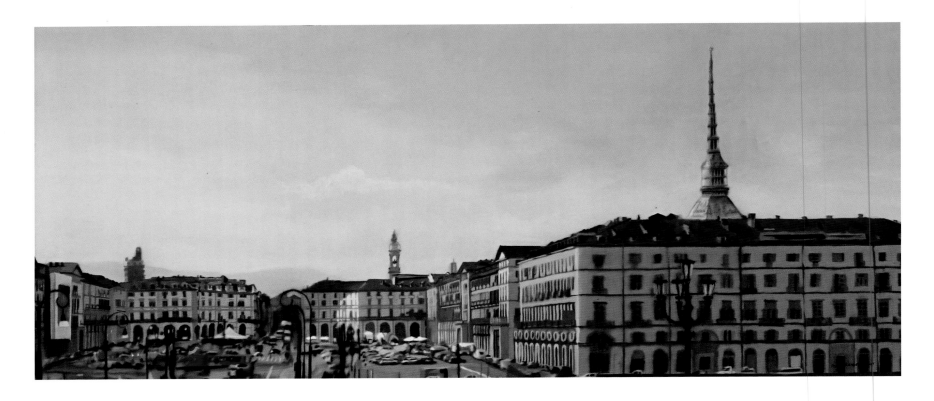

Galleria Vittorio Emanuele
2004
Oil on linen
62 x 146 cm

Railway Station, Milan
2004
Oil on canvas
46 x 64 cm

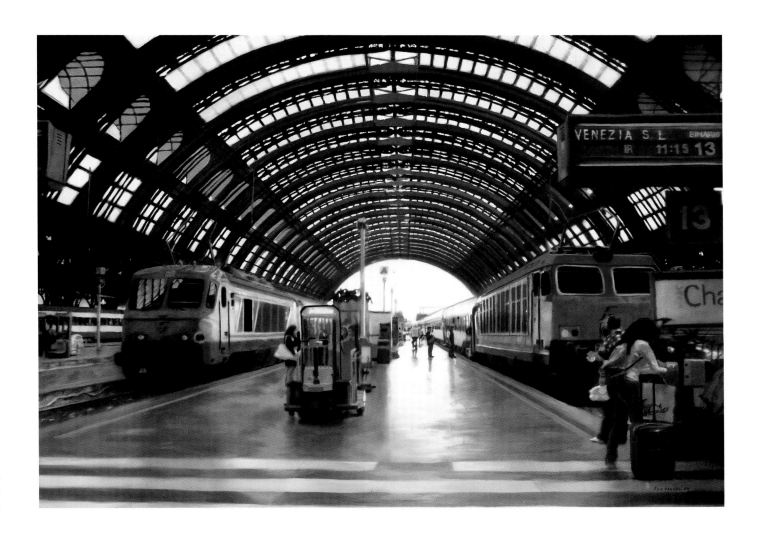

Richmond
2008
Oil on canvas
97 x 130 cm

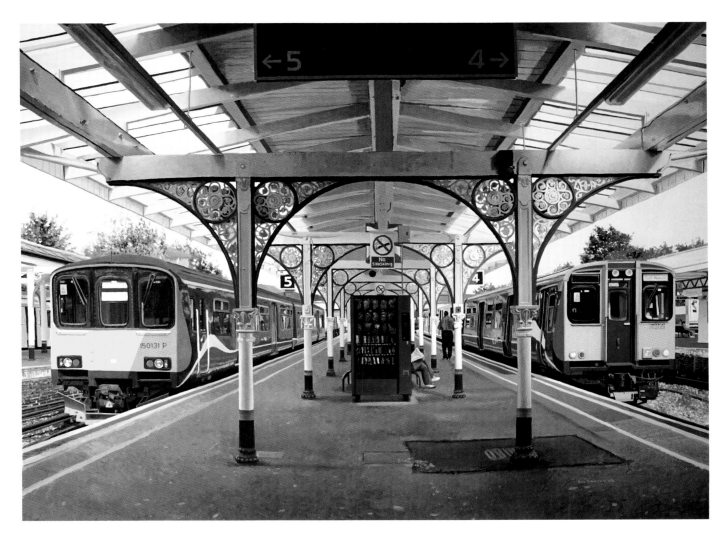

Albert Bridge
2007
Oil on linen
116 x 89 cm

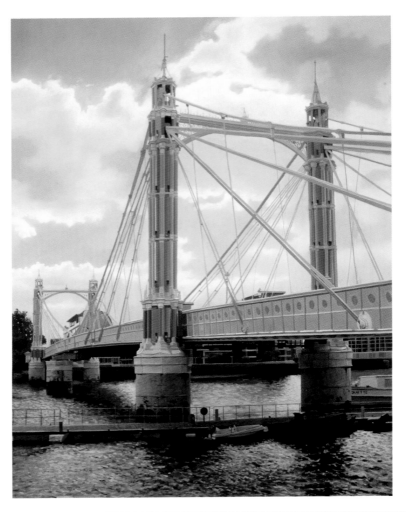

Lambeth Bridge
2007
Oil on linen
130 x 195 cm

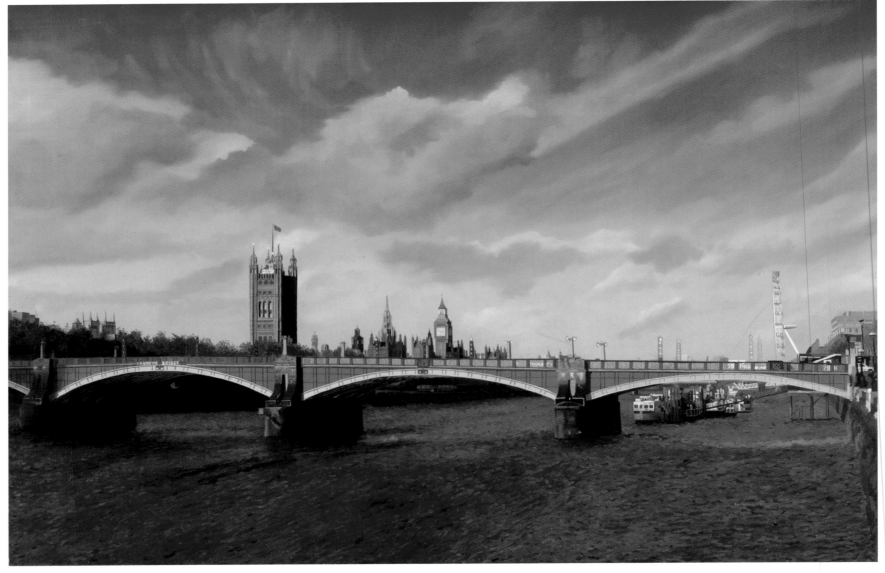

Blackfriars Bridge
2007
Oil on linen
195 x 130 cm

Chelsea Bridge
2006
Oil on linen
130 x 195 cm

Waterloo Bridge
2007
Oil on linen
130 x 195 cm

JOHN SALT

JOHN SALT COMES THE NEAREST of any British artist to being a founding father of American Photorealism. He was born in Birmingham (England, not Alabama, as one might rather suspect from his art) in 1937, and has been drawing and painting as long as he can remember. A crucial experience in his early life was a visit to the Festival of Britain organised by his secondary school art teacher, Donald Knight; the thirteen-year-old Salt, unlike his classmates, was particularly excited by the Festival's art, which brought most of the leading British artists of the day into play. ('Mother of Triplets Chips Festival Statue', flashed up the *Daily Mail*, desperate to find a human angle for a picture of Barbara Hepworth carving *Contrapuntal Forms*.) And Knight it was who encouraged Salt's artistic efforts while he was in school, and urged him to apply (at the age of fifteen) for a place at Birmingham College of Art.

Salt was mainly interested in contemporary art, and responded particularly to the work of Prunella Clough, which he knew initially in reproduction, then from her retrospective at the Whitechapel Art Gallery in 1960: something about her interest at that period in combining human figures with romantically viewed industrial machinery exerted a special attraction for him. Inevitably, the teachers and teaching at Birmingham College of Art were much more conservative than he might have wished, but he went conscientiously through the usual academic hoops there, learning all he needed to know about painting and drawing from life.

After a supplementary year in Birmingham, Salt went on to the Slade School of Fine Art, from which he graduated in 1960. The attitudes of staff at the Slade were hardly more advanced that those in Birmingham, but just living in London was an education in itself: there Salt became acquainted with the first exhibited works of such British Pop artists as Richard Hamilton and David Hockney, and, more important for him, such American contemporaries as Jim Dine, James Rosenquist and Robert Rauschenberg, whom he felt to be more serious and substantial.

By 1969 his main ambition was to go and see America for himself. He wrote off to a number of American art schools, and received a favourable reply from just one. Maryland Institute College of Art, Baltimore, offered him a scholarship with a teaching assistant post attached. Salt settled happily there, enjoying both the teaching and Baltimore's proximity to Washington, DC, where he was able to see at first hand the work of American artists that previously he had only been able to admire in reproduction. In was in the galleries of Washington that he saw the automobile sculptures of Ed Kienholz properly for the first time, and also became acquainted with the photography of Garry Winogrand, Bruce Davidson and other Americans who had come to the fore after the war.

He was not really satisfied with his own work, however, until he began to paint directly from photographs, and to paint specifically cars, at first in various stages of brand new splendour and then, later, in squalid yet pathetic decay. It should perhaps be explained that when he was a child his father ran a motor repair shop, and his father's stepfather was a sign-writer who also painted pinstripes on cars, so cars were built into his psyche early on, along with the will to make art.

Maybe it was inevitable that the art and the cars would come together in his life sooner or later, but it must have been fate that when he showed Maryland's external assessor, the realist painter Alex Katz, a portfolio of his work to qualify for his degree, Katz was unexcited by the first American works, but sat up and took notice when he brought out a black-and-white painting he had just done transcribing exactly a picture in a Buick brochure. 'Oh, this is better', Katz exclaimed; 'This may not even be art.'

Salt says: 'That was what I wanted. I wanted something that's not art. Something that's different, cool.' Evidently, he had found it. And with it, a sort of early Photorealist credo. His attitude to his own painting at this period adumbrates exactly the separation of the artist from the art so widely sought by Photorealists, yet personal at the same time. 'I realised that I had something that was mine. It may not be very good, but it was original. After all this time I'd finally got rid of all those influences and it was really true. I was happy with what I'd got, or I was happy with the way it was going.'

The die was cast, the obsession with cars and the obsession with photography had at last fused together, and virtually all Salt's subsequent work, no matter which side of the Atlantic it is done, follows the same formula, taking photographs of American cars and transcribing them in paint. Mechanical, impersonal in a certain sense it is. And yet no Photorealist is more immediately recognisable, his vision as distinctive as the way he presents it on canvas. What more could one ask from any devotee of Exactitude?

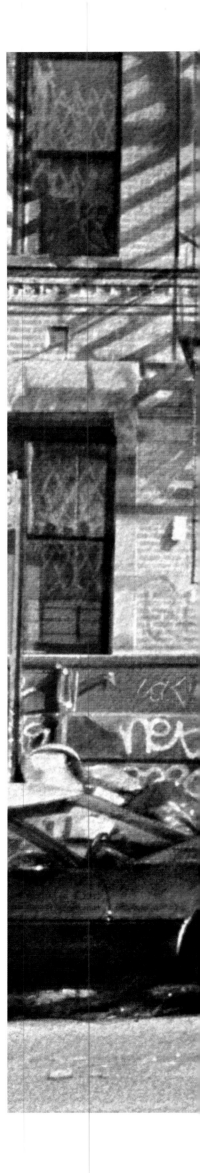

Street (For Sale)
(detail)
2006
Watercolour on linen
34.5 x 51 cm

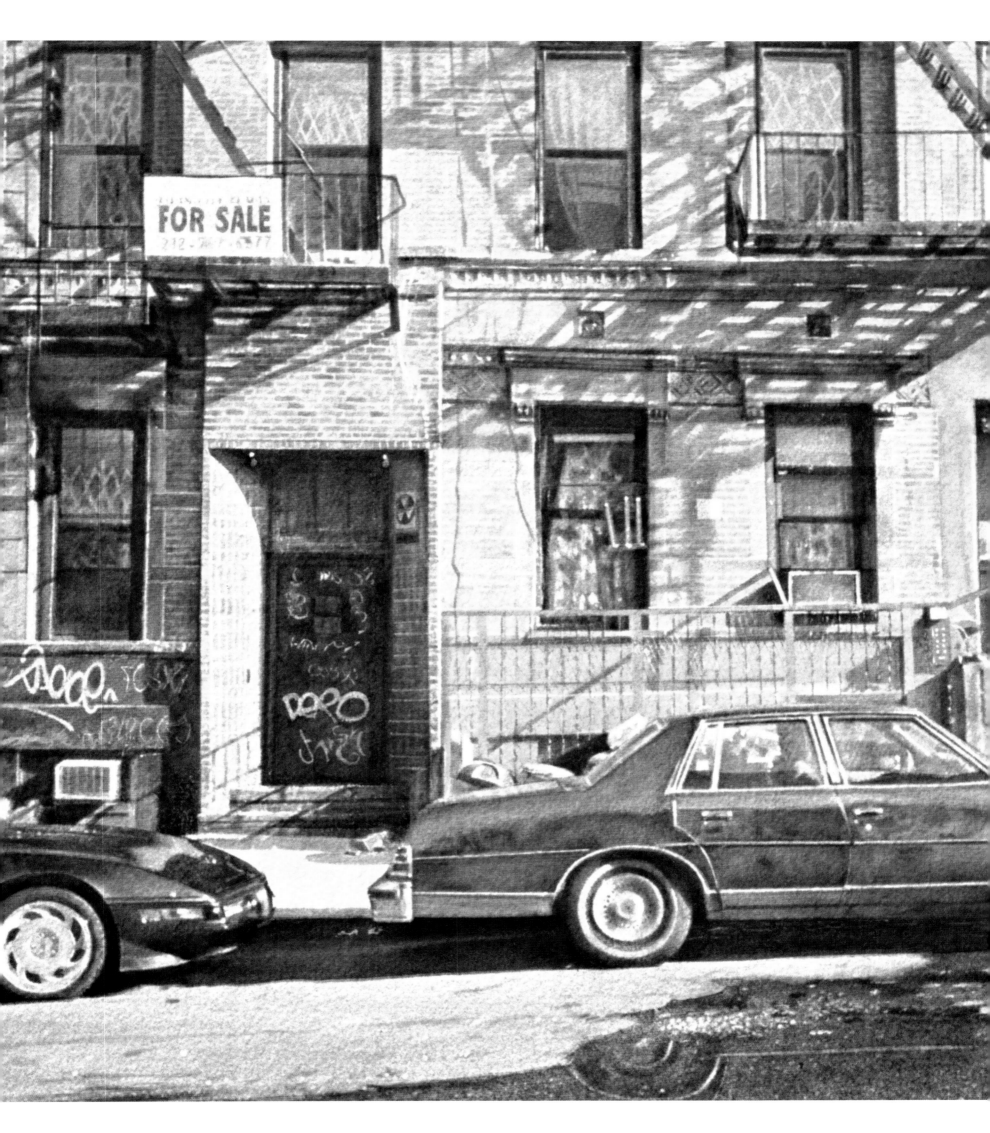

Falcon
1971
Oil on canvas
117 x 162.5 cm

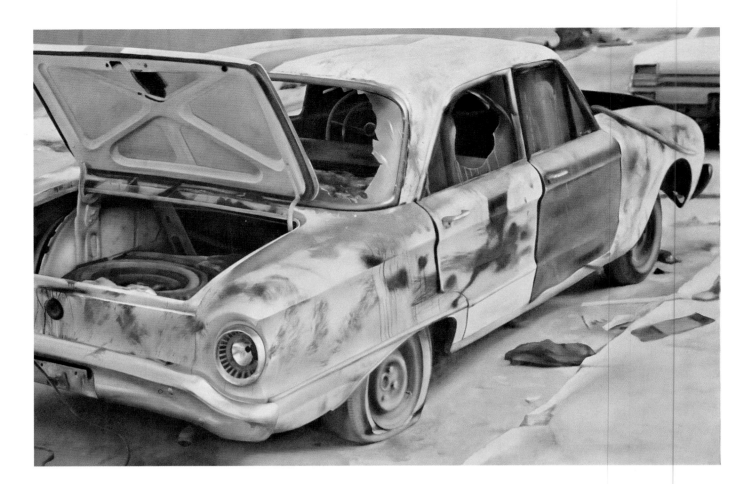

Arrested Auto No. 2
1970
Oil on canvas
134.5 x 195.5 cm

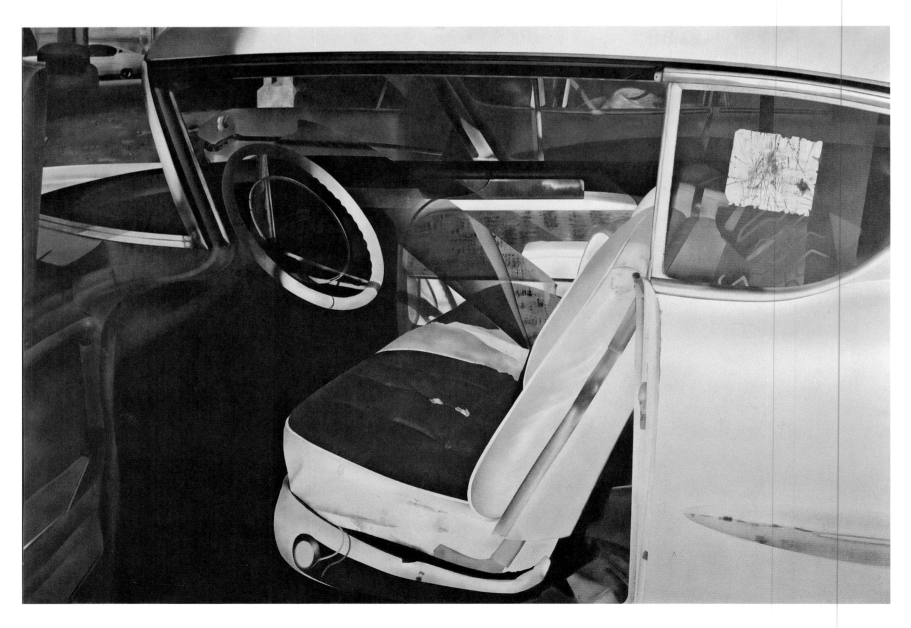

No Parking
2007
Oil on canvas
112 x 165 cm

Untitled
1989–90
Oil on linen
110.5 x 169 cm

Mobile Home with Porches
1977
Watercolour on paper
30.5 x 46 cm

Blue Mobile Home
1992–93
Oil on linen
110.5 x 165 cm

**Blue Car and Air
Stream Trailer**
2005
Casein on linen
109 × 166 cm

Catskill Cadillac
1994–96
Casein on linen
112.5 × 170 cm

La Isla Café
2008
Watercolour
14 x 21.5 cm

Winter, Mott Street
1979
Watercolour on paper
32 x 46 cm

School Bus and Red Pickup
1973
Oil on canvas
124.5 x 183 cm

Red Chevrolet Rear View
1975
Watercolour on paper
30.5 x 43 cm

Crushed Bonneville
1971
Oil on canvas
124.5 x 175.3 cm

Tree
2001
Casein on linen
108.5 x 165 cm

Street (For Sale)
2006
Watercolour on linen
34.5 x 51 cm

Porch and Camper
1990
Watercolour on paper
28.5 x 44 cm

Chevy and Garage Doors
1999
Casein on linen
109 x 165 cm

Hobo Deli
2003
Watercolour on paper
37.5 x 56.5 cm

CESAR SANTANDER

THOUGH CESAR SANTANDER IS SPANISH, born in Spain, all his adult life and artistic training has been in North America, partly Canada and partly the United States. Coincidentally, there is a strong tradition of Superrealism in Spain, as is only fitting for the birthplace of Surrealism. Regardless of this, Santander's painting does not look at all Spanish, but instead manifests a noticeably American form of realism, much closer to Pop Art than to the normal run of Photorealism.

This is partly on account of Santander's choice of subject matter. Surely only an American would wish to paint, in luscious and almost edible detail, a tray of assorted doughnuts, chocolate gleaming on three against the sprinkled sugar on the fourth. Any Brit, admittedly, might see the charms of a battered metal box emblazoned with the insignia of Horseshoe Solace Smoking Tobacco. And Betty Boop is undeniably an international icon these days, though Americans – perhaps especially Americans in their sixties, like Santander – probably feel a more intimate, less self-conscious connection with her than would anyone on the eastern side of the Atlantic.

All of these, it will be gathered, are images from recent work by Santander. And all of them raise the obvious question about Santander's relationship with photography. They all look, even on superficial acquaintance, much more like a painting than a photograph. Clearly these are not routine examples of Photorealism, or at any rate not of the kind of classic Photorealism that prides itself on advertising its nature by making the painting look as much as possible like the photograph on which it is based. Santander does use photographs in his painting process, but in a fashion that seems to start at the wrong end.

That is to say, while most Photorealists take, or find, their photograph first, then set about laboriously converting it, with as few deviations as possible, into paint, Santander begins with the idea of a painting, then arranges the people and things he means to depict as an installation, to be shifted around and modified at will until the desired effect is achieved. Only then does the camera come into play. Santander photographs his assemblage from the relevant angle, seeing it always as a sort of halfway house between the things to be painted and the painting itself.

But even then, the photograph once taken is not regarded as any sort of absolute. Rather, it is the starting point for further elaboration and modification: it is the photograph as sketchbook, a more or less tentative beginning which is expected to lead into further cogitation. As Santander puts it:

> Superficially, I appear to copy the photograph, but I make many adjustments to the photographic image as I complete the painting. I try to impose my own vision by subtle adjustment of colours, edges and details so that the finished painting is the strongest representation of the original idea.

Santander is, no doubt as a consequence of this, one of the most obviously, even flamboyantly painterly of the painters associated with Exactitude. We take it on trust that he feels the photographic stage of creation is essential to setting his creation free. But we would be hard put to guess it if he had not so obligingly told us.

The Reunion (detail)
1998
Oil over acrylic on panel
117 x 170 cm

Tobacco Tin
2004
Oil and acrylic on canvas
93 × 122 cm

Cigar Tin and Reflection
2005
Oil and acrylic on canvas
76.5 × 99 cm

Edgeworth Tin
2005
Oil and acrylic on canvas
91.5 × 130 cm

Union Leader
2007
Oil and acrylic on canvas
91 x 122 cm

John Bull
2007
Oil and acrylic on canvas
81 x 196 cm

Betty, The One and Only
2005
Oil and acrylic on canvas
165 x 112 cm

Betty and Boa
2007
Oil and acrylic on canvas
127 x 91 cm

Personal Values II
2007
Oil and acrylic on canvas
91.5 x 122 cm

Donald Duck Choo-Choo
1989
Acrylic on masonite
62 x 91.5 cm

The Reunion
1998
Oil over acrylic on panel
117 x 170 cm

Headliners
2008
Acrylic and oil on canvas
77 x 102 cm

Passing the Harbour
2008
Oil and acrylic on canvas
77 x 112 cm

Night Messenger
2005
Oil and acrylic on canvas
165 x 122 cm

Jupiter Robot
2000
Acrylic on canvas
81 x 103 cm

Rocket Racer
2000
Oil on panel
113 x 160 cm

Space Toys and Reflections
2000
Oil on canvas
75.5 x 100.5 cm

Tom and Jerry
1999
Graphite on board
20.5 x 24 cm

Daisy with Mirror
2007
Acrylic and oil on canvas
111 x 76 cm

The Mechanical Robot
2003
Acrylic and oil on canvas
76 x 61 cm

Crayons
2007
Oil and acrylic on canvas
61 x 76 cm

M & M Bumper
2006
Oil and acrylic on canvas
91.5 x 122 cm

BEN SCHONZEIT

EN SCHONZEIT WOULD SEEM AT FIRST GLANCE an unlikely associate of a movement dedicated to Photorealism. Not so much for the 'Photo' part: one can clearly see photography influencing him in myriad details, when it does not pervade the whole composition. But the 'realism' part. So much of Schonzeit's work loudly proclaims itself as fantasy that one must wonder how realist such a painter can ever be accounted.

Not that minute realism in a painter's execution never occurs, even when his subject matter is fantastical. One need only think of Dalí's brand of Surrealism, which frequently looks as though he has miraculously acquired the facility to photograph something that exists only in the furthest reaches of his mind. Viewed in this light, Schonzeit's combination of style and content does not seem so bizarre. Also, it comes as no surprise that at some earlier points in his artistic journey he has gone through explicitly Surrealist phases.

Schonzeit has had an unusually bumpy progress in art education. Born in Brooklyn in 1942, son of a New York City fireman, he lost his left eye at the age of five, and when he was nine he was asked to leave the neighbourhood art school because of 'intractability'. What is significant, obviously, is that he was in the neighbourhood art school at all at the age of nine; testimony, as much as the 'intractability', that he was destined to be an artist with a mind of his own. The next year he was attending morning art classes at Brooklyn Museum of Art, and when he graduated from his high school in 1960 he was named 'Boy Artist' of the year for paintings, magazine illustrations and set designs for school plays.

He started immediately at the age of fifteen in the architecture programme of the Cooper Union art school, but the following year transferred to the fine arts programme. Still unsure which direction he would go with his art, he painted in Surrealist and Cubist manners, made large sculptures, and was influenced by the works of Miró, Picasso and Matisse. After receiving his degree from the Cooper Union he set out on his first trip to Europe, returned to teach in New York, and combined geometrical abstraction and Morris Lewis-like stain paintings with extensive street photograph. Marrying in 1968, he spent his honeymoon hitchhiking in Europe and building up an archive of travel photographs from which he proceeded to draw some of his first Photorealist works, and which he still uses today in his painted work.

During the Seventies he was consistently painting in a classic Photorealist style, and in 1973 he began, at the suggestion of Chuck Close, painting on smooth, wet, sanded surfaces, which allowed him to work in ever finer detail. The first results of this were a series of amazingly detailed – indeed almost trompe l'oeil – pictures of flowers. But by the end of the decade he felt the need to widen his scope, and admitted various other influences to his work. Outside events affected this to some extent. A trip to China sparked his interest in Asian aesthetics. The death of both his parents within a year set him off on a cycle of 'black paintings'. A visit to Japan brought Japanese motifs into his work. He took up flower painting again in 1988, with a series of almost menacingly large pieces, and added characters and costumes from the *commedia dell'arte* to his repertoire, after a commission for a mural on that theme from a restaurant in Cologne.

The key to understanding Schonzeit's recent work seems to be a recognition that he is still everything that he has ever been. Styles that he tried out as a student or a very young man are still hovering in his mind as possibilities. So, for example, he may be inspired by the stark forms of the rocks and buildings seen on a trip to Lanzarote to take a renewed interest in Cubism; while some of the weird juxtapositions in the black paintings immediately suggest Surrealism. When he embarked on a series of self-portraits under the title *Seven Ages of Man* (1993), looking to his own young manhood at the age of twenty (obviously in the light of photographs) and projecting his own future forward to the age of seventy in almost forensic detail, complete credence must be part of the overall effect, and so what could be more natural than harking back to his Photorealist phase, particularly the period when he was most affected by proximity to Chuck Close?

All these facets of his multifarious talents, however, only further serve to exemplify his own persistent taste for pictorial precision. However fantastic his juxtapositions or unpredictable his variations of scale, however spectacularly he may saturate his compositions in colour, or drain all colour away, in detail after detail, Exactitude rules.

Aalto Gold Spring (detail)
2007
Acrylic on linen
86 x 168 cm

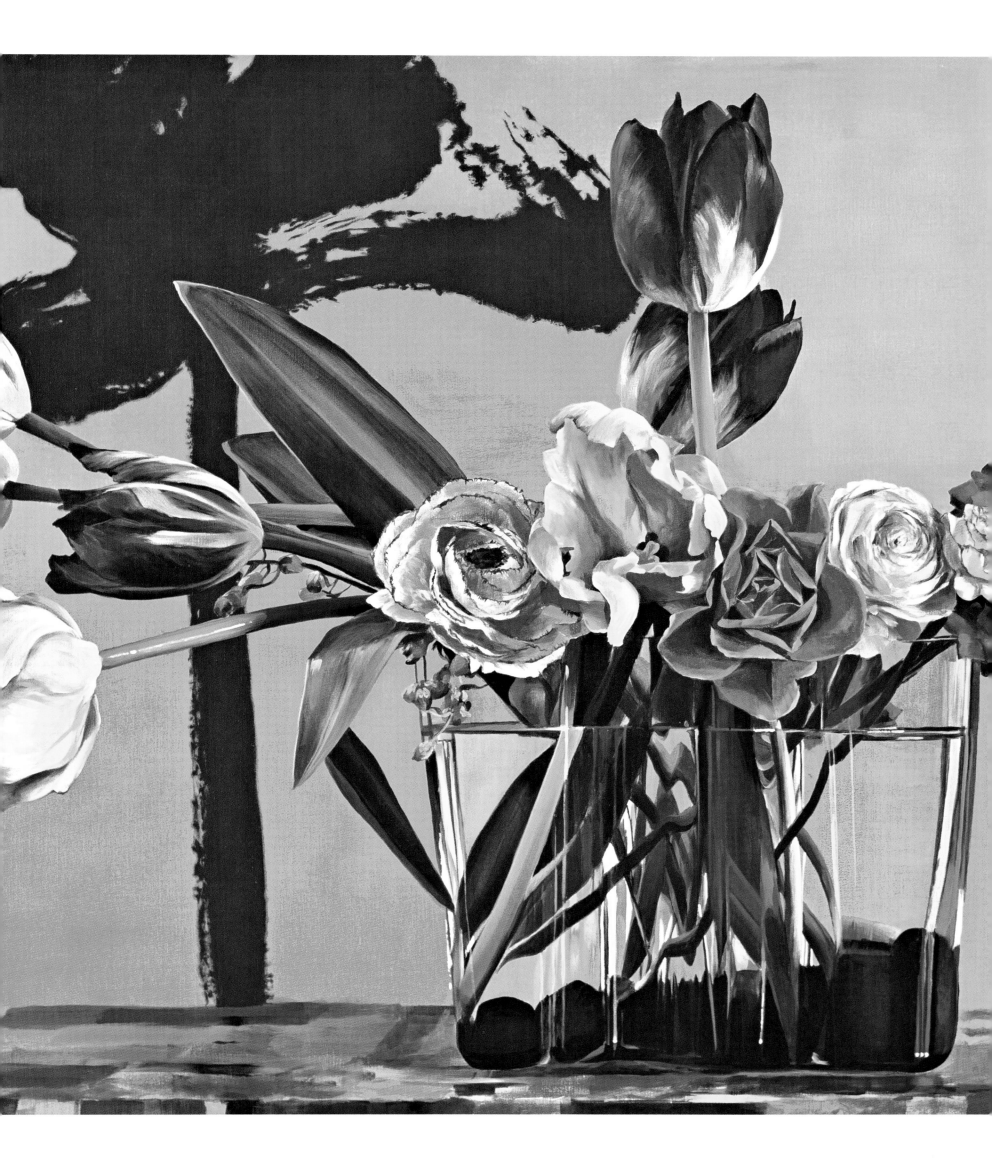

Key Stuy
1974
Acrylic on canvas
183 x 183 cm

Large Coke
1969
Acrylic on canvas
76 x 91.5 cm

Tools
1974
Acrylic on canvas
152.5 x 122 cm

Cabbage
1973
Acrylic on canvas
228.5 x 274 cm

Honey Tangerines
1974
Acrylic on canvas
183 x 183 cm

Two and One
1985
Acrylic on canvas with
louvre door
244 x 406.5 cm

Aerialists
1970
Acrylic on canvas
152.5 x 213.5 cm

Edge of Night
2008
Acrylic on canvas
117 x 137 cm

Bartos Moon
1986
Acrylic on canvas
168 x 183 cm

Southold Road
2000
Acrylic on linen
76 x 101.5 cm

Hazy Lake Placid
2008
Acrylic on linen
112 x 122 cm

Yellow Flowers by the Sea
2008
Acrylic on linen
137 x 213 cm

Tall Aalto Blue
2007
Acrylic on linen
106.7 x 203 cm

Flowers on Grey
2000
Acrylic on linen
91.4 x 122 cm

Blue Night Flask
2006
Acrylic on linen
112 x 102 cm

Aalto Gold Spring
2007
Acrylic on linen
86 x 168 cm

Dances
1999
Acrylic on linen
168 x 244 cm

Roses Les Halles
2005
Acrylic on linen
100 x 100 cm

Lucca Rose
2000
Acrylic on linen
183 x 183 cm

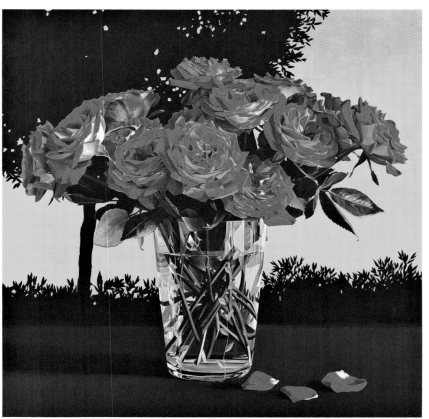

STEVE SMULKA

STEVE SMULKA HAS CHOSEN, from all the genres open to the contemporary superrealist, to concentrate on the still life. His work in this form is entirely within the classical tradition (in that sense we might well call it post-modern) except for its fascination with, not only light, but transparency, the light flooding the pictorial space and often penetrating through to it by way of transparent glass objects within the composition, or, shielded but still strongly present, through the translucency of shells, feathers and such. (In that sense we might call his work, literally if not in accordance with normal usage, post-Impressionist.)

Such devotion to one form of painting is rare today, and might well be apprehended as constricting the artist's self-expression. But not, I think, in Smulka's case: he is truly one of those who can see the world in a grain of sand, and heaven in a wild flower. What does he need with any wider canvas? Even in this form, he can and does in some ways confound our expectations. For some reason, or no reason in particular, the traditional still life is usually rather dark, perhaps so that the colours of flowers and fruit and plumage can, front-lit as though behind the footlights, glow out of the obscurity at us.

That is not what the Impressionists cared about, in their artistic preoccupation with light and its transformative powers. Yet even the specialist in still life most closely allied with the Impressionists, Fantin-Latour, preserved in the main the tradition of letting his still life subjects glow against a subdued background. Even William Nicholson, the greatest English master of the genre, though he loved to capture the reflective quality of glass, ceramic and silver, seldom if ever tackled the effect of light filtering, let alone blazing, through glass or crystal into the heart of the composition. Smulka is thus strikingly original in his combining of Impressionistic drenching in light with the normally staid, sober form of the still life.

His outlines, however, are still sharp and precise: that is where the relation with Photorealism comes in. In *Artifacts* he reaches a high point of virtuosity in his handling of two transparent glass vessels and a translucent feather, behind, around and in front of which is entwined a small branch covered in leaves. There are all sorts of traps in the objects selected. The bottles are not straightforward plain glass, but instead inscribed in relief with the nature of the former contents, through which we see some of the green leaves, convincingly distorted by the curvature of the glass. We glimpse the leaves also through the feather, only this time their colour is altered but their shape remains undistorted.

Smulka was born in Detroit, and must have grown up with the same background of industry in decay as Randy Dudley. But no two humans react alike, and no two artists find inspiration in the same places. If Smulka turns away from the harsh realities of 'the rust belt' to the purer, more remote tabletop world of shells and cones and silver-white vessels, who shall blame him?

Artifacts (detail)
2003
Oil on canvas
76 x 92 cm

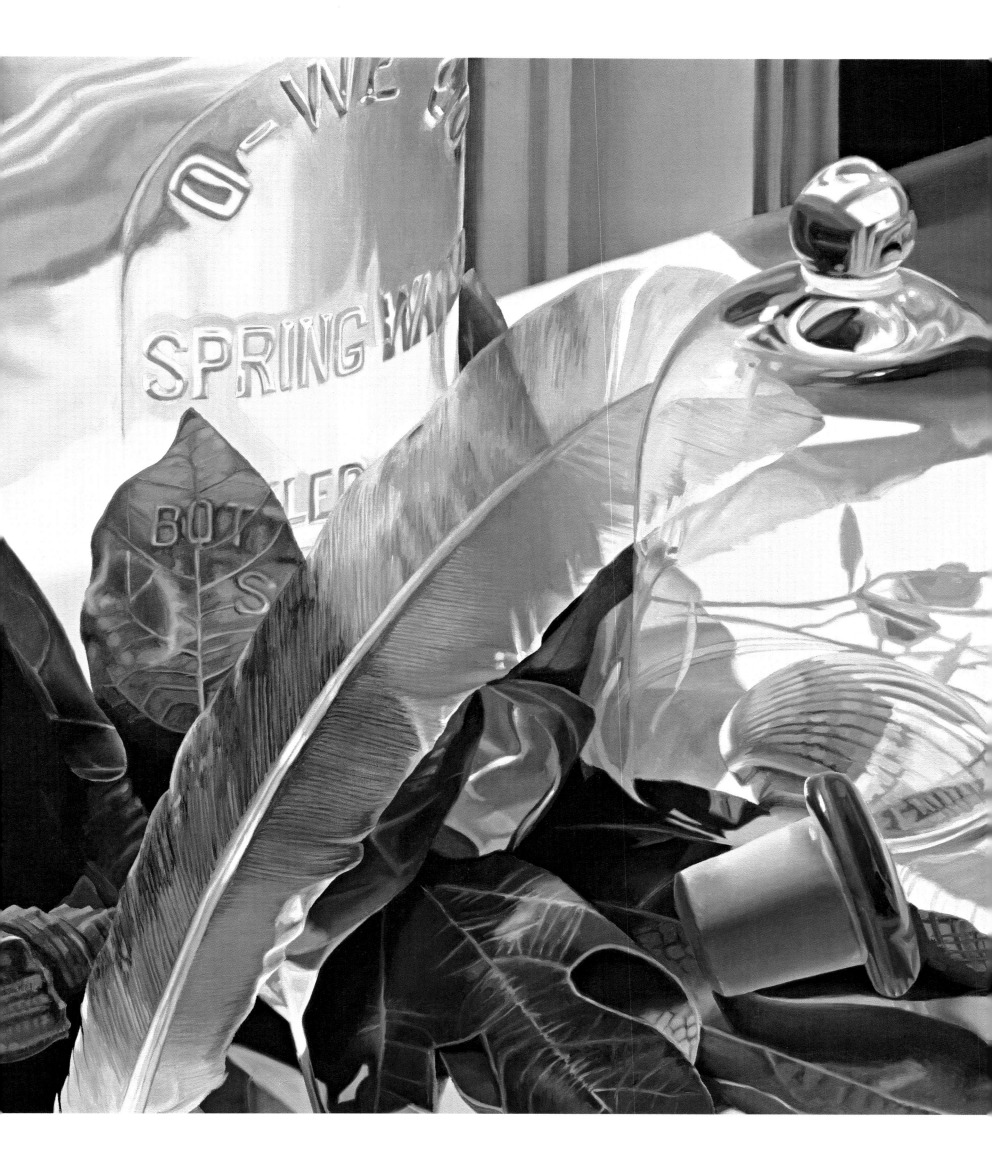

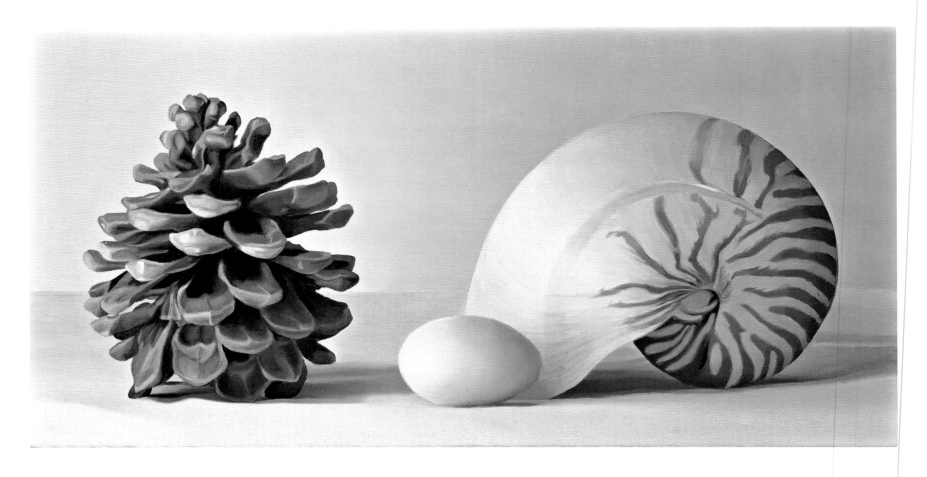

Adam & Eve
2003
Oil on canvas
20 x 41 cm

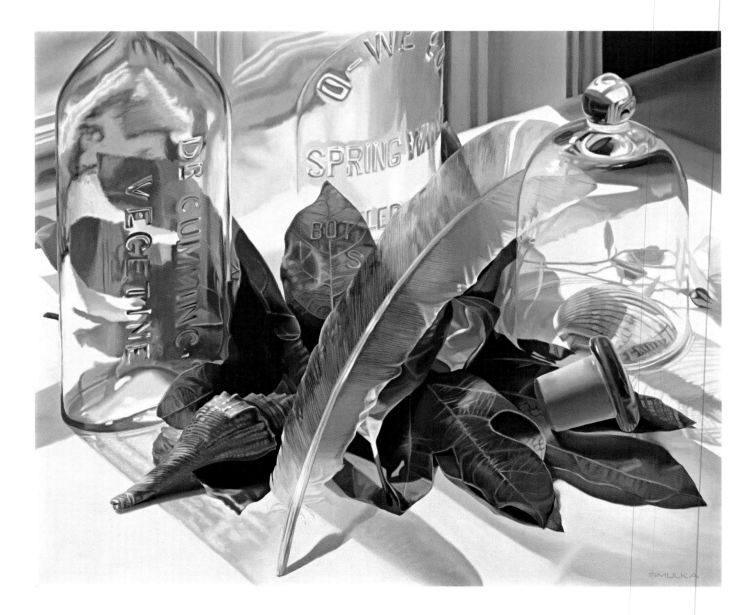

Artifacts
2003
Oil on canvas
76 x 92 cm

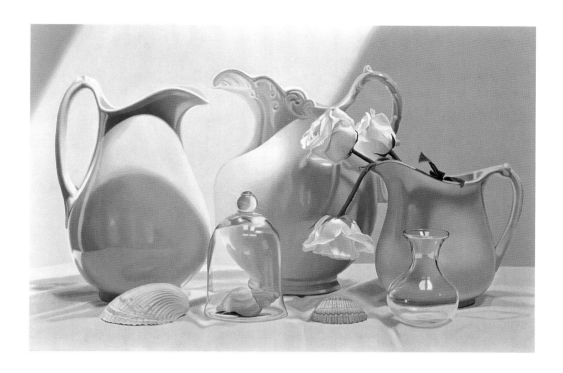

Winter Solstice
2003
Oil on canvas
61 x 92 cm

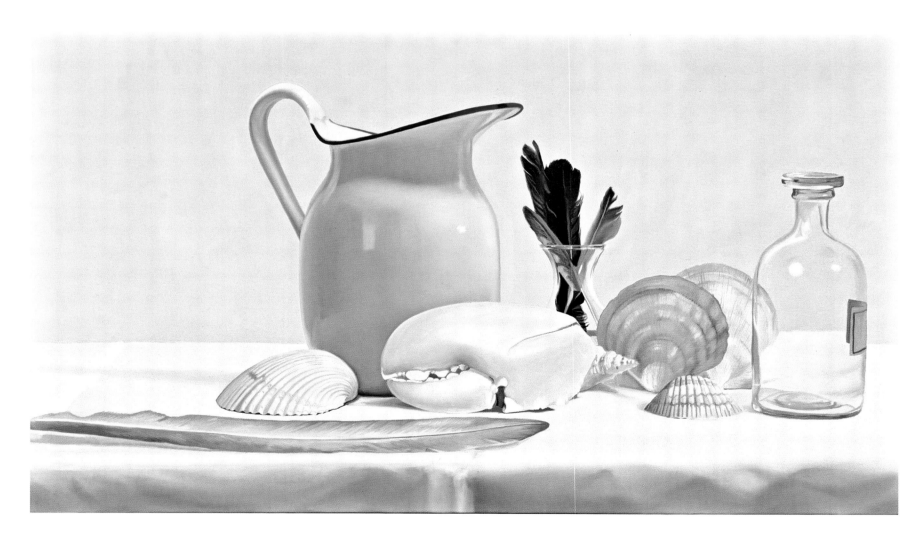

Beachcomber
2004
Oil on linen
51 x 89 cm

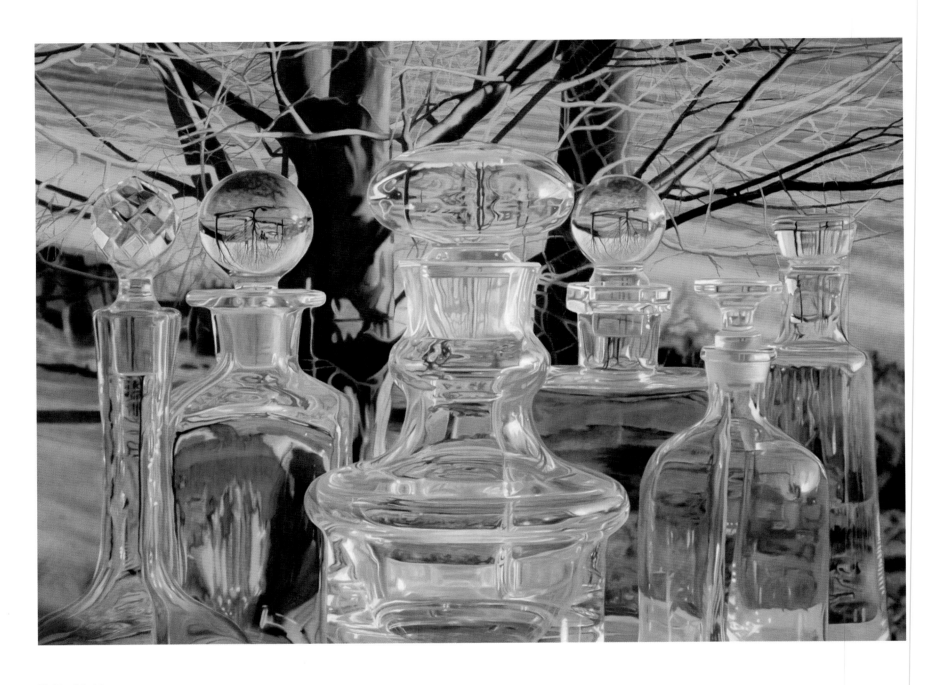

Field of Gold
2007
Oil on linen
91 x 127 cm

Winter Sun
2006
Oil on linen
66 x 107 cm

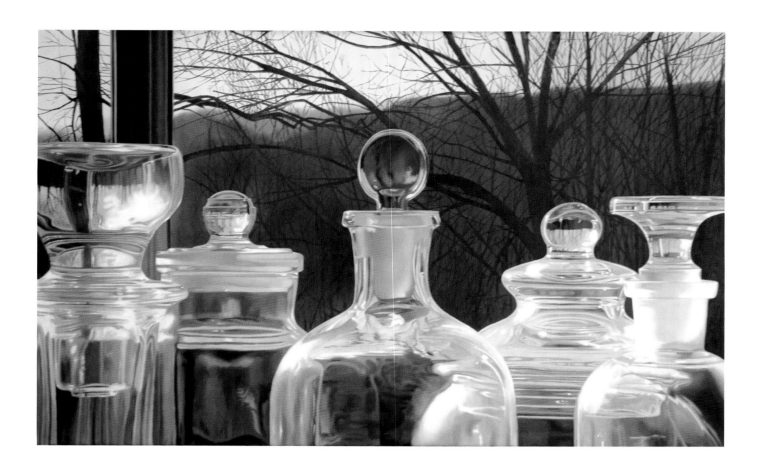

Waiting for Spring
2007
Oil on linen
91 x 137 cm

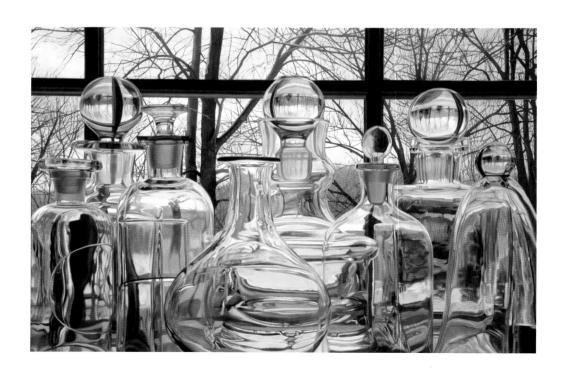

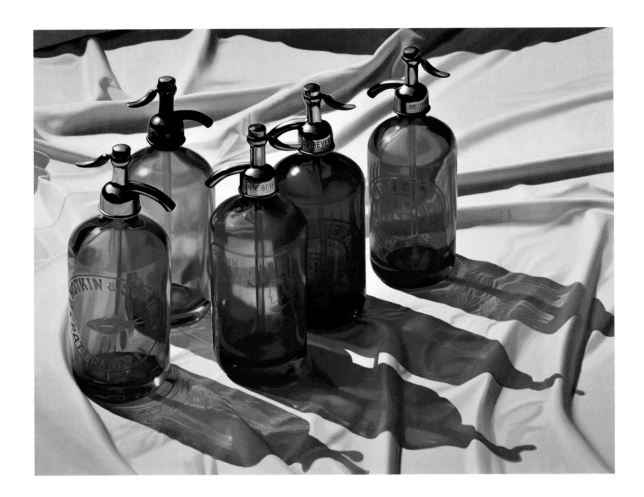

CO$_2$
1996
Oil on canvas
112 x 140 cm

Ace
2007
Oil on linen
91 x 168 cm

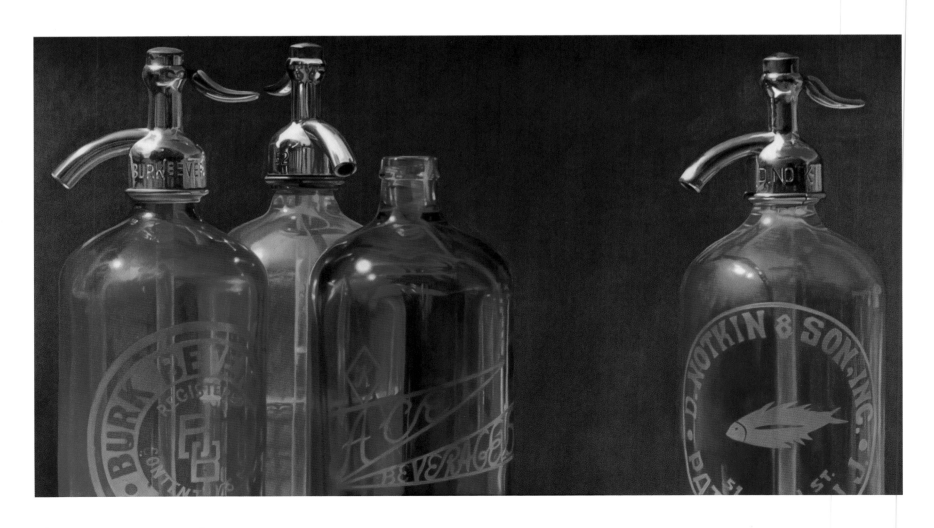

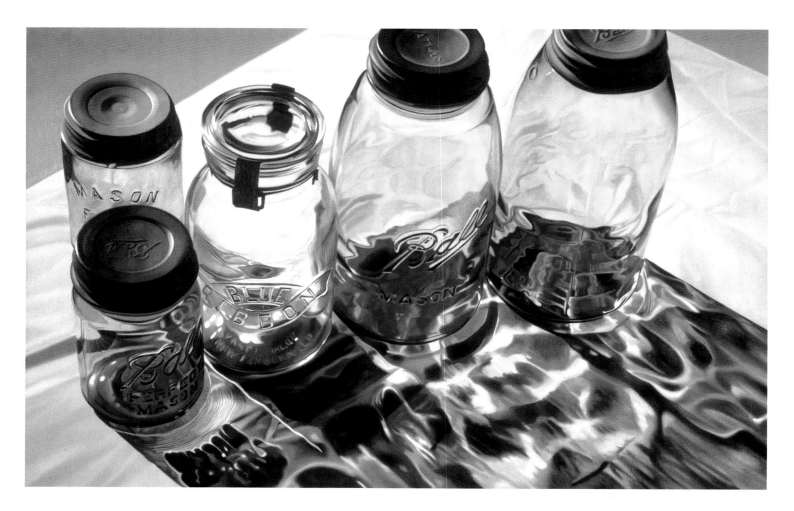

Her Majesty
2006
Oil on canvas
71 x 102 cm

Isn't it Chromatic?
1996
Oil on canvas
91.5 x 142.5 cm

Summer Shower
2007
Oil on linen
86 x 117 cm

Sparkling Skies
2007
Oil on linen
86 x 102 cm

Moxie
2007
Oil on linen
81 x 127 cm

Back Porch
2002
Oil on canvas
102 x 152.5 cm

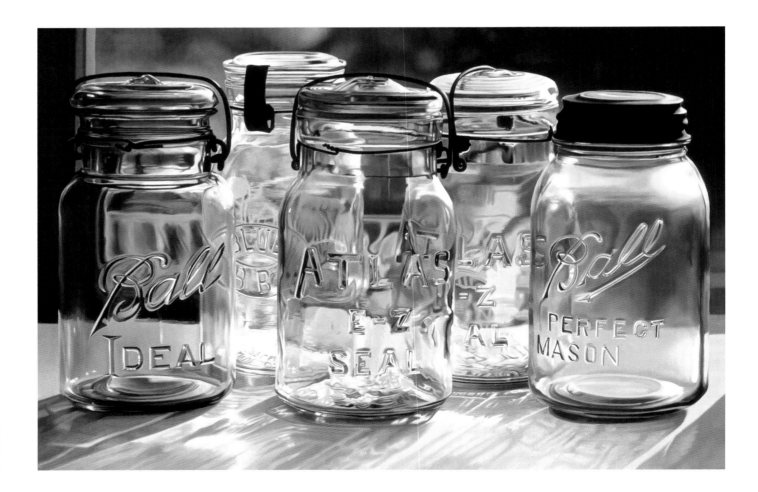

Pink Shadows
1996
Oil on canvas
71 x 112 cm

TJALF SPARNAAY

T HE EXACTITUDE MOVEMENT has not been without its parallels elsewhere in the world. Indeed, one of the artists who first appeared in this context with *Exactitude III* had already begun his own similar movement, Mega-Realism, in Holland a few years earlier. We are not told whether, in its native environment, it was ever more than a one-man band, but clearly its instigator, Tjalf Sparnaay, has recognised that there is safety in numbers: the bigger the collective target, the less likely any individual member is to be hit by a random volley of vitriol.

Not that Sparnaay is ever likely to be the target of too much critical vitriol. He is in fact one of the most approachable painters today, his art spiced with so much good humour, if not humour *tout court*, that it is difficult to imagine anyone taking it seriously amiss. Even if 'seriously' is the operative word, there is enough evidence in his work to indicate that he is no mindless lightweight. On the contrary, Sparnaay's sunny disposition proves not in any way incompatible with seriousness of purpose. This is unmistakably a painter who has thought long and hard about what he is doing.

Sparnaay's paintings clearly belong to Photorealism, in that they are undeniably realistic, and, even at a superficial acquaintance, look as if they are based on photographs. None of which Sparnaay has ever denied. All the same, the paintings themselves would never be mistaken for photographs. There are various reasons for this, and the reasons often differ from painting to painting. With some of the earlier ones, for instance, he has found it interesting, and maybe challenging, to reproduce, not an original Vermeer, but a photographic reproduction of a Vermeer, and a very cheap one at that, to judge from the price sticker, which reads €2.95.

The price sticker of course complicates matters further, in that it appears not to be attached to the actual surface of the reproduction, but rather to the crumpled plastic wrapping that adheres to it. All of which, wrapping and sticker, is summoned up in the best trompe l'oeil manner, so that, if one does not imagine that the painting itself is the real thing (though ironically it now is – a real Sparnaay if not a real Vermeer), one might well be deceived as to the tangibility of its integument. A British viewer at least may remember that the abstract painter Sandra Blow had a whole show at the Royal Academy inspired by the half-removed wrappings of her previous entries in the Summer Exhibition.

Sparnaay, who is formidably gifted in sheer oil painting technique, though entirely self-taught, has turned to a rather different aspect of Photorealism for his more recent work. Here the play is largely with scale. His rendering of a one-third-empty ketchup bottle may be meticulously correct in detail, the degree of viscosity of the ketchup remaining in the bottle just right, the gleam of the bottle itself exactly caught. But whoever heard of a ketchup bottle more than 200 cm tall? The same with *Lollypop* (1999), which presents, with mouth-watering richness of colour and almost palpable stickiness, the head of a wildly polychrome lollypop, still wrapped in its plastic hood. Except that it is a lollypop some 40 cm across – a fancy almost beyond the imagining of the greediest child in Willy Wonka's chocolate factory. Painting, for Sparnaay, starts where photography leaves off.

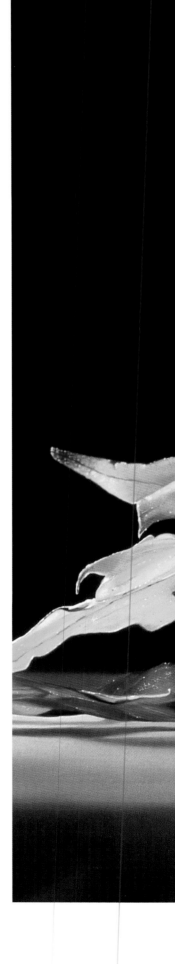

Autumn Leaves (detail)
2002
Oil on canvas
100 x 130 cm

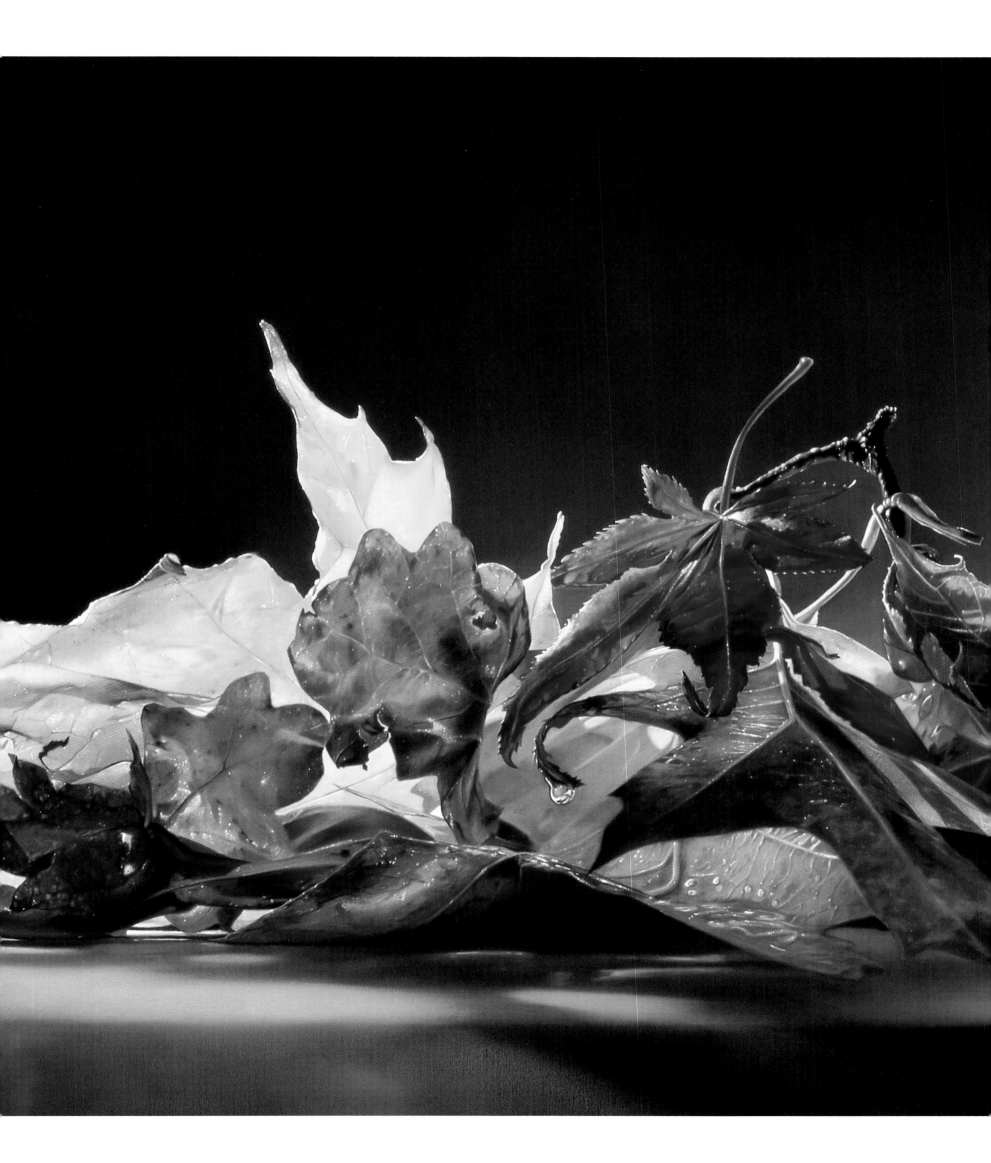

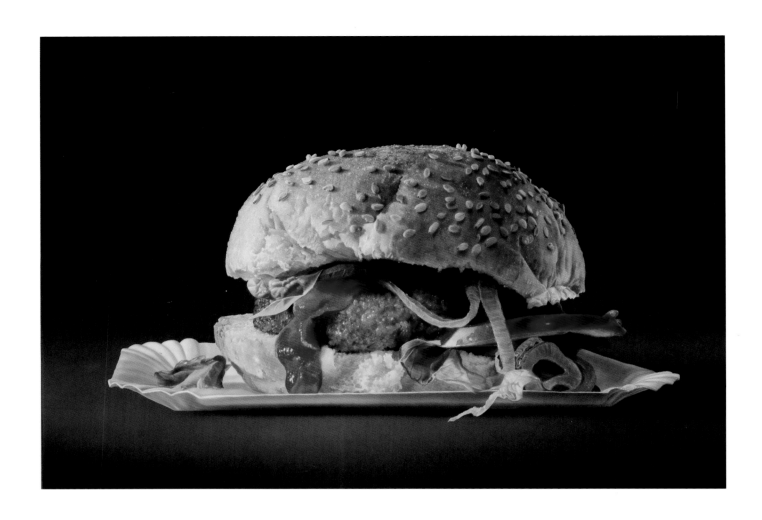

Hamburger II
2007
Oil on canvas
75 x 95 cm

French Fries in a Tray
2007
Oil on canvas
60 x 70 cm

Baguette
2006
Oil on canvas
60 x 75 cm

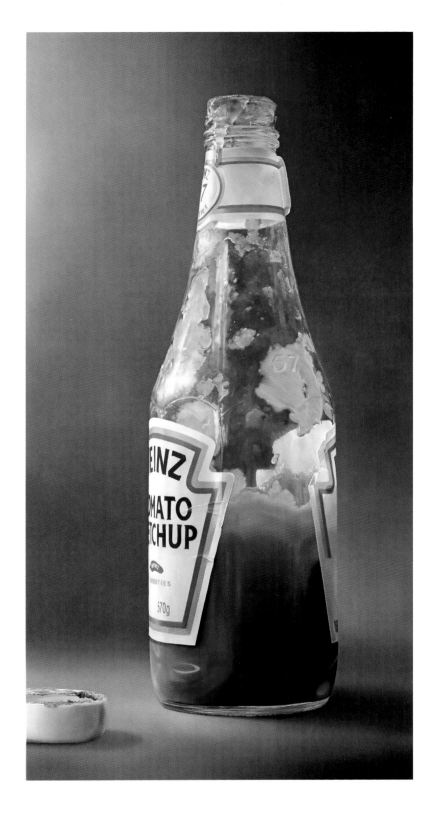

Boterhammen
2006
Oil on canvas
90 x 100 cm

Large Ketchup II
2007
Oil on canvas
200 x 100 cm

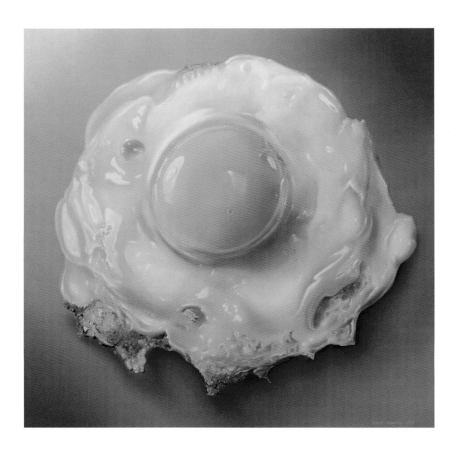

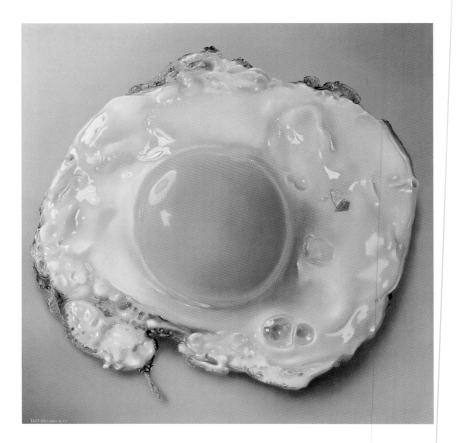

Fried Egg '07
2007
Oil on canvas
80 x 80 cm

Fried Egg '08
2008
Oil on canvas
80 x 80 cm

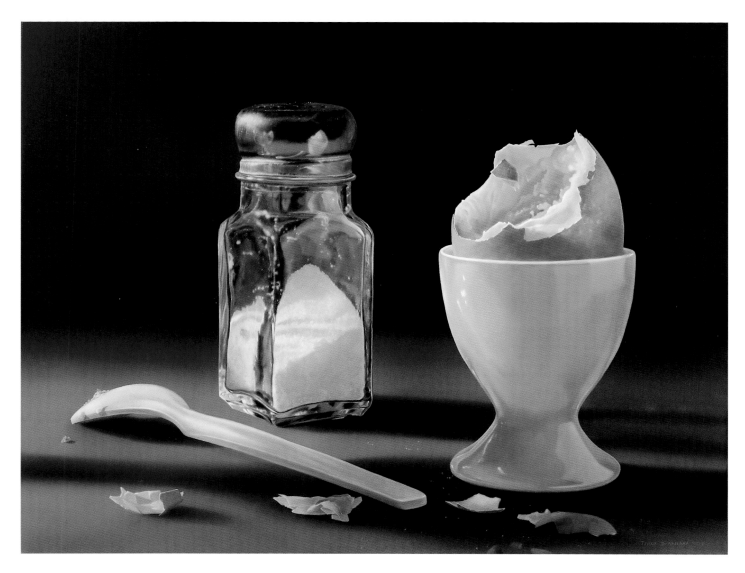

Boiled Egg
2007
Oil on canvas
80 x 100 cm

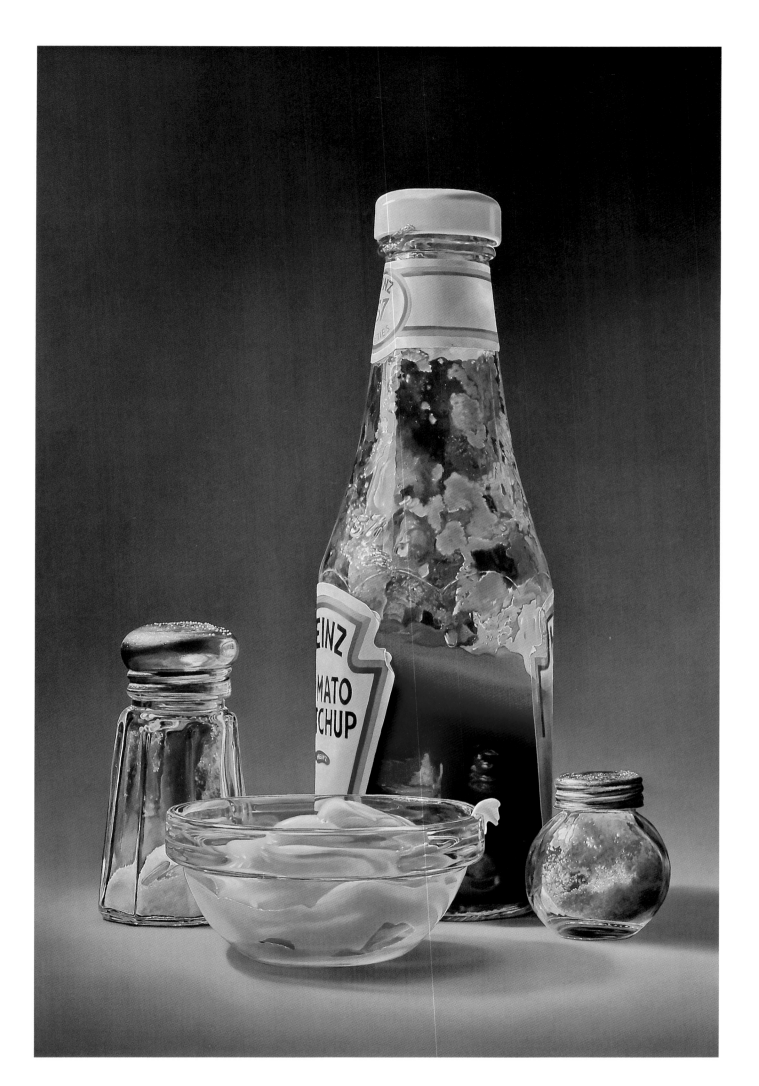

Mayonnaise '08
2008
Oil on canvas
150 × 100 cm

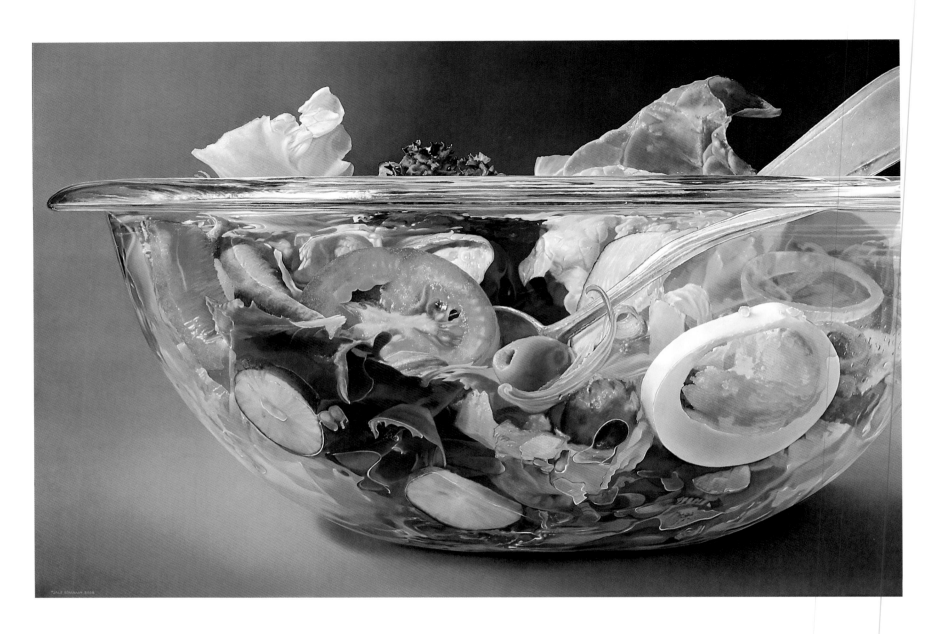

Salad Bowl '08
2008
Oil on canvas
120 x 180 cm

Apple III
2006
80 x 80 cm
Oil on canvas

Lemon
2006
Oil on canvas
40 x 60 cm

Casino Wit
1998
Oil on canvas
75 x 100 cm

Tulips
2001
Oil on canvas
120 x 160 cm

Tulips in Plastic II
2007
Oil on canvas
120 x 160 cm

Large Tulips
2006
Oil on canvas
150 x 80 cm

Dishwasher
1999
Oil on canvas
185 x 125 cm

Bicycle
2000
Oil on canvas
100 x 80 cm

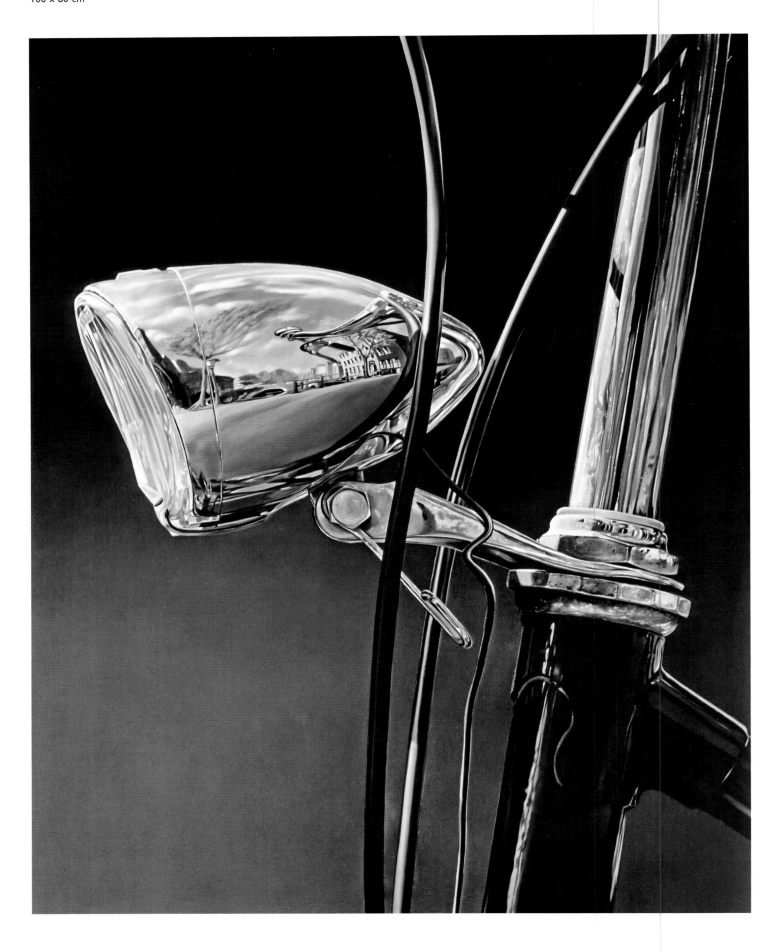

Autumn Leaves
2002
Oil on canvas
100 x 130 cm

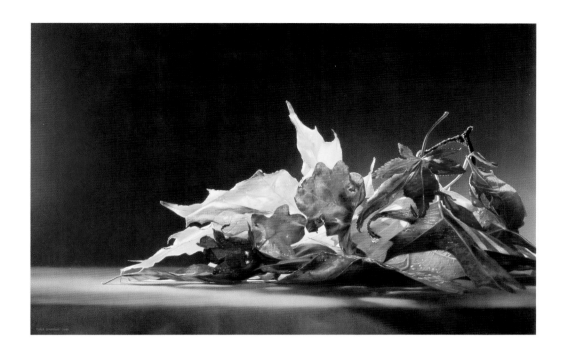

Autumn Leaves II
2008
Oil on canvas
80 x 160 cm

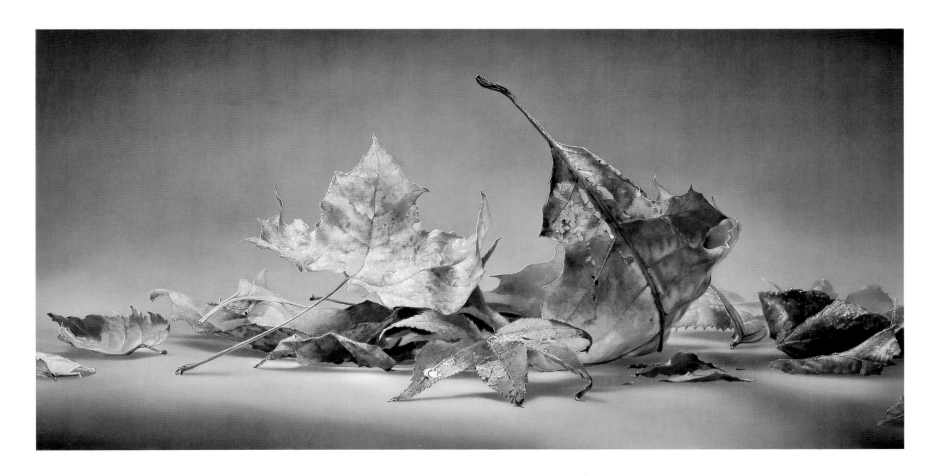

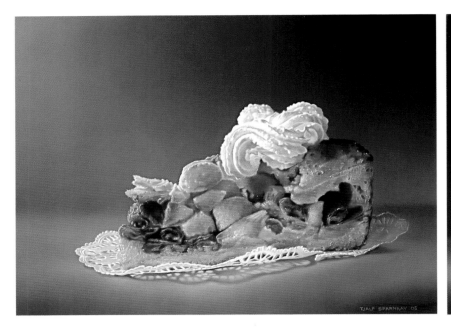

Apple Pie
2006
Oil on canvas
30 x 40 cm

Pastry with Berries
2002
Oil on canvas
40 x 60 cm

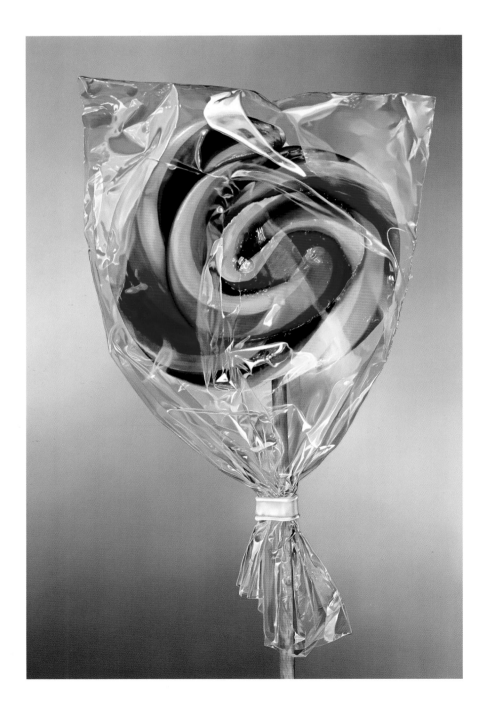

Lollypop
1999
Oil on canvas
150 x 100 cm

**Girl with a Pearl Earring
in Plastic**
2002
Oil on canvas
75 x 60 cm

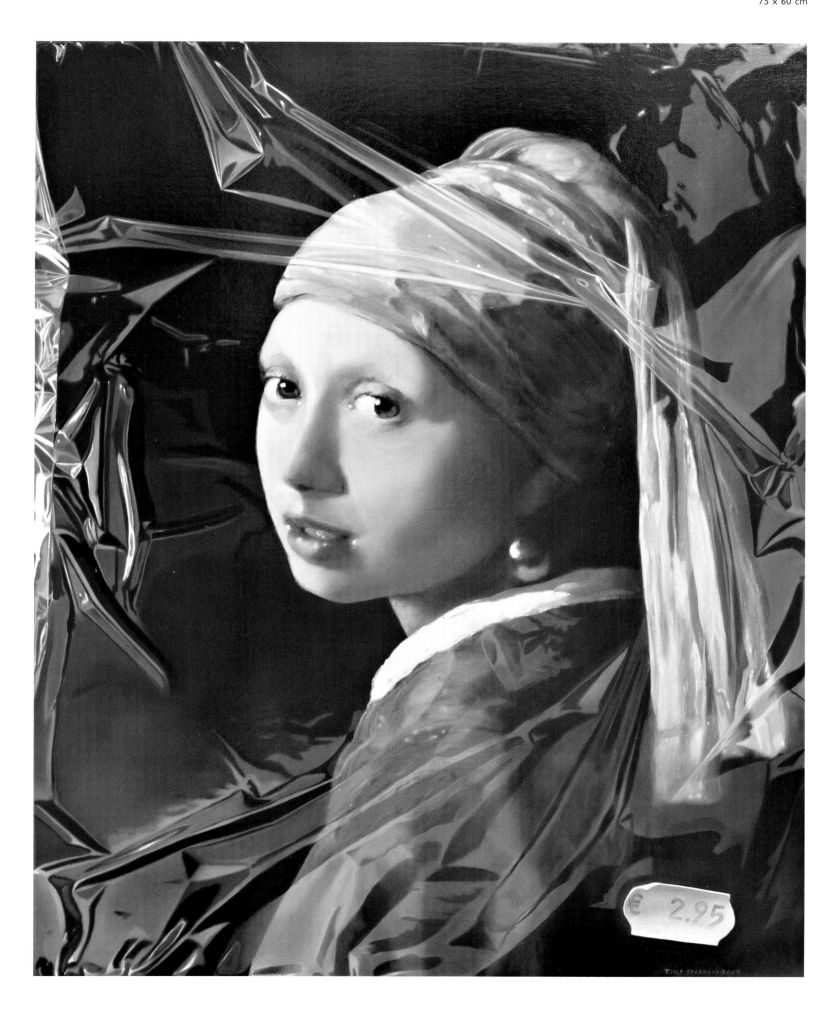

JAMES VAN PATTEN

EVERY PHOTOREALIST ARTIST seems to have his or her own explanation of what they do and why they do it. Not surprisingly, James Van Patten has his own distinctive explanation, as he has his own distinctive look and choice of subject matter. Almost alone of the Photorealists connected with Exactitude, his subject matter is entirely non-urban, and his preoccupation with water in the landscape is virtually unique. Whereas others may from time to time incorporate a stretch of river or a pool in an urban park into the scene painted, Van Patten concentrates entirely on the margins of water in the wild. Sometimes it may be a long shot involving a stretch of water bounded by a little piece of land; at other times it is an obsessively detailed close-up of the plants that grow with their roots in the water and their heads in the sky.

Van Patten is unmistakably a Photorealist, in that his paintings look as much as possible like photographs: indeed, it would be difficult to distinguish one of the original photographs from a reproduction of the painting based on it. This, of course, is quite deliberate and self-conscious:

> When I have found the image that I wish to paint, I use the intermediate eye of the camera to see the nuances that I have missed. The anomalies of the camera lens also provide additional information that exists only in the photograph of the image. By incorporating these qualities, such as a softening and colour-rimming of the edges, my paintings provide surprises to me and, I hope, to the viewer. From the beginning of the painting

process I know what the image is, but I am never sure what the picture will be when brought to paint.

Van Patten is distinctive in a number of other ways, too. Most Photorealists paint primarily or entirely in acrylic, which makes sense in terms of the speed of application and impermeability of the medium, facilitating a painted result closer to the effect of a photograph than would otherwise be possible. Van Patten does use acrylic, but he also works a lot in watercolour and mixed media including crayons and pencil. To obtain the requisite colour density and solidity of image in such media must be incredibly work intensive, but that surely contributes satisfactorily to the process of constant discovery that Van Patten values so highly in the whole business of painting.

Discovery is in fact the keynote of his work. Not for him the spectacular highlights of landscape. He seeks rather to penetrate deeper and deeper into the secret places:

> Though taken from nature, the imagery in my paintings might, at first glance, be unnoticed in the natural world. At best, a throwaway memory. Yet it is the mystery of reflection, shadow and light, and unexpected colour, that makes me want to paint these throwaway scenes.

We should never forget that one of photography's great assets in relation to the unaided human eye is its ability to seize the moment and fix it forever. Consequently, Photorealists can do something that the Impressionists wanted to do and could never quite achieve.

Shadow and Reflection
(detail)
2002
Acrylic on linen
122 x 183 cm

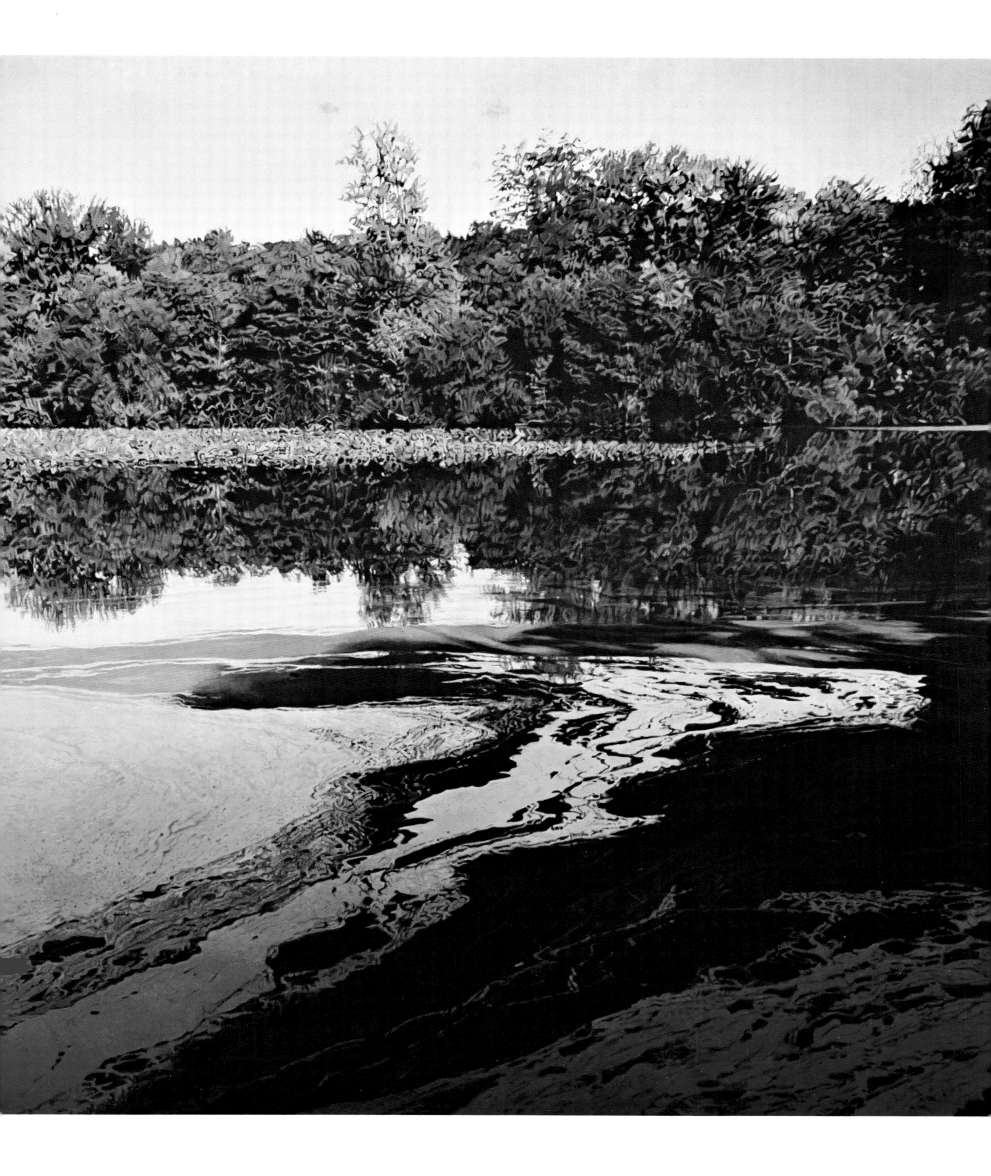

Study in Orange and Blue II
2006
Watercolour on paper
35 x 25.5 cm

Sunshine and Fog
2005
Watercolour on paper
25.5 x 35 cm

**Charlotte's Valley
Small Swamp**
2007
Watercolour on paper
26 x 34 cm

Growing Gloaming
2002
Watercolour on paper
25.5 x 35 cm

Spring Flooding
2005
Watercolour on paper
35 x 25.5 cm

Hudson Backwater
1992
Crayon and watercolour
on paper
21 x 86 cm

Lake Carnegie
1992
Crayon, coloured pencil and
watercolour on rag board
61 x 61 cm

Mist Morning
2005
Acrylic on linen
91.5 x 137 cm

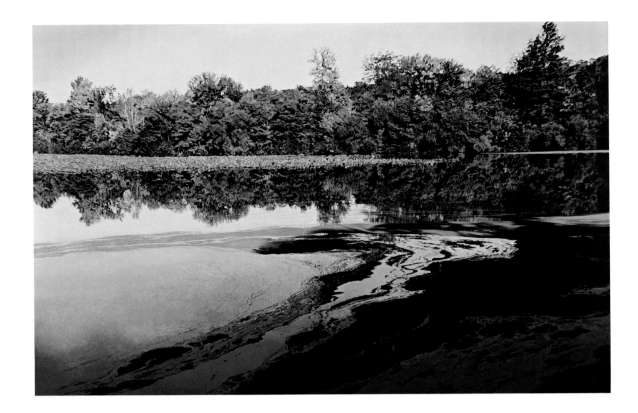

Shadow and Reflection
2002
Acrylic on linen
122 x 183 cm

The River Blyth
2006
Watercolour on paper
34 x 26 cm

Almost Unnoticed
2007
Watercolour
35 x 25.5 cm

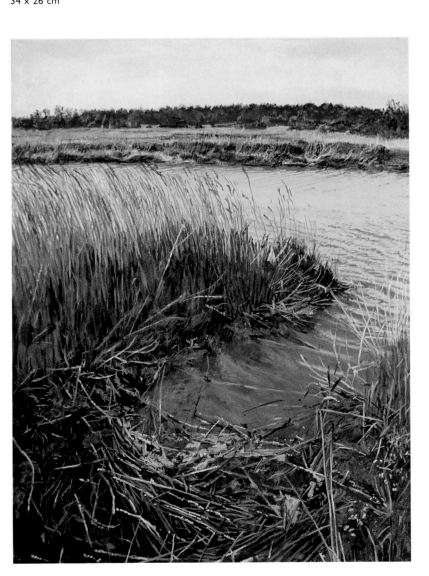

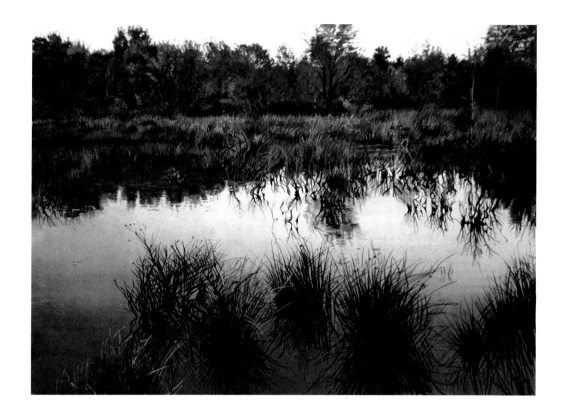

Just After
2001
Watercolour on paper
25.5 x 35 cm

**Study in Orange and Blue
with Other Colours**
1996
Acrylic on linen
122 x 122 cm

Over the Edge
2007
Acrylic on linen
122 x 152.5 cm

Blueberry Lake 1
1987
Acrylic on linen
122 x 183 cm

Flood Mud
2003
Watercolour on paper
25.5 x 35 cm

Blythe
2006
Watercolour on paper
25 x 35 cm

STEVE WHITEHEAD

USUALLY, IN FILMS AT LEAST, menace lurks in the shadows, depending for its effect on the way our imagination works on what we do not see, rather than zapping us with what we do. Not invariably, though. One of the Hitchcock sequences that everybody remembers is the one in *North by Northwest* in which, as Cary Grant traverses a newly ploughed field on a bright sunny day, a crop-dusting plane lazily hovering in the distance descends suddenly upon him, spitting bullets.

Some of Steve Whitehead's innocent-looking images of the English countryside have much the same effect. Rather more mysterious, though: looking at a painting like *The Road to Wold Newton*, we may find ourselves thinking of Coleridge's haunting lines:

> Like one, that on a lonesome road
> Doth walk in fear and dread,
> And having once turned round walks on
> And turns no more his head;
> Because he knows a frightful fiend
> Doth close behind him tread.

The question is, why do we feel that? There appears to be nothing untoward in the landscape we are looking at. It is a bright sunny day, with some clouds in the sky, more decorative than threatening; there is a neatly ploughed field to the right of the road, with the tractor far away in the distance. Nothing there to worry about, surely? Not even the prehistoric monument that enlivens Whitehead's *Landscape with Menhir* (2002), which might disturb someone who had read a story like M. R. James's *Reading the Runes* or *Whistle and I'll Come To You*, and remembers that no good comes to anybody who meddles with the mysterious past.

Does Whitehead intend his paintings to have this sort of effect on those that view them? Possibly not – it may well be a side effect of the technique he uses. We are familiar enough with Photorealism in a city context, but to have this relentless detailing applied to the gentle English countryside can be unnerving. It reminds us, if anything, of the unnatural precision with which the early Pre-Raphaelites depicted every leaf and petal, giving their scenes the extravagant, undiscriminating clarity one suspects can come only in an opium dream – a by no means impossible association for a generation that swore by laudanum, for strictly medical purposes of course.

Today's artists do not need drugs to obtain this effect. Why should they, when the camera is always at hand? It is difficult to pick up any clues to Whitehead's use of photography in his open, rural landscapes. But other paintings of his, like his *Sentinels* (2002), which shows a harbour-side building in a forced and distorted perspective which no human eye could capture without the aid of a wide-angle lens, would clearly indicate something of which anyway he makes no secret: that his extraordinary panoramic pictures derive directly from photographs.

Only, the photographs would be quite unremarkable, so the paintings' haunting effect must come entirely from the artist's creative input, transferring the photograph meticulously into paint. When Jack Mendenhall talks about 'visual alchemy', Whitehead unwittingly shows exactly what he means.

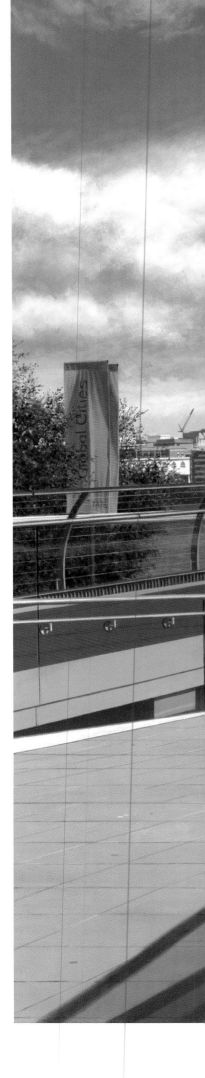

View North Over Millennium Bridge
(detail)
2008
Acrylic on canvas
100 x 162 cm

Aphrodite's Rock
1999
Oil on canvas
122 x 152.5 cm

Coast to Coast
2003
Oil on canvas
81 x 183 cm

Sentinels
2002
Oil on canvas
63 x 166 cm

Boat Sheds, Lindisfarne
2005
Oil on canvas
61 x 122 cm

Robin Hood's Bay
2006
Acrylic on canvas
79 x 99 cm

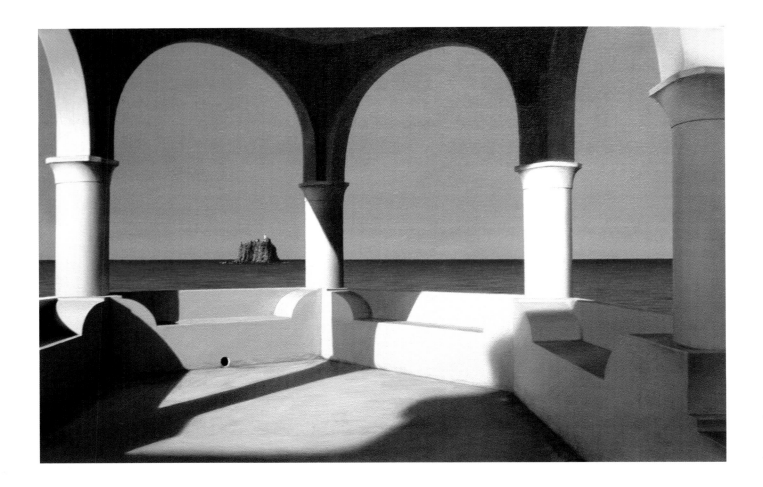

Strombolicchio
2004
Oil on canvas
43 x 61 cm

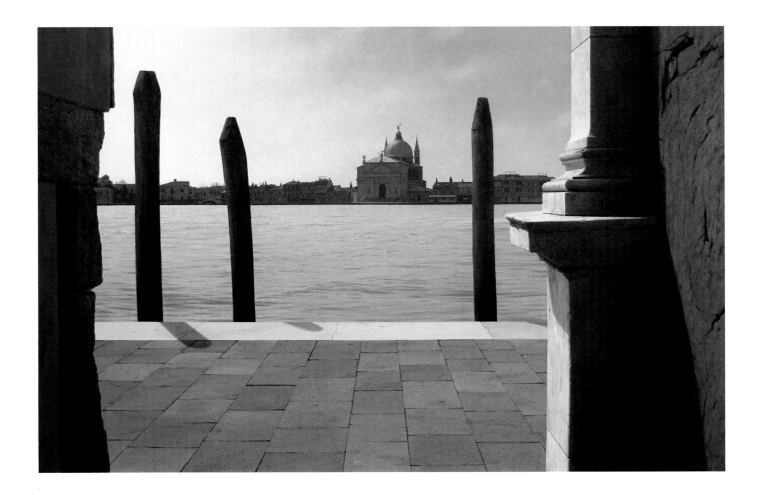

Il Redentore
2008
Acrylic on canvas
61 x 91.5 cm

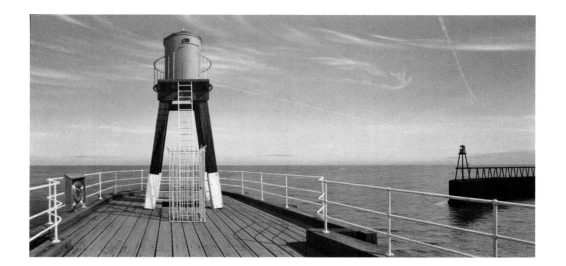

Two Lights
2004
Oil on canvas
61 x 122 cm

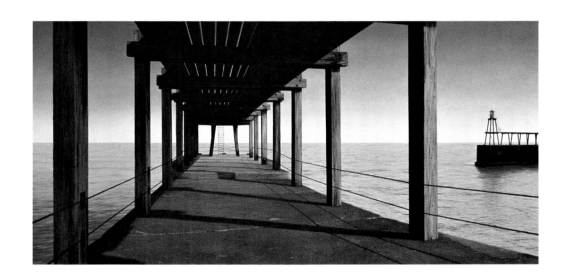

Whitby Jetty
2003
Oil on canvas
61 x 122 cm

Whitby Piers
2007
Acrylic on canvas
91.5 x 147.5 cm

Ticket to Ryde
2004
Oil on canvas
91.5 x 122 cm

Albert Hall and Memorial
2008
Acrylic on canvas
122 x 122 cm

Trafalgar Square Panorama
2008
Acrylic on canvas
64 x 168 cm

Millennium Bridge
2008
Acrylic on canvas
122 x 183 cm

**View North Over
Millennium Bridge**
2008
Acrylic on canvas
100 x 162 cm

Tower Bridge from City Hall
2008
Acrylic on canvas
122 x 183 cm

Thames Barrier
2008
Acrylic on canvas
122 x 183 cm

CRAIG WYLIE

THE TERMS 'PHOTOREALISM' AND 'HYPERREALISM' tend to be used interchangeably for certain kinds of realist painting – perhaps, obviously, of the most realistic kinds of painting. There may well be no practical differences in the ways the two kinds of painting are originated and elaborated. But there are surely some differences in the effect the two kinds have on the spectator. If anyone can make clear what these differences might be, it is Craig Wylie.

A true Photorealist painter glories in the photographic connection. Not only using photographs as source material, but making it explicit that a photograph is being painted rather than the reality within the photograph. At the very least, the distortions inevitable to a photograph are lovingly reproduced, in full consciousness that the human eye unaided does not, cannot, perceive things that way.

Wylie is not that kind of painter. He is undoubtedly a realist: his outlines are usually hard, his forms clearly defined. He has a deep concern for colour and texture, not merely because they are there, but for what they contribute to the overall composition, the patterns of tension and relaxation within the painting. Wylie's art is meticulously thought out, intellectual. It is all from reality, but reality carefully selected and rearranged in the light of the painter's very specific intentions.

In other words, Wylie is essentially a painters' painter: so much so that from his work we might be uncertain whether he had ever set eyes on a camera. It is notable that in discussions of his BP Portrait Prize winner *K* (2008), Craig talks in terms of a number of sittings – the sitter being his longtime girlfriend – rather than revealing the exact camera used and the exposures required. No doubt he does use photographs, if only as a sort of sketchbook, but the precise reproduction of one photograph in paint has never been part of his plan. Some idea of what he does want to do is given by his statement about his prize-winning portrait:

> On a formal level this work is about contradiction. I wanted to use a strictly classical composition, formal, even stiff, and then try to subvert the stillness these tenets imply. This internal friction between elements in the painting gives it its quiet dynamism. The gravity of the sitter's expression, enhanced by overhead light from the skylight in my studio, has as counterpart the crisp whiteness of the shirt, the irony and visual lightness of pink in the bright cardigan and spots. The compression created by the stripes on the shirt, accompanied by the variation in spots and colour, is also complemented in opposition by the grey/green background colour, which in itself is a contradiction, as it implies depth, but also appears to be a flat colourfield. This uncluttered quality is further irritated into balance by the texture and detailing of the cardigan and the undulating topography of form created through top lighting. Through these internal conflicts a visual magnetic torsion grips the structure of the work and propels the attitude of the sitter.

All this might almost suggest too much calculation on the part of the painter, especially when he goes on to theorise about the effect of the very large scale he has chosen, but the painting itself rebuffs any such notion, coming over as fresh and spontaneous. And it certainly makes it clear that Wylie's painting is not the work of an adept copyist, mechanically reproducing a single photograph, but of an artist who thinks deeply and effectively about his art.

K.R. (detail)
2005
Oil on linen
157 x 167 cm

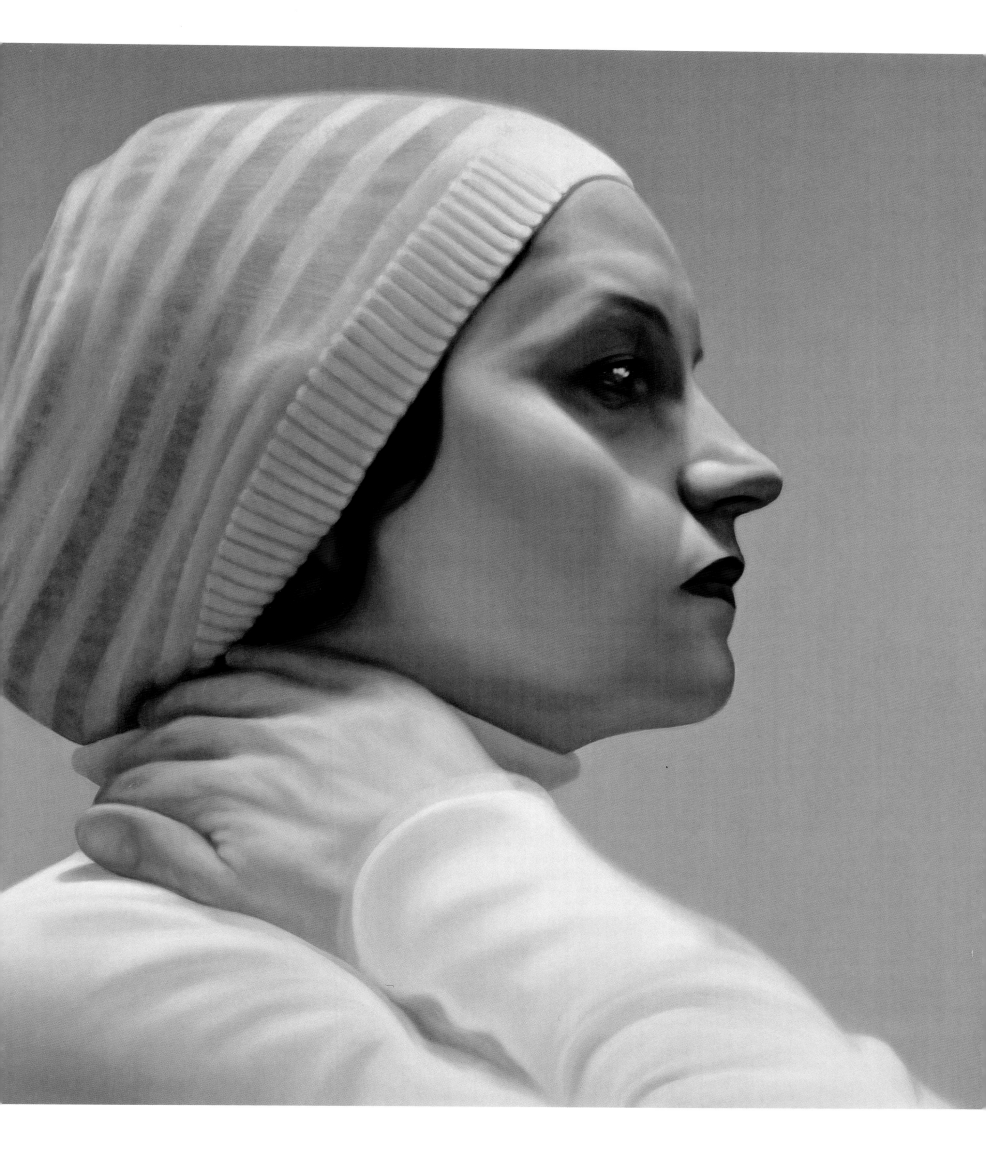

Naked Man Standing
2001
Oil on canvas
135 x 80 cm

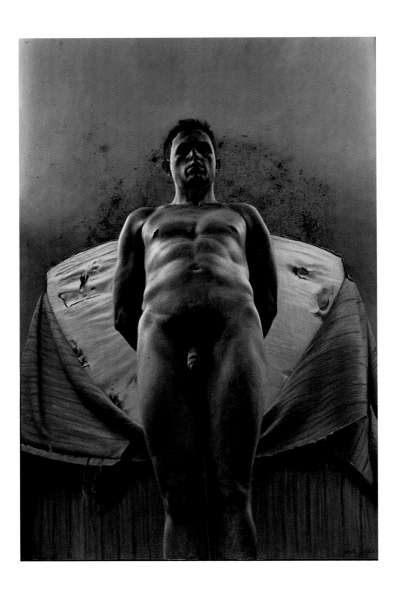

Woman on a Red Chair
2007
Oil on canvas
100 x 100 cm

Portrait of T.F.
2001
Oil on canvas
110 x 110 cm

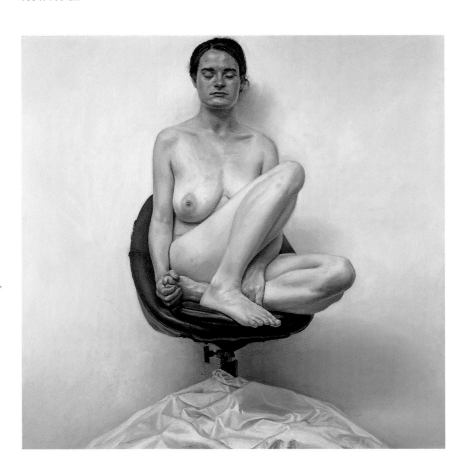

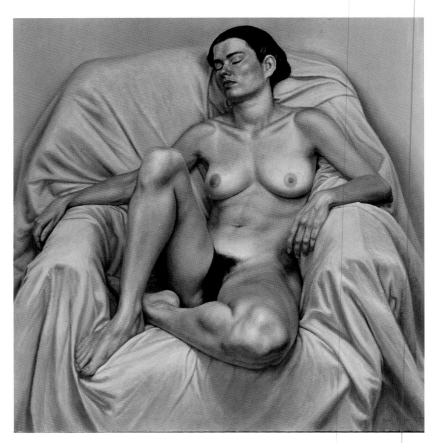

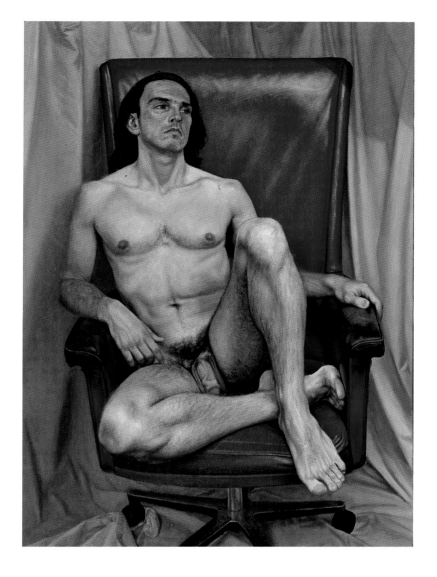

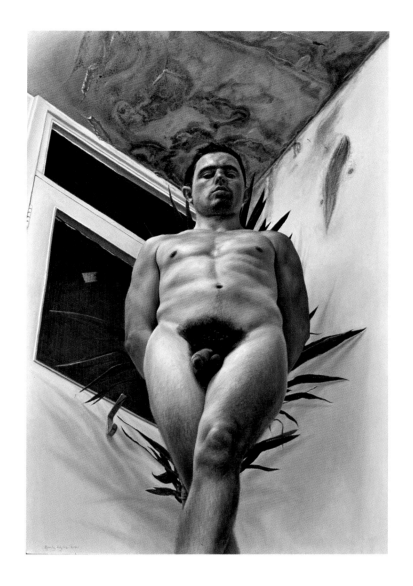

Naked Man on Red Chair
2000
Oil on canvas
135 x 80 cm

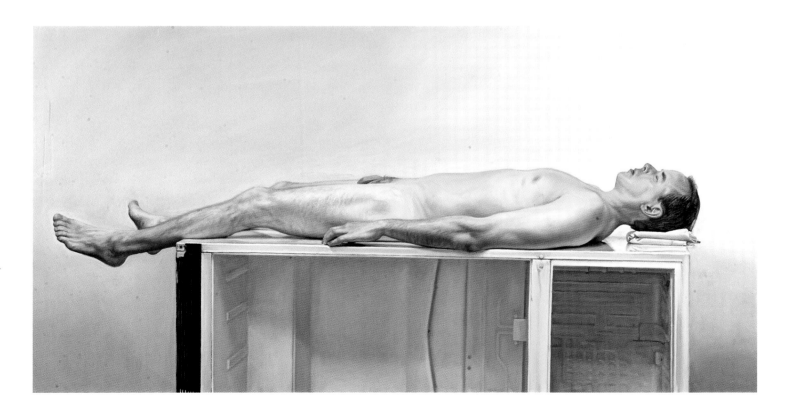

Convert
2008
Oil on linen
97 x 187 cm

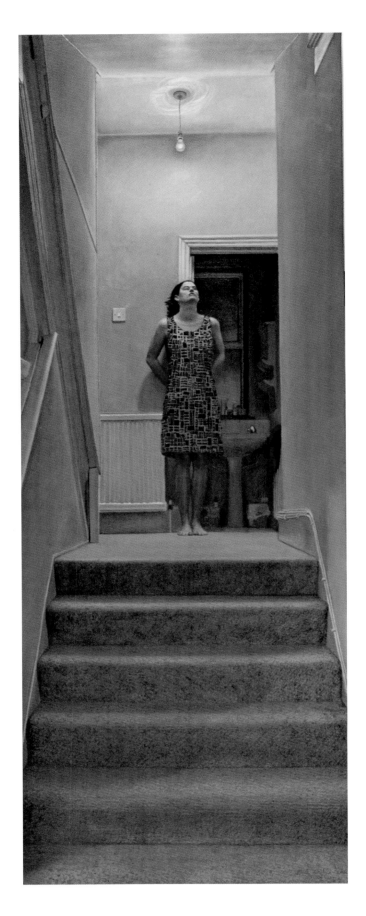

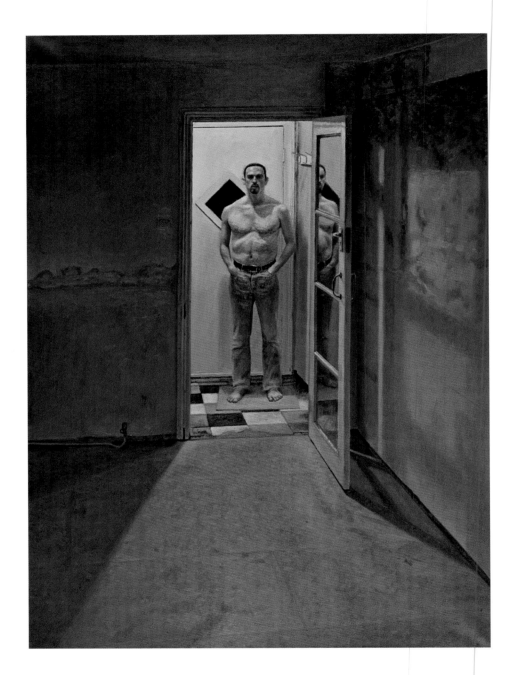

Woman on the Landing
2001
Oil on canvas
100 x 40 cm

Man in a Doorway
2001
Oil on canvas
90 x 60 cm

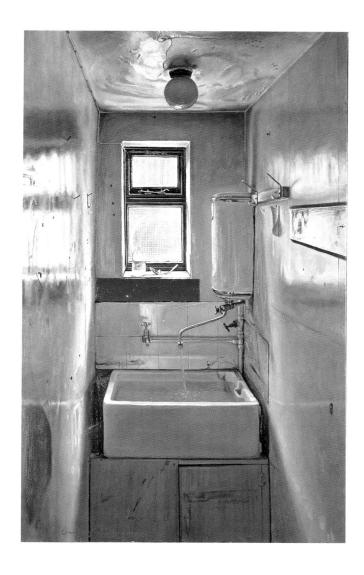

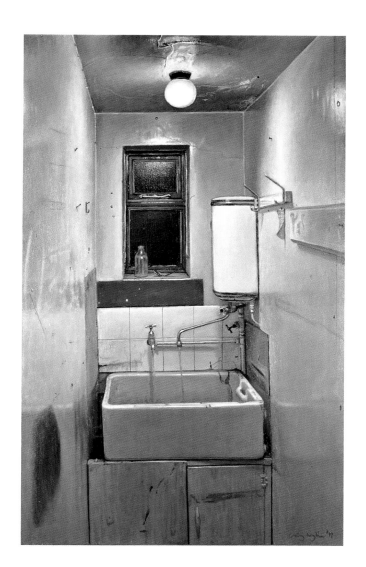

Studio Washroom, Day
1999
Oil on canvas
90 x 56 cm

Studio Washroom, Night
1999
Oil on canvas
90 x 56 cm

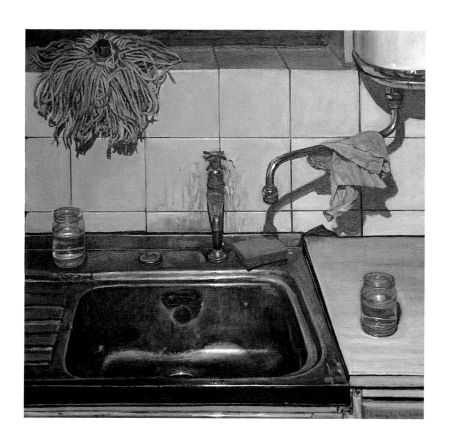

Studio Sink
1999
Oil on canvas
71 x 71 cm

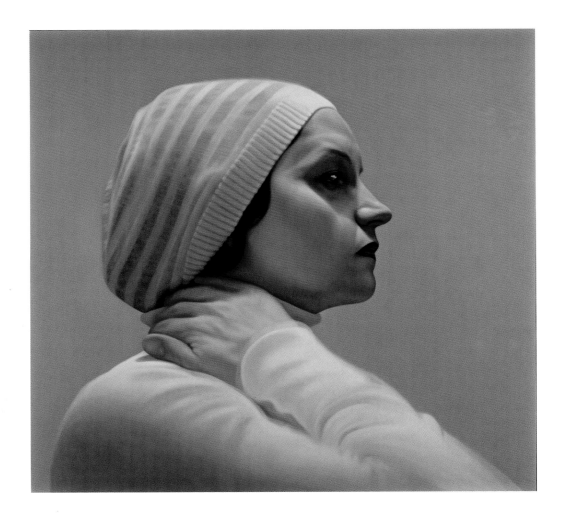

Doug
2003
Oil on canvas
60 x 85 cm

K.R.
2005
Oil on linen
157 x 167 cm

Mask (Self-Portrait)
2005
Oil on linen
165 x 165 cm

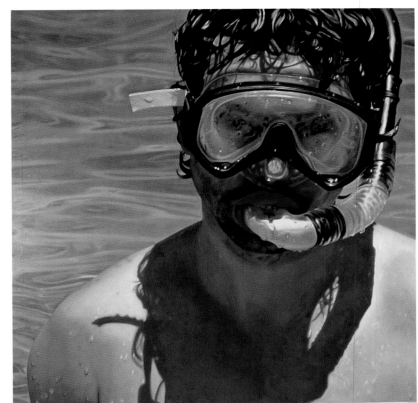

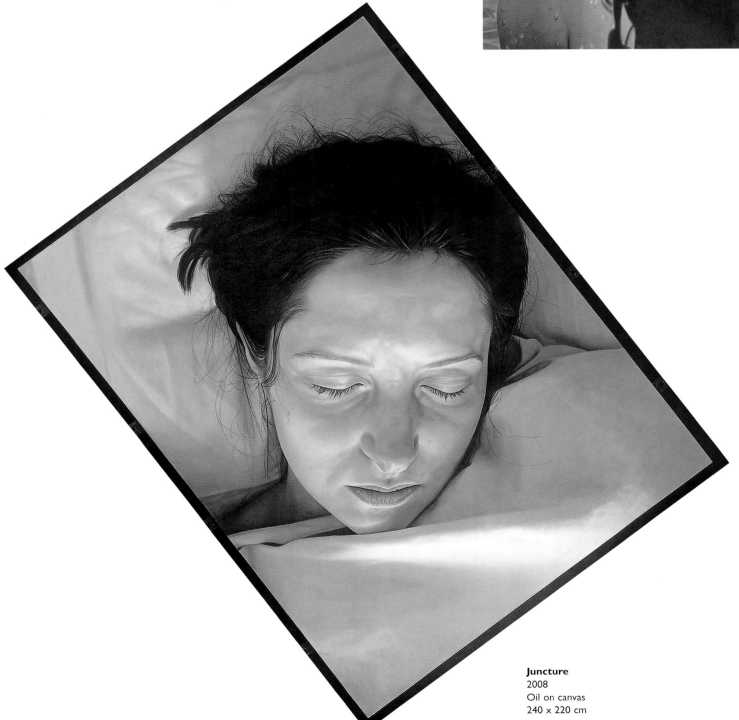

Juncture
2008
Oil on canvas
240 x 220 cm

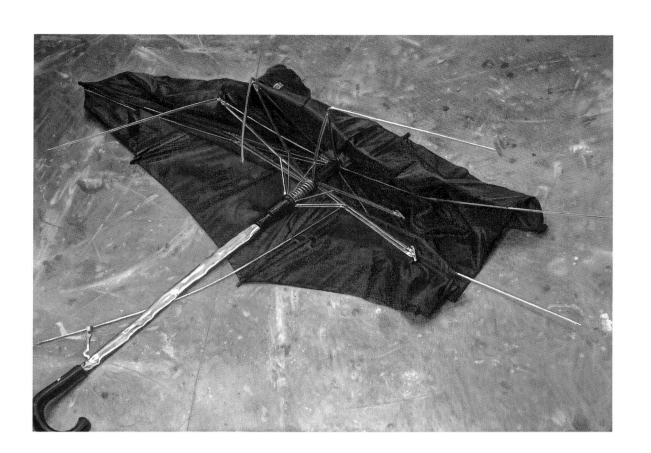

Broken Umbrella
2008
Oil on canvas
55 x 82 cm

Untitled (Pulse)
Diptych
2006
Oil on linen
183 x 260 cm

ARTISTS' BIOGRAPHIES

JOHN BAEDER

Born:

1938, South Bend, Indiana, USA

Education:

1960, Auburn University, Auburn, Ala.

Solo Exhibitions:

2003 O.K. Harris Works of Art, New York

2003– *Los Angeles Taco Trucks* (watercolours), Paul

2004 Kopeikin Gallery, Los Angeles, and other US cities

2004 *The Early Eighties* (watercolors), Cumberland Gallery, Nashville, Tenn.

2005 *Diners*, Galerie Patrice Trigano, Paris

2006 Plus One Gallery, London

2007– *Pleasant Journeys and Good Eats along the Way:*

2009 *A Retrospective Exhibition of Paintings by John Baeder*, Morris Museum of Art, Augusta, Ga., and other US cities

2008 O.K. Harris Works of Art, New York

Articles, Books, Catalogues:

John Baeder, *Gas, Food, and Lodging*, New York: Abbeville Press, 1982

John Baeder, *Diners*, New York: Harry N. Abrams, 1978, updated and reissued 1995

John Baeder, *Sign Language: Street Signs As Folk Art*, New York: Harry N. Abrams, 1996

This is America, exh. cat., Århus Kunstmuseum, Åarhus, Denmark, 2001

Louis K. Meisel and Linda Chase, *Photorealism at the Millennium*, New York: Harry N. Abrams, 2002

Ray Zone, 'John Baeder', *ArtScene*, June 2003

'Roadside America for the 21st Century', *Los Angeles Times Sunday Magazine*, 1 June 2003, p. 10

Photorealism: Cultural Icons, exh. cat., Jonathan Novak Gallery, Los Angeles, 2006

Jay Williams (ed.), *Pleasant Journeys and Good Eats along the Way: The Paintings of John Baeder*, Jackson, Miss. and Augusta, Ga.: University of Mississippi Press/Morris Museum of Art, 2007

Linda Chase, *Photorealist Watercolors: The PieperPower Collection*, Milwaukee, Wisc.: PPC Partners Inc., 2007

Bartholomew F. Bland, *I Want Candy: The Sweet Stuff in American Art*, exh. cat., Hudson River Museum, Yonkers, N.Y., 2007

PAUL BELIVEAU

Born:

1954, Quebec City, Canada

Education:

1977, BA Visual Arts, Université Laval, Quebec City, Canada

Solo Exhibitions:

2003 *Les humanités*, Galerie de Bellefeuille, Montréal

 Les humanités, Drabinsky Gallery, Toronto

2004 *Apparence de faux*, Centre d'exposition de Baie-Saint-Paul

2005 *New Paintings*, Drabinsky Gallery, Toronto

2005 *Œuvres récentes*, Galerie de Bellefeuille, Montréal

2005 *New Paintings*, Arden Gallery, Boston, Mass.

2006 *New Works*, Stricoff Fine Art, New York

2007 Robert Kidd Gallery, Birmingham, Mich.

2007 Arden Gallery, Boston, Mass.

2007 Galerie de Bellefeuille, Montréal

2007 Stricoff Fine Arts, New York
2007 Drabinsky Gallery, Toronto

Articles, Books, Catalogues:

Francine Paul and David Burnett, *Paul Béliveau: Les apparences*, exh. cat., Drabinsky Gallery, Toronto and other locations, 1992

Robert Bernier, *Un Siècle de peinture au Québec, nature et paysage*, Quebec City: Les Éditions de l'Homme, 1999, pp. 278, 287

Dany Quine, *Paul Béliveau, le théâtre des correspondances*, exh. cat., Galerie de Bellefeuille, Montréal, 2001

Seamus Kealy, *Les Humanités: New Work by Paul Béliveau*, exh. cat., Drabinsky Gallery, Toronto, 2003

Michel Bois, 'Du visible à l'invisible', *Le Soleil*, 31 July 2004, p. C8

Bertrand Bergeron et al., *L'atelier des apparences: peintures nouvelles*, Quebec City: L'instant même, 2004

Yves Lacasse, John R. Porter et al., *La Collection du Musée national des beaux-arts du Québec. Une histoire de l'art du Québec*, Quebec City: Musée national des beaux-arts du Québec, 2004, p. 199

Debbie Hagan, 'Paul Béliveau: Les Humanités', *Art New England*, June/July 2005, p. 36

Joshua Rose, 'Paul Béliveau – Shelf Life', *American Art Collector*, September 2007, pp. 116–21

PEDRO CAMPOS

Born:
1966, Madrid, Spain

Education:
1988, Escuela Superior de Conservación y Restauración de Bienes Culturales, Madrid

Solo Exhibitions:
1999 Casino de Salamanca
2000 Galeria Almirante, Lugo
2000 Casino de La Union, Segovia
2002 Galería Detursa, Madrid
2004 Fornara Gallery, Marbella

Articles, Books, Catalogues:

Joaquín Castro Beraza, 'The Realism of Pedro Campos', in exh. cat., Galería Detursa, Madrid, 2000

Rose Mary White, 'Pedro Campos', in exh. cat., Fornara Gallery, Marbella, 2004

RANDY DUDLEY

Born:
1950, Peoria, Illinois, USA

Education:
1973, BS, Illinois State University, Normal, Ill.
1976, MFA, Virginia Commonwealth University, Richmond, Va.

Solo Exhibitions:
2003 O.K. Harris Works of Art, New York
2005 O.K. Harris Works of Art, New York

Articles, Books, Catalogues:

Louis K. Meisel and Linda Chase, *Photorealism at the Millennium*, New York: Harry N. Abrams, 2002

Seeing Photographically: Photorealist Paintings, The Sydney and Walda Besthoff Collection, exh. cat., New Orleans and Los Angeles, 2004

Louis K. Meisel and Linda Chase, *American Photorealism*, exh. cat., Iwate Museum of Art, Iwate, Japan, 2004

Exactitude III, exh. cat., Plus One Gallery, London, 2006

Abby Cronin, 'Hello Photorealism – Goodbye Pop Art', *American in Britain Magazine*, Summer 2006

DAVID FINNIGAN

Born:
1964, Fulford, North Yorkshire, England

Education:
1985–88, BA Fine Art, Falmouth School of Art

Group Exhibitions:
2003 *Exactitude*, Plus One Gallery, London
2004 *Exactitude II*, Plus One Gallery, London
2006 *Exactitude III*, Plus One Gallery, London
2008 *David Finnigan and Simon Hennessey*, Plus One Gallery, London

Articles, Books, Catalogues:
American Art Collector, May 2008

SIMON HARLING

Born:
1950, Colchester, Essex, England

Education:
1967–68, London College of Printing

Group Exhibitions:

2004 *Four Square*, Lamont Gallery, Phillips Exeter Academy, N.H.

2005 *California Visions*, Long Beach Museum of Art, Long Beach, Calif.

2005 *A Celebration of South Maine Artists*, University of New England, Portland, Maine

2006 *Exactitude III*, Plus One Gallery, London

2007 *Myths, Messages and Morals*, Southern New Hampshire University, Manchester, N.H.

2007 *Biennial*, Portland Museum of Art, Portland, Maine

2008 Writer and director of award-winning short film *Under the Hood*

Articles, Books, Catalogues:

ArtNews, July 1985

'The World Trader', *NH Port Authority Magazine*, 1994

Getting Real, South Bend Regional Museum of Art, South Bend, Ind., 1994

Island Light; Isle of Shoals, Portsmouth, N.H.: Blue Tree Publishing, 2005

Exactitude III, exh. cat., Plus One Gallery, London, 2006

Biennial, exh. cat., Portland Museum of Art, Portland, Maine, 2007

Visions in Granite, vol. 2, Portsmouth, N.H.: Blue Tree Publishing, 2008

CLIVE HEAD

Born:
1965, Maidstone, Kent, England

Education:
1983–86, BA Visual Art, University College of Wales, Aberystwyth
1987–89, MPhil Visual Arts, University of Lancaster

Solo Exhibitions:

2003 *Clive Head, New Paintings*, Louis K. Meisel Gallery, New York

2005 *View of London from Buckingham Palace*, commissioned to commemorate the Golden Jubilee of HM The Queen, Museum of London

2007 *Clive Head, New Paintings*, Marlborough Fine Art, London

Articles, Books, Catalogues:

Kate Nicholas, 'Too Real for Comfort', *Artists and Illustrators*, April 1997

Linda Chase and Tom Flynn, *Clive Head, Paintings 1996–2001*, Blains Fine Art, 2001

Louis K. Meisel and Linda Chase, *Photorealism at the Millennium*, New York: Harry N. Abrams, 2002

John A. Parks, 'Studies Deserving Study', *American Artist*, June 2002

Gianni Mercurio, *Iperrealisti*, Rome: Viviani, 2003

Gregory Saraceno and Clive Head, *The Prague Project*, exh. cat., Roberson Museum and Science Center, Binghamton, N.Y., 2004

Maev Kennedy, 'Panoramic Painting from Buckingham Palace on Display', *The Guardian*, 12 March 2005

Robert Neffson and Clive Head, *Clive Head, New Paintings*, exh. cat., Marlborough Fine Art, London, 2007

GUS HEINZE

Born:
1926, Bremen, Germany

Education:
1947–50, Art Students League, New York and School for Visual Arts, New York

Solo Exhibitions:

2002 Bernarducci.Meisel.Gallery, New York

2003 Modernism Inc., San Francisco

2004 David Klein Gallery, Birmingham, Mich.

2004 Plus One Gallery, London

2004 Bernarducci.Meisel.Gallery, New York

2006 Bernarducci.Meisel.Gallery, New York

Articles, Books, Catalogues:

Robert McDonald, 'Photorealism as Abstraction', *Artweek*, No. 10, 1985

'Artwalk Returns to San Francisco', *Art-Talk*, February 1988, p. 38

Harry Roche, 'Critic's Choice', *San Francisco Bay Guardian*, 28 June 1989, p. 57

David Bonetti, 'S.F. Art World Knows No Season', *San Francisco Examiner*, 25 June 1991, p. C1.

Louis K. Meisel, *Photorealism Since 1980*, New York: Harry N. Abrams, 1993

Katrin Bettina Müller, 'Trash-Kultur und Status-Symbole', *Kunst und Antiquitäten*, No. 15417, 14 October 1995, p. B3

Peter Frank (intro.), *Gus Heinze*, exh. cat., Mendenhall Gallery, Pasadena, Calif., 1997

Louis K. Meisel, *Photorealism at the Millennium*, New York: Harry N. Abrams, 2002

Jonathon Keats et al., *Modernism, Twenty-Five Years, 1979–2004*, Los Angeles: Modernism Inc., 2004

'Summer Suite Group Show', *American Art Collector*, June 2006

American Art Collector, September 2006

SIMON HENNESSEY

Born:
1973, Birmingham, England

Education:
2000–2003, BA Fine Art, Solihull College

Group Exhibitions:
2006	*Exactitude III*, Plus One Gallery, London
2007	*ArtLondon 2007*, Royal Hospital Chelsea, London
2007	Plus One Gallery, London
2007	*FORM London*, Olympia, London
2007	*Birmingham Open 07*, Birmingham Museum & Art Gallery
2007	Plus One Gallery, London
2008	*David Finnigan and Simon Hennessey*, Plus One Gallery, London
2008	*Summer Show*, Plus One Gallery, London
2008	*ArtLondon 2008*, Royal Hospital Chelsea, London

Articles, Books, Catalogues:
A & N Artists' Newsletter, August 2003

Metro, September 2004

Birmingham Mail, 12 June 2006

Exactitude III, exh. cat., Plus One Gallery, London 2006

'The London Connection', *American Art Collector*, November 2006

Art London, exh. cat., Royal Hospital Chelsea, London 2006

Simon Hennessey and David Finnigan, 'Recording the Visual Experience', *American Art Collector*, May 2008

ANDREW HOLMES

Born:
1947, Bromsgrove, West Midlands, England

Education:
1970–71, Part I and Part II, RIBA, London
1972, Diploma, Architectural Association, London

Solo Exhibitions:
2002	*Head Light*, Plus One Gallery, London
2003	*Gas Tank City*, Plus One Gallery, London
2007	*The Other Side of Nowhere*, Getty Research Institute, Los Angeles
2007	*9 Volt Heart*, Getty Research Institute, Los Angeles
2007	*No Particular Place*, Getty Research Institute, Los Angeles
2008	*Light Signatures*, Sefton Park, Liverpool

Articles, Books, Catalogues:
Cedric Price, *The Harvest of a Quiet Eye*, London: Architectural Association, 1986

Lawrence Alloway et al., *Modern Dreams*, Cambridge, Mass.: MIT Press, 1988

Thomas Crow, *Art in the Common Culture*, London and New Haven: Yale University Press, 1997

Naomi Salaman and Ronnie Simpson, *Postcards on Photography*, exh. cat., Cambridge Darkroom Gallery, 1998

Ross Alderson, *BlowUp: New Painting and Photoreality*, exh. cat., St Paul's Gallery, Birmingham, 2004

BEN JOHNSON

Born:
1946, Llandudno, Wales

Education:
MA, Royal College of Art, London

Solo Exhibitions:
2001	*Jerusalem, The Eternal City*, Chester Beatty Museum, Dublin
2002	*Still Time*, Blains Fine Art, London
2008	*Ben Johnson's Liverpool Cityscape 2008 and the World Panorama Series*, Walker Art Gallery, Liverpool
2008	Artist in Residence, Walker Art Gallery, Liverpool

Articles, Books, Catalogues:

Charles Jencks, *Ben Johnson – Structuring Space*, exh. cat., Fisher Fine Art, London, 1986

Charles Jencks, *The New Moderns*, London: Academy Editions, 1990

Colin Amery, 'Reflections on Infinity', *Perspectives*, August 1995

Keith Patrick, *Oil on Canvas*, London: BBC Books, 1997

Doris Lockhart Saatchi, *Still Time*, exh. cat., Blains Fine Art, London, 2002

Helen Castle and Ivan Margolius, 'At the Still Point of the Turning World', *Architectural Design*, vol. 73, no. 3, May/June 2003

Steve Pill, 'My Studio', *Artists and Illustrators*, February 2008

Ann Bukantas, *Cityscape: Ben Johnson's Liverpool*, Liverpool University Press, 2008

CARL LAUBIN

Born:
1947, New York, USA

Education:
1973, B.Arch., Cornell University, Ithaca, N.Y.

Solo Exhibitions:

2003 *Stone Guests*, July Riverhouse Gallery, Walton on Thames

2003 *Classic, Romantic, Modern*, Plus One Gallery, London

2004 *Strong Reason and Good Fancy*, Plus One Gallery, London

2007 *Carl Laubin: Elegos*, Castle Howard, York

2007 *Verismo*, Plus One Gallery, London

Articles, Books, Catalogues:

Richard Economakis (ed.), *Building Classical: A Vision of Europe and America*, London: Academy Editions, 1993, pp. 12, 40, 43, 48, 81, 87ff.

London in Paint, Paintings in the Collection of the Museum of London, Museum of London, 1996, pp. 450, 499

London Arts Cafe Newsletter, no. 11, Autumn 2002, cover, pp. 10, 11

'A Classical Fantasia', *Apollo Magazine*, March 2006, pp. 94–97

David Watkin and John Russell Taylor, *Carl Laubin, Paintings*, London: Philip Wilson Publishers and Plus One Publishing, 2007

'A Broad Canvas of Romance and Fantasy', *Building Design Magazine*, 26 October 2007

DAVID LIGARE

Born:
1945, Oak Park, Illinois, USA

Education:
1963–65, Art Center College of Design, Los Angeles

Solo Exhibitions:

2002 *Viewpoint: The Pastures of Heaven, National Steinbeck Center*, Salinas, Calif.

2002 *Objects of Intention: Still Life Paintings*, Hackett-Freedman Gallery, San Francisco

2003 *Sea Paintings*, Koplin Del Rio Gallery, West Hollywood, Calif.

2005 *Offerings: A New History*, Plus One Gallery, London

2006 *Ritual Offerings*, Koplin Del Rio Gallery, Los Angeles

2007 *Aparchai*, Hackett-Freedman Gallery, San Francisco

Articles, Books, Catalogues:

David Ligare: Various Structures, exh. cat., Koplin Gallery, Los Angeles, 2000

Artists of the Ideal: Nuovo Classicismo, exh. cat., Galleria d'Arte Moderna, Verona, 2002

Kathryn McKenzie Nichols, 'David Ligare: Paintings with a Steinbeck Point of View', *The Monterey County Herald*, 30 April 2002, p. D1

Rick Deragon, 'A Certain Slant of Light', *The Weekly*, 25 April 2002, p. 32

Susan Laudauer, William H. Gerdts and Patricia Trenton, *The Not-So-Still Life – A Century of California Painting and Sculpture*, Berkeley, Calif.: University of California Press, 2003

Donald Kuspit, *California New Old Masters*, Newport Beach, Calif.: Literary Press Publishing, 2004

Ben Bamsey, 'The Balancing Act of David Ligare', *Artworks*, Summer 2005, pp. 21–30

Donald Kuspit, *New Old Masters*, exh. cat., National Museum, Gdansk, Poland, 2005

John O'Hern, 'Collecting Still Life Paintings', *American Art Collector*, April 2006, pp. 40–44

'Exhibitions', *American Arts Quarterly*, Winter 2007, pp. 63–64

CHRISTIAN MARSH

Born:
1979, Dudley, West Midlands, England

Education:
1999–2002, BA Illustration, University of Wolverhampton
2002–4, MA Illustration, University of Wolverhampton

Group Exhibitions:
2007 Plus One Gallery, London
2007 *ArtLondon*, Royal Hospital Chelsea, London
2008 *Summer Show*, Plus One Gallery
2008 *ArtLondon*, Royal Hospital Chelsea, London
2008 *Exactitude IV*, Plus One Gallery
2008 *Celebrating Palladio*, Plus One Gallery

TOM MARTIN

Born:
1986, Wakefield, England

Education:
2004–2005, Art Foundation Course, Rotherham College of
Arts and Technology
2005–2008, BA Interdisciplinary Art and Design, University
of Huddersfield

Group Exhibitions:
2005 The North Street Gallery, Leeds
2006 The Pump House Gallery, Harrogate
2007 Rotherham Open Art Exhibition
2007 Derby City Open Art Exhibition
2008 *Summer Show*, Plus One Gallery, London

Articles, Books, Catalogues:
Principles (organised by the British Red Cross), catalogue,
 2005
Barnsley Chronicle, 20 June 2008
Artists Open Studios South Yorkshire (organised by Open Up
 Sheffield), catalogue, 2008

JACK MENDENHALL

Born:
1937, Ventura, California, USA

Education:
1968, BFA, California College of Arts and Crafts, Oakland,
Calif.
1970, MFA, California College of Arts and Crafts, Oakland,
Calif.

Solo Exhibitions:
2002 O.K. Harris Works of Art, New York
2006 O.K. Harris Works of Art, New York

Articles, Books, Catalogues:
Louis K. Meisel and Linda Chase, *Photorealism at the
 Millennium*, New York: Harry N. Abrams, 2002
Margaret Lee, 'Reviews: Fifth Annual Realism Invitational',
 ARTnews, September 2003, p. 139
Seeing Photographically: Photorealist Paintings, The Sydney
 and Walda Besthoff Collection, exh. cat., New Orleans
 and Los Angeles, 2004
Louis K. Meisel and Linda Chase, *American Photorealism*,
 exh. cat., Iwate Museum of Art, Iwate, Japan, 2004
Exactitude III, exh. cat., Plus One Gallery, London, 2006
Abby Cronin, 'Hello Photorealism – Goodbye Pop Art',
 American in Britain Magazine, Summer 2006

ROBERT NEFFSON

Born:
1949, New York, USA

Education:
1971, BFA, Boston University School of Fine Arts, Boston,
Mass.
1973, MFA, Boston University School of Fine Arts, Boston,
Mass.

Solo Exhibitions:
1997 Gallery Henoch, New York
2001 *Recent Work*, Hammer Galleries, New York
2004 *Selected Works*, Hammer Galleries, New York
2009 *Solo Exhibit*, Hammer Galleries, New York (April
 2009)

Articles, Books, Catalogues:

Meredith Mendelson, 'Robert Neffson – Recent Paintings', *Art News*, April 2004

Robert Neffson – Recent Paintings, exh. cat., Hammer Galleries, New York, 2004

Robert Neffson, *Clive Head – Recent Painting*, exh. cat., Marlborough Fine Art, London, 2007

'Robert Neffson – Ponts de Paris', *New York Daily News*, 25 January 2008

Celebrating 80 Years, 1928–2008: Contemporary Artists, exh. cat., Hammer Galleries, New York, 2008

CYNTHIA POOLE

Born:
1956, Bulawayo, Zimbabwe

Education:
1975–77, RIBA part I, University of the Witwatersrand, South Africa
1985, Dip.Arch., University of Westminster
1998, PhD, University of Westminster

Solo Exhibitions:
2006 Plus One Gallery, London

Articles, Books, Catalogues:
American Art Collector, February 2007

FRANCISCO RANGEL

Born:
1971, Querétaro, Mexico

Education:
1995, B.Arch., Querétaro, Mexico
2002, MA Theory and Practice of Contemporary Art, Complutense University of Madrid

Solo Exhibitions:
2004 *Col tempo*, Galeria Marieschi, Milan
2006 *Rastros del cine mexicano contemporaneo*, Museo Regional de Querétaro, Mexico
2007 *The Bridges of London*, Plus One Gallery, London

Articles, Books, Catalogues:
Col tempo, exh. cat., Galeria Marieschi, Milan, 2004

Rastros del cine mexicano contemporaneo, exh. cat., Museo Regional de Querétaro, Mexico, 2006

The Bridges of London, exh. cat., Plus One Gallery, London, 2007

'The Bridges of London', *American Art Collector*, July 2007

JOHN SALT

Born:
1937, Birmingham, England

Education:
1952–58, National Diploma in Design, Birmingham College of Art
1958–60, Diploma in Fine Arts, Slade School of Fine Art, London
1969, MFA, Maryland Institute College of Art, Baltimore, Md.

Solo Exhibitions:
2000 O.K. Harris Works of Art, New York
2003– *The Hidden Hand: John Salt*, Southampton City Art
2004 Gallery
2007 Oriel Davies Gallery, Newtown, Wales

Articles, Books, Catalogues:
Gerald Silk, *Automobile and Culture*, New York: Harry N. Abrams, 1984

Vivien Raynor, 'Seeing Beauty or Problems', *New York Times*, 6 October 1991, p. 14

Eileen Watkins, 'Art', *New Jersey Star-Ledger*, 11 October 1991, p. 49

Louis K. Meisel, *Photorealism Since 1980*, New York: Harry N. Abrams, 1993

Louis K. Meisel and Linda Chase, *Photorealism at the Millennium*, New York: Harry N. Abrams, 2002

Seeing Photographically: Photorealist Paintings, The Sydney and Walda Besthoff Collection, exh. cat., New Orleans and Los Angeles, 2004

Louis K. Meisel and Linda Chase, *American Photorealism*, exh. cat., Iwate Museum of Art, Iwate, Japan, and other locations, 2004

An American Odyssey 1945–1980, exh. cat., Circulo de Bellas Artes, Madrid, and other locations, 2004

Cars and Ketchup: Photorealist Images of the American Landscape, Herbert F. Johnson Museum of Art, New York, 2005

CESAR SANTANDER

Born:
1947, near Cadiz, Spain

Education:
1969, BFA, Pratt Institute, New York
1972, MFA, Pratt Institute, New York

Solo Exhibitions:
2001 Modernism Inc., San Francisco
2003 Peterson Fine Art, Toronto, Ontario
2005 Plus One Gallery, London
2007 Plus One Gallery, London

Articles, Books, Catalogues:
'The Tin Toy Art of Cesar Santander', *Airbrush Action Magazine*, October 1996
John E. Bowlt and Jonathon Keats, *Modernism: Twenty-Five Years: 1979–2004*, San Francisco: Modernism Inc., 2004

BEN SCHONZEIT

Born:
1942, Brooklyn, New York, USA

Education: 1960–64, BFA, The Cooper Union, New York

Solo Exhibitions:
2002 Michael Berger Gallery, Pittsburgh, Penn.
2002 *The Secret Schonzeit*, Butler Institute of American Art, Youngstown, Ohio
2003 Elaine Baker Gallery, Boca Raton, Fla.
2004 Gerald Peters Gallery, New York
2005 Elaine Baker Gallery, Boca Raton, Fla.
2005 Holden Luntz Gallery, Palm Beach, Fla.
2006 Plus One Gallery, London
2007 Elaine Baker Gallery, Boca Raton, Fla.
2007 Gerald Peters Gallery, New York
2007 Stable Gallery, Roundstone, County Galway, Ireland

Articles, Books, Catalogues:
Louis K. Meisel, *Photorealism*, New York: Harry N. Abrams, 1972
Charles Riley, *Ben Schonzeit: Paintings*, New York: Harry N. Abrams, 2001

Hypermental, Rampant Reality 1950–2000: From Salvador Dali to Jeff Koons, exh. cat., Kunsthaus, Zurich and Hamburger Kunsthalle, Hamburg, 2001
Double Take: Photorealism from the 1960s and the 1970s, exh. cat., Rose Art Museum, Waltham, Mass., 2005
American Photorealism, exh. cat., Zimmerling Museum of Art, Rutgers University, N.J., 2005
Valerie Ann Leeds, *Ben Schonzeit: Four Decades*, exh. cat., Gerald Peters Gallery, New York, 2007

STEVE SMULKA

Born:
1949, Detroit, Michigan, USA

Education:
1967–71, School of Visual Arts, New York
1971–73, MFA, University of Massachusetts

Solo Exhibitions:
2004 Klaudia Marr Gallery, Santa Fe, N. Mex.
2006 Klaudia Marr Gallery, Santa Fe, N. Mex.
2007 Plus One Gallery, London

Articles, Books, Catalogues:
'The State of the Realist Nation', *American Art Collector*, October 2005
'Upcoming Show', *American Art Collector*, September 2006
John O'Hern, 'Rarified Air', *American Art Collector*, July 2007

TJALF SPARNAAY

Born:
1954, Haarlem, The Netherlands

Solo Exhibitions:
2001 Tjalf Sparnaay Gallery, Amsterdam
2002 Tjalf Sparnaay Gallery, Amsterdam
2002 Gallery Utrecht, Utrecht
2007 OK Harris Works of Art, New York

Articles, Books, Catalogues:
'The Aesthetic of the Ordinary', *Rush on Amsterdam*, Summer 2002
'Het schone van het gewone', *Elegance*, September 2004
Exactitude III, exh. cat., Plus One Gallery, London, 2006

I Want Candy: The Sweet Stuff in American Art, exh. cat., Hudson River Museum, Yonkers, N.Y., 2007

Representation, exh. cat., Jenkins Johnson Gallery, San Francisco, 2007

'Sparnaay Solo in New York', *De Gooi- en Eemlander*, 24 January 2007

Wim Boevink, 'Draadjesvlees', *Trouw*, 26 January 2008

JAMES VAN PATTEN

Born:
1939, Seattle, Washington, USA

Education:
1961–65, BA, University of Washington, Seattle, Wash.
1965–68, MFA, University of Michigan, East Lansing, Mich.

Solo Exhibitions:
1993 O.K. Harris Works of Art, New York
1999 O.K. Harris Works of Art, New York
2003 O.K. Harris Works of Art, New York
2008 O.K. Harris Works of Art, New York

Articles, Books, Catalogues:
Miami Herald, 7 April 1988 (review of one-man show at OK South)

A Survey of Contemporary American Realism, exh. cat., Posco Gallery, Seoul, South Korea, 1996

John Driscoll and Arnold Skolnick, *The Artist and the American Landscape*, Cobb, Calif.: First Glance Books, 1998, p. 87

'Wetlands, the Paintings of James Van Patten', *Watercolor* (an American Artist publication), Winter 1999

New American Painting, no. 27, Spring 2000

STEVE WHITEHEAD

Born:
1960, Coventry, England

Education:
1978–81, BA Visual Art, University College of Wales, Aberystwyth
1982–84, MA Visual Art, University College of Wales, Aberystwyth
1985–86, Conservation of Wall Paintings, Courtauld Institute of Art, London

Solo Exhibitions:
2003 Panter & Hall Gallery, London
2005 Panter & Hall Gallery, London
2006 Panter & Hall Gallery, London
2008 Plus One Gallery, London

Articles, Books, Catalogues:
Resurgence Magazine, January 2002
Art of England Magazine, July 2006
Who's Who in Art, 2006
Michael Paraskos, *Steve Whitehead*, London: Orage Press, 2008

CRAIG WYLIE

Born:
1973, Masvingo, Zimbabwe

Education:
1992–96, BFA Rhodes University, Grahamstown, South Africa

Exhibitions:
2003 Plus One Gallery, London
2005– *BP Portrait Award*, National Portrait Gallery,
2008 London
2006 *Secret Portrait*, National Portrait Gallery, London
2006 *The Portrait*, Ashwin Street, London
2006 Jonathan Cooper, London
2007 Everhard Read, Johannesburg
2007 *Craig Wylie – Paintings*, Karen McKerron, Johannesburg
2008 Jonathan Cooper, London

Articles, Books, Catalogues:
Sunday Telegraph Magazine, 21 June 2003
Country Magazine, October/November 2004
Artists & Illustrators, September 2006
'Masterclass', *The Artist's Magazine*, September 2006
'Best of British', *Country Life*, March 2008
Sarah Vine, 'BP Portrait Award at the National Portrait Gallery', *The Times*, 10 June 2008
Mark Brown, 'Portrait of Lover Wins BP Prize', The *Guardian*, 17 June 2008
'Rhodes-trained Artist Clinches BP Portrait Award 08', The *South African Art Times*, July 2008

CM3270